The Structure and Agency
of Women's Education

The Structure and Agency of Women's Education

Edited by
Mary Ann Maslak

STATE UNIVERSITY OF NEW YORK PRESS

Published by
State University of New York Press, Albany

© 2008 State University of New York

For information, contact State University of New York Press, Albany, NY
www.sunypress.edu

Production by Ryan Morris
Marketing by Anne M. Valentine

Library of Congress Cataloging-in-Publication Data

The structure and agency of women's education / edited by Mary Ann Maslak.
 p. cm.
 Includes bibliographical references and index.
 ISBN 978-0-7914-7275-0 (hardcover : alk. paper)
 ISBN 978-0-7914-7276-7 (pbk. : alk. paper)
1. Women—Education—Cross-cultural studies. 2. Education and state—
Cross-cultural studies. 3. Educational equalization—Cross-cultural studies.
I. Maslak, Mary Ann, 1960–

LC1481.S83 2008
371.822—dc22

 2007002075

10 9 8 7 6 5 4 3 2 1

To Evelyn, Hilda, and Peg,
remarkable women and exceptional role models

Contents

PART II
Structure and Agency of International Forces for Female Education

PART III
Social Relations as Structural Parameters
Defining Females' Agency in Education

PART IV
Women and the Research Setting:
The Intersection of Structure and Agency in Methodologies

Illustrations

FIGURES

TABLES

Introduction

MARY ANN MASLAK

The field of development encompasses the study of how society functions
with specific regard to the betterment of all individuals in particular commu-
nities. It is widely acknowledged and accepted that education—the formal,
nonformal, and informal ways and means that enable and facilitate the trans-
mission of knowledge—plays a critical role in development because it provides
the foundational intellectual resources for the enhancement of an individual's
life. In other words, education enables development by offering, widening, and
deepening individuals' knowledge and skills, which are essential for advance-
ment (Stromquist 2005; Young 2000). Thus, studies in international and com-
parative educational policies and programs, by judiciously exploring the edu-
cation-development nexus in both industrialized and nonindustrialized
settings, have no doubt furthered our understanding of development. This
book is another attempt to shed light on the intimate relationship between
education and development in comparative terms, but it does so by focusing
on one segment of the population—adolescent girls and young women.

In the last three decades or so, a plethora of scholarship has revealed the
unquestionable underenrollment and underachievement of primary school-age
girls in many parts of the world. At the same time, it should be noted that there
has been discernable progress. Many factors, such as the enactment of better
and more effective policies, the increase in funding, and the implementation of
sound initiatives, have contributed to the general improvement of the educa-
tional situation of girls in many parts of the world, especially at the primary
level. However, the case of the education of adolescent girls and young women
presents a far less rosy picture. To begin with, not as much attention has been
devoted to the study of this segment of the population. Studies that have been
conducted reveal the indisputable, disconcerting fact that adolescent and adult

females in many countries have neither enjoyed the same access to schooling nor obtained the same levels of schooling as their male counterparts. Moreover, their experiences in educational programs warrant attention to understand the successes and failures of projects designed to meet the needs of this segment of the population. While there have been calls and actions to address the inequity besetting adolescent girls and women, they generally espoused vague, albeit well-intentioned, goals and objectives that are far from comprehensive or effective. Although there is the obviously right and necessary emphasis on the need for equity between the sexes, the laudable aim has not been nearly adequately realized by programmatic schemes.[1]

The dearth of literature on the education of adolescent girls and young women leaves us with many unanswered questions. How have educational policies addressed the needs of the adolescent girl and adult woman? How have international, national, regional, and local initiatives addressed education for this segment of the population? How have international and national non-government organizations worked to address the educational aspirations of females? And in terms of studying and researching, what methods have been developed and used in order to reach a clearer understanding of the female research participant? In short, we have not yet critically, systematically, and methodically examined the phenomenon of the undereducation of adolescent girls and adult women.

If we believe that education is one conduit through which advancement toward a better life can be obtained, we must examine the situations, circumstances, and conditions that contribute to and/or hinder the enrollment in and successful completion of educational programs on the part of adolescent girls and young women. In short, we must pinpoint and evaluate the educational policies, programs, and practices that offer and/or deny the individual, within the given social structures that define her home and work settings, opportunities for change and amelioration. In addition, we must also identify and assess the extent to which organizations and agencies are encouraged to or prohibited from developing and initiating policies and implementing programs for girls and women in order to promote educational obtainment. Hence, this volume's exploration of adolescent girls and adult women's education[2] is based on the premise that the use of interdisciplinary and comparative approaches to examine educational policies, programs, and practices will reveal the complexities of the factors, situations, circumstances, and conditions that specifically pertain to this sector of the population.

This introductory chapter lays out the general parameters of the intellectual concerns and investigative approaches of the volume's chapters, while offering the conceptual premise that underpins this anthology. The conceptual underpinning of the present endeavor derived from the major tenets of both the Women in Development (WID) and Gender and Develop-

ment (GAD) bodies of feminist literature. The various chapters, all seeking to understand the plight of females, draw from the strengths and insights from WID and GAD, but they also illuminate their inadequacies. To rectify their shortcomings, many of the chapters, without always explicitly saying so, complement and extend the WID and GAD interpretations by utilizing social theory's methodological relationism.[3] As Ritzer (1975a; 1975b; 1979; 1991), Ritzer and Gindoff (1994), and House (1990) note, methodological relationism, demonstrates the ways in which structures and agency are inextricably and meaningfully integrated. It refers to both methodological holism and methodological individualism.[4] Methodological holism uses social structures as units of analysis to build *macroscopic* social theories of how society functions. Methodological individualism uses the *microscopic* individual (or group of individuals) as the unit of analysis to examine how the actions, behaviors, and perceptions of the individual (or group of individuals) relate to the larger social systems. Accordingly, the authors of this volume contend, in one way or another, that the *integration* of agency and structure offers a more complete and accurate foundation for, conceptualization of, and explanation of the phenomenon of the undereducation of adolescent girls and young women.

To illustrate this major intellectual concern and analytic approach of ours, a brief definition of the two major conceptual terms of *agency* and *structure* is helpful. *Agency* is the action that propels deliberate movement through a structure(s) by an individual(s) and/or collective(s), with the expressed purpose of achieving a goal or desired outcome. It assumes recognition and response from others.[5] Two types of agency are useful in our work. *Oppositional agency* is the act of challenge in which an individual, alone or in concert with others, acts and plans to act against the established norms in a system (Jeffrey 2001). *Allegiant agency* is the collective and collaborative movement of an individual or group that aligns with popular thought in order to achieve a purpose (Jeffrey 2001). *Social structure*, on the other hand, refers to a set of interrelated and coexisting frameworks that provide the social conditions for and requirements of action (Ritzer 1991; Ritzer and Gindoff 1994). Macroobjective structures include institutions and organizations such as the state, the church, the community, and the family. Macrosubjective structures include communal values and societal norms, both secular and religious, that are developed and endorsed by the objective structures.[6] Relational characteristics among structures develop from both the location of and interaction between individuals belonging in some way to a group structure, which, in turn, promotes associations of membership, feeling of belonging, and identification that determines different groups (Merton 1968).[7] To put it another way, the nexus between agency and structure is engendered and determined by the fact that social relationships are forged and structured by the organizational patterns and experienced by individuals (or groups of individuals) (Radcliffe-Brown 1952).

AN INTERDISCIPLINARY LENS OF
FEMINIST THOUGHT: WID AND GAD

Feminist thought, of which WID and GAD are integral parts, to the extent it focuses on the female epistemological perspectives, is a useful foundation upon which to base our study of women's education, especially when it is filtered through the agency-structure analytic lens. From the angle of agency, feminist thought enables us to understand women's lives from a *personal* perspective, examining the particular social, economic, cultural, geographic, and/or historical circumstances, situations, and conditions that affect their lives (see Boswell 2003; Choi 2004; Hauser and Kuo 1998). From a structural perspective, feminist thought grapples with "*systems* . . . [that] describe and explain *women*'s situations and experiences" (Frye 2000, 195, emphasis added). For example, it illuminates how the societal divisions and categories of gender, class, and religious and ethnic affiliation relate to women and their education (see Adbi 1998; Coats 2000; Patel 1998; Wermuth & Monges 2002).

These perspectives are incorporated in both the WID and GAD frameworks as they relate to women's education, with varying degrees of success. WID comprises a set of principles that emphasizes women's roles in the development process.[8] WID emerged as a reaction to international development policies and programmatic initiatives based on the notion that every individual had equal access to opportunities for achieving goals and objectives. In order to include women in the development discourse, WID usually depicts women as oppressed individuals whose situation is defined by the universally accepted notions of social, cultural, and economic inequities.[9] Although the WID policies and programs of the 1970s and 1980s have indeed advanced the ways we think about women's oppression and the strategies used to alleviate it, development practitioners and scholars agree that they achieved relatively meager success in realizing the central goal of elevating women's standing. Consequently, there was a shift in development thinking from the focus on the individual (woman) as an explanation for inequity, largely based on her lack of agency, to an emphasis on the complex and interrelated forms of *social structures* that cause women's oppression.[10]

The GAD movement takes essentially the macroscopic perspective of society as the primary force that causes gender inequity. Specifically, it calls for a holistic conceptualization and analysis of the problems women face by focusing on social inequality resulting from social, cultural, political, and economic structures and their forces. Moreover, it assumes that gender, "a critical component of development, relates to culturally specific forms of social inequality, which are inherent in particular social and cultural institutions" (Young 1993, 135).[11]

As with WID, although the GAD literature has advanced the way we *think* about women's issues, it is not *realized* in educational policy. As the appendix

clearly shows, women's issues remain at the center of international meetings, and are often prominently featured in the policies generated at those conferences, but policy language remains focused in lofty goals and pragmatic "solutions" in terms of services and programs for adolescent girls and adult women, rather than in holistic conceptualization and specific mention of *how* social constructs shape and ultimately influence the lives of adolescent girls and young women.[12] The problem is that WID and GAD, in the final analysis, offer inadequate and incomplete depictions of both the causes of women's oppression and the means for their emancipation. The WID approach must be criticized for its focus on the individual, independent of her social settings, exclusive of the social forces that dictate her actions. This shortcoming points to the need to examine the agency of the individual (or individuals) *in the context of* the social, cultural, religious, economic and political structures, and/or organizations and systems that shape and ultimately define her life. The GAD approach contends that social structures relate to oppression, but it fails to critically tease out the ways in which the structures are constructed and perpetuated by individuals. Additionally, although both the WID and GAD feminist frameworks have been used extensively in the educational literature, neither fully recognize the relationship between agency and structure, nor adequately explain how agency and structure permeate and percolate to aid our understanding of adolescent girls and adult women's education. Such a shortcoming is consciously and deliberately addressed in this volume by drawing on the insights of social thought.

AN INTERDISCIPLINARY LENS
OF SOCIAL THEORY: RELATIONISM

When couched in extreme terms, pitted against each other or seen separately, neither macroscopic (structure) nor microscopic (agency) theories adequately explain sociological phenomena. The macro model ignores the importance of history and the process of social change, failing to consider the influence the individual wields in the forging of the social system and how the social relations affect one's ability to advance. The micro paradigm discounts the importance of the institutional and organizational parameters that shape the social structures in which people inexorably live and work, inadequately explaining how institutions and organizations enable and disable individuals' social action and movement. In short, one-sided adherence to either the macrostructural perspective (i.e., the social facts paradigm) or the micro-individual perspective (i.e., the social definition and social behavior paradigms) results in the inability to comprehensively depict the existing forces, circumstances, situations, and conditions that account for sociological phenomena, thereby ignoring the interactions among them, some of which may help to explain the phenomena.[13]

Thus, analytic frameworks without sufficient explanations of the relationship *between* and *among* individuals and the social structures fail to examine the multifaceted and interrelated parts of the whole of girls' and women's education. By examining the nexus of social structures and their relationships vis-à-vis the gendered relationships of individuals, or groups of individuals, we may provide a deeper understanding of existing theory and/or practice in and for the field.[14] In this way, methodological relationism, integrating both agency and structure, provides a useful general analytic framework for the chapters in this volume.

Methodological relationism is an epistemological framework in which the macro (or structure) and micro (or agency) are conceptualized both independently and in relation to each other (Ritzer and Gindoff 1994). We use it to identify, comprehend, and explain existing phenomena. Scholars who have written in the field, including but not limited to James House, George Ritzer, and Pamela Gindoff, assert methodological relationism shows that a social phenomenon can only be fully understood by investigating the dynamic conditions, circumstances, and situations of the players in a particular situation, focusing on the *interaction* between the macroscopic social elements and microscopic individual movement. It consists of two basic tenets. First, there is the existence of both individuals and wholes. *Individuals* include members of the population, who, to varying degrees, recognize the persistent pattern of expectations and relations in a social system.[15] The *wholes* are the systems and structures in which organizations and institutions function. Second, in order to understand a social phenomenon, both individuals (or collectives of individuals) and wholes (or social structures) cannot be adequately explained without analyzing the inherent relationships between them. In other words, methodological relationism posits that *neither* individuals *nor* wholes alone sufficiently explain a social phenomenon, since the phenomenon is formed by the relationships between individuals and governed by the social-structural elements of the community.[16] Especially influential is George Ritzer (1975a; 1975b; 1979), who gives us the integrated sociological paradigm. Ritzer suggests that the interrelationships among the model's micro/macro and subjective/objective quadrants reveal four major levels of social analysis.[17] The macroobjective quadrant simply identifies maintenance systems, such as organizations and institutions, which define the society's structural parameters. The macrosubjective quadrant includes representations that constitute structural constraints and opportunities. It also includes inherent values and norms that are represented by the institutions. The microsubjective level reflects individuals' perceptions of, attitudes toward, beliefs about, and valuations of the macroobjective structural parameters. Finally, the micro-objective section deals with the patterns of observable action and interaction between individuals and the organizations and institutions.

Unlike other works that focus on social theory's concept of dualism (that is, agency versus structure), this book extends the work of earlier scholars by focusing on the ways in which the dynamic interaction of the concepts help clarify and shed light on educational policies, practices, and programs for adolescent girls and young women. Although most popular from the late 1960s through the 1980s, prompted by the groundbreaking studies on kinship by Levi-Strauss, and later by the sociological works of Bourdieu, Berger and Luckmann (1966), and Giddens (1976; 1977; 1979; 1982), this sociological framework continues to provide a useful perspective for any work that deals with agency and structure.

CONTENTS AND PURPORTS: THE SECTIONS AND CHAPTERS

The book consists of four parts: "Structure and Agency of Educational Policy for Adolescent Girls and Adult Women"; "Structure and Agency of International Forces for Female Education"; "Social Relations as Structural Parameters Defining Females' Agency in Education"; and "Women and the Research Setting: The Intersection of Structure and Agency in Methodologies."

Part I: Structure and Agency of Educational Policy for Adolescent Girls and Adult Women

Significant efforts by development theorists and practitioners over the past three decades have created new opportunities and expanded existing opportunities for education, driven by the initiatives in educational policies. Part I of the book outlines fundamental principles of public policy and their applications in education for females. It defines structure in terms of policies' overarching parameters as outlined by international and national bodies and agency in terms of the abilities of both policies and individuals to promote action and change in the realm of female education.

In chapter 1, "The Intersection of Public Policies and Gender: Understanding State Action in Education," Nelly P. Stromquist examines the case of female education in terms of public policy. She defines structure with reference to the various types of public policies and agency by exploring gendered educational policies that attempt to serve the needs of women and girls. In the past decade activists in the women's movement, as well as researchers and observers of our social world, have reached a consensus that for social change to take place at a comprehensive scale and in sustainable form, the role of the state is essential. The engagement of the state implies that public policies must become a key mechanism to solve certain problems, particularly those involving social inequalities.

Chapter 2, "Assessing the Status and Prospects of Women's Empowerment through Education: A Case Study of Women Students at the University of The Gambia," by Caroline Manion, offers a theoretical discussion of Bourdieu's concept of habitus and its usefulness for our understanding of how gender influences Gambian governmental policy on women's education. Using women's decision-making ability as an indication of empowerment, Manion assesses the impact of the Gambian government's policy efforts to increase women's access to and retention in university as a component of the country's plan to strengthen its human capital resource base. Her findings suggest that structures of patriarchy and economics influence the educational policy that governs women's agency to participate and perform in formal education.

An alternative perspective on policy is offered by Sandra L. Stacki in chapter 3, "Structure and Agency in India's Teacher Education Policy: Women Teachers' Progress through a Critical Feminist Lens." Here, Stacki examines India's National Policy on Education that provides specific directives concerning teachers and teacher-education institutions. Through the lens of critical feminist ethical thought, this chapter explores the ways in which the policy's framework defines women teachers' rights to obtain and maintain teaching positions, and the extent to which its implementation empowers them to function as agents of change for the profession.

Lucy Mule's work concludes this section on educational policy. In "Feast or Famine for Female Education in Kenya? A Structural Approach to Gender Equity," she argues that educational policy and practice in Kenya fail to address educational gender inequity. Mule presents a brief history of educational gender inequity in Kenya, critically analyzes the failure of the expansionist methods of school development used by the state to address the gender divide, especially in the public/private sector, and suggests an alternative discourse that may lead to a reformulation of educational policy and schools that effectively promote educational gender equity in the country.

Part II: Structure and Agency of International Forces for Female Education

One function of globalization is the use of bilateral and multilateral organizations to assist national governments in their quest to improve the lives of their citizens. Large-scale international organizations and governmental offices, including but not limited to UNICEF and ministry of education offices, have maintained enduring and significant influence in the design and implementation of policies and programs for adolescent girls and adult women. Small-scale operations, such as nongovernmental programs and individual scholarship programs, have also had significant impact on the chances and experiences of educational programs for adolescent girls and adult women. Thus, part II of the book substantiates contemporary applications of social

theory by demonstrating the various ways in which structure and agency intersect in the context of globalization as a result of the presence of the international organizations, big and small, on the local scene. The contributors identify structure either in terms of large- or small-scale programs that have shaped and governed education for females. They define agency in terms of the collective actions taken by the international organizations, as well as the individual actions of both the donors and recipients in the smaller programs.

David Chapman and Shirley Miske inaugurate this section of the book with their comparative research in Africa. Their chapter, "Promoting Girls' Education in Africa: Evidence from the Field between 1996 and 2003," sums up the work of thirty-four countries that participated in UNICEF's African Girls' Education Initiative (AGEI). They draw on Galal's (2002) three approaches to policy formulation: the *engineering approach* that views education as a production function in which the quantity, quality, and mix of inputs (structures) determine educational outputs and longer-term outcomes (agents); the *industrial organization approach* that considers educational structures in terms of policies and agents in terms of actors (school administrators, teachers); and the *political accountability approach* that concerns the ability of citizens (agents) to influence policymakers' formulation of educational policies and allocation of resources (structures) for female education.

Chapter 6, "The Dance of Agency Structure in an Empowerment Educational Program in Mali and the Sudan," by Karen Monkman, Rebecca Miles, and Peter Easton uses social and feminist thought to analyze data from a study of one nongovernmental organization's program in central Africa. They tell the story of six Malian and Sudanese villages' experiences with an "empowerment program" designed to promote community decision-making and action. Their findings reveal the ways in which an NGO (as a structure of a civil society), and their individual members (as citizens with agency), together, exert impact on the political institutions and society in democratic states.

Cathryn Magno's chapter takes a different perspective on *education*, defining it as the acquisition of information to function as a politically active member of a community. In "Res publica Revisited: Gendered Agency through Education in NGOs," she demonstrates how individual participation in the political process varies across social groups in a democratic society. Magno furthers the earlier work of both Molyneux (1985) and Hasan (1994) by exploring the critical role played by Israeli and Palestinian nongovernmental organizations (NGOs) in providing structure for women's participation in society and in enabling women's agency through educational processes. Magno's findings suggest that NGOs can provide an alternative structure within which women can safely cultivate and activate their agency to critique the government, gain more political power, and make contributions to public discourse on behalf of women in the community.

Vilma Seeberg's essay, which constitutes chapter 8, presents qualitative results of a mixed methodological study of an international scholarship program for adolescent girls' education in northwestern China. In her chapter entitled "Their One Best Hope: Educating Daughters in China," through the use of the female students' poignant stories, she shows how social, cultural, and economic structural parameters of life influence and affect the agency of the girls to enroll in, continue through, and graduate from school, which is, in large part, funded by the individual financial contributions of sponsors.

Part III: Social Relations as Structural Parameters
Defining Females' Agency in Education

The question of the intersection and interaction of structure and agency in the study of adolescent girls' and adult women's education can also be examined more specifically in terms of the weight of sociocultural forces. The authors of this section examine three different cases and correspondingly provide three different perspectives from which to view the intervening power of sociocultural values. They give us meaningful descriptions and discussions of the ways elements of a sociocultural system function as enabling or disabling factors in the agency of adolescent girls and adult women, giving consideration to the microsubjective components (individuals' wishes, aspirations, and actions) as well as the macrosubjective ingredients (sociocultural settings that promote communal values and maintain histories) (Ritzer 1991). In this part of the book, the authors parse the meanings of these contexts so as to show how individual agency is negotiated and mediated through norms generated and defined within the particular social, cultural, and political environments of the school, community, and state.

The authors of chapter 9, "Female Classroom Assistants: Agents of Change in Refugee Classrooms in West Africa?," Jackie Kirk and Rebecca Winthrop show how participants in the International Rescue Committee (IRC) are actually involved in the implementation of an innovative program of training and deploying female classroom assistants in the refugee schools they support. They shed light on the relationship between agency and structure by analyzing the classroom assistants' approach in IRC schools in Sierra Leone and Guinea. Drawing on data collected during recent fieldwork, the authors discuss how agency within the underlying gender-power dynamics of the classroom (in terms of female classroom assistants' creation of a gender equitable and girl-friendly school space) and structure (in terms of the school's administration that promotes, supports, and executes such a program) work in conjunction to advance adolescent girls and adult women in these locations.

Chapter 10, "A World Culture of Equality? The Institutional Structure of Schools and Cross-National Gender Differences in Academic Achievement,"

uses comparative cross-national data that the author, Alexander Wiseman, marshaled. It examines the reasons academic achievements differ by gender. His work not only challenges the assumption that the anticipation of future opportunities (structure) shapes current performance (agency) but also shows how individual association (agency) with citizenship (structure) relates to adolescent girls' achievement in school.

Chapter 11 bears the title of "Looking Beyond the Household: The Importance of Community-Level Factors in Understanding Underrepresentation of Girls in Indian Education." Its author, Amita Chudgar, while acknowledging the importance of household-level factors in understanding differences in school participation by sex, focuses on the role of factors "outside the household." Using empirical data from India, she examines external factors that relate to the social status of women within the community. Her findings indicate that the structure of social class and the agency (or lack thereof) of social status influence household decision-making as regards educational choices and chances for women.

Part IV: Women and the Research Setting:
The Intersection of Structure and Agency in Methodologies

Human beings act within the social perimeters that circumscribe their lives. Thus, individuals, regardless of the role they play, experience agency and structure simultaneously. This section of the book examines the interaction of agency and structure as they relate to innovative methodologies and techniques in research that investigates the question of the education of adolescent girls and adult women. The authors accomplish two goals. First, they show how the agency of the participant and researcher functions within the structures of the research setting. The research setting provides the framework for the participant; the research questions provide the structure for the researcher. The interaction between the participant(s) and researcher offers opportunities for agency between and/or among the research participants and researchers. Second, the authors demonstrate how innovative techniques in drawing and photography provide frames within which the individuals can act and react to the methods employed.

In the chapter by Flavia Ramos, "Life's Structures and Individual's Agency: Making Sense of Women's Words," the stories told by Hispanic women and adolescent girls in inner-city America reveal how individual actions and interactions shape and are shaped by the social structures that define life experiences. Ramos focuses on a group of low-income Hispanic women and adolescent girls taking part in two community-based organizations' self-help groups in Massachusetts. Using the structure of the FotoDialogo method, a research tool that uses pictures and storytelling as projective

props that record the voices of both girls and women, Ramos illuminates the ways in which the nonformal groups function in the lives of their participants.

In chapter 13, "Policy as Practice, Agency as Voice, Research as Intervention: Imag(in)g Girls' Education in China," Heidi Ross offers a fitting conclusion for the book. In this work, Ross uses photovoice, a dialogical research methodology that employs photography, to examine data collected from a study of Shaanxi Province's largest NGO-supported girls' education project. In so doing, she demonstrates how the adolescent girls' critical consciousness reflects agency, which is shaped by the social-structural conditions in which they live, and contributes to their school achievement and aspirations.

In short, in one way or another, the various authors interrogate the common underlying theme of this anthology: the inexorable links between agency and structure, and the mutual dependence of the microscopic and macroscopic elements, in the domain of the education of adolescent girls and young women. In the process, we hope to have complicated, and thus enriched, nuanced, and furthered, our current understanding of the manifold factors and forces at work in the complex endeavor of delivering and improving the education of a significant segment of the population, such that it may become a productive citizenry and human capital that readily contributes to and participates in national development and social amelioration.

NOTES

I would like to thank St. John's University for funding conference participation that led to the completion of this edited book. Portions of this chapter are based on Maslak (2003).

1. See the appendix, which, in some parts, is directly quoted from the original documents.

2. We chose to focus our work on both adolescent girls and adult women. UNICEF defines girls (and boys) as children ages 0–18. Adult women are over the age of 18. We do not focus on the "girl child."

3. Whereas Lengermann and Niebrugger-Brantley (1990), more than fifteen years ago, illuminated the points of interface between agency and structure in their review of feminist thought of the late nineteenth and early twentieth centuries, they did not use this argument to specifically address adolescent girls' and women's education.

4. The American sociological literature often uses the terms *microscopic* and *macroscopic*. The European sociological literature often uses the terms *agent/agency* and *structure*. Space does not permit extensive discussion of the similarities and differences of the terminology.

5. This distinction is sometimes described as that of action from mere behavior. For example, Naila Kabeer (1999a, 437), who has written extensively on gender and development, defines female agency as "processes by which those who have been

denied the ability to make strategic life choices acquire such an ability," Kabeer (1999b).

6. See Ritzer (1975a; 1975b; 1979; 1991) for an in-depth explanation.

7. Radcliffe-Brown (1952) supports the notion of a nexus between agency and structure in terms of social relationships structured by organizational patterns and experienced by individuals or groups of individuals.

8. For discussion of the theoretical frameworks used in the WID literature, see Maslak (2003).

9. For articles that examine the WID movement with regard to women's education in the governmental sector of nations, see Nelly P. Stromquist (1998; 1999).

10. See Moser (1993) for five approaches to development during this period, 1970 to the mid-1990s.

11. Alili Mari Tripp (2000) and Ferree, Lorber, and Hess (1999) assert that women within the gender schema do not exist in a vacuum, but rather, their gender is intertwined with class, race, and economy, all of which relate to the issues and conditions of domination and oppression. Nupur Chaudhuri (1992, 222) also mentions this point regarding the Muslim population. She states, "the status and role of Muslim women in the Indian subcontinent are best understood by analyzing the socioeconomic strata to which these women belong and the political and economic status of the Muslim community itself in the context of wider social, cultural, and economic conditions of the entire India society." England (1993) provides a useful review (and debate) of sociological theories that have been used to examine gender stratification.

12. See Maslak (2005) for an analysis of EFA (Education for All) policy and GAD.

13. We must keep in mind that that both micro and macro approaches to the study of a phenomenon were developed from the male perspective. Social theory developed by women may advance our understanding of issues concerning women.

14. See Dunn, Almquist, and Chafetz's (1993) volume that offers a number of chapters dedicated to the discussion of the macro/micro debate. Bulbeck (2001) uses the concepts of agency and structure to examine college students' understandings of feminisms.

15. This definition is based on the work of James House (1990).

16. Indeed the landmark works of Robert Merton (1975), Hugh Mehan and Houston Wood (1975), and Arthur W. Staats (1976) all emphasize the need to examine both social structural and individual aspects of social systems. Later, James House (1991, 50) grappled with "individual behavior and social organization as joint functions of properties of the individual and of the social situation" (48–49) in an effort to "understand, explain, and predict consequential real-life phenomena and problems."

17. Ritzer provides an extensive review of the literature that relates to and grounds this work on the integrated sociological paradigm. See George Ritzer (1991) for details.

REFERENCES

Adbi, A. A. 1998. Economic liberalization and women's education: Prospects for post-apartheid South Africa. *McGill Journal of Education*, 33 (1): 71–84.

Berger, P. L. and T. Luckmann.1966. *The social construction of reality: A treatise in the sociology of knowledge*. Garden City: Doubleday.

Boswell, B. 2003. WEAVEing identities. *Feminist Studies*, 29 (3): 581–591.

Bulbeck, C. 2001. Articulating structure and agency: How women's studies students express their relationships with feminism. *Women's Studies International Forum*, 24 (2): 141–156.

Chaudhuri, N. 1992. Women in Asia. *NWSA Journal*, 4 (2): 219–227.

Choi, C. (Hwa Young). 2004. Art as a political act: Expression of cultural identity, self-identity and gender in the work of two Korean/Korean American women artists. DAI-A64/12.

Coats, M. 2000. Barriers or building blocks? *Adults' Learning*, 11 (7): 16–18.

Dunn, D., E. M. Almquist, and J. Saltzman Chafetz. 1993. Macrostructural perspectives on gender inequality. In *Theory on gender: Feminism on theory*, edited by P. England, 69–93. New York: Aldine de Gruyter.

Edel, A. 1959. The concept of levels in social theory. In *Symposium on sociological theory*, edited by Llewellyn Gross, 24–38. Evanston: Row Peterson.

———. 1990. *Education for all*. Jomtien: Thailand.

England, P. (Ed.). 1993. *Feminism on theory*. New York: Aldine de Gruyter

Enslin, P. and M. Tjiattis. 2004. Liberal feminism, cultural diversity and comparative education. *Comparative Education Review*, 40 (4): 503–516.

Ferree, M. M., J. Lorber, and B. B. Hess (Eds.) 1999. *Revisioning gender*. Thousand Oaks: Sage Publications.

Frye, M. 2000. Feminism. In *Encyclopedia of feminist theories*, edited by L. Code, 195–197. London: Routledge.

Galal, A. 2002. The paradox of education and unemployment in Egypt. Working Paper No. 67. Cairo: Egyptian Center for Economic Studies.

Giddens, A. 1976. *New rules of sociological method: A positivist critique of interpretive sociologies*. New York: Basic Books.

———. 1977. *Studies in social and political theory*. New York: Basic Books.

———. 1979. *Central problems in social theory: Action, structure and contradiction in social analysis*. Berkeley: University of California Press.

———. 1982. *Profiles and critiques in social theory*. Berkeley: University of California Press.

Hasan, Z. (Ed.). 1994. *Forging identities: Gender communities and the state*. New Delhi: Kali for Women.

Hauser, R. M. and H. H. D. Kuo. 1998. Does the gender composition of sibships affect women's educational attainment? *Journal of Human Resources*, 33 (3): 644–657.

House, J. 1990. Social structure and personality. In *Social psychology: Sociological perspectives*, edited by M. Rosenberg and R. Turner, 525–561. New Brunswick: Transaction.

Jeffrey, P. 1998. Agency, activism, and agendas. In *Appropriating gender: Women's activism and politicized religion in South Asia*, edited by P. Jeffrey and A. Basu, 42–57. New York: Routledge.

———. 2001. Agency, activism and agendas. In *Women, gender, religion: A reader*, edited by E. A. Castelli, 465–491. New York: Palgrave.

Kabeer, N. 1999a. *Reversed realities: Gender hierarchies in development thought*. London: Verso.

———. 1999b. Resources, agency, achievements: Reflections on the measurement of women's empowerment. *Development and Change*, 30: 435–464.

Kosambi, M. 2000. A Window in the prison-house: Women's education and politics of social reform in nineteenth-century western India. *History of Education*, 29 (5): 429–442.

Lengermann, P. M. and J. Niebrugger-Brantley. (Eds.) 1990. *The women founders: sociology and social theory 1830–1930*. Boston: McGraw Hill.

Maslak, M. A. 2003. *Daughters of the Tharu: Gender, ethnicity, religion and the education of Nepali girls*. New York: RoutledgeFalmer.

———. 2005. Re-positioning females in the international context: Guiding frameworks, educational policy and future directions for the field. In *International perspectives on education and society*, edited by D. P. Baker and A. W. Wiseman, 145–171. London: Elsevier Science.

Mehan, H. and H. Wood. 1975. *The reality of ethnomethodology*. New York: John Wiley and Sons.

Merton, R. 1968. *Social theory and social structure*. New York: The Free Press.

———. 1975. Structural analysis in sociology. In *Approaches to the study of social structure*, edited by P. Blau, 21–52. New York: Free Press.

Mill, J. S. 1869. *The subjugation of women*. London: Longman, Green, Reader and Dyer.

Molyneux, M. 1985. Mobilization without emancipation? Women's interests, state and revolution in Nicaragua. *Feminist Studies*, 11: 227–254.

Moser, C. 1993. *Gender planning and development: Theory, practice and training*. New York: Routledge.

Patel, I. 1998. Analysis of the effects of sibling gender composition on women's educational attainment. *International Review of Education*, 44 (2–3): 155–175.

Radcliffe-Brown, R. (1952). *Structure and function in primitive society*. New York: The Free Press.

Ritzer, G. 1975a. *Sociology: A multiple paradigm science. Revised ed.* Boston: Allyn and Bacon.

———. 1975b. Sociology: A multiple paradigm science. *American Sociologist*. 10: 156–167.

———. 1979. Toward an integrated sociological paradigm. In *Contemporary issues in theory and research: A metasociological perspective*, edited by W. E. Snizek, E. R. Fuhrman, and M. K. Miller, 25–46. London: Aldwych Press.

———. 1991. *Metatheorizing in sociology*. Lexington: Lexington Books.

Ritzer, G. and P. Gindoff. 1994. Agency-structure, micro-macro, individualism-holism-relationism: A metatheoretical explanation of theoretical convergence between the United States and Europe. In *Agency and structure: Reorienting social theory*, edited by P. Sztompka, 3–23. Amsterdam: Gordon and Breach.

Robinson-Pant, A. (2004). Education for women: Whose values count? *Gender and Education*, 16 (4): 473–489.

Staats, A. W. 1976. Skinnerian behaviorism: Social behaviorism or radical behaviorism. *The American Sociologist*, 11: 217–219.

Stone, L. 1994. *The education feminism reader*. New York: Routledge.

Stromquist, N. P. 1998. The institutionalization of gender and its impact on educational policy. *Comparative Education*, 34 (1): 85–100.

———. 1999. Women education in the twenty-first century. In *Comparative education: The dialectic of the global and the local*, edited by R. Arnove and C. Torres, 179–205. New York: Rowman & Littlefield.

———. 2005. Comparative and international education: A journey toward equality and equity. *Harvard Educational Review*, 75: 89–111.

Tripp, A. M. 2000. Rethinking difference: Comparative positions from Africa. *Signs: Journal of Women in Culture and Society*, 25 (3): 649–675.

Wermuth, L. and M. A. K. Monges. 2002. Gender stratification. *Frontiers*, 23 (1): 1–14.

Young, K. 1993. Frameworks for analyses. In *Planning development with women: Making a world of difference*, 127–146. New York: St. Martin's Press.

Young, Y. J. 2000. Educational development. In *Encyclopedia of sociology*, x–x. New York: Macmillan.

PART I

Structure and Agency of Educational Policy for Adolescent Girls and Adult Women

CHAPTER 1

The Intersection of
Public Policies and Gender

Understanding State Action in Education

NELLY P. STROMQUIST

INTRODUCTION

After a long period of discarding collaboration with the state, the women's movement now increasingly considers it necessary to influence public policy. This view is shared by feminist academics. Public policies acquire importance because of their potential for the attribution of legitimacy to a given social problem, the national coverage they may provide, their access to substantial financial and human resources, the duration they can enjoy, and the incentives or sanctions that accompany their implementation.

In the contemporary globalized world, education is acclaimed as a key element in the emergent "knowledge society." Education is seen as the main instrument by governments and society in general to achieve equality among diverse social groups, and especially between women and men. Both international organizations, particularly the United Nations, and civil society groups from many countries strongly advocate increasing opportunities for women to enter formal education. The World Bank, which wields inordinate influence on public policies in developing countries, assures us that "education is the most important productive asset most people will ever own" (Perry et al. 2003, 26). Social critics holding perspectives that generally oppose those of the World Bank nevertheless coincide with the Bank in asserting that access to and quality of educational services, along with health services, are the main paths to social integration.

Empirical evidence shows that policies tend to be more easily enacted than implemented. While the history of policy execution has typically shown a wide gap between declaration and reality, it is nonetheless the case that "laws are not just regulatory orders, but also normative frameworks, with the scope to enforce normative conceptions of the good, as well as shape them" (Subrahmanian 2002, 228). The presence of public policies on any given issue signals its specificity, importance, and the government's desire to work on it.

This chapter examines various types of public policy and discusses the prevailing forms and character of educational policies aimed at redressing gender asymmetries. To do so, it reviews the empirical evidence on public policies in various parts of the world, although it relies primarily on the Latin American experience.

DEFINING PUBLIC POLICY

Public policies are authoritative proposals emanating from above. They can take the form of legislation, programs, regulations, administrative practices, and court decisions. Public policies signal the identification of governmental priorities and, while they indicate a decision to act, implementation of such policies determines whether policies become a reality or not. Consequently, policies should be seen as a package that comprises four inseparable elements: enactment of intentions, regulations, implementation, and assessment of impact. These components do not occur in a mechanistically linear way as they are part of an active political process; nonetheless, they represent essential components of all policy. Below we explore various types of public policy and connect them to action on gender issues.

TYPES OF PUBLIC POLICY

Lowi (1964) proposes a comprehensive typology of *policy design* that can be extended to gender analysis. In his view, public policies fall under three categories:

- Distributive—those benefiting certain groups through service, contracts, and subsidies. Extending this categories to women, such policies could target them as a visible group, deserving to receive certain benefits such as electoral quotas or affirmative action to certain jobs.
- Regulatory—those that seek to have an impact on the general population and function in the sense of dictating norms that either limit or expand the choice of individuals and groups. Applying this to gender issues, such poli-

cies might set norms regarding nondiscrimination, abortion, rape, domestic violence, and labor rights, among others.
- Redistributive—those that affect the material differences between the rich and the poor and that imply substantial reallocation of resources. Extending these policies to gender issues, they would seek to provide women with greater material resources than they had previously such as higher wages, rights to property, and rights to inheritance.

Many of the feminist demands for policy have a redistributive character, but since resources are limited, a vigorous resistance to such policies emerges, particularly to those pertaining to wages and conditions of employment. Feminist thinkers, notably Fraser (1998), consider that in order to alter gender relations it is crucial to have both policies of recognition and policies of redistribution. She defines policies of recognition as those that acknowledge the specificity of women and their right to be different and yet enjoy the same rights as men. These policies of recognition, which at first sight seem to be easily accepted, are deeply contested as they challenge the ideological status quo. Adding to these policies the possibility of asset redistribution tends to make gender policies even more controversial.

A second typology of public policy is one that focuses on the *leverage* used to assure implementation and thus to attain an intended solution. Under this type of policy, we consider the mix of mechanisms used for compliance, which can be either threats if certain existing practices do not change or incentives to engage in new practices. One good example of this derives from U.S. gender policies in education. Title IX is a comprehensive antidiscrimination law that threatens to withhold federal contracts or federal assistance to institutions that discriminate against women. A complementary law, the Women's Educational Equity Act (WEEA) provides funds for the development of programs and curricular materials to encourage schools and universities to engage in new teaching practices and promote women-friendly educational environments. Thus, the persuasive character of policies may function through negative or positive strategies.

A third typology of public policy centers on the *human and financial resources* provided to attain a solution. Two key types emerge. The first may be called *rhetorical* (earlier in the literature, Edelman [1971] called them "symbolic"). In this case, there is visible recognition of the importance of a given problem but little specificity of the human and monetary resources, the governmental agencies in charge, and the mechanisms for enforcing its implementation and for monitoring or evaluating progress. The other, which might be called *substantive*, would include policies that assign human and financial resources in proportion to the objectives, present detailed and clear action plans, indicate timelines for the attainment of objectives, and are accompanied

by evaluation measures to assess impact. In this typology, policies range from superficial response to commitment as solid action. We can find contemporary examples of rhetorical policies. One of them is the *Attacking Poverty* report, produced by the World Bank (2001) ostensibly to demonstrate a shift in policy and to announce that the bank intended to work with "civil society" and with "empowerment." Yet the document does not give due attention to one of the most capable vehicles to carry out the new policies, nongovernmental organizations (NGOs). Further, it defines *empowerment* as participation in formal elections, without considering other fundamental components of the concept, such as consciousness-raising, identity formation, and mobilization carried out by women-led NGOs. In other words, the World Bank's policy implicit in this document fails to acknowledge key institutions constituting civil society and does not acknowledge the role of individual and collective change outside formal politics.

Whereas the dominant academic literature offers a rather normative view of the process of policymaking, feminist research indicates that the trajectory that gender policies have followed is quite distinct. Often the role of the women's movement through mobilization and particularly the institutionalized role of NGOs has been a key to identifying women's needs and calling for redress and solutions. Many of the most important changes affecting the social relations of gender have been generated by the women themselves and have taken the form of actions and programs at local levels before they became issues incorporated in national policies. Figure 1.1 illustrates the difference between normative and empirical views of public policy related to gender.

A fourth typology of public policies classifies them in terms of their *coverage*. Two main forms can be identified. Those that seek to reach everybody (system wide) and those that concentrate on a specific group or subgroup of the population (targeted). Title IX represents the first form as it applies to all public educational institutions. In contrast, WEEA is available only to those who present innovative proposals and succeed in the competition for funds.

In today's terminology, policies aimed at a small group are called *focal policies* and those that center on poor and vulnerable groups are called *compensatory policies*. Compensatory policies are those that seek to redress inequalities by focusing on the most extreme or needy groups; these policies represent the most tangible form of equity in public policy. Using Latin America as a referent, it can be observed that this region has so far adopted very few compensatory policies. The largest in scope and complexity is PROGRESA (now called *Oportunidades*), a Mexican effort that brought education, nutrition, and health services to poor rural families, which by 2005 had reached 5 million families in 82,856 localities. It is also the only compensatory policy in the region that considers the intersection between social class and gender; thus, it gives differential attention to older girls, in an attempt to lower the dropout

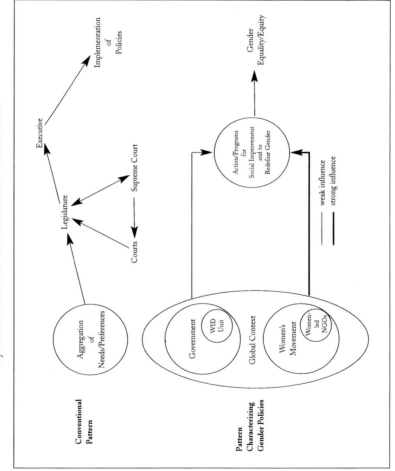

FIGURE 1.1

Dynamics Involved in the Formulation of Public Policies

rate among secondary school girls in rural areas. By 1999, Mexico's compensatory programs of various kinds had expanded to cover 46 percent of all public schools (Reimers, 2002). The existing compensatory programs in the Latin American region are few and subject to brief existence. They tend to address only social class (focusing on poor populations) but not ethnicity or gender. Critics of compensatory policies argue that these policies tend to be formulated and implemented in a context and through mechanisms that reproduce the very inequalities these policies seek to correct, for example, procedures characterized by paternalism or identification of the Other as deviant or as totally passive. Universal policies usually employ coercive tools (i.e., sanctions) rather than financial incentives. Focal policies rely more on incentives.

EDUCATIONAL POLICIES

If education is such a powerful tool for economic and social betterment, we would expect that public policy would seek to make education more accessible to all, to provide education of high quality, and to distribute it equitably at all levels—not just basic education but also secondary and tertiary education. Yet, the empirical picture is more complex and ambivalent in the allocation and quality of education.

Education, more than any other policy field, is characterized by multiple sources of authority and thus of policy formulation and implementation (Coombs 1994). The classroom, the school, the county or regional office, the state are some of the possible spheres, each comprising its respective actors engaged in educational policy. A study of educational policies must, consequently, be sensitive to the presence of these multiple actors and the varied agendas they pursue.

Speaking in the context of educational evaluation, but making an observation that can be extended to other areas, Reimers (2002) finds that in Latin America educational policies are shaped by competition between two forces: the institutional rules of state domination and elite decision-making and the wider transactions among the state, international agencies, and the local educational research community. Plank (1996) holds a similar view. After examining the political context of Brazil's education, he concludes that the poor performance of the educational system is not the result of poor implementation but rather the seizure of the educational system by the private interests of politicians and bureaucrats.

Simultaneously, educational policies are also shaped by both domestic and international influences. Within national politics in Latin America, ideas that have been translated into educational policies usually come from the executive branches, with only modest efforts to contest state dominance coming from

teachers' unions (Grindle 2002) and from universities and nongovernmental institutions (Reimers 2002). With the increasing pressures of economic globalization and large external debts owed by many developing countries, policies influenced by neoliberalism and neoconservatism have initiated an economic restructuring that has both questioned the capacity of governments to provide social services, including education, and diminished their financial capacity to invest in education (Carnoy 1995; Colclough 1997; Ball et al. 2003). Externally, international lending agencies have positioned themselves as key sources of proposals for reform and pressure to comply (Krawczyk 2002; Reimers 2002). In the Latin American region, international lending agencies (the World Bank and the Inter-American Development Bank) have become very influential, while UN agencies that support gender issues (UNESCO, UNICEF, UNIFEM, UNFPA) have, as a result of reduced budgets, found their influence weaker.

Two current global policies promote attention to gender in education. The Education for All (EFA) initiative, first announced in Jomtien (1999) and reiterated in Dakar (2000), upholds the need to secure educational access, learning, and successful completion of schooling at primary levels for both girls and boys and to attain gender parity in primary education by 2005 and at all levels of education by 2015. EFA commitments also identify the importance of quality schooling. The second global policy, the Millennium Development Goals (MDGs), accepted unanimously by all UN member countries in 2000, further identifies the need for education for all at the basic level, the provision of good quality education, and the elimination of gender gaps in schooling (UN 2000). These global policies have acquired significant weight in recent years because they are strongly endorsed by bilateral and multilateral development agencies. Countries are responsible for developing action plans responding to these global commitments and to implement them according to the timelines established for objective attainment.

EDUCATIONAL POLICIES ON GENDER

Public policies with a gender perspective are those dealing with issues shaping resource distribution, daily sociocultural transactions, and the quality of life of *men and women* around the world. Some policies may seek to transform the nature of social relations between men and women; others may seek to ameliorate them (e.g., the attainment of gender parity in access to basic education); yet others may seek to make questions of femininity and masculinity even more marked than in the past (e.g., the current possibility of revisiting the *Roe v. Wade* U.S. Supreme Court decision permitting abortion). Gender policies issued by the state, therefore, are not inherently advantageous for

women. Moreover, there is evidence that some general policies, particularly macroeconomic policies, have not been neutral toward gender (López Montaño 2005).

Educational policies from a gender perspective tend to be global in nature, as national policies often emanate from international agreements such as EFA and the UN MDGs. Following these agreements, most countries seek to provide universal basic education for both girls and boys and to reduce gender disparities in school access at all levels of education. Few countries, however, are making efforts to improve the schooling *content* and *experience* from a gender perspective.

Two major targets for transformation of gender through schooling are textbook revisions and teacher training. In actual practice, textbook revisions are usually in the hands of teams comprised of curriculum specialists but rarely persons with expertise in gender and education. Teacher training on gender is still limited to a small number of teachers as part of in-service training. Mexico—one of the most advanced countries in the Latin American region and the country with the largest and most powerful teacher union—has no gender component in its various teacher training programs (Cortina 2001). Until recently, no Latin American country incorporated gender issues in its initial teacher training programs. Some inroads seemed to have been made in Mexico, as a handful of its pedagogical universities are beginning to offer a gender and education specialization at the graduate level (Palencia Villa 2001).

Schooling as a Site for Reproducing Social Asymmetries

Gender is the social construction of biological sexual differences and the attribution of particular traits, abilities, and responsibilities to women and men, with the end result that asymmetrical power relations are built to the disadvantage of women. The construction of gender is linked to the development and imposition of notions of masculinity and femininity, for which cultural institutions such as public schools, the mass media, and the Catholic Church are essential.

Education is such a pervasive cultural value that few people are willing or able to see schools as institutions that protect a very uneven gender status quo. Connell (1996) refers to the gendered regimes of institutions, which through structural arrangements and daily practices recreate ideologies that are oppressive to girls and women. Schools are clearly gendered regimes: they engage in a sexual division of labor with women usually teaching at lower levels and men as teachers of higher levels and administrators. In their daily interactions, the young and the adults that inhabit the schools face ideas of masculinity as counterposed to notions of femininity (Eisenstein 1993). Authority patterns foster the mindset that men are naturally endowed to control and lead. Mas-

culinizing practices in discipline, sports, the peer culture, and some of the sex-segregated courses tell students and teachers alike that boys and men are superior to girls and women in many respects (Connell 1996). Numerous gender codes in school serve to recontextualize what is appropriate gender behavior in the family and community and translate it into appropriate gender academic and social practices in educational environments. The teachers' own ideology regarding sex roles is a major factor in determining their willingness to use nonsexist or antisexist materials (Streitmatter 1994); teachers untrained in gender issues, therefore, usually reproduce conventional views of femininity and masculinity. In other words, not only cognitive but also cultural, ideological, and emotional outcomes are reproduced by the schools. Some researchers, in fact, consider it difficult to separate from academic achievement and school knowledge such gendered aspects of schooling concerning sexuality, gender identity, gendered aspects of adolescent discourse, and subcultural norms of masculine and feminine behaviors that abound within school environments (Abraham 1995).

There have been shifts over time in the ideological construction of femininity and masculinity.[1] But a rationality that favors men prevails and thus men in administrative roles constitute the majority of educational leaders. School organizations and their processing of knowledge create venues that are not sufficiently critical of dominant social class and gender division to discourage their reproduction. Ironically, adults—either educators or parents—engage in a posture of denial vis-à-vis the total functioning of schools, not acknowledging the highly influential role of peers in the creation of gendered subcultures that often match the influence of the gendered regimes the schools themselves provide.

What Is Being Done

Given the tendency toward stability rather than change in educational systems, we can ask: How is gender constructed in public policies? How does the state respond to needs to change the power differentials that gender creates? How does the state respond to gender issues in society through the use of the educational system?

The most important educational policies in the Latin American region almost always do not mention gender. The content of a 1994 international seminar bringing together educators and policymakers from Bolivia, Chile, Mexico, and Peru (Edwards and Osorio 1995) is quite illustrative. The proceedings of the seminar reveal that important nationwide improvements in the quality of education are occurring in some countries that are assigning greater instructional, nutritional, and health resources to schools and improving the pedagogical levels of teachers. Yet, the proceedings of this seminar

reveal an absolute silence regarding gender issues, as references to girls or women simply do not appear in the text. A second example derives from the initiatives taken by PREAL (Partnership for Educational Revitalization in the Americas), an NGO deeply committed to improving and modernizing education in Latin America operating since 1995. According to a position paper, PREAL's main areas of action focus on quality (defined as improved performance in math and reading), decentralization of schooling, greater investment per student, and improvement of the teaching profession. PREAL is also interested in alternative ways of financing education, which suggests that it favors privatization (PREAL 1997). Most of the measures identified by PREAL will contribute to the betterment of public schools; however, it neglects gender issues. The only references the position paper makes to gender note that girls outnumber boys in enrollment, that there is a need to eliminate gender stereotypes, and that there is a need also "to provide girls with the same rewards as boys so that they may perform well in difficult subjects, such as math and science" with no further development of these ideas (PREAL 1997, 9). A third example is drawn from Pronunciamiento Latinoamericano, an Internet coalition of educators that seeks to defend the public school in Latin America. It upholds the principles of equality and social justice, calling for increased attention to children's rights, ecology, the situation of teachers, and for the importance of having education for citizenship, identity as a right, and education as resistance. While treating themes related to gender equality and equity, the exchanges of this coalition, which by 2005 comprised some two hundred NGOs working in both formal and normal education, are oblivious to the treatment of gender.

Not surprisingly, few countries in Latin America have developed comprehensive gender equity policies. They include Paraguay, Bolivia, and Argentina. Paraguay's gender policies in education seek curriculum reform, teacher training, and a review of textbooks. According to persons in charge of the Gender Unit in the Ministry of Education, they were able to change the curriculum to reflect women's contribution to society and to initiate a debate with teachers on sexuality. The unit produced modules on gender and sexuality, but as supplementary not core materials (Colazo 2000). Bolivia's policies sought to make gender a crosscutting theme throughout the curriculum and to incorporate such issues as health, sexuality, equity, and sustainable development. By 2002, the gender reformers had been able to provide training to resource teachers (i.e., those assisting classroom teachers) and to design general guidelines and curriculum content with a gender perspective for the first three years of primary schooling. The reformers have also provided training on school violence through a module—also as supplementary materials—entitled "Violence in the Schools" (Lazarte and Lanza 2000). In Argentina, which enacted the first national policy on gender and education

in Latin America, the PIOM (National Program for Equal Opportunity in Education) functioned for four years in active mode. It fostered in-service teacher training of gender through the creation of teacher teams in some twenty provinces, using contacts with universities and NGOs to develop its interventions. PIOM was able to affect the use of nonsexist language in education in the national education reform of 1993. Moreover, it eliminated sexual stereotypes from textbooks and introduced a discourse about the need for greater equality of opportunity between women and men. It worked with the mass media through exhibits during one year to promote alternative messages on gender. As PIOM was about to translate its pilot efforts to a national scale, the Catholic Church intervened to stop the dissemination of the new textbooks and teaching strategies, charging that the new texts were promoting homosexuality, were against the nuclear family, and opposed the "natural differences between men and women" (Bonder 1998). The work on education and gender continues in Argentina but under very controlled content and teaching strategies. The opposition by the Catholic Church in Latin America has been detected also in Mexico (Bayardo 1996), Peru and the Dominican Republic (Stromquist 2006b), Chile (Avalos 2003), and Costa Rica (Stromquist 2006a).

The gender strategies that are allowed to remain tend to be those that are uncontested because they promote access over content. Strategies that are used also include those that seek to provide a neutral language (less reliance in the use of masculine pronouns, adjectives, and subjects) as well as those that provide more reference to women and more illustrations and stories focusing on them. Since an analysis of these textbooks at the regional level has not been undertaken, it is unknown to what extent these changes have taken place. It appears unlikely that many book modifications have reached the extent of being nonsexist (removing all detrimental sexual stereotypes beyond the use of neutral language) and even more unlikely that they are antisexist (i.e., portray a reality in which women have more assertive and nontraditional roles).

Statistical data indicate that over time progress has been made in most countries in terms of the expansion of education. In basic education, in all developing countries boys have increased their school enrollment and girls have increased at an even greater pace (Lloyd 2005). In Latin America and the Caribbean, gender parity has been reached in primary and secondary education; in a number of countries in the region, there are more women in tertiary education than men. Other world regions, however, still show disparities between women and men, differences that are more marked at higher levels of schooling and particularly at the tertiary level. Throughout the developing world as a whole, rural populations benefit from schooling less than urban populations, and girls in poor and ethnic minority families face educational obstacles greater than boys in similar positions (Lloyd 2005; Stromquist 2004).

State support of gender in education is often cast in terms of reducing gender disparities in access, and global policies today emphasize primary or basic education over the higher two levels. However, very few specific measures can be detected in national plans to increase the enrollment of girls. Consequently, the expansion of girls' primary enrollment seems linked much more to the overall schooling expansion than to specific interventions to help female students. In the majority of public policies, the reference to gender is invoked to protect and strengthen the family, and *family* often means women. *Gender* thus emerges as a substitute for the word *women* rather than a conceptual tool to understand the nature and effects of relations between men and women.

In the context of Latin America, government statements on the importance of education are elegant and promising. An example of this is reflected in the most recent declaration on education by the Organization of American States. At its Third Meeting of Educational Ministers for Latin America and the Caribbean, these officials acknowledged "education must be made one of the development tools to attain greater social equity and overcome poverty" (OEA 2003). They also recognized the need for greater investments in education in order to increase access and continuation of studies and to prevent children from dropping out of school. A year later, at another regional meeting, the current Latin American and Caribbean presidents stated: "We reiterate that the empowerment of women, their full and equal participation in the development of our societies and their equal opportunity to exercise leadership are fundamental for the reduction of poverty, the promotion of economic and social prosperity, and human-centered sustainable development" (Cumbre Extraordinaria de las Américas 2004). It is seldom clear how these endorsements will translate into greater attention to gender issues in future action.

The main tool for addressing EFA objectives is the elaboration of EFA national plans, which were to be developed in all nations "by 2002 at the latest" (World Education Forum 2000).[2] But, as we saw in the preceding paragraph, discussions at the various regional forums by high-level officials suggest that EFA plans tend to be dissociated from prevailing actions endorsed by their ministries of education. A review of countries throughout the world indicates that only a small proportion have produced such plans (Stromquist 2006c). By early 2003 only five out of thirty-four countries in the Latin American region (15 percent) had produced the EFA national plans.

Analyzing EFA plans developed by several countries, it can be seen that they seldom identify measures and resources addressed specifically to girls or women. While a few of these national education plans include measures to provide more access to basic education for girls, remove sexual stereotypes from textbooks, and offer literacy programs for adult women, rarely do they state clear budgets and timelines for goal attainment (Stromquist 2006c). In

the entire world, only a handful of compensatory programs focusing on girls exist, and they trace their existence to measures independent of EFA. They include PROGRESA, addressed to primary and early secondary schooling of rural girls in Mexico; a short-lived effort to provide scholarships for primary rural girls in Guatemala; financial incentives for primary school access in Malawi; and a secondary school stipend for girls in Bangladesh.

Educational policies of many countries display a discourse that recognizes the importance of women's education and advocates women's participation at all levels of schooling. In practice, these commitments become shallow both on the part of the developing countries, which often fail to implement accordingly, and on the part of the industrialized countries, whose governments and financial institutions are supposed to collaborate toward goal attainment by assigning additional funds for this purpose. Most national educational budgets have not been augmented in the proportion needed to satisfy the tripartite goals of access, learning, and completion. Teachers' wages have shrunk rather than increased over time. Decentralization measures often seek to reduce government support and rely increasingly on parental financial contributions. Efforts to serve the weakest groups, comprised of mostly adults in rural areas and minority groups, are scarce and reach typically a small segment of those in need.

In all, global policies, while bringing attention to gender, produce a narrow definition of its functioning in the area of education. Countries following them become satisfied with statistical tables reporting increases in girls' rates of enrollment and years of attainment. Ideological aspects of schooling tend to be discarded, and the persistent patterns of women's weak participation in politics and the economy are not only delinked from education but even ignored.

Classifying Gender Policies in Education

The accumulated empirical evidence about gender policies in education indicates that these policies have tended to be: distributive (seeking the expansion of schooling that, although not focused on them, benefits girls), regulatory (antidiscriminatory), and symbolic (enjoying frequent and visible discourse). The evidence also indicates that issues of gender-sensitive content and training are considered infrequently and, when attention is given to them, it is in limited and weak ways. Gender problems are examined typically as if they existed connected only to poverty and thus only when considering poor and rural women. Very few redistributive policies, in the form of compensatory measures, are in existence.

Because of the concatenation of forces in shaping gender issues, many of these problems fit into what Rittel and Webber (1973) have termed "wicked

problems"—those that are complex, interrelated, and less amenable to technical or scientific solutions since they depend primarily on value preferences. For a satisfactory resolution, wicked problems need a great amount of dialogue, conversations among different groups to search for common grounds and develop compromises. Unfortunately, gender policies are seldom characterized by widespread dialogue and rarely include the most affected parties—the women—in their design.

Not only are gender problems "wicked" problems, but also governments tend to engage in constant attempts to depoliticize and diffuse gender issues (Shapiro 1998; Baden and Goetz 1997). As Pringle and Watson observed, "The state does not simply reflect gender inequalities but through its practices plays an important role in constituting them; simultaneously, gender practices become institutionalized in historically specific state forms" (1998, 214). The weak response by the state in effect creates limits to efforts to institutionalize gender in the machinery of government. New agencies and units have been established to address gender issues, but they are poorly staffed and funded (Baden 1999), thus constraining their ability to act. Most states have by now ratified the Convention to End All Forms of Discrimination Against Women (CEDAW, first agreed upon in 1979); few have implemented its various principles (Longwe 2002; Pitanguy and Linhares Barsted 2003).

What Should Be Done

Though formal schooling may provide knowledge that reinforces rather than challenges the gendered nature of society, the acquisition of intellectual skills and habits by women tends per se to be conducive to social change. The power to reflect, calculate, analyze, and draw conclusions has helped many women to see their realities and subsequently to devise means to transform societies. It is no accident that the leaders of the numerous women-based groups and nongovernmental organizations that have been established in the past twenty years are led by women with high levels of education, certainly much more than the national average for women of their age (Stromquist 2006b).

Transformative education is that which provides knowledge that raises awareness about social inequalities and enables individuals to organize for progressive social transformation (Freire 1970; Gramsci 1994 and 1996). Education to be transformational must not only provide knowledge about the conditions of one's subordination but also give the emotional support and the political skills to visualize and implement social change. Such knowledge is unlikely to be disseminated by the public school system with the same intensity as educational venues outside the formal school; in addition, transformative messages tend to be more impacting with adult women than with girls and female adolescents, as adults have experienced more situations of gender

disadvantage throughout their lives. Therefore, education as a means to achieve equality for women alongside men looms large in its nonformal (NFE) and informal modes.

Over time, there have been reductions in husband/wife disparities in schooling and in age at marriage. This suggests an improvement in the balance of power within the household. But because of inheritance laws, differences in wages, and accumulated wealth, asset ownership of men at marriage continues to be greater than that of women (data from Bangladesh, Philippines, Mexico, Guatemala, Ethiopia, and South Africa in Quisumbing and Hallman 2006). We have other indicators that suggest that educational progress purely in terms of enrollment is not enough to alter women's conditions. In Latin America, where common educational indicators reflect almost gender parity, women earn considerably less than men, and indigenous and black women earn the lowest wages, although the gap narrows in urban areas (Perry et al. 2003). Throughout the world, women are still underrepresented in high-level administrative and political positions. Their share of the national wealth is small, even though they tend to live longer than men by an average of seven years.[3] On the average, women earn 77 percent of what men earn in industrial countries and an average of 73 percent of what men earn in developing countries. In addition to their weak position in the public sphere, women occupy subordinate positions in the private sphere. Women continue to behave passively vis-à-vis sexual relations, still having unwanted pregnancies and often not protecting themselves or not asserting their right to effectively refuse unsafe sexual encounters—a behavior that is producing in Africa and, to a lesser extent, in other developing regions an increasing mortality of women due to AIDS. This suggests that a number of societal factors that produce gender inequalities have not been corrected by current practices in the provision of education (Unterhalter and Dutt 2001).

In the struggle to attain greater access to schooling, some fundamental facts are minimized or even denied. Women are now more educated and more economically active than in the past, yet they still function under patriarchal values (López Montaño 2005). The fact remains that, despite a more promising discourse, the state (notwithstanding variation along many dimensions) is not neutral to women (Pateman 1988; Phillips 1998). In the contemporary world, it is to the state's advantage to recognize women as agents of care but less as full-fledged citizens with autonomy. Since it is difficult these days to deny human rights, they are extended, often reluctantly, to women. Yet the rights extended do not modify current definitions of femininity and masculinity. Instead, they frequently represent state accommodations that while ostensibly responding to women's demands, do so very selectively. Policies tend to respond primarily in terms of welfare and security provisions but not in terms of the ultimately more important autonomy and

redefinition of gender frameworks. It is also the fact that education, paradoxically, derives its greatest power from its scarcity. Were everyone to attain high levels of education, society as a whole would benefit from a well-educated citizenry, but individual returns to those with PhDs would decrease because many more would be competing for the same jobs. A third fact is that because education does grant certain benefits, it is a heavily contested area. Today, in the era of globalization, the high-stakes competition is framed less in terms of access but is decidedly characterized by struggles for quality and prestige, and for access to university education.

Often in efforts to advance the condition of women through schooling, the issue of knowledge content has been left aside. Even women in the feminist movement in many developing regions see access to schooling as the prime and almost exclusive educational goal. While access is indeed crucial, to put women on par with men educationally and professionally, much more has to be done. It is necessary to go beyond access and revise conventional values and messages in the curriculum, and to alter practices by teachers, principals, and students who at the school site constantly reproduce gendered expectations. The lived experience of schooling is an important arena for the production of gender identities and must therefore be part of educational policies to improve schooling. The contributions of critical pedagogy have made us very aware not only of instances of accommodation to the gendered status quo by students but also of instances of resistance (Apple 1996; McLaren 1995; Giroux and McLaren 1989). While instances of resistance and defiance can be found among students, both girls and boys, in schools, it must be recognized that they are very small compared to the prevailing everyday practices in schools.

For education to be a resource for women, it has to been seen in its entirety, not only in formal schooling but also in its NFE and informal learning manifestations. It has to be seen not only at the basic level but also at the secondary and at the tertiary levels—this last level being the one where its graduate can wield the greatest political and economic influence.

FORMULATING GENDER POLICY

Underlying policy formulation is the question, What interventions could make a given situation be better? Every policy, therefore, implies a theory of action. This is best defined as the set of mechanisms and actors in place and the sequence of events needed to reach established goals. To exemplify this theory of action, let us examine two major U.S. policies referred to previously dealing with gender in education: Title IX and WEEA, the first in existence since 1972 and the second since 1975. Title IX is a law against sex discrimi-

nation in a broad range of circumstances, ranging from program admission to sexual harassment. Its theory of action is that fear of discrimination and monetary sanctions will compel institutions into more egalitarian practices toward women and men. WEEA is a program that provided financial resources for the provision of teacher training and the development of nonsexist educational materials. Its theory of action is that the availability of resources will encourage institutions to adopt new practices and knowledge content and that both would contribute to changing gendered attitudes among students and teachers. Unfortunately, the resources made available to WEEA became extremely limited and thus very few school districts and universities benefited.

Internationally, we have other gender policies that promote alternative theories of action. One of these models has been developed by USAID. This model encourages working with notables, mostly entrepreneurs, in efforts to bring the education of girls onto the governmental agenda. It recommends working with businessmen from large enterprises, holding visible national conferences, deploying the mass media to raise awareness of the plight of rural poor girls, and mobilizing well-known groups into the formulation of a law to promote girls' education. The actual experience of this model in Guatemala (Stromquist et al. 2000) and Peru (Stromquist 2006a), however, exposes some weaknesses: since the proposed interventions have not been designed with the support of the women's movement, the initiative does not have widespread or solid support. In the case of Peru, even though a national policy on girls' education was enacted, this policy was devoid of any resource allocation. So far, it has been a symbolic action with limited consequences. Moreover, this policy has framed its measures to help only "rural girls."

Another model in existence is the target-setting exercises in education. These policies typically identify a given statistical target to be attained. Examples of these policies are the targets expressed in the EFA objectives and in the UN MDGs, both of which commit signatory countries to reduce literacy by half (between 2000 and 2015) and to secure 100 percent access to basic education by 2015 (World Education Forum 2000). These target-setting exercises lack a theory of action because they assume that merely setting a target will be sufficient to unleash energies in the amount and form necessary to attain their goals.

In terms of altering and improving the educational systems from a gender perspective, the knowledge accumulated by many feminist researchers to date highlights the following essential components:

• Preschool and early childhood programs with nutrition and health care services, both to ensure the initial development of the child and to release girls and women from tasks linked to childcare;
• Textbooks and curriculum guides that are nonsexist and antisexist;

- Pre- and in-service teacher gender training and attention to teachers' conditions as professionals, especially in issues of pay and advancement;
- Introduction and promotion of gender-sensitive instructional practices in the classroom; and
- Introduction of new and contestatory knowledge so that teaching addresses issues pertaining to identity, human rights, equality, sexuality, sex education, and masculinity and femininity.[4]

To implement these components successfully, however, requires public policies with a clear theory of action to plan for and attain not only changes in the relations of gender but also regarding change in society. This points to the need to formulate and rely on theories of gender to support the enactment of *all* public policies from a gender perspective.

By most accounts, the more transformative gender processes occur outside the state and outside the formal educational system. It is also more likely to occur among adult women rather than young girls, who have not yet confronted the full extent of the gendered social system. Transformative or empowering education is typically conducted by organized groups in women-led NGOs.

KEY ELEMENTS IN THE DESIGN AND IMPLEMENTATION OF GENDER POLICIES

Several elements come to mind. First, statistical information in the form of quantitative indicators is indispensable. It is crucial to have data about the distribution of education by sex. But since inequalities work in compounded ways, it would also be essential to have the distribution of education simultaneously by sex and social class or by sex and ethnicity or urban/rural residence, not to mention statistical information on the distribution of resources by level of education, measured in terms of expenditures in education as a proportion of the GNP per capita. These types of data—combining sex and other social markers—are rarely collected through regular educational statistics in developing countries, thus preventing the design of well-informed policies. Additional studies will be necessary to produce a more complete picture.

The educational conditions of women vary a great deal across developing areas. In Africa, gender policies have to be attuned to equality of access in primary and secondary education. In Latin America, the problem is beyond access. In two-thirds of the Latin American countries there are more women than men at the higher education level (although the differences are not great) (UIS 2001). The problem in that region is the selection of fields of study, which continue to reflect gender stereotypes and culminate in sex segregation.

But in all regions—both developed and developing—considerable problems still exist in terms of the nature of the educational experience and what is learned (and not learned) in school.

Second, while educational policies per se are necessary, it is also important to consider the external environment and the way it affects the implementation and impact of policy. Educational policies on gender alone are not sufficient. They need to be integrated with other macroeconomic policies such as employment (increasing and improving women's access to the labor market) and mass media (eliminating negative sexual stereotypes). Gender policies in education also need to combine intervention on macro- and micro-level variables. Examples of policy issues at the macro level are: the gender division of labor in the household and the economy, the ratio of men to women in the society, technological conditions (ranging from electricity to sewage), the subsistence base of the economy, the form and extent of political organization, the degree of equal access of men and women to resources in society. Examples of policy issues at micro levels are: individual behaviors and process, and outcomes of direct interpersonal interactions that result in the myriad behaviors, choices, priorities, cognitive and emotional processes of men compared to women.

Feminist economist Diane Elson (1998, cited in Lind 2001) underlines the importance of learning to "talk to the boys," by which she means becoming familiar with the gender dimensions of macroeconomic and social policy frameworks, particularly those associated with neoliberal polices. In her view, to be successful, women have to learn to analyze the local and global economy from a gender perspective and learn to use terms and knowledge that economists (mostly men) use. Not surprisingly, it is only women who have addressed gender issues in policy design and implementation (Lind 2001).

Third, careful consideration of the actors and forces affecting the functioning of gender in a particular society must take place. This requires assessing the actual and potential intervention and role of actors such as ministry officials and advisors, the influence of international agencies in the country, and the position of teachers' unions. In Latin American society, a key institution in the maintenance of gender norms and values is the Catholic Church. The oldest and largest bureaucracy in the world, the Catholic Church is also a very efficient and effective organization. Therefore, public policies from a gender perspective must consider this institution among the stakeholders to be studied.

Fourth, we need to understand how gendered agendas are set and how bureaucratic policies influence results. According to Prügl (1996) this implies two paths. The first one calls for documenting the gendered character of the bureaucratic rules, their emergence from specific historic contexts, and their coercing effects. This path leads to recognizing the importance of policies endorsed by the UN and various international institutions, which significantly

shape discourse and frame gender issues in particular ways, even though implementation of such policies has been typically weak. The second path highlights the struggles of the women's movement in modifying these rules in a multiplicity of diverse sites, including UN world conferences, development projects, and international organizations. This second path results in emphasizing agency by women in international organizations and NGOs. In reality, careful consideration of both paths is necessary because many UN actions have been the reflection of previous action by the women's movement and its many women-led NGOs.

Prerequisites to the Formulation of Gender Policies

While an essential goal of the women's movement is the reduction of inequalities between men and women, this result cannot be obtained merely through demands for human rights. A prerequisite to reaching the goal must be women's self-identification as members of a specific group of disadvantaged persons. For this to occur, internal action (e.g., consciousness-raising and empowerment) must precede external action (e.g., pressuring the state). In other words, to attain the resources and assets for basic human functioning (the notion of capabilities, according to Nussbaum 2000), women must gain an identity of themselves as women and mobilize around it. A limitation of human rights activism is that it is based on a juridical model of individual complaints against state agents for their denial of civic liberties. Brysk notes that this is a "model singularly inappropriate for indigenous people's concerns; victims are often the community at large, violators include state and non-state agents, and the violations combine denial of economic and cultural rights with more narrowly defined political coercion" (2000, 202). A similar argument can be extended to women, since the nature of gender problems permeates the entire society and the state has not emerged as a neutral adjudicator. Yet, the human rights principle is key to the women's movement and a major source of global support. As Dorsey observes, "The human rights framework is predicated on the principle that transnational linkages and global norms are essential for the protection of all human rights and could readily serve as an organizing principle upon which women's political claims could be advanced globally" (1997, 357). Women, consequently, need education to find forms of personal and collective awareness and, after being so prepared, to demand their human rights.

ENGAGING IN POSITIVE ACTION

The state's behavior toward women is one of marginal accommodation to gender, concentrating on access and favoring lower levels of education—reflected

in their global concern for basic education but doing little for higher levels. Further, the current global situation does not leave much margin for social action, for economic competition shifts educational systems toward increasing rates of productivity but does not encourage solidarity across groups.

What accounts for attempts to promulgate public policy addressing gender, only to have them persistently weakened in content or by failure to provide funds and human resources for their implementation? Several factors come to mind: gender ideologies are deeply rooted in people's psyche, pervasive, and difficult to eliminate. As states modernize, they endorse values that go with democratic governance such as the participation of all citizens, including women. This leads states to recognize a host of obstacles that girls and women face. But subsequently there seems to emerge the fear, in the form of opposition from influential cultural and religious institutions, that changes to the status quo may alter the current equilibrium and create profound consequences for power and authority relations in private and public spheres. As is well known in Latin America, the Catholic Church is convinced that feminist ideas mean opposition to family values, the promotion of homosexuality, and the endorsement of abortion.

International development agencies express their concerns for gender issues. However, they frame gender problems and solutions in rather conventional ways. The most influential agency, the World Bank, has adopted a mild version of gender transformation. Existing global policies in education circumscribe themselves to numerical parity and their definition of quality is totally centered on academic fields rather than a richer curriculum that is sensitive to gender knowledge. Several agencies, such as bilateral and semi-autonomous institutions from Sweden, Norway, and the Netherlands, endorse more transformative policies; however, they refrain from exercising strong pressures upon recipient states, with the result that many such states manage in the end to do less than expected. Achievements made through global educational policies are quite modest, as reflected in the evaluations that have taken place in meetings such as Beijing+10 and MDG+5.

The absence of women-led NGOs at many of the negotiating tables and in the subsequent design of policies dealing with textbook modifications and teacher training permits national governments to enact educational policies with weak content regarding the questioning and elucidation of gender. Faced with myriad problems, many women-led NGOs have given priority to basic issues and needs (employment, family planning, violence, reproductive health, and migration) rather than formal education (Domínguez 2001; Stromquist 2006b). There are nonetheless important NGO initiatives to alter schools through action by NGOs.[5] The Catholic Church, which has been able to stop important reforms in sex education in Latin America, continues so far unchallenged by the women's movement.

Influential NGOs working on education in the region call for the modernization of the educational system or the adoption of more egalitarian and democratic practices in the school, but in the final analysis gender issues are ignored. While equity is recognized as a major problem facing the region, it is defined to mean equality between rural and urban areas, and to a lesser extent between the rich and the poor. In either case, gender issues are ignored. Moreover, even for the areas recognized as receiving priority, support for equality is mild, judging from the investments made so far.

Education remains an important tool for social transformation even if it is not purposefully utilized for that end. The recognition that schooling is situated in a broad environment of socialization forces makes the engagement of other social sectors crucial in change efforts throughout the world and in Latin America as well. There is a need to act in a holistic manner that comprises not only curriculum content but also a protective learning environment, a supportive social environment, alternative pedagogies to accommodate differences in cognitive styles, and moral arguments to question power asymmetries between men and women (Wyn and Wilson 1993). On the other hand, the potential of education to become transformative guides our attention toward nonformal education and informal education among adult women, and, in turn, leads us—or should lead us—to investigate and make full use of the contributions of women-led NGOs. Hence, the contributions of women-led NGOs remain to be more centrally utilized.

PENDING RESEARCH QUESTIONS

The analysis of public policies from a gender perspective is just beginning to develop. In this chapter I have attempted to identify a few issues regarding the conceptualization of gender policies, their various types, and their potential content. I have also called attention to the fact that a clear theory of action underlying gender policies is often either missing or weakly assumed in current governmental action.

Within the contemporary social context, with the growing privatization of social services and the reduction of state functions and responsibilities (see Reimers 2001 for empirical evidence on the decrease of state investment in education in Latin America), it is likely that fewer redistributive policies will emerge and that even regulatory and distributive policies may become less salient in the dominant political agendas. Nonetheless, a large task remains for those who seek to influence state action in the direction of gender transformation. Given the current challenges and still-emerging understanding of public policies to advance the conditions of

women and to transform our beliefs and practices about gender, it may be more useful to raise a few research questions than to provide some tentative answers:

- What educational problems are recognized by the state as being linked to gender dynamics? What principles, values, and norms are invoked? What is rendered visible? What is made invisible?
- How are gender problems in education defined? Do policies derived from them seek marginal improvements for girls and women or deeper transformations in gender meanings and practices? For example, do education policies recognize only problems of access or do they seek to alter conceptions of femininity and masculinity?
- How is gender inequality linked to other forms of inequality, especially those of social class, ethnicity, or "race"? And when these links are acknowledged, what measures are then proposed?
- Who are the main actors in the design and enactment of education policies from a gender perspective? Specifically, what roles have institutions such as the Catholic Church or other religious institutions, the teachers' unions, women-led NGOs, and reform-minded politicians played in the development of educational policies?
- What changes can be perceived so far in terms of curricular content and teacher training? What values and norms are being debated through those potential interventions?
- What timelines are identified for action and goal attainment, and what financial resources are assigned to the educational policies?
- Are the strategies envisaged for implementation proposed only within the educational sector or are there efforts to engage in multisectoral work?

NOTES

1. In the past few years there has been an increasing interest in the links between masculinity and power, masculinity and violence, masculinity and crime, masculinity and child abuse, and masculinity and the law. While there is a need for a materially based analysis of gendered power relations (Hearn 1996), the concept often leads to cultural as opposed to materialistic analysis of men's practices.

2. Other regions do better than Latin America. According to internal UIS reports, the following proportion of countries had produced action plans by early 2003: 55 percent of African countries (including the Arab states in Northern Africa), 80 percent of South Asian countries, 50 percent of those in East and Southeast Asia, and 38 percent of those in Central and Southwest Asia.

3. Exactly why this happens is not clear. There exist theories that women have stronger circulatory systems and are thus less susceptible to heart attacks. Infant boys

seem more vulnerable to early deaths. Third, because of the dominant sexual division of labor, women are involved in less dangerous and stressful occupations and engage in less risky activities.

4. Although with less frequency, sexual orientation is also becoming recognized as an educational task. This issue does not meet wide consensus and is part of an incipient dialogue within the feminist movement.

5. One such example is occurring in Mexico, through GEM (Girls' Education Movement), an NGO providing both teachers and parents (mothers and fathers) knowledge and skills to eliminate the reproduction of sexual stereotypes of children in kindergarten (Valenzuela y Gómez Gallardo, 2001).

REFERENCES

Abraham, J. 1995. *Divide and school: Gender and class dynamics in comprehensive education.* London: The Falmer Press.

Apple, M. 1996. *Education and cultural politics.* New York: Teachers College Press.

Avalos, B. 2003. Gender parity and equality in Chile: A case study. Background paper for *EFA Global Monitoring Report 2003/2004.*

Baden, S. 1999. Gender, governance, and the "feminization" of poverty. Paper presented for meeting on Women and Political Participation: Twenty-first-Century Challenges, organized by the UN Development Programme. New Delhi, March 24–26.

Baden, S. and A. M. Goetz. 1997. Who needs [sex] when you can have [gender]? Conflicting discourses on gender at Beijing. In *Women, international development and politics: The bureaucratic mire,* edited by K. Staudt, 37–58. Philadelphia: Temple University Press.

Ball, S., G. Fischman, and S. Gvirtz (Eds.). 2003. *Latin America's educational hopscotch: Understanding the legacy of neo-liberal approaches to educational reform.* New York: RoutledgeFalmer.

Bayardo, B. 1996. Sex and the curriculum in Mexico and the United States. In *Gender dimensions in education in Latin America,* edited by N. Stromquist, 157–186. Washington, D.C.: Organization of American States.

Bonder, G. 1998. La equidad de género en las políticas educativas: La necesidad de una mirada reflexiva sobre premisas, experiencias y metas. Paper presented at the Latin American Studies Association meeting, Chicago, September 20–23.

Brysk, A. 2000. *From tribal village to global village: Indian rights and international relations in Latin America.* Stanford: Stanford University Press.

Carnoy, M. 1995. Structural adjustment and the changing face of education. *International Labor Review,* 13 (6): 653–673.

Colazo, C. 2000. Public policies on gender and education in Paraguay: The project for equal opportunities. In *Distant Alliances: Promoting the education for girls and*

women in Latin America, edited by Cortina and N. Stromquist, 13–27. New York: RoutledgeFalmer.

Colclough, C. 1997. *Marketising education and health in developing countries: Miracle or mirage?* IDS Development Studies Series. Oxford: Clarendon Press.

Connell, R. 1996. Teaching the boys: New research on masculinity, and gender strategies for schools. *Teachers College Board*, 98 (1): 206–235.

Coombs, F. 1994. Education policy. In *Encyclopedia of policy studies*, second volume, edited by S. Nagel, 587–616. New York: Marcel Dekker.

Cortina, R. 2001. Políticas públicas y formación docente: Una mirada desde la perspectiva de género. Paper presented at the Latin American conference on Gender and Education, organized by Programa Universitario de Estudios de Género, UNAM. Mexico, October 22–26.

Cumbre Extraordinaria de las Américas. 2004. *Declaración de Nuevo León*. Nuevo Leon, Mexico, January 13.

Domínguez, M. E. 2001. Género, diversidad y educación formal en Colombia: Tendencias investigativas e implicaciones políticas. Paper presented at the Latin American conference on Gender and Education, organized by Programa Universitario de Estudios de Género, UNAM. Mexico, October 22–26.

Dorsey, E. 1997. The global women's movement: Articulating a new vision of global governance. In *The politics of global governance: International organizations in an interdependent world*, edited by P. Diehl. Boulder: Lynne Rienner.

Edelman, M. 1971. *Politics as symbolic action*. Chicago: Markham Publishing.

Edwards, V. and J. Osorio (Eds.). 1995. *La construcción de las políticas educativas en América Latina*. Lima: CEAAL and Tarea.

Eisenstein, H. 1993. A telling tale from the field. In *Gender matters in educational administration and policy: A feminist introduction*, edited by J. Blackmore and J. Kenway, 1–8. London: The Falmer Press.

Fraser, N. 1998. From redistribution to recognition? Dilemmas of justice in a "postsocialist" age. In *Feminism and politics*, edited by A. Phillips, 430–640. Oxford: Oxford University Press.

Freire, P. 1970. *Pedagogy of the oppressed*. New York: Herder and Herder.

Giroux, H. and P. McLaren. 1989. *Critical pedagogy, the state, and cultural struggle*. Albany: State University of New York Press.

Gramsci, A. 1994. *Letters from prison*. New York: Columbia University Press.

———. 1996. *Prison notebooks*. New York: Columbia University Press.

Grindle, M. 2002. Politics of education reform in Latin America in the 1990s. Presentation at Rockefeller Center for Latin American Studies, Harvard University, March 19.

Hearn, J. 1996. Is masculinity dead? A critique of the concept of masculinity/masculinities. In *Understanding masculinities*, edited by M. Mac an Ghaill, 202–217. Buckingham: Open University Press.

Krawczyk, N. 2002. La reforma educativa en America Latina desde las perspectiva de los organismos multilaterales. *Revista Mexicana de Educación*, 7 (16): 627–663.

Lazarte, C. and M. Lanza. 2000. Gender equity in Bolivian educational policies: Experiences and challenges. In *Distant alliances: Promoting the education for girls and women in Latin America*, edited by R. Cortina and N. Stromquist, 29–46. New York: RoutledgeFalmer.

Lind, A. 2001. Making feminist sense of neoliberalism: The institutionalization of women's struggles for survival in Ecuador and Bolivia. In *Through the eyes of women: Gender, social networks, family, and structural change in Latin America and the Caribbean*, edited by C. Menjívar, 231–261. Willowdale, Canada: de Sitter Publications.

Lloyd, C. (Ed.). 2005. *Growing up global: Transitions to adulthood in developing countries*. Washington, D.C.: National Academy of Sciences.

Longwe, S. 2002. NEPAD reluctance to address gender issues. Draft, October 11.

López Montaño, C. 2005. Cómo Crear un Mundo con justicia social? Presentation at World Social Forum, Porto Alegre, Brazil. January 29.

Lowi, T. 1964. American business, public policy, politics, and political theory. *World Politics*, 17: 677–715.

McLaren, P. 1995. *Critical pedagogy and predatory culture: Oppositional politics in a postmodern era*. New York: Routledge.

Nussbaum, M. 2000. *Women and human development: The capabilities approach*. Cambridge: Cambridge University Press.

OEA. 2003. Tercera reunión de ministros de educación. Declaración desde México. Mexico, D.F.: Organización de Estados Americanos, August 13.

OREALC. 2001. *Balance de los 20 años del proyecto principal de educación en América Latina y el Caribe*. Santiago de Chile: OREALC.

Palencia Villa, M. 2001. De políticas públicas a una nueva cultura escolar. Paper presented at the Latin American conference on Gender and Education, organized by Programa Universitario de Estudios de Género, UNAM. Mexico, October 22–26.

Pateman, C. 1988. *The sexual contract*. Cambridge: Polity.

Perry, G., F. Ferreira, and M. Walton. 2003. *Inequality in Latin America and the Caribbean: Breaking with history?* Washington, D.C.: The World Bank.

Phillips, A. (Ed.). 1998. *Feminism and politics*. Oxford: Oxford University Press.

Plank, D. 1996. *The means of our salvation: Public education in Brazil 1930–1995*. Boulder: Westview.

Pitanguy, J. and L. Linhares Barsted. 2003. Direitos Humanos das Mulheres. *Jornal do Brasil*, November 24, 2003.

PREAL. 1997. *La Educación en las Américas: El Futuro está en Juego. Informe de la Comisión Internacional sobre Educación, Equidad y Competitividad Económica en las Américas*. Santiago: Inter-American Dialogue and CINDE.

Pringle, R. and S. Watson. 1998. "Women interests" and the poststructuralist state. In *Feminism and politics*, edited by A. Phillips, 203–223. Oxford: Oxford University Press.

Prügl, E. 1996. Gender in international organizations and global governance: A critical review of the literature. *International Studies Notes*, 21 (1): 15–24.

Quisumbing, A. and K. Hallman. 2006. Marriage in transition: Evidence on age, education, and assets from six developing countries. In *The Changing transitions to adulthood in developing countries: Selected Studies*, edited by C. Lloyd, J. Behrman, N. Stromquist, and B. Cohen, 200–216. Washington, D.C.: The National Academies Press.

Reimers, F. 2001. Educational finance and economic adjustment in developing nations. In *International encyclopedia of education*, 1784–1789. London: Elsevier.

———. 2002. Something to hide? The politics of educational evaluation in Latin America. Working Paper No. 01/02–1. Cambridge: The David Rockefeller Center for Latin American Studies, Harvard University.

Rittel, H. and M. Webber. 1973. Dilemmas in a general theory of planning. *Policy Sciences*, 4 (2): 155–169.

Shapiro, V. 1998. When are interests interesting? The problem of political representation of women. In *Feminism and politics*, edited by A. Phillips, 161–192. Oxford: Oxford University Press.

Streitmatter, J. 1994. *Toward gender equity in the classroom*. Albany: State University of New York Press.

Stromquist, N. 2004. Inequality as a way of life: Education and social class in Latin America. *Pedagogy, Culture and Society*, 12 (1): 95–120.

———. (Ed.). 2006a. *La construcción del género en las políticas públicas: Perspectivas comparadas desde América Latina*. Lima: Instituto de Estudios Peruanos.

———. 2006b. *Feminist organizations and social transformation in Latin America*. Boulder: Paradigm Publishers.

———. 2006c. Trends in education across the world. In *Handbook for achieving gender equity through education*, edited by S. Klein, x–x. Mahwah: Lawrence Erlbaum Associates.

Stromquist, N., S. Klees, and S. Miske. 2000. USAID efforts to expand and improve girls' primary education in Guatemala. In *Distant alliances: Promoting education for girls and women in Latin America*, edited by R. Cortina and N. Stromquist. New York: RoutledgeFalmer.

Subrahmanian, R. 2002. Engendering education: Prospects for a rights-based approach to female education deprivation in India. In *Gender justice, development, and rights*, edited by M. Molyneux and S. Razavi, x–x. Oxford: Oxford University Press.

UIS. 2001. *Latin America and the Caribbean: Regional Report*. Montreal: UNESCO Institute for Statistics.

UN. 2000. *United Nations millennium declaration*. New York: UN General Assembly.

Unterhalter, E. and S. Dutt. 2001. Gender, education and women's power: Indian state and civil society intersections in DPEP (District Primary Education Programme) and Mahila Samakhya. *Compare*, 31 (1): 57–73.

Valenzuela y Gómez Gallardo, M. 2000. Other ways to be teachers, mothers, and fathers: An alternative education for gender equity for girls and boys in preschool.

In *District alliances: Promoting education for girls and women in Latin America*, edited by R. Cortina and N. Stromquist, 103–118. New York: Routledge Falmer.

World Bank. 2001. *Attacking poverty: World development report 2000/2001.* Oxford: Oxford University Press.

World Education Forum. 2000. *Dakar framework for action.* Paris: UNESCO.

Wyn, J. and B. Wilson. 1993. Improving girls' educational outcomes. In *Gender matters in educational administration and policy: A feminist introduction*, edited by J. Blackmore and J. Kenway, 71–80. London: The Falmer Press.

Assessing the Status and Prospects of Women's Empowerment through Education

A Case Study of Women Students at the University of The Gambia

CAROLINE MANION

I n the field of international development, women's rights and women's roles have gained increasing attention in development theory and practice since the early 1970s.[1] During these early years, the Women in Development (WID) movement focused on the economic integration of women into development processes, and therefore education and training for women was viewed as a means of providing women with the knowledge and skills necessary to compete equally with men (Vavrus 2002). In the decades following the "discovery" of women as productive and not just reproductive agents, the value accorded to women's education has expanded from an emphasis on its instrumental role in increasing women's productivity to include a focus on the relationship between education and women's empowerment.[2]

In the current Gender and Development (GAD) literature, a more holistic perspective is deployed that seeks to include consideration of all aspects of women's lives. As part of this broader emphasis, GAD focuses not just on women (as WID tended to), but on the social relations between men and women and seeks a redistribution of power within as well as between societies. More specifically the GAD approach uses an analytical framework that emphasizes gender relations in both the labor force and the reproductive spheres.

However, there has been difficulty concerning how to "measure" or evaluate the extent to which women are "empowered" through education (Kabeer 1999). As some have argued, it is not necessarily the quantity of education a woman receives but what kind of education that is critical to processes of her empowerment (Moser 1993). Important here is that the concept of empowerment has been applied to both individual women and women as a collective group. The challenge is to better understand the actual dynamics of empowerment and how individual women navigate their social surroundings to overcome structural challenges to their advancement and how these actions and attitudes in turn influence these very structures.

In the social science literature, agency has been largely defined in terms of decision-making power. In terms of the agency/structure debate, the concept may be mobilized to better understand how structural conditions and culturally, socially, and religiously based norms and rules interact with individual and collective agency, assessed using decision-making authority as a key indicator (Kabeer 1999). I argue that the fields of comparative education, international development, and feminist advocacy must engage with theories that help us move away from deterministic understandings of the agency/structure relationship (Brettell 2002). Specifically, we need to not only move toward a more holistic understanding of the way individual agency is structured through objective structural conditions existing in societies, but also to determine how international normative discourses as well as the practices manifest in international development efforts shape the structures that influence (but do not necessarily determine) individual agency and in turn are affected in reverse order by individual and collective agency within and across national boundaries.

The objective then of this chapter is to contribute to the emerging debates concerning women's empowerment through education and to suggest the important impacts of global discourses of gender equality, education, and development on women's social practice in the field of education in The Gambia. Through an application of Bourdieu's central concepts of habitus, capital, and field, I will explore how gender relates to international educational policy, school practice, and women's educational decision-making, which are used here as an indicator of empowerment. Highlighted in the findings are the critical role of families, and particularly the role of mothers, as well as the gender regime at the global level in reconfiguring the gender habitus of women in The Gambia.

My empirical exploration of women's empowerment through education draws on findings from field research in The Gambia from May 2002 to October 2002 (Manion 2003), concerning issues of women's education. The research examined women's academic choices in relation to programs of study at the University of The Gambia (UOTG). A key component of the research

was the effort to link the participant's decision-making at the tertiary level, and attitudes toward education more generally, with their early educational experiences. This chapter draws from unpublished data pertaining to participants' decision-making to loosely frame the central exploration of the dynamics of change and continuity in terms of the gender habitus and women's empowerment in the social fields of the family and formal education.

Common in feminist research is the use of multiple research methods. I chose to follow this tradition and incorporated a variety of research methods, including archival data collection, participant observation, semistructured interviews, and group interviews, into the current study's methodological structure. This decision reflected my opinion that the use of several different research methods would facilitate a stronger contextual understanding of Gambian women in Gambian society, reflexively recognizing that I would always be an "outsider" in terms of any insights I may draw from my work. While I apply this contextual understanding to the current discussion, I primarily draw upon the data emerging from the sixteen in-depth interviews I completed with women students enrolled at the UOTG. The content analysis phase of the research focused on pulling out, categorizing, and analyzing data according Kabeer's (1999) typology of the three interrelated dimensions of the ability to exercise choice: 1) resources, 2) agency, and 3) achievements (436).

It is important to note that the research was carried out solely in semi-urban and urban areas of The Gambia. Therefore only limited insight can be gained with respect to the situation of girls' and women in the rural areas. I do acknowledge the importance of further studies concerning the significant disparities between rural and urban regions in terms of women's socioeconomic conditions and access to and retention in formal education, with direct implications for processes of women's empowerment (Department of State for Education [DoSE] 2002).

ORGANIZING FRAMEWORK

McLeod (2005) identifies two main approaches represented in current feminist engagements with Bourdieu's conceptual framework in the context of education and gender research. The first is characterized by a focus on the "reproductive" aspects of habitus (see Arnot 2002 for a discussion of the utility and potential pitfalls inherent to this approach). The second approach is distinguished by its focus on how Bourdieu's conceptual, theoretical, and methodological apparatuses create spaces for theorizing change and contradiction (McLeod 2005, 17).

Exemplifying this second approach and in opposition to Bourdieu's view of the durability of gender norms, Lois McNay (1999; 2000) works

from an understanding that gender norms are inherently unstable (McLeod 2005). Whereas the habitus and field are seen relationally and as two aspects of the same thing, McNay "uses the term 'refraction' to emphasize the non-corresponding forms habitus can take" (McLeod 2005, 21). The contribution made by this understanding is to direct our attention away from what has been criticized as the structural determinism characterizing Bourdieu's work (McNamara Horvat 2003) and toward the recognition of the multiplicity of possible subjectivities within and across different social fields. However, McLeod (2005) argues that while McNay's counterconceptualization of the habitus/field relationship "more easily allows for theorizing change and disruption," it contributes less to efforts to theorize continuity and repetition (23).

In Lisa Adkins's (2005) approach, an emphasis on the instability of gender norms, and thus the possibilities for change and disruption, is tempered by the idea that what appear as evidence of discontinuity in gender norms and patterns should be understood as examples of coexistence between "heightened forms of reflexivity" and the "reinscription of 'traditional' gender in new but old ways" (McLeod 2005, 23). The findings of the current study lend support to Adkins's argument in the sense that while the participant's habiti appeared to differ from what we could expect given the objective conditions of endemic poverty and women's low socioeconomic status in Gambian society, there were also instances where their actions and attitudes indicated the influence of deeper, more internalized forms of symbolic violence (Bourdieu 1994) attributable to persistent patriarchy coexisting with an "empowered" habitus.

One of the central objectives in Bourdieu's theoretical conceptualizations is to dismantle and demonstrate as false the supposed agency/structure dichotomy informing and shaping social science, and particularly, sociological research concerned with social interaction (Bourdieu 2001). The concept of *habitus*—a system of durable, transposable dispositions which functions at every moment as a matrix of perceptions, appreciations, and actions" (Bourdieu 1977, 82–83, italics in original, cited in McNamara Horvat 2003, 6)—is a critical component of Bourdieu's efforts in this regard. In this way, Bourdieu's habitus/field framework compels a movement away from deterministic sociological understandings of structure and agency toward analyses that account for the dialogical dynamics between social agents and the world around them.

The habitus is anchored in early familial socialization processes and therefore it can be understood as the embodiment of the objective structures that shape and direct societal interaction. Importantly however, Bourdieu theorizes that habitus as a conceptual tool enables the transcendence of the agency/structure dichotomy (Reay 1997). Bourdieu argues that the relation-

ship between individuals and the social world in which they live is a dialecti-
cal one, mediated by the habitus in which the actions and attitudes of indi-
viduals influence the very structures that in turn structure the actions and atti-
tudes of individuals (McNamara Horvat 2003).

What this suggests for sociological research that explores issues of gender
and education is the need to account for and understand the behavior and
choices of individuals within the structural context as well as how these same
actions and decisions interact with and affect the structural elements governing
social interaction, or what Bourdieu calls "practice" (Bourdieu 1977; McNamara
Horvat 2003). Particularly relevant for this work, Naidoo (2004) reminds us
that for Bourdieu the concepts of habitus, field, capital, and practice need to be
understood and used as part of a relational framework in order for them to func-
tion fully (457). Therefore, it is to an overview of these concepts that we now
turn so as to lay the groundwork for the remainder of the discussion.

A key relational concept deployed in Bourdieu's method for approaching
the social field is that of capital (Bourdieu 1987). Forms of capital identified
by Bourdieu include social, cultural, linguistic, and symbolic, with each cate-
gory denoting specific and more general attributes or resources that gain value
and confer on those individuals possessing them the benefits of membership
within a given social field (Bourdieu 1987). While differing in several
respects, what these forms share is "that each requires and is the product of an
investment of an appropriate kind and each can secure a return to that invest-
ment" (Moore 2004, 446). Important for the current discussion is that all
forms of capital represent power to varying degrees depending on the social
field and the dominant culture conferring value on them. And furthermore, all
forms of capital can be converted into other forms, depending similarly on the
social field of interaction.

It is useful to imagine the field as a site of social interaction in which rela-
tions of power constantly circulate and function to define and redefine the
"rules of the game" (Bourdieu and Wacquant 1992). This idea has important
implications for understanding women's empowerment through education
because it establishes a theoretical basis for understanding social change as
necessarily involving the renegotiation of power relations, which is a funda-
mental objective of the empowerment approach characteristic of the GAD
paradigm. Each field has its own logic, specific to its own system of valuation,
thereby structuring the dominant and subordinate positions within it (McNa-
mara Horvat 2003; Naidoo 2004). Such an understanding of the organiza-
tional and institutional basis and implications of the field of education under-
scores the importance of the current discussion concerning the structural
parameters of individual agency within the education system.

For Bourdieu, it is the interaction of habitus and capital within a given
field that produces what he refers to as practice (Bourdieu 1977; McNamara

Horvat 2003). When considered in reverse, the conceptual contribution this formulation makes becomes even clearer. For example, take the practice of women students enrolling in degree programs at the UOTG. In this case the act of enrolling and participating in higher education must be understood as the relational product of the interaction between the habiti of individual women and the capital resources each woman possesses, mobilized within the field of education.

The habitus is structured by myriad social forces operating at different levels and within different spheres of society. However, it may also be argued that the interaction of habitus and capital within the field can also be used as a conceptual "spyglass" to uncover misrecognized systems of power that reproduce patterns of women's oppression. Furthermore, this model provides researchers with more room to maneuver and tease out how the interactions between habitus and capital within a field influences social practice.

THE CASE STUDY

The Gambia is a small coastal country in West Africa, bordered by Senegal on all sides. In 2004 it was ranked 155th out of 177 countries on the UN Human Development Index (UNDP 2005), placing it among the world's least developed countries. While making modest gains in terms of the goals for poverty reduction, education, and health as detailed in the government's Poverty Reduction Strategy Paper (PRSP), rates of poverty, disease, and illiteracy remain unacceptably high (Republic of The Gambia 2002).

The Gambian economy continues to rely heavily on the agricultural sector, which accounts for approximately 28 percent of the GDP and employs the majority of the labor force (World Bank 2003). Women, accounting for 45 percent of the labor force (World Bank 2003), are concentrated in the agricultural sector and in the manufacturing of agricultural products.

As a former British colony, The Gambia inherited a highly centralized and elitist education system, which excluded most citizens. The immediate post-independence era was characterized by the spread of mass education, assumed to be a cornerstone of social transformation, as well as a highly visible symbol of the legitimacy of the postcolonial leadership and its commitment to reducing poverty and increasing the overall well-being of the people (Samoff 2003; Mundy 1998). It is important to recognize the remarkable achievements of many newly independent African states in this regard (Samoff 2003). However, the capacity of governments—with the government of The Gambia being no exception—to maintain the level of public expenditure required to meet ever-increasing demands for schooling deteriorated as a result of declining economic conditions beginning in the early 1980s (Dei 1999).

Gender disparities in educational access, retention, and outcome have historically characterized the education system in The Gambia (DoSE 2002). While the Primary Net Enrollment Rate was 70 percent for girls and 76 percent for boys in 2000, the completion rate for boys was 82 percent with that of girls' being a mere 60 percent (World Bank 2003).[3] Considering girls' low completion rate for primary education, it is hardly surprising that in 2000 women accounted for only 27 percent of enrollments at the secondary level (UNESCO 2001). Following the declining trend in women's participation in formal education in the country at the primary, junior, and senior secondary levels, women account for a small fraction of tertiary-level enrollments, particularly true in the case of women's enrollments in degree programs at the University of The Gambia (UOTG).[4]

WOMEN AND EDUCATION POLICY IN THE GAMBIA

In terms of national education policy, The Gambia has in place well-formulated and articulated goals and strategies for promoting the empowerment and advancement of women through education. The focus of the *National Policy for Advancement of Gambian Women* is on mainstreaming women's issues into national development processes (Republic of The Gambia 1997). To accomplish this, the policy establishes a framework of goals and strategies for various sectors to operationalize in order to facilitate the effective implementation of "sustainable programmes for the advancement of women" (Republic of The Gambia 1997). Moreover, the mainstreaming of women's issues into development processes is conceived by the government as a precondition for enhancing the human resource base in The Gambia, which is viewed as necessary for the achievement of national development goals (Republic of The Gambia 1997). The human capital approach to development planning is reflected in The Gambia's *Vision 2020* statement that establishes the nation's development goals of becoming a self-reliant and developed country by the year 2020 (Republic of The Gambia 1997). A key strategy identified toward the achievement of these goals involves the expansion of educational opportunities to all citizens, but with particular attention given to increasing girls' and women's access to and performance in formal education (DoSE 2002).

Two key state agencies are responsible for advocating for the unique needs of women and girls as well as promoting the socioeconomic advancement of women through education—the National Women's Council and Bureau and the Girls' Education Unit (GEU) respectively.[5] Both of these agencies have contributed to the development and implementation of the National Education Plan (1997) and the Girls' Education Initiative, which broadly aims to stimulate the participation of girls' in education at all levels.

A key policy move by the government in this regard was the Free Education for Girls policy, implemented in 2000. Underpinning each of these policy efforts is the idea that disparities in the socioeconomic performance of men and women are attributable to gender-based differences in levels of education (DoSE 2002).

THE GENDER HABITUS: CHANGE AND CONTINUITY

This section discusses in tandem the research findings that suggest a reconfigured gender habitus among the study participants and the key structural conditions that have been identified as constraining girls' participation in formal education. This exercise will enable us to explore the sites and dynamics of change produced through the dialectical relationship between habitus and field.

The Household/Compound Social Field

Women are key players in family survival in The Gambia, and their contributions to family, community, and indeed national well-being would be difficult to overstate. However, their capacity for making or even significantly influencing decisions concerning themselves or their households remains quite low (Parrett 2004). This is attributable to patriarchal attitudes and practices—which some view as products of the colonial legacy—that view the male as the natural head of household and therefore the only one responsible and capable of making decisions on the behalf of the rest of the family, his wife included.

Household poverty, a common characteristic of families in The Gambia, especially pronounced among the majority rural population, has significant implications for the development of gender habitus and girls' access to formal education opportunities. In this regard, the opportunity and direct costs of schooling as well as institutional practice interact with the dispositions of parents and children in complex ways (Pryor 2001). A World Bank study found that educating one child per year at the primary level in The Gambia requires 20 percent of a household's disposable income (World Bank 1995). Because of the prohibitively high costs of schooling, the family must make important decisions, although this often means a decision by the father as to which children will be sent to school.

In the majority of cases where such decisions are required, the choice is made to educate the boy(s) in the family. The general pattern of privileging boys' education over that of girls is a symptom of the persistent undervaluing of girls' education in Gambian society, a pattern reproduced through sociocultural and religious norms that view formal education as redundant with respect to women's "natural" role in the domestic sphere. These norms are fur-

ther supported through household survival strategies that view the education of boys as a better investment in terms of men's greater earning potential and thus their presumed greater capacity to financially support their parents as they grow older.

Noteworthy however is that the research showed that this long-standing pattern of undervaluing of girls' education is beginning to be challenged in Gambian society. In several instances older men told me quite explicitly that it is their daughters who contribute the most financial resources through family remittances that serve to supplement the family income. Importantly, in these conversations, such observations seemed even surprising to those making them, and were more often than not followed by some variation of "had I known this would be so, I would have made sure to educate all my daughters." I use this anecdote as preliminary evidence of the role of women agents in promoting a positive shift in attitudes toward women and their contributions to family and indeed national well-being. In a society where "the grass is always greener syndrome" is a common affliction and many young men dream of leaving the country in search of a better life elsewhere, it has become increasingly difficult to deny that it is women who are actively engaged in strategies for making a better life for themselves and their families in their homeland.

The structural conditions of poverty, which are intimately connected to the entrenched inequality and power imbalances that characterize the current world order and trade regimes, interact as well with sociocultural mores and practices in ways that shape the range of opportunities available to women and girls beyond the social field of the family. As the family is centrally important to the social structure and processes that characterize Gambian society, the structural conditions and the dispositions of family members play key roles in determining a woman's future and composite life experiences. Considering then, the integral nature of family relations in the lives of individual women, it is not surprising that participants frequently stated that family responsibilities and expectations heavily influenced the decisions they made as well as the decisions that were made for them.

Conditions of poverty demand that families maximize their resources in order to survive. Within the field of the family, girls' and women's household and agricultural labor is valued and maximized, whereas as previously noted, boys' contributions will be realized later as they become educated members of the labor force and "give back" to the family. Early socialization processes that relegate menial and labor-intensive childcare, housework, and cooking tasks as the responsibilities of women structure the lives of young girls physically and psychologically.

It is widely acknowledged in the literature that the heavy domestic work burden of girls and women constrain their access to and performance in formal

schooling (Moller Okin 1995; Njeuma 1993). However, in terms of the gender habitus, a "taboo system" that promotes the belief that this is the natural order of man/woman responsibilities also serves to structure what girls and women view as acceptable activities for them to engage in and pursue (i.e., formal education and careers in nontraditional fields such as science and technology). In other words, the cultural reproduction of the gender division of household labor is secured early through the internalization by girls' of their expected roles as caregivers and workers within the field of the family. Fortunately, the rising number of educated, professional women in positions of power in The Gambia suggests, at least, the beginning of a process whereby the taboo system is dismantled, opening up space for the emergence of more balanced gender relations and expectations.

Interestingly, for several of the participants in this study, their home life was different. In several instances it was noted that mothers ensured that there was an equal distribution of work in the house between boys and girls so that all the children would have the same amount of time to study and rest. Such a system would act to reconfigure the gender habitus in the sense that it shakes up the "rules of the game" (Bourdieu and Wacquant 1992) and the hierarchy of power that serves to perpetuate an unequal sexual division of labor in the home, thus mitigating some of the traditional constraints on girls' performance in formal education.

The interaction between poverty and sociocultural norms prevalent in The Gambia is further reflected in the practice of early marriage.[6] Even if young girls are fortunate enough to attend formal schooling, many will be removed prior to completion of primary education, although it may happen at any level. However, even if a woman is "permitted" to continue attending school, the responsibilities of married life demand so much time and energy that she may be ultimately unable to continue her studies and/or perform to her full educational potential. An emergent theme from the research suggests that the challenges presented by the practice of early marriage and/or pregnancy may be further compounded by the strong influence of husbands and in-laws over the life-choices of women and in particular decisions regarding their education. Indeed, the married participants were not immune to the challenges presented by husbands and in-laws in terms of the degree of personal autonomy they perceived themselves to have.

ATTITUDES TOWARD (DIS)EMPOWERMENT

Perhaps the most surprising finding emerging from this research was the general ambivalence of the participants to the gendered dynamics of classroom politics and the power imbalances that generally characterize gender relations

in The Gambia. Fatoumata stated, "There was no form of stereotyping in class except in textbooks which used the pronoun 'he' most of the time." Miriama noted, "I often contribute in class, particularly on issues that have nothing to do with gender." Indeed, there were contradictions between the apparent ambivalence of the participants toward the manifestations of gender bias and gender disadvantage within the field of education and their expressed concern for the challenges posed by these practices manifest within the household/domestic social field, particularly when they spoke of the barriers "other women" faced in The Gambia. Whereas the majority of the participants identified the general lack of "voice" women have in their homes concerning decisions affecting their schooling, it was in the field of education and specifically within the classroom context that the women in this study felt "heard," and thus "empowered." Therese stated, "I do always speak in class . . . and my ideas are always well received by both students and professors." And Halimatou said, "They [teachers] treated me with respect and I didn't encounter any discrimination from them." Halimatou, whose parents were highly educated and relatively affluent, reflected that her very positive experiences with teachers and schooling more generally may be attributable: "to the fact that they [teachers] were aware of my background in the sense that I come from a literate home and know my rights and privileges . . . so obviously they will be mindful toward me."

Here Halimatou is tacitly suggesting that students from literate homes have an "edge" in the struggle against gender disadvantage in the field of education. Specifically, this is in the sense that they are endowed with forms of capital that interact with the gender habitus to create a social practice (teacher-learner relationship) that differs from what one could expect if an individual did not know his or her "rights and privileges." The notion that the educational attainment of parents is correlated with the capital endowment of children coincides with participant's perceptions that they were "different" from the majority of women in The Gambia and that they had been "liberated from ignorance" as a result of their higher education.

So how did the participants explain this "difference"? That the women attributed their intense motivation and high performance in the field of education to their home life is perhaps not surprising considering this is the field in which, as previously noted, the structural conditions and sociocultural norms have historically constrained girls' access to and performance in formal schooling, and thus would logically be a key site for change processes. Additionally, the participants all highlighted the importance of the emotional support provided by their mothers, and their desire to "please" their mothers through their success in school was poignantly expressed in several cases. Musu stated, "My mother . . . emotionally helped me a lot by advising me to take my books as my friend. . . . She told me I am lucky to be in school, for in

her time no parent dare to take her girl child to school . . . and that was the biggest regret of her life." Musukuta said, "It's [higher education] really important to me because it makes me feel better and relieved that I am fulfilling the dreams of my mom who didn't have the opportunity and wanted me to."

That the majority of the participants indicated that their parents had paid for private tutoring for them throughout their secondary education suggests an important intersection between social class and gender with implications for how we can understand the structural barriers to women's education access and performance. However, controlling for the effect of private tutoring, another theme emerged from the findings concerning the active role the participants' mothers took in their education from the primary years forward. Ida said, " My mom was like pushing us to go to school, making sure we didn't miss school. . . . She comes to school to see what we are doing." Vivian exclaimed, "My mother is very concerned in my education, which she expresses by having conversations with me, going through my records at school, helping me do my assignments, and guiding me in solving problems."

The importance placed on their mother's interest and assistance in terms of their schooling, by the participants, parallels the findings in the growing literature on the gendered nature of parental involvement in children's education (David 1993; David et al. 1993; Reay and Ball 1998). Reay (2004) offers a further elaboration of the relationship between mothers and their children's education using the concept of emotional capital (57). Emotional capital can be viewed as a variant of social capital (the social networks, associations and bonds shared among individuals that gain value within specific fields and can be used in the acquisition of cultural, economic, or symbolic capital) but is "characteristic of the private rather than public sphere" (Reay 2004, 60). Drawing on similar work by Nowotny (1981), Reay (2004) notes that emotional capital is "generally confined within the bounds of affective relationships of the family and friends and encompasses the emotional resources you hand on to those you care about" (60). In this regard, Reay (2004) notes that while Bourdieu does not explicitly refer to emotional capital in his work, he does "highlight the key role of women in affective relationships" (60).

Emotional capital has been theorized as a form of capital that women have in greater abundance than men (Reay 2004, 60). Furthermore, Notwotny (1981) suggests that it is through adverse circumstances that emotional capital is developed, with mothers passing it on to bolster their children's emotional resources in contexts of educational struggle and in response to barriers to educational achievement. Significant however is Reay's (2004) suggestion that "poverty is not an environment in which emotional capital can normally survive" (69). However, the research this statement was based upon was set in contemporary Britain, thus suggesting the need to further explore the nature

and dynamics of emotional capital in economically disadvantage societies. The intense and critical emotional support provided by mothers that was noted in the current study suggests that while, relatively speaking, the participants came from more privileged backgrounds, these were generally not comparable to the middle- or upper-class families, nor even working-class families in Reay's study. Thus I argue the need for further research into the relationship between gender habitus, emotional capital, and the social field of education in order to facilitate a deeper understanding of women's empowerment in conditions of absolute and relative poverty.

LABOR-MARKET CONSIDERATIONS

The participants' attitudes toward their future positions in the social field of the labor market provide further evidence of a reconfigured gender habitus embodied in the women. Specifically, this is in terms of the high level of self-efficacy that the participants viewed themselves as possessing as a result of their higher education credentials. Halimatou said, "Higher education is very important to me. It helps me discover my potentials and capabilities and also enables me to specialize in a field that I can make an impact on the socioeconomic development of my country." Isatou said, "It [higher education] helps me to become a critical thinker and to contribute to national development."

For those three participants who were pursuing Bachelor of Science degrees, each expressed their desire and intentions to pursue post-graduate work or pursue specialized training in the health sciences. The occupational choices these women were pursuing were certainly not in "traditional" areas for women, yet the historically marginal participation of women in these fields did not appear a significant factor in the participant's decisions. This suggests further distinctions between the gender habitus of the participants and the more general habiti (Moore 2004) of women in The Gambia.

However, a more complex picture emerges when we compare these findings to those of Parrett (2004), in her analysis of powerful, educated professional women in The Gambia, in which she describes the processes whereby even "successful" women constantly have to negotiate the constraints of family and societal gender expectations: "Even the most educated and modern women maintain a high level of contact with their extended families, marriage and motherhood was, for the most part, still highly valued and men's position as household head and chief decision-maker was, on the surface at least, widely accepted" (Parrett 2004, 5). So even though the study participants all indicated that they had ambitious career plans, often in nontraditional fields, the reality of professional life for women in The Gambia is more akin to Adkins (2005) idea that "heightened forms of reflexivity" and the "reinscription of 'traditional'

gender in new but old ways" can coexist (cited in McLeod 2005, 23). Thus we find women who have "beat the odds" and become highly educated and employed in powerful positions still situating themselves to fit the model of a "respectable" woman on as many fronts as possible, especially within the home and with respect to marriage and childbearing (Parrett 2004, 6). We as "outsiders" must be sensitive to the dynamics of such negotiations, and not be too quick to judge these as examples of disempowerment. For as Kabeer reminds us, agency (or habitus in the language of the current discussion) can take many forms, including "bargaining, negotiation, deception, manipulation, subversion and resistance" (437). Furthermore, when comparing these two studies we can also see that efforts to define and measure empowerment are further complicated because women's status is determined in culturally and socially specific ways.

CONCLUDING REMARKS

This chapter has mobilized Bourdieu's theory of social practice and applied the key concepts of habitus, capital, and field to questions of women's education and particularly women's empowerment. The findings suggest evidence of a reconfigured habitus among the study participants, compared with what we could expect the nature of the more general gender habitus to be among the majority of women in The Gambia. The analysis has highlighted policy, school, and the family/household as important sites of change and as sources of inspiration and emotional support for girls' and women's empowerment. The discussion has also included an examination of the field of formal education, where we found a complex array of contradictory perceptions and attitudes emerging from the participants. It was suggested that the school is potentially a site for change, as well as continuity.

I have also identified the need for further research aimed at assessing the extent to which participants were aware of or became aware of aspects of global gender equity and women's rights discourse and the implications of this. For it is argued that discourses do have material effects (Ninnes 2004), and we can see such effects at the national and micro level in terms of education policy development focusing on improving women's socioeconomic status. However, what is needed is further attention to be paid to the impact of global development and gender equity discourse on the cognitive and behavioral aspects of the social practice of individual agents in their social contexts. For example, how does the global norm of women's equality impact on micro level processes in terms of facilitating empowerment in the sense of enabling or fostering women's greater control over decisions affecting their educational experiences and future careers? In summary, this chapter has

demonstrated the conceptual contribution of Bourdieu's theory of social practice, and in particular the notion of habitus as a generative structure that enables us to understand the agency/structure relationship as it applies to women of The Gambia.

NOTES

I would like to acknowledge the financial support of the Canadian International Development Agency (CIDA) that made this research possible.

1. This shift can be traced back to Edna Boserup's influential book *Women's Role in Economic Development* (1970).

2. This shift can be seen in the evolving theoretical frames of Women in Development, Women and Development and Gender and Development, which have guided the policies and practices of donor agencies and international institutions. Empowerment has been defined by CIDA as "people taking control over their lives" and "becoming aware of the unequal power relations" and thereby "acquiring greater voice to overcome inequality in the home, workplace, and community" (CIDA 1999, Internet www.cida.gv.ca). The shift from WID to GAD is largely attributable to insight offered by various feminist critiques of the lack of attention paid in WID to the need to challenge the very structures and asymmetrical power relations that give rise to gender inequality.

3. In connection to the widely recognized problems in terms of the reliability of statistics (for a variety of political economic reasons) provided by the governments of "developing countries," I want to emphasize here that the actual numbers offered are not as important as the underlying patterns they represent.

4. The UOTG was established in 2000 through a partnership between the government of The Gambia, the Department of State for Education (DoSE), and Saint Mary's University, Halifax, Nova Scotia.

5. The National Women's Council and Bureau was established in 1980 through an act of Parliament, however the Girls' Education Unit has a much shorter history being established only in 1995.

6. Approximately three-quarters of women are married, or have been married at least once by the age of 24 (Republic of The Gambia [2000]. The 1998 National Household Poverty Report. Banjul: Central Statistics Bureau).

REFERENCES

Adkins, L. 2005. *Reflexivity: Freedom or habit of gender? Feminists evaluate Bourdieu.* University of Manchester 2002. www.socialsciences.manchester.ac.uk/sociology/ Seminar/afterbourdieu.shtm.

Arnot, M. 2002. *Reproducing gender? Essays on educational theory and feminist politics.* London: Routledge.

Boserup, E. 1970. *Women's role in economic development.* New York: St. Martin's Press.

Bourdieu, P. 1977. *Outline of a theory of practice.* Cambridge: Cambridge University Press.

———. 1987 [1979]. The forms of capital. In *Handbook of theory and research for the sociology of education,* edited by J. G. Richardson, 241–258. New York: Greenwood Press.

———. Bourdieu, P. 1994. *Language and symbolic capital.* Cambridge: Harvard University Press.

———. 2001. *Masculine domination.* Stanford: Stanford University Press.

Bourdieu, P. and L. J. D. Wacquant. 1992. *An invitation to reflexive sociology.* Chicago: Chicago University Press.

Brettell, C. B. 2002. The individual/agent and culture/structure in the history of the social sciences. *Social Science History,* 26 (3): 429–445.

David, M. E. 1993. *Parents, gender and education reform.* Cambridge: Polity Press.

David, M. E., R. Edwards, M. Hughes, and J. Ribbens. 1993. *Mothers and education: Inside out? Exploring family-education policy and experience.* Basingstoke: Macmillan.

Dei, G. J. Sefa. 1999. Educational reform efforts in Ghana. *International Journal of Educational Reform,* 8 (3): 244–260.

———. 2004. *Schooling and education in Africa: The case of Ghana.* Trenton: Africa World Press.

Department of State for Education (DoSE). 2002a. Annual sector review 2002. Banjul: Department of State for Education/Government of The Gambia.

———. 2002b. The basic education programme. Banjul: Department of State for Education/Government of The Gambia.

———. 2002c. Third education sector programme 2002: Annual donor review report. Banjul, The Gambia: Department of State for Education/Government of The Gambia.

Kabeer, N. 1999. Resources, agency, achievements: Reflections on the measurement of empowerment. *Development and Change,* 30 (3): 435–464.

Manion, C. 2003. *Gender and academic choice in national-capacity building: The case of the University of The Gambia* (Unpublished MA thesis). Interdisciplinary Studies, Saint Mary's University, Halifax.

McLeod, J. 2005. Feminists re-reading Bourdieu: Old debates and new questions about gender habitus and gender change. *Theory and Research in Education,* 3 (1): 11–30.

McNamara Horvat E. 2003. The interactive effects of race and class in educational research: Theoretical insights from the work of Pierre Bourdieu. *Penn GSE Perspectives on Urban Education,* 2 (1):1–25.

McNay, L. 1999. Gender, habitus and the field. *Theory, Culture and Society,* 16 (1): 95–117.

———. 2000. *Gender and agency: Reconfiguring the subject in feminist and social theory.* Cambridge: Polity Press.

Moller Okin, S. 1995. *Women, culture and development: A study of human capabilities.* Oxford: Oxford University Press.

Moore, R. 2004. Cultural capital: Objective probability and the cultural arbitrary. *British Journal of Sociology of Education*, 25 (4): 445–456.

Moser, C. 1993. *Gender planning and development: Theory, practice and training.* New York: Routledge.

Mundy, K. 1998. Educational multilateralism and the world disorder. *Comparative Education Review*, 42 (4): 448–478.

Naidoo, R. 2004. Fields and institutional strategy: Bourdieu on the relationship between higher education, inequality and society. *British Journal of Sociology of Education*, 25 (4): 457–471.

Ninnes, P. 2004. Critical discourse analysis and comparative education. In *Reimagining comparative education: Post-foundational ideas and applications for critical times*, edited by P. Ninnes and S. Mehta, 43–62. New York: RoutledgeFalmer.

Njeuma, D. 1993. An overview of women's education in Africa. In *The politics of women's education: Perspectives from Asia, Africa and Latin America*, edited by J. Conway and S. C. Bourque, 123–133. Ann Arbor: University of Michigan Press.

Nowotny, H. 1981. Women in public life in Austria. In *Access to power: Cross-national studies of women and elites*, edited by C. Fuchs Epstein and R. Laub Coser, 147–156. London: George Allen and Unwin.

Parrett, L. 2004. Big women in a small country: Negotiating female identity and status in urban Gambia. Political Studies Association, www.psa.ac.uk/cps/2004/Parrett.pdf

Pryor, J. 2005. Can community participation mobilise social capital for improvement of rural schooling? A case study from Ghana. *Compare*, 35 (2): 193–203.

Reay, D. 1997. Feminist theory, habitus and social class: Disrupting notions of classlessness. *Women's Studies International*, 20 (2): 225–233.

———. 2004. Gendering Bourdieu's concepts of capitals? Emotional capital, women and social class. *The Sociological Review*, 52 (2): 57–74.

Reay, D. and S. J. Ball. 1998. "Making their minds up": Family dynamics of school choice. *British Educational Research Journal*, 24 (4): 431–448.

Republic of The Gambia. 1997. Draft education master plan: 1998–2005. Banjul: Department of State for Education.

———. 2002. Third education sector programme: 2002 annual donor review report. Banjul: Department of State for Education.

Samoff, J. 2003. No teacher guide, no textbooks, no chairs. In *Comparative Education: The dialectic of the global and the local*, edited by F. Arnove and C. A. Torres, 409–445. Oxford, UK: Rowman and Littlefield.

UNESCO. The world's women. www.un.org/womenwatch/world

United Nations Development Programme (UNDP). 2005. International cooperation at a crossroads: Aid, trade and security in an unequal world. www.hdr.undp.org/reports/global/2005/pdf/HDR05_HDI.pdf

Vavrus, F. 2002. Constructing consensus: The feminist modern and the reconstruction of gender. *Current Issues in Comparative Education*, 5 (1): no pagination.

World Bank. 2003. The Gambia at a glance. www.worldbank.org

World Bank. 1995. Why Gambian households under invest in education of girls. Report No.14536-GM. Washington, D.C.: World Bank.

Structure and Agency in India's Teacher Education Policy

*Women Teachers' Progress
through a Critical Feminist Lens*

SANDRA L. STACKI

Throughout Asia, despite constitutional equality for women, class and caste distinctions persist along with patriarchal dominance. In the countries of South Asia, the underlying culture including government, colonialism, and religion limit women's choices (Tinker 2004). Outside pressure from development agencies and NGOs to include women in the development process stimulated movement toward gender equity. Contemporary women's organizations have documented women's conditions, begun to change inequities of customary and family law, and women from community levels in both urban and rural areas are becoming more empowered along with the women leaders from the educated elite class (Tinker 2004). Women's indigenous knowledge has also become more recognized and valued. Most Asian countries have set quotas for women in political office and have developed five-year plans and education policies that contextually recognize the need for women's agency for a developed society. Yet comprehensive progress toward gender equity takes small steps.

Through a lens of critical feminist thought, this chapter will explore aspects of structure, agency, and empowerment in India's teacher education policy and its implementation and use in government teacher education institutions. An overview on conceptualizations of structure, agency, and empowerment through a critical feminist lens is followed by methodological

commitments and methods that guide my research. Education policy is explored as it relates to decentralization, teacher education, state-level District Institutes of Education and Training (DIET) for teachers, and women teachers. An evolving ideology and framework of educational decentralization creates opportunities for discussion of structure and agency for women educators. These structural institutions define parameters within which women teachers learn and work in schools. Strategies of implementing the policy demonstrate the difficulties and the possibilities that have emerged for varied types of women educators' personal, professional, and economic agency as they live a dialectical relationship within and against these structures.

CRITICAL FEMINIST CONCEPTUALIZATIONS: THE INTERACTIVE DIALECTIC OF STRUCTURE AND AGENCY

Both critical and feminist theorists evaluate the ideals of justice, freedom, happiness, and social change as they discover and discuss hidden power and knowledge connections within these ideals (Ingram and Simon-Ingram 1991; Lennon and Whitford 1994). Through individual capacities to reason, people have the potential to liberate themselves from dogma, superstition, and ideology—social, cultural, religious, and political. However, the possibility also exists that individuals and groups will become subordinated to structures and to the demands and uses of others, consciously and often unconsciously (Ingram 1990). Groups in society such as women and teachers struggle with each other over social class, power, and economic issues and create various kinds of cultures and interactions in institutions in society.

Critical theorists have primarily analyzed the macro aspects of society, social institutions, and processes in the public sphere, not individuals. Rather than primarily blaming or holding responsible the individual for not succeeding in a system, a critical theory approach recognizes that the system must be restructured to allow more democratic participation if it is to better meet the needs of the participants, enable agency or empowerment, and encourage normative change in the system (Schapiro 1995).

Feminists demand the analysis of the micro sphere, of individuals as self-determining agents interacting with social institutions in the private and public spheres and the recognition of gender issues and women in the analysis of social processes, systems, and problems. They insist that women must gain an equitable place in societal restructuring because change must focus on gender equity. Inequitable socially constructed relationships between men and women are linked to the norms that serve as organizing principles of society, the state, the economy, and all macro and micro processes and institutions.

This position is consistent with Gender and Development (GAD) and gender mainstreaming approaches that argue that uncoordinated methods of integrating women in development should be replaced by measures to change the structural relations that keep women in a position subordinate to men (Stromquist 1994). Policies should make a genuinely sustainable contribution to equality between men and women (Ministry of Foreign Affairs 2002), not offer a surface level solution that dissolves over time.

Individual women need to gain consciousness and achieve empowerment to become agents capable of changing these norms and coexisting equally in society (Weiler 1988). Discussions of empowerment with structure and agency require attention to specific historical struggles within the structures and discourses of power operating at all levels (Parpart, Rai, and Staudt 2002). Thus, education policy and its implementation discourse are appropriate topics. The concept of empowerment recognizes that human agency and positive possibilities can result through individuals or groups opposing oppressive systems and processes. Although empowerment has been theorized, framed, and modeled in private, professional, and public spheres in the work of many feminists (cf. Friedmann 1992; Hall 1992; Karl 1995; Monkman 1998; Moulton 1997; Stacki and Monkman 2003; Stromquist 1994; Troutner and Smith 2004) and development agencies (Troutner and Smith 2004, 8; UNICEF 1994), central to these models are issues of "power to" not "power over" and "power with and within." These notions emphasize the exercise of power including individual conscientization (*within*) and the ability to work collectively leading to politicized power *with* others that provides the power *to* bring about gender equity and social change. Also important in discussions of women's empowerment are the recognitions that power pertains to specific issues and contexts and that gender roles that vary from context to context are subject to change (Troutner and Smith 2004). Individual empowerment is often not sufficient as it does not tackle the structures of class, caste, and gender oppression (Jaquette 2004) found especially in many developing countries. Thus some processes and transformations of power can be disempowering for women, perhaps robbing them of status, access, or voice.

In cross-cultural studies, feminists must be sensitive to adapting theories and models to recognize contextual structures, voices, and the way these interact. For instance, South Asian feminist Kumar (1994, 4) believes that researchers should build bridges and cautions that we should "not reject feminist and critical theory in the fear that they threaten to model our data in their own images, but to question, modify and adapt the theory to make sense of specific South Asian discourses." Although institutional obstacles must be acknowledged, the way to conceptualize women and write about them is to understand the hidden, subversive ways in which they exercise their agency even though they are outwardly part of a repressive normative order.

Thus, feminists reject theories that see women as totally passive in their responses to structures within which they exist (Haraway 1988; Kumar 1994). Feminists recognize individual, subjective experience in knowledge construction as part of a flexible, dynamic flow between public/private systems for all individuals (Fraser 1991; Messer-Davidow 1991; Strickland 1994). Knowledge creation is a dialogical and dialectical interaction, a tension between individuals' subjective perspective and the ideology, policies, structures, and institutions in individuals' public context that create the ideology of the context within which they live (Stacki and Monkman 2003) and that influence individual political and gender socialization (Ginsburg and Lindsay 1995).

The combination of the two words *teacher* and *empowerment* has become a commonly understood concept in teacher development theory in Western industrialized countries. Restructured designs in education systems invite the stakeholders to participate, share power, and make decisions at the school level. This emphasis in restructuring has often involved decentralization and has fostered teacher inservice that focuses on empowering teachers to be well functioning, responsible professionals. In many developing countries, the concepts of empowerment and agency have often not been as well developed or understood. However, empowered teachers are essential actors in promoting social and political change and gender equity (Stacki 2002; Stacki and Monkman 2003).

INTERDEPENDENCE IN METHODOLOGY AND METHODS

My study in India has shared interdependent aspects of interpretive, feminist, phenomenological, and policy analysis approaches. This chapter focuses primarily on presenting and discussing Indian education policy most specifically in regard to decentralization, teacher education, and women educators. However, discussion of key strategies to implement the policy share some of the aspects of an interdependent approach to research that is part of my more comprehensive study of Indian policy, teacher education and empowerment, women teachers, and girls' education.

Policy analysis can explore the policies themselves and/or the evaluation of policies. Another key aspect, especially for interpretive researchers is to focus on the experiential, lived realities and the interests of numerous stakeholders involved or affected in these aspects of policy. In this chapter, I share the knowledge and thoughts of several Indian education officers and women educators at District Institutes of Education and Training (DIET) sites in the state of Uttar Pradesh. This trend to focus on lived realities, consistent with interpretive work, focuses on process rather than a charter or political act

(Sutton and Levinson 2001). The purpose is to create dynamic models of policy processes and encourage a more contextualized understanding of policy as practice. In looking at the policy statements themselves, we see how policymakers are framing issues and gain insight into the underlying assumptions and agendas used in the language to discuss educational policy, and into the implementation and programs of action that develop from the policy. Language and the framing of issues influence how we think and act, and therefore, do make a difference materially and symbolically (Apple 1982).

Interpretive and/or naturalistic inquiry encourages interaction with people in their natural environments. Meaning is created in the intersubjective experience (Prus 1996) of attempting to understand respondents' social constructions of reality. A shared, collaborative construction of knowledge between researcher and respondents is phenomenological insofar as knowledge is intersubjective, developed through social relations and negotiations, allows for reciprocity and caring, brings private and public together (Grumet 1988). Phenomelogy focuses on the things themselves, a representation that lets the data speak for itself from a given point of view.

Feminist inquiry includes documenting the lives and activities of women to correct patriarchal bias of social science and to get closer to women's realities: making their lives visible and audible; understanding the experiences of women from their own point of view to contribute to women's social construction or standpoint and complement the androcentrically created knowledge construction of women; and conceptualizing women's behavior as an expression of social contexts to allow feminist researchers to rethink social contexts in terms of women's experiences and power relations (cf. Fonow and Cook 1991; Maynard and Purvis 1994; Reinharz 1992; Sutton 1998; Warren 1988). Using feminist interpretive methodology helps researchers to better see and understand the culture, meaning, and processes (Crossley and Vulliamy 1997) in women's lives—their daily lived realities.

However, standpoints of the subjugated, often women, are not innocent positions. Consistent with an interactive dialectic or methodological relationism, the individual is an active agent, not a passive subject in a deterministic knowledge process. Feminists debate whether to privilege women's and feminists' knowledge standpoints, to continue to value "objectivity" as a standard criterion by which to measure all standpoints, or to see knowledge creation as a dialogical interaction (Fiumara 1994) that does not privilege or yield priority to either side. I seek to understand the meanings of teacher education policy and implementation in the lives of women teachers, acknowledging that respondents' critical views as active agents are only part of a larger social and cultural knowledge.

With this focus on the dialectical aspects of structures and human agents in natural settings as a way to constitute reliable and valid knowledge claims

(Eisner and Peshkin 1990), in fieldwork I use a combination of research methods such as participant observation, interviewing, shadowing, and video-taping. I analyze written sources, particularly historical materials, Government of India policy documents, and research literature. Through these methods, I understand more about the macro environment of Indian education ideology, policy, and goals and their effects on educational practices and women teachers' lives.

NATIONAL POLICY DOCUMENTS AND TEACHER EDUCATION: A CONTEXT OF DECENTRALIZATION AND AGENCY FOR ALL TEACHERS

In several decades of India's National Policy on Education (NPE) and other review documents that critique the policies, goals for teacher education and the agency of teachers have been emphasized. Political and educational decentralization through amendment in 1992 provided impetus for changes in teacher education policy and implementation. The ideology of society and the politicians evolved in ways that advocated more self-esteem, status, and voice for all teachers, not just women. Yet these changes bode well for the personal, professional, and economic empowerment of the increasing number of women educators in India. A decentralized system in which more power and decision-making devolves to the teachers at regional and local levels represents a macroobjective macrosubjective system. The macroobjective represents the maintenance structure that defines the society's structural parameters in the education system and the macrosubjective represents the structural constraints and opportunities for individuals. A more decentralized education system represents a change in the relationship between the system and the structural barriers or opportunities for individuals.

This section will chronologically review some of the notable aspects of policy foci that pointed out barriers and hoped for opportunities for teachers and their education. The first NPE of independent India 1968 addressed status, emoluments, and education of what were generically assumed to be male teachers. The policy recognized that the success of education and national development depends on teachers: their character, qualifications, and professional competence. Teachers should be honored and provided satisfactory conditions. "Teacher education, particularly in-service education, should receive due emphasis" (NPE 1968 cited in Pandey 1992, 56–57).

In 1979, reforms supporting more decentralized control and agency for teachers were addressed but were not written into the policy until the NPE 1986. These ideas of the Janata political party included three main points: 1) For teachers to play a pivotal role in reforming education, they should be

inspired by creative idealism, feel pride in their professions, receive education to improve professional competence, and be assured of academic freedom for research; 2) Teachers should be model citizens who are conscious of their crucial role in the lives and character of future citizens and committed to national and social reconstruction; 3) To aid them in this reform role, the curriculum of teacher education and pedagogical preparations will be changed. Facilities for inservice training and centers for developing curricular materials and teaching aids will be established, especially for teachers in rural areas and for both formal and nonformal education (Pandey 1992).

In *The Challenge of Education* (Ministry of Education 1985), a review of the NPE, numerous aspects of the policy were criticized. Salient foci were the authoritarian management structure that helped to cause the widespread apathy of teachers and the community in regard to primary education and increased education for teachers. The reviewers lamented the lack of a democratically decentralized structure stating, ". . . the school system is now a part of a gigantic bureaucratic set up which leaves no room for intervention at the local levels and is, in effect, equally frustrating to a teacher with some initiative. If the community is to be involved, to be effective, its involvement will have to be multi-dimensional" (38).

The *Challenge* perspective recognized that the "sheer size of the present monolithic system creates an environment of anonymity for the teachers and the individual schools, in which any kind of default or creativity fails to come to notice" (Ministry of Education 1985, 39). However, these reviewers also envisioned the kind of decentralization that would aid education efforts: the Challenge encouraged the inclusion of education planners, teachers, students, parents, intellectuals, and citizens interested in education as sources in any future initiatives.

Also echoing previous policy documents, the *Challenge of Education* recommended comprehensive structural changes for teachers including changing "the orientation, work ethic, knowledge and skills of the teachers, who will have to function much more creatively in a learning rather than a teaching environment, in which they will have to struggle continuously with new ideas as well as new technologies (1985, 12). These documents recognize the need for major structural changes focused on both decentralization and the possibilities for teachers within a decentralized system.

Education Policy as an Agent for Women:
NPE 1986 and Programme of Action (POA) 1992

Although continuing to support decentralization and teacher professionalism in the areas of improved status, working conditions, professional unions, and teacher education, especially with the creation of the District Institutes of

Education and Training (DIET), in noticeably significant parts of the new NPE 1986 (revised in 1992) and the POA, gender equity and the empowerment of women in general and women educators were featured in the policy language. Decentralization would include involving more people, including nongovernmental agencies and volunteers and "*inducting more women in the planning and management of education*" (NPE 1992, italics added).

Training of planners, administrators, and heads of institutions at the state, district, and school levels was also stressed. Women were thus to be a key part of the stakeholder groups who were to plan and manage education. Education priorities for women and girls were also sharpened in the NPE, promising to favor women and promote empowerment. Under 4.2 and 4.3, Education for Women's Equality,

> education will be used as an agent of basic change in the status of women. In order to neutralise the accumulated distortions of the past, there will be a well-conceived edge in favour of women. *The National Education System will play a positive, interventionist role in the empowerment of women. It will foster the development of new values through redesigned decision-makers and administrators, and the active involvement of educational institutions.* This will be an act of faith and social engineering. Women's studies will be promoted as a part of various courses and educational institutions encouraged to take up active programmes to further women's development. . . . The removal of women's illiteracy and obstacles inhibiting their access to, and retention in, elementary education will receive overriding priority, through provision of special support services, setting of time targets, and effective monitoring. (NPE 1986 cited in Shukla 1988, 7, italics added)

In addition, the elementary education section emphasized that at least two teachers should teach at all schools and that one should be a woman. The number of teachers should continue to increase until each class has a teacher, thus improving working conditions for teachers, opening more opportunities for economic empowerment for women teachers, and improving learning conditions for students. Teachers were envisioned as having multiple roles: teaching, researching, and developing learning resource materials.

Under the women's equality chapter of the POA, a document citing more specific details of the policy goals and written with the inclusion of women on every task force, "Research and Women's Studies" emphasizes the aim "*to investigate and remove structural, cultural or attitudinal causes of gender discrimination, and thus empower women to achieve effective participation in all areas of national or international development.*" Included in dimensions to support this aim are "*teaching to change present attitudes and values of men and women to one of concern for gender equality.* Existing biases and deficiencies in curriculum will

be addressed" and programs will be developed for "training *teachers*, decision makers, administrators and planners to enable them *to play a positive interventionist role for gender equality*" (2, italics added).

Fundamental to this aim is the concept of empowering women. The POA (Department of Education 1992) describes the parameters of women's empowerment as follows:

* enhance self-esteem and self-confidence of women; [*sic*]
* building a positive image of women by recognizing their contribution to the society, polity and the economy;
* developing ability to think critically;
* fostering decision making and action through collective processes;
* enable women to make informed choices in areas like education, employment and health [especially reproductive health; *sic*]
* ensuring equal participation in developmental processes;
* providing information, knowledge and skill for economic independence;
* enhancing access to legal literacy and information relating to their rights and entitlements in society with a view to enhance their participation on an equal footing in all areas. (POA 1992, 2)

To achieve these parameters, education has a key role to play. Among the measures to be taken are *training all teachers and instructors as agents of women's empowerment*; developing gender and poverty sensitization programs for teacher educators and administrators; developing core curriculum to promote a positive image of women; developing gender-sensitive curriculum and removing sex bias from textbooks and *training of trainers/teachers*; *giving preference to female teacher recruitment to motivate parents to send girls to school*. By these means "an environment will be created whereby all the sections of the education sector will become alive and sensitive to the role of education in eliminating gender disparities" (POA 1992, 2, italics added).

In this policy and the planned actions, a critical feminist philosophy and pedagogy are stressed. This language expresses a strong inclusiveness of women and women educators that had not been present in previous policies. The specific focus on women teachers to be agents of women's empowerment along with curriculum and pedagogical changes evidences a more comprehensive understanding of the underlying problems of inequity within the educational system. Defining specific aspects of empowerment also indicates the importance of women's agency in education and national development. No longer is a reactive practice allowed as the policy calls for taking proactive interventionist steps to change structural as well as attitudinal and cultural barriers. Yet these are words on paper. The real test in is the implementation of the policy.

STRATEGIES TO IMPLEMENT
TEACHER EDUCATION AND GENDER EQUITY

Opening of the DIET

With a decentralized structure, one significant result for teacher education has been the creation of the District Institutes of Education and Training (DIET). These institutes are charged to develop a teacher assistance program and resource center in each district or one DIET for two smaller systems. These will be the institutional base for in-service, elementary teacher training, and preservice training. Over four hundred DIETs now exist (Seshadri 2002).

In discussing the need for DIETs, Grover, the undersecretary in the Elementary Education Department/Department of Education explained to me:

> It's simply not possible to dictate all of the things from the center in such a vast country. And our clientele of teachers is also a very large community; we have about forty lakh [four million] teachers in the country, in the formal system. And there may be many more in the nonformal and adult education system. So we need to decentralize—there is no other way. And we have to create the resource institutions for operation of competencies of the instructors and teachers, at every level. One or two or ten institutions will not suffice for a country of this size. That is why the District Institutes of Education [and Training] were thought of. (Interview with Grover, January 3, 1996)

State governments manage the DIETs but are given support by the central government. As the NPE emphasized, the DIET as a centrally funded scheme provides an institutional base, a framework for recurrent teacher education. Subbarao, the Director of Elementary Education, noted, "One short teacher training would not be of much use. So DIETs assist in having initial orientations followed up" (Interview with Subbarao, 1-3-1996).

My research in the state of Uttar Pradesh (UP), allowed me to talk with S. P. Pandey, the Administrative Director for the State Council of Educational Research and Training. He described some of the specific roles of the DIETs in UP. For example, the staff in eighteen districts is looking at math and science curriculum that teachers find difficult to teach. In addition, as key resource persons are trained at the DIET, they are responsible to train other teachers in their districts. At the subdistrict level, teacher resource centers are planned for both the block and the cluster levels. As Subbarao noted, these are the ultimate thrust of decentralization.

> We are thinking that the district is also a big geographical unit, and we need to have much closer units, closer to the school complex, school to the clus-

ter, so that we have a facility for teachers who cannot be away for a long period from the schools. . . . So we are trying on an experimental basis in a few states what are called the block resource centers and school complex centers. [School complex centers are for the secondary level.] This has been tried out in Andra Pradesh, and in Uttar Pradesh. . . . So that is for peer group learning. The teachers meet once a month, interact, and discuss issues related to school effectiveness, use of teaching aids, and basically problems which teachers encounter in the schools. Ultimately, what I'm saying is the structure is so designed because of the vastness, the heterogeneity of the country. You can't have a uniform pattern. But this structure basically is to go down as much as possible, decentralize it, go down to that level. (Interview with Subbarao, 1-3-1996)

The decentralization to DIETs provide more local level opportunities for all teachers to become more professionally and economically empowered through both preservice and in-service education. Yet the structure of district and even more local block resource centers can additionally empower women. The logistics of a location closer to their school or home facilitates their domestic roles as mothers and housekeepers. The less they need to travel or stay overnight, the more opportunities they can participate in. In my observations at DIETs, I have seen women find support with peers or in group work. They have time to socialize and discuss their teaching work as well as learn new curriculum and pedagogy.

Increasing the Number of Women Educators

Recruitment of more women teachers especially at the primary level has been a high priority in both national and state policies. The POA 1992 claims that the will to implement and the institutional mechanisms to insure the reflection of gender sensitivity in educational programs are *still* strongly needed. The revised policy formulations postulate that at least 50 percent of teachers recruited in the future should be women and that teacher training facilities should be augmented to insure adequate numbers of qualified female teachers in different subjects, including mathematics and science (POA 1992). Rajput, head of the National Council of Teacher Educators, noted the following in our interview: "There was a very encouraging response. In some cases the number went up 60, 70, 80 percent. In certain remote areas, it was slightly on the lower side, but the target was achieved. . . . I have been a teacher educator, and I have seen the admission process in many colleges. Now there are 90 percent girls and 10 percent boys, more girls are coming" (Interview with Rajput, 12-12-1995).

In UP, S. P. Pandey indicated that students take an exam and the number recruited is based on planned need—an attempt to create better balance

between supply and demand, so there will be no large excess of unemployed teachers. This will also allow smaller classes and more individual attention. "A queue system exists so there is a commitment to induct those trained, even if not in the first year. At present, 70 percent female and 30 percent male intake on recruitment exists. After a few years, we will find we have a majority of female teachers" (Interview with S. P. Pandey, 12-20-1995).

I asked Pandey about the reasons for this increase in women teacher's recruitment. He replied that it was felt that females were the best suited for the job, especially for primary education. They can influence and look after small children, both male and female. Pandey did not say that more women teachers would encourage more girls to come to school, be good role models, and promote gender equity and social change.

At the DIET in Lucknow, UP, I first wandered into a room where ladies were drinking tea. They invited me in. As we began to talk, I discovered they were teacher educators at this DIET, so I asked them about their preservice students. In the first-year class, there are twenty students, but in the second-year class, sixty-three—more they explained because they have a combination of Urdu students. One woman who spoke English well said the ratio of students was one male to three females admitted. I asked her if this is because more female teachers are needed. Confirming that teacher education institutions have been augmented, she said she thinks this is government policy. Echoing Pandey's rationale, she added, "We think females make good primary teachers."

As she said these words, I reflected that this pattern was repeating the history of women teachers in the United States, when in the mid-1800s Horace Mann claimed female teachers as the better nurturers and thus more desirable for primary teacher roles. I would never claim that women teachers do not make excellent primary teachers. However, the type of rationale I was hearing has hurt women teachers in the United States by limiting their opportunities for growth beyond the primary teacher role. This ideology has lead to limiting women to lower pay and status within teaching. Will the same ideology develop in India as, or if, women become the majority of primary school teachers?

At the Government Junior Training College for Women in Mirzapur, UP, also the DIET location for that district, the woman principal indicated that before 1992, the school had 160 trainees, then all female. Now with the plan not to train more teachers than are demanded, the number has been reduced: fifteen students are allowed in each of the first- and second-year classes. In the first-year class, this school had eleven girls and four boys; the second-year had twelve girls and two boys. As with the Lucknow preservice students, this is roughly the 70/30 percent policy recruitment ratio of females to males that UP state policy recommends.

In closing my conversation with Rajput, I asked him what he believes are still the challenges for teacher education in India. He responded with many. However, he seems to feel that the discrimination issues of gender and caste that I asked him about have already been solved, perhaps because they are written in the policy. His continual use of the pronoun *he* also begged the question.

> These points which you have raised in discrimination, the teachers' discrimination. These are not my concerns. How responsive, how dynamic my teacher educator is. Is he getting inservice education? Is he familiar with the new technology, is he adopting a partnership-based learning technique in the institution? They are the biggest concerns. Is he getting a chance for occupational development. That is the concern. Maybe for several decades these were the concerns that you mentioned, but not I think of this time. (Interview with Rajput, 12-12-1995)

POLICY LANGUAGE, STRUCTURE, AND AGENCY FOR WOMEN

The NPE of India is a national structure that shapes opportunity for the country's men and women. To share collective goals in national policy statements makes these goals prioritized and publically available for praise or critique from groups both inside and outside the country. The policy itself becomes a structure through which and against which women teachers and other stakeholders within the system must act, interact, and resist as they interpret private, professional, and public meanings. Thus, the language has power in shaping the ways in which women think about educational issues. These policy statements reflect a desire to facilitate teacher professionalism through decentralized democratic structures that give more voice to teachers and provide for more equitable relationships. Much language exists in the policy that encourages individual and professional agency of teachers. The policy language evidences a commitment to educating women and girls that actually began with the Constitution in 1950 (Chitnis 1989). Yet for many years, this goal was more rhetoric than reality and the later NPE 1986 (revised in 1992) and POA 1992 are the documents that address more specific goals for women's empowerment and agency, including women teachers.

A critical feminist lens calls into question issues of power and encourages empowerment of women at important decision-making levels in their personal, social, cultural, and political spheres. Thus, it is important to ask if the language obscures power relationships and transformative processes, or is there an overt agenda to change structural inequalities at high decision-making levels. This language does identify the imbalance of power in education

and the inequities that exist in society and other institutions such as education that have not been addressed or balanced. The structures themselves have in the past not helped to create an ideology of empowerment in women or to demand their access and sustainability within the system. This policy does take a broad approach to women teachers' empowerment through language of more decentralized control in schools and classrooms, a commitment to their learning through preservice and inservice education so that they can be more knowledgeable and confident in the teaching and the language that explicitly promotes empowerment. The POA described dimensions of empowerment that included personal, economic, and political empowerment through statements such as "developing ability to think critically," "providing information, knowledge, and skill for economic independence," and "fostering decision-making and action through collective processes."

India's NPE and POA are thus consistent with GAD and with goals of feminist pedagogy. Yet the ideology and the institutional structures will take longer to change. The opening of the DIET and block resource centers and the access of more women teachers to preservice education are steps in the direction of their agency. With the affirmative action target quotas of 50 percent or more women who are part of the requirements for preservice education (similar to quotas for women established in other levels of government), the policy eases more women educators' entry into the professional field of teaching in which they can earn a moderately good income if they are hired. More numbers of women in both administrative leadership positions and the teaching force will help facilitate women's agency in the education system, allowing them more voice in decision-making in their professional and economic lives. As dependency feminists would note, this will help to lessen the patriarchal influence of the social system and support more women in decision-making at regional and local levels. Thus women teachers are encouraged by and benefiting from the decentralized education system, the policy language designed to empower them, and the implementation strategies. This represents an allegiant agency in which women teachers can now align with an education policy that has called itself an agent for women. Although influenced from outside development and United Nations agencies, educating and empowering women has become political and popular thought in India's goals for educational development.

Yet access to what has been a male-controlled patriarchal system represents primarily a microscopic WID approach: that alone will not be enough to change the ideology, attitudes, traditions, and values of society. Women teachers must be valued not only for their nurturing and teaching abilities at the primary level, but also as positive role models for girls and boys and social change agents. The policies can stimulate this action, but some education officials, teacher educators at the DIETs, and the preservice students themselves are still in need of some further gender-sensitizing training that will allow them to

understand and promote the goals of a GAD approach. In this way, the DIET context and thus elementary schools will facilitate the macroobjective microsubjective integrated paradigm. Knowledge of gender equity and need for structural change can cause women to rethink their attitudes and perceptions about what has been a patriarchal maintenance structure of society and influence their agency both individually and collectively on behalf of gender equity.

Two examples of collective empowerment include women forming separate teacher organizations. The Karnataka State Primary School Teachers Women's Association has struggled to form this separate association as they claimed that problems of, for instance, harassment are not addressed by the mixed sex union, which also has a 33 percent quota for women (Anupama 2003). The Bihar Women Teachers' Federation has pressured the GOI to formulate a separate national policy for women by making amendments in the Constitution. A goal is to encourage women teachers to motivate girl students to launch a positive struggle for the welfare of the nation, especially exploited and disgraced women (*Times of India* 2003). These are examples of collective political empowerment with goals of changing structures that affect women's lives at various levels. However, the work of agency to change structures has a long and winding path. The GOI and state governments in India have an ethical as well as a policy commitment. "Continual investment in women's empowerment is called for, so that they themselves can help shape the mainstream" (Ministry of Foreign Affairs 2002, 1).

REFERENCES

Anupama, G. S. 2003. Women teachers resent male domination. *Times of India*, May 19.

Apple, M. W. 1982. *Education and power*. Boston: Ark Paperbacks.

Chitnis, S. 1989. India. In *International handbook of women's education*, edited by G. P. Kelly, 135–162. New York: Greenwood Press.

Crossley, M. and G. Vulliamy. (Eds.). 1997. *Qualitative research in developing countries: Current perspectives.* New York: Garland.

Department of Education, Ministry of Human Resource Development. 1992a. *National policy on education—1986 (with modifications undertaken in 1992).* New Delhi, India: Author.

———. 1992b. *Programme of Action 1992.* New Delhi: Author.

Eisner, E. and A. Peshkin. (Eds.). 1990. Introduction to *Qualitative inquiry in education: The continuing debate*, 1–14. New York: Teachers College Press.

Fiumara, G. C.1994. The metaphoric function and the question of objectivity. In *Knowing the difference: Feminist perspectives in epistemology*, edited by K. Lennon and M. Whitford, 31–44. New York: Routledge.

Fonow, M. M. and J. A. Cook. (Eds.). 1991. *Beyond methodology: Feminist scholarship as lived research.* Bloomington: Indiana University Press.

Fraser, N. 1991. What's critical about critical theory? In *Critical theory: The essential readings,* edited by D. Ingram and J. Simon-Ingram, 357–387. New York: Paragon House.

Friedmann, J. 1992. *Empowerment: The politics of alternative development.* Boston and Oxford: Blackwell Publishers.

Ginsburg, M. and B. Lindsay. (Eds.). 1995. Conceptualizing the political dimension in teacher education. In *The Political dimension in teaching education: Comparative perspectives on policy formation, socialization and society,* 3–20. London: The Falmer Press.

Grumet, M. 1988. *Bitter milk: Women and teaching.* Amherst: University of Massachusetts Press.

Hall, C. M. 1992. *Women and empowerment: Strategies for increasing autonomy.* Bristol, Pa.: Hemisphere Publishing.

Haraway, D. 1988. Situated knowledges: The science question in feminism and the privilege of partial perspective. *Feminist Studies,* 14 (3): 575–599.

Ingram, D. 1990. *Critical theory and philosophy.* New York: Paragon House.

Ingram, D. and J. Simon-Ingram. 1991. (Eds.). *Critical theory: The essential readings.* New York: Paragon House.

Jaquette, J. S. 2004. Foreword. In *Promises of empowerment: Women in Asia and Latin America,* edited by P. H. Smith, J. L. Troutner, and C. Hunefeldt, vii–ix. Lanham: Rowman and Littlefield.

Karl, M. 1995. *Women and empowerment: Participation and decision making.* Atlantic Highlands: Zed Books.

Kumar, N. (Ed). 1994. Introduction to *Women and subjects: South Asian histories,* 1–25. New Delhi: Stree.

Lennon, K. and M. Whitford. (Eds.). 1994. *Knowing the difference: Feminist perspectives in epistemology.* New York: Routledge.

Maynard, M. and J. Purvis. (Eds.). 1994. *Researching women's lives from a feminist perspective.* Bristol, Pa.: Taylor and Francis.

Messer-Davidow, E. 1991. *(En)gendering knowledge: Feminists in academe.* Knoxville: University of Tennessee Press.

Ministry of Education, Government of India. 1985. *The challenge of education—A policy perspective.* New Delhi: Author.

Ministry of Foreign Affairs. 2002. *Institutional and organisational change.* Netherlands: Author.

Monkman, K. 1998. Training women for change and empowerment. In *Women in the third world: An encyclopedia of contemporary issues,* edited by N. P. Stromquist with K. Monkman, 498–509. New York: Garland.

Moulton, J. 1997. *Formal and nonformal education and empowered behavior: A review of the research literature.* Washington, D.C.: Academy of Educational Development.

Pandey, S. P. 1992. *National policy of education in India*. Allahabad: Horizon Publishers.

Parpart, Jane. L., Shirin M. Rai, and Kathleen Staudt. 2002. *Rethinking empowerment: Gender and development in a global/local world*. London: Routledge.

Prus, R. 1996. *Symbolic interaction and ethnographic research*. Albany: State University of New York Press.

Reinharz, S. 1992. *Feminist methods in social research*. Oxford: Oxford University Press.

Schapiro, R. M. 1995. Liberatory pedagogy and the development paradox. *Convergence*, 28 (2): 28–47.

Seshadri, C. 2002. Educating the educators: Review of primary teacher training. In *India education report: A profile of basic education*, edited by R. Govinda, 202–217. Oxford: Oxford University Press.

Shukla, P. 1988. *The new education policy in India*. New Delhi: Sterling Publications.

Stacki, S. L. 2002. Women teachers empowered in India: Teacher training through a gender lens. New York: UNICEF Programme Division, Working Paper Series: UNICEF.

Stacki, S. L., and K. Monkman. 2003. Change through empowerment processes: Women's stories from South Asia and Latin America. *Compare*, 33 (2): 173–189.

Strickland, P. 1994. Feminism, postmodernism, and difference. In *Knowing the difference: Feminist perspectives in epistemology*, edited by K. Lennon and M. Whitford, 265–274. New York: Routledge.

Stromquist, N. P. 1994. Gender and basic education in international development cooperation. New York: UNICEF Staff Working Papers: 13. UNICEF.

Sutton, M. 1998. Feminist epistemology and research methods. In *Women in the third world: An encyclopedia of contemporary issues*, edited by N. P. Stromquist with K. Monkman, 13–23. New York: Garland.

Sutton, M. and B. Levinson. (Eds). 2001. Introduction to *Policy as practice: Toward a comparative sociocultural analysis of educational policy*, 1–22. Westport: Ablex.

Times of India. 2003. Women teachers seek separate national policy. May 19.

Tinker, I. 2004. Many paths to power: Women in contemporary Asia. In *Promises of empowerment: Women in Asia and Latin America*, edited by P. H. Smith, J. L. Troutner, and C. Hunefeldt, 35–59. Lanham: Rowman and Littlefield.

Troutner, J. L., and P. H. Smith. 2004. Introduction: Empowering women: Agency, structure, and comparative readings. In *Promises of empowerment: Women in Asia and Latin America*, edited by P. H. Smith, J. L. Troutner, and C. Hunefeldt, 1–30. Lanham: Rowman and Littlefield.

UNICEF. 1994. Gender equality and empowerment of women and girls: A policy review. New York: United Nations: Economic and Social Council. E/ICEF/1994/L.5 22.

Warren, C. 1988. *Gender issues in field research: Qualitative research methods series #9*. Newbury Park, Calif.: Sage.

Weiler, K. 1988. *Women teaching for change: Gender, class and power*. New York: Bergin and Garvey.

Feast or Famine for Female Education in Kenya?

A Structural Approach to Gender Equity

LUCY MULE

INTRODUCTION

Educational policy and practice in Kenya, like in many postcolonial African states, often fail to address educational gender inequity. *Educational gender inequity*, a term used in this chapter to refer to the unequal learning opportunities and educational outcomes experienced by females in formal schooling contexts (Lee 1998; Sadker and Sadker 2001; Stromquist 1999), may result from a number of factors, including the state. Since the 1970s, researchers and critics of Kenya's educational system have argued that the state has historically endorsed an expansionist approach that has obscured the goal of gender equity in education and failed to address gender inequity in its obvious and subtle forms. While remaining fully cognizant of the efforts that the state has made and continues to make regarding access for both males and females, this chapter critically analyzes the expansionist discourse in Kenya and the educational structure it supports, with the goal of foregrounding an alternative discourse that engenders agency and targets the elimination of all forms of educational gender inequity.

The chapter presents a brief history of educational gender inequity in Kenya. Next, it examines the expansionist discourse of the state and ways the state may have historically obscured educational gender inequity, especially at the secondary school and university levels. Lastly it maps out an alternative discourse that can lead to the reformulation of educational policy and practice that promotes educational gender equity in the future.

EDUCATIONAL GENDER INEQUITY: A HISTORY

Educational gender inequity has a long history in Kenya that can be traced back to colonial times and the inception of formal education (Kiluva-Ndunda 2001). The patriarchal ideology embedded within the colonial system, combined with deeply entrenched beliefs about the role of the woman in traditional African societies, served to privilege the education of males over females (Odaga and Heneveld 1995). Even long after independence in 1963, the concept of educating females in any systematic way beyond basic literacy skills was slow to take root both at the state level as well as in most communities. While low enrollment for females at all levels has historically characterized education in Kenya, the numbers have steadily risen at the primary level since the international literacy campaigns of the 1970s and the implementation by the state of some major steps toward Universal Primary Education (UPE).[1] Subsequent national and international agendas such as those resulting from the 1990 World Conference on Education for All in Jomtien, Thailand, as well as the World Education Forum in Dakar, Senegal, ten years later, have continued to shape the state's commitment to boost female enrollments (Chege and Sifuna 2006; Wamahiu et al. 1992).

The secondary and university levels have also experienced expansion since independence, both in terms of increased facilities and enrollment (MoEST 2000; Eshiwani 1993; Nungu 1997). However, as will be argued in more detail in a later section, boosting enrollments as well as other strategies that have been used by the state since independence to expand education have failed to adequately address educational gender inequity in Kenya. Although more females are now entering secondary school than was the case in the past, they continue to register low participation in school, perform worse than males in key subjects in national examinations, learn under adverse conditions when compared to males, and in general benefit less from education. Gender disparities are even more glaring at the university level. Clearly the current educational structure has failed females and will continue to do so unless educational gender equity becomes a priority of the state.

EXPANSIONIST DISCOURSE AND EDUCATIONAL GENDER INEQUITY AT THE SECONDARY AND UNIVERSITY LEVELS

Expansionist discourse refers to a preferred way of thinking, talking about, and organizing schooling that is focused on expansion of both enrollment and facilities with little regard for quality and equity. Claudia Buchmann's 1999 description of Kenya's education aptly captures this approach. She posits that

The contemporary educational system is a direct result of civil society's early involvement in school expansion and the state's conciliatory response to this expansion . . . the fragile Kenyan state has repeatedly responded to popular pressures by promoting policies that signal mass educational opportunity. It has little capacity to alleviate disparities in educational opportunities or shape the educational system to suit the long-term needs of the nation. (105)

Kenya, like many other postcolonial states in Africa, has historically adopted an expansionist discourse in the provision of education. There are two important characteristics of this discourse. The first is the political nature of the expansionist discourse. The second is the misguided emphasis on essential readings that inform policy development.

THE POLITICAL NATURE
OF THE EXPANSIONIST DISCOURSE

In his examination of the application of the legitimation theory to schooling, Rees Hughes (1994) explains that legitimacy involves the capacity of the system to engender and maintain the belief that the existing political institutions are the most appropriate ones for society. Schools, he argues, play a critical role in promoting and sustaining the legitimacy of the state. In Kenya, as Buchmann suggests, the approach to educational development is historically characterized by uncontrollable expansion that the state is unable and unwilling to check for fear of losing its legitimacy. Following are examples of the political nature of the expansionist discourse at the secondary and university levels of schooling in Kenya.

At both the secondary and university levels, several interventions have served the legitimating function for the state. Claudia Buchmann (1999) explains how Harambee, which started out as a community-based initiative to promote development in the early years after independence, was quickly co-opted by the government to become a means of providing cheap secondary schools that required limited financial commitment from the government. Two types of Harambee schools have existed in Kenya until recently. In assisted Harambee schools, the government provided teachers while the local community met all the other costs. Unaided Harambee schools were entirely funded by the local community. Since independence, Harambee schools have outnumbered both government-maintained schools and/or private schools.[2] Herein, the increase in number of schools did not necessarily mean increased educational opportunity. Harambee schools had fewer educational facilities and less financial resources. Moreover, students performed poorer in national examinations compared to government-maintained schools. In other words,

the government has supported educational expansion by encouraging the growth of the Harambee schools, while shifting significant costs associated with secondary schooling to parents.[3] The legacy of the Harambee school system continues to have a negative impact on equity in public secondary education today. In the current structure, public secondary schools are ranked as national, provincial or district. Most former Harambee schools are now district schools, which means that they receive more oversight from the government. However, this new label has done little to alleviate the inequity of resources that has historically characterized Harambee schools. The Harambee school phenomenon also has gender implications. Eshiwani (1993) notes that the growth in Harambee school enrollment between 1975 and 1984 was primarily due to female secondary school enrollment. Given that fewer funds and facilities were available in these schools, female students received a lower quality education than males, who were better represented in government-maintained schools (Buchmann 1999; Eshiwani 1993; Kinyanjui 1993).

The restructuring of the educational system from the British-style 7-4-2-3 to the current 8-4-4 system in the mid-1980s was another legitimating strategy in the expansionist discourse. The 8-4-4 system, first implemented in 1985, was marketed by the government as a populist, practical, relevant, and less elitist system than the previous 7-4-2-3 system. More emphasis was given to technical and vocational subjects like agriculture, woodwork, and home science, as well as post-primary technical education and training for students who did not proceed to higher levels of schooling dominated the curriculum. The argument was that such a focus would solve the problem of wastage as graduates and/or dropouts of primary and secondary levels would readily join the workforce using the practical skills they had learned in school and in post-primary training institutions, like village polytechnics.

The new educational system was packaged to appeal to the rural majority population who were also experiencing high unemployment rates. Concerns about cost, the idealistic nature of the system, and the poor plan for implementation were largely ignored.[4] Parents were increasingly asked to contribute money to build and supply workshops and classrooms, as well as cover the cost of textbook purchases. Although now in hindsight many are quick to point out the weaknesses and contradictions inherent in the 8-4-4 system, few in the 1980s wanted to name it for what it was—an educational project that had to be kept alive at any cost for political reasons—to avert a looming crisis due to a stagnant economy.

Like the Harambee school system, the 8-4-4 system has gender implications as well. While it has exposed females to science-based, technical, and vocational subjects than was previously the case in the 7-4-2-3 system, females continued to perform poorly in these subjects compared to males

(Abagi et al. 2000; Bunyi 2004). In addition, parents often choose to educate males when resources are scarce (Eshiwani 1993; Kakonge et al. 2001).

Two good examples of expansionist strategies at the university level include massive subsidies and increased enrollment. Until 1991, university education was practically free. Kenya, until the early 1990s, offered higher education to students at a highly subsidized rate. Prior to 1974–1975, the government met all costs associated with higher education—tuition, books, room and board, clothing allowance, plus a cash maintenance allowance for each student (Eshiwani 1993). After 1991, the government continued to shoulder the burden of tuition and capitation fees, and a loan scheme was started. University students used to receive government "loans" under the University Students Loan scheme introduced in 1974–1975 to cover the cost of personal expenses, for example, accommodations, meals, textbooks, travel, and so forth. Until the 1990s, the system in place to recover these student loans was weak and thoroughly abused such that the government was in actual fact still meeting all the expenses for higher education. For instance, in 1991 of the 400 million Ksh owed, only Ksh 63 million had been recovered (Hughes 1994). It has been argued that those government subsidies on tuition, as well as the relaxed attitude toward student loans, were more a political strategy than a result of sound economic/educational policy. Hughes (1994), for instance, notes that policies to cost share at the university level especially in the 1980s were "characterized by rhetoric that generally melted with the first sign of opposition" (197).

University students have a history of opposition to government policies, and this opposition was at its peak in the 1980s. The explosion of university enrollments in the 1980s and 1990s (the second indicator of the expansionist discourse) marked some of the highest figures in history (Eshiwani 1993; Hughes 1994). By 1992–1993 university enrollments had reached over 40,000, up from 8,900 in 1985–1986 (Hughes 1994). Two "double-intakes" were responsible for this shift, and both involved some form of political intervention. The 1987–1988 "double-intake" was deemed necessary to clear a two-year backlog (Eshiwani 1993). That year, according to Hughes (1994) 13,832 students had qualified to enter the university; they had met the minimum requirements for university admission by passing the Kenya Advanced Certificate of Education (KACE). The initial plans by the university admissions board to admit just over one-quarter of this number were later adjusted to allow 7,000 students to enroll. The president, who was also the chancellor of the four state universities, gave a presidential directive urging the vice chancellors of the four universities to admit most of the 13,000 qualified students left out of the selection process. A second double-intake in 1991–1992 was considered necessary to accommodate the A-level graduates of the old 7-4-2-3 system and the first O-level graduates of the new 8-4-4 system. The expanding enrollments in the 1980s and 1990s strained the capacities of the

universities, which at that time were not adequately staffed to accommodate the expanding enrollments. More importantly, it failed to address in any significant way the educational gender inequity in terms of access that continued unabated as discussed by Nungu (1997). Female enrollment has stagnated at 30 percent (Nungu 1997; MoEST 2000).

Although each of these among other legitimating strategies at the secondary and university levels required massive government spending, research indicates that their adoption by the state was primarily at the expense of quality and gender equity. These strategies help maintain the state's legitimacy, achieved in part by the financial resources contributed by the government, thereby sparking even greater legitimacy and popular demand for more schooling.

HOW LITERATURE MAY OBSCURE EDUCATIONAL GENDER INEQUITY AT THE SECONDARY AND UNIVERSITY LEVELS

By virtue of its nature, the expansionist discourse cannot adequately acknowledge, let alone alleviate, educational gender inequity. In instances when educational gender inequity is acknowledged, it is discussed in terms of boosting enrollment for females toward parity with males. In this regard, Kenya continues to stand out from other sub-Saharan countries due to its large proportion of females in school, both absolutely and compared to the proportion of males at the primary and secondary school levels (Eshiwani 1993; Lewis 1993). Educational statistics show a trend toward gender parity at the secondary level, although this is happening at a much slower pace when compared to the primary level (Abagi 1997a; Abagi and Olweya 1999). In 1998, for example, 46.7 percent of those enrolled at the secondary level were females (MoEST 2000). Indeed, statistics from the Ministry of Education Science and Technology show that in the period between 1990 and 1998 female enrollments at the secondary level ranged between 42.8 and 46.7 percent. At the tertiary level, female enrollment has also gradually increased over time, despite the fact that the percentage of females enrolled at this level remained at around 30 percent (MoEST 2000).

The expansionist discourse, with its emphasis on enrollment statistics as well as expanding facilities, popularizes two main readings (Hall 1993) about the status of females' education that may have far-reaching negative implications in the struggle to eradicate educational gender inequity. One reading, as Kinyanjui (1993) has noted, suggests that females have gained more than males from the educational expansion since independence.[5] A related second reading is that the near gender parity in enrollment statistics at the secondary level is a clear indicator of the state's success in addressing the problem of edu-

cational gender inequity. These readings, while benign in themselves, could serve to promote educational gender inequity when they become inscribed within the dominant discourse. They could serve to institutionalize educational policies that are unresponsive to concerns about gender inequity. They may also suggest that educational gender inequity is no longer a problem warranting special consideration in terms of policy and allocation of resources. It is these messages that must be interrogated through a critical analysis of the expansionist discourse.

RETHINKING ACCESS: A CRITICAL INTERROGATION OF EDUCATIONAL GENDER INEQUITY

Concerns that the expansionist discourse in Kenya masks serious educational gender inequity have been expressed since the 1970s, and are evident from an impressive corpus of research by educational researchers based in the universities, research organizations, and NGOs. This research supports a critical analysis of the expansionist discourse. The term *critical* here is borrowed from critical theory and refers to "engaging in a rigorous probing and analytical investigation of social and educational conditions in schools and society that aim to uncover exploitative power relationships and bring about reforms that will produce equity, fairness, and justice" (Gutek 2004, 309). Embarking on such an analysis shatters the myth of the educational structure as a putatively impersonal system, and not just for the purpose of grasping the gendered nature of the world, but more generally for recognizing how such myths are reified (Calhoun 1995, 187). Rethinking the notion of "access" allows for a critical interrogation of the expansionist discourse at the secondary and university levels.

The expansionist discourse seems to imply that access for females is sufficient. Those familiar with Kenya's educational system know that the type of school one attends has implications for the quality of education received. The types of schools students attend are not immediately decipherable from enrollment statistics, which as noted earlier, indicate a near gender parity at primary and secondary levels. However, educational gender inequity is revealed when the type of schools females attend are compared to those attended by males. Kinyanjui (1993) analyzed enrollment patterns based on the data by the 1986 Economic Survey, which indicated that the majority of females enrolled in secondary school end up in Harambee schools, which receive partial or no government funds, or in schools that are privately owned for profit.⁶ Kinyanjui noted, for instance, that in 1984, 62 percent of female secondary students attended these types of schools, a trend that was observed in the ten years prior to his study. On the other hand, only 34 percent of students attending government-maintained schools, which are

considered to be the best in terms of facilities and quality of education, were females. Another study (RoK 1993) reported similar trends in 1987 and 1990. In the two years respectively, 45.7 percent and 43.4 percent of males attended government-maintained schools compared to 39.8 percent and 31.78 percent among the females. The study also reported that a higher percentage of females attended assisted and unaided Harambee as well as private schools compared to males.

The point that these researchers have made is that males, who are comparatively better represented in fully government-sponsored schools, benefit more from public spending than females. It has been noted that males consistently perform better than females in national examinations, and that females perform comparatively poorly in math- and science-based subjects. In the 1996 Kenya Certificate of Secondary Education examination (KCSE), for example, 12.51 percent of males scored an average of B– and higher compared to females' 7.54 percent (Abagi 1997a, 39). In the same year females contributed 57 percent of grade E in mathematics and 24 percent of grade A (Abagi et al. 2000, 14). In 2000 the national mean score in the KCSE mathematics was 42.3 percent for males compared to 26.8 percent for females (Njeru and Orodho 2003b, 3). In short, the discussion of adolescent girls of secondary school age and young adult women of university age should move beyond enrollment access and parity to include ways of expanding the entry of females into quality schools. This is especially important because unless the patterns of educational gender inequity at the secondary level are checked, they get reflected and magnified at the university level in two main ways.

The first way is reflected in university admission policy that is based on grades obtained in the national examination taken at the end of secondary schooling (KCSE). Given that fewer females than males are enrolled in high-quality secondary schools, fewer females are admitted to university. In 1998–1999, for instance, female students comprised 30.5 percent of the student population in public universities (MoEST 2000). The argument made here is that males continue to be advantaged at this level because higher education receives a greater share of public spending and a lion's share of international aid compared to the other levels.[7] A second way is noted in "occupational segregation" (Sohoni 1995) when they get to the university. Musembi Nungu's 1997 study of three public universities (Nairobi, Kenyatta, and Moi) revealed a glaring underrepresentation of women in fields that are considered traditionally male (such as law, medicine, engineering, architecture, and the natural sciences), especially when compared with their overrepresentation in fields such as home economics and teaching. In Nairobi University, for example, participation by sex between 1974 and 1994 showed that female enrollment in medicine ranged between 10 and 24 percent. In engineering, the range was between 0 and 10 percent for the same period (Nungu 1997, 20).

Nungu's findings reflect statistics reported by MoEST (2000) that indicate that in 1998–1999, only 21.4 percent and 9.1 percent of females in public universities were represented in science and engineering respectively. On the other hand, there was a higher representation of females in education (37.7 percent), arts (34.9 percent), and commerce (30.3 percent). These figures show that females not only continue be underrepresented at the university level, but also are victimized by occupational segregation in institutions of higher learning that is orchestrated from lower levels of education. The existence of the "glass wall" (Sadker et al. 1993) at the secondary and university levels means that future prospects for jobs in lucrative careers are minimal even for those few females who survive the system. In this sense females continue to be disadvantaged in the job market. The disenfranchisement takes place in a system heavily imbued within an institutionalized patriarchal ideology that is highly resistant to any form of affirmative action, as the following quote from a senior lecturer in one university quoted in Nungu's study illustrates: "Generally speaking everyone wants an opportunity. We should not artificialise the issue of problems in our education system by talking on gender lines. Every girl needs a chance just like the next boy. There is no gender problem" (Nungu 1997, 28). While it is alarming that the general perception even among some highly educated individuals is that educational gender inequity is not a major concern in Kenya, it is not surprising given the little attention the issue receives in the dominant expansionist discourse. The aforementioned literature used to support the expansionist discourse needs to be challenged if Kenyans hope to develop an accurate understanding of educational gender inequity.

ALTERNATIVE DISCOURSE: TARGETING THE ELIMINATION OF ALL FORMS OF EDUCATIONAL GENDER INEQUITY

So far I have argued that the collective action resulting from the expansionist discourse used in Kenya, as well as the educational structures it supports, are insufficient to effectively address educational gender inequity in Kenya. In this section, I highlight three broad, interrelated areas around which an alternative discourse of agency toward educational equity for adolescent girls and adult women may be shaped. They include: increased funding for education; reconceptualization of the depth and scope of affirmative action beyond rural areas to all levels of education; and curriculum change. I believe that these areas, when taken together, may generate new educational models for confronting educational gender inequity in twenty-first century Kenya.

Increased Government Funding for Education

An alternative discourse to the current expansionist discourse would focus more on finding ways to increase funding for education. Currently in Kenya, as is the case in most emerging countries, the emphasis is on reduced government spending for education. Mainly bowing to pressure from the current trend toward globalization and market values such as those brought about by structural adjustment programs (SAPs) dictated by the World Bank and the International Monetary Fund, the state's support for public education has been dramatically reduced (Abagi 1997b). The 1980s saw a drastic reduction of public expenditure per pupil and in general at all levels but more sharply at the primary and secondary levels (Abagi 1997b; World Bank 2004). For instance, the state's expenditure going to education as percentage of GDP fell from 18.1 percent in 1988–1989 to 6.89 percent in 1991–1992 fiscal year (Abagi 1997b, 15). The FPE policy in 2003 has seen increased funding at the primary level but dwindling funding at the secondary and tertiary levels (Njeru and Orodho 2003a; Ogot and Weidman 1993; Sanyal and Martin 1998).[8]

These funding policies have an extremely detrimental impact on educational gender equity at secondary and university levels. First, decreased funding combined with demands to comply with the expensive 8-4-4 system of education can only spell disaster for females who, as noted earlier, attend low-quality secondary schools when compared to boys. Second, according to available research, it is more likely that parents will opt to educate a son rather than a daughter when resources are scarce (Achola and Pillai 2000; Kakonge et al. 2001). Third, because the gender gap is greatest at the tertiary level, decreased funding at this level will probably increase gender differentiation. The alternative discourse needs to support an educational model that emphasizes increased funding for education. Such a model recognizes that equipping females with a basic education, without supporting higher levels of education as is being implied by the current funding policies, will ultimately perpetuate educational inequity.

Rethinking Affirmative Action

An alternative discourse will need to involve a broader understanding of the concept of educational affirmative action than one that currently exists. This new understanding must go beyond the rural areas and the primary school level and target all levels of schooling. It must also embrace a rights-based approach in demanding the right of all females to quality education. The perception that only rural poor are in need of affirmative action may have inadvertently resulted from the substantial attention that FAWE, other NGOs, feminist groups, as well as individual researchers have bestowed on the educa-

tion of rural girls in Kenya. These groups have argued that many so-called women in rural areas are actually adolescent girls who have been forced into adult roles too early. The fact that the law in Kenya does not clearly specify the minimum age for marriage, coupled with myriad gender discriminatory attitudes and practices, disadvantage young females.[9]

Without undermining the need to continue with affirmative action directed at ensuring access for disadvantaged females such as ones discussed in this literature, I want to emphasize an educational model that insists on the right of all females to a quality education across geographical regions and educational levels. The idea of education as a basic right is not new in Kenya, and is even enshrined in some of the national and international policies to which Kenya is committed (Abagi 1999; Chege and Sifuna 2006; Children Act Monitor 2004). The reality, however, is that adolescent girls and adult women are not always guaranteed the rights implied in these documents. Education as a right must not be understood only in terms of access. Research has revealed that there is more to educational gender inequity than access, and that equity issues span across regional and economic differences. Equity issues are also manifested in the type of school females attend as well as the field of study they undertake when compared to males. As noted elsewhere in this chapter, females continue to receive poor quality education in former Harambee and some for-profit private schools when compared to males, who enjoy greater participation in former government-maintained schools. Females are also victims of occupational segregation in both secondary and higher institutions of learning. It is hypocritical to talk about "equal opportunity" of access when the system ensures never-ending advantages for males. The move by the state to designate schools as either public or private is laudable. However, it will remain an empty gesture unless the existing hierarchy that ensures that some categories have limited access to well resourced schools and government subsidies is eradicated. Policy toward this end is crucial. In other words, future policy efforts should be directed at moving toward quality public secondary education for all. More adolescent girls in quality secondary schools may eventually lead to increased access for young women at the tertiary level, and into areas of study that have traditionally been designated as male. The question of a rights-based education is inextricably linked to a commitment for increased government funding in all levels of education.

Curriculum Change

Since the 1990s, promising efforts that challenge the structure of the curriculum have taken place, perhaps more than in any other area, toward envisioning an alternative discourse. The emerging discourse has emphasized examining the school/patriarchy nexus and its implications for the quest for

educational gender equity in more systematic ways. Examples that mark this change range from increased scholarship since the 1990s that has examined the dominance of patriarchal ideology in curriculum materials, and the ways in which a gendered education affects female students in Kenya's schools, to the practical efforts to change curriculum at the university. A number of studies since the 1990s have examined the school curriculum and noted the dominance of the patriarchal ideology in school textbooks, the institution of school in general, and the ways that classroom instruction is organized. These studies, which have targeted all levels of schooling in Kenya, help reveal females as "excluded majorities" (Giroux 1988). Anna Obura's 1991 study, for instance, focused on gender bias in curriculum materials that she criticized not so much for failing to include females but rather for their stereotypical depictions. These depictions, she found, portray gender-biased roles that emphasize the invisibility of women and male visibility. More recent studies have expanded the notion of curriculum and examined how Kenya's gendered system affects students' experiences of schools. This research indicates that even in coed learning contexts, the females are treated differently than the males, which negatively affects females' education (Lloyd et al. 1998; Wamahiu et al. 1992). A cursory look at current materials being used in Kenyan classrooms indicates that the research cited here has had some impact on the gendered messages carried by these materials. There is need, however, for continued research on gendered interactions and pedagogy in educational settings with the view of changing current practices.

At the university level, rethinking the curriculum is evident. Recognizing curriculum as a tool to challenge the systemic gender inequities, male dominance and female compliance in Kenya's education, individuals, groups, and NGOs such as the African Forum for Women Educationists (FAWE) and the Association of African Universities (AAU) have pressed for some promising initiatives. For instance, according to Onsongo (2006), three public universities (Kenyatta, Maseno, and Egerton) had established Gender Centers in response to the AAU's requirement that the universities institute gender equity curricular programming by 2002. The other three universities (Nairobi, Moi, and JKUAT) have some programs related to gender issues. It is true, as an emerging body of research into these gender-sensitive curricular initiatives has revealed, that they are faced with daunting challenges such as isolation, lack of resources and qualified staff, marginalization, and, in some cases, outright disdain (Chege and Sifuna 2006). However, their existence is a positive indication that the universities are becoming increasingly aware of the need to institute curricular measures to challenge systemic gender bias in education. It is likely that the intellectual work at the universities, combined with increased pressure from networking and outreach activities by scholars, gender-oriented groups, and NGOs, will continue to impact curriculum change in Kenya. A

concerted effort is needed from various parties to formulate academic and curriculum structures that will promote collective agency to enhance educational gender equity. Such approaches allow us to pose interrelated questions that are often treated separately. Why, for instance, does the state lack the political will to enforce policies and laws that protect females' right to education? Why is the fact that females are overrepresented in poor quality secondary school rarely questioned? Why is it that affirmative action at the university level faces the institutionalized resistance discussed by Nungu, Onsongo, and Bunyi, among other researchers? Why is it that females rarely hold lucrative careers or influential policy positions even when they have completed the highest levels of education? Do the answers to these questions imply that the patriarchal ideology that is so insidious in the institutions of the state and school, as well the labor market, conspire to disadvantage females? It is doubtful that the current educational policy and practice are impacted in any significant way by these questions that may reveal the relationship between school and patriarchy, and how collectively they impact educational gender equity. Work to date suggests that new educational models committed to educational gender equity are possible and desirable for Kenya in the twenty-first century.

CONCLUSION

This chapter has emphasized that even with increased access to education that started in the 1970s females in Kenya continue to experience educational gender inequity. The expansionist discourse points to impressive enrollment figures and the near gender parity in these figures to show its commitment to economic development and social equity, and to increase its legitimacy. However, the complete story of females' education in Kenya cannot be told by such statistics. First, statistics can and do popularize "readings" about females' education that have far-reaching negative implications in the struggle to eradicate educational gender inequity. Second, once in school, "access" for females may mean something less than the opportunities available to their male counterparts.

Neither educational gender inequity nor the state's inattention to it is unique to Kenya. As Nelly Stromquist (2004) has rightly observed with reference to the global situation, "These days, to talk about gender equality in education is patently legitimate and acceptable; to see tangible measures or public policies to enhance the conditions of women education and the reframing of gender in society is quite another story" (iii). Ending educational gender inequity is one way of transforming the Kenyan society, a challenge that has persisted since the establishment of formal education in Kenya. Yet in this struggle we are cautioned to not just challenge the expansionist discourse and the educational structure it supports but also to develop an alternative discourse

that will uproot the very base on which educational gender inequity flourishes. Such a discourse must insist on increased government funding for education, seek broad-based affirmative action, and aggressively support curriculum change. If action is not taken to institute or support new ways of thinking, talking about, and organizing education as suggested in each of these areas the prevailing educational gender inequity is likely to continue.

NOTES

1. In December 1973, a presidential decree provided free primary education for standards 1 to 4. Another decree in 1978 abolished fees in all primary schools. However, the mid-1980s saw the introduction of cost sharing in education, which shifted the education financing burden to parents. The FPE policy in 2003 reaffirmed the state's commitment to provide free schooling for all primary level students. According to the 2003 report of the Task Force on Implementation of Free Primary Education, the new policy would abolish all kinds of fees, levies, and user charges that have kept a large number of children and youth out of school (MoEST 2003, x).

2. For instance, while Harambee schools were virtually nonexistent at independence in 1963, by 1986 there were 1,435 Harambee compared to 698 government-maintained schools (see Eshiwani 1993, 54).

3. The state sets the fee guidelines for each category of schools based on unspecified criteria. The fixed fee approach has been highly challenged by school administrators on the grounds that it fails to take into account the specific needs of the school. Furthermore, currently only national and provincial schools can be assured of benefiting from the dwindling government grants and subsidies. The new policy has forced especially administrators in district schools to use loopholes within the law to charge educational levies that are often spent without proper accountability, thereby increasing the financial burden borne by parents (*Daily Nation*, June 22, 2005; Njeru and Orodho, 2003).

4. The 8-4-4 education program would cost KSh 218,881,740 to implement (Eshiwani 1993, 147).

5. It is easy to arrive at this conclusion by looking at the percentage increase of female enrollment compared to males at all levels. For instance, between 1990 and 1998 the percentage increase in the enrollment of females at the secondary level was 23.5 percent compared to males at 5.6 percent (MoEST 2000,15). It is also easy to forget that female percentage increases are higher because they started very low in the first place.

6. Historically, Harambee schools especially are characterized by poor facilities such as laboratories, libraries, and workshops as well as a large number of untrained teachers. Private schools, especially those owned by individuals for profit (as opposed to those run by churches or companies) have equally, if not poorer, educational facilities.

7. Abagi (1997b, 24), for example, notes that in 1997 the national recurrent expenditure per student in public universities was forty-two times higher than that for a primary school student.

8. Funding policies have resulted in an increased educational financing burden shifting away from the state to the parents. Njeru and Orodho (2003, 26) discuss the decline at the secondary level on the expenditure per student as well as the development expenditure per school. For instance, the recurrent expenditure per student and development expenditure per school declined from KSh 824 and 7,523.30 during the 1996–1997 fiscal year to KSh 163.40 and 750.50 during the 1999–2000 fiscal year. At the university level, Ogot and Weidman (1993) caution that while the investment the government has made in the higher education sector in the past seems to be quite commendable, the trend will not continue. For instance, government loans hitherto easily available to university students are harder to get. According to Sanyal and Martin (1998), the loan scheme now offered through the Higher Education Loan Board (HELB) started in 1995 covers only about one-third of the yearly higher education costs that must be borne by the student and family.

9. This argument is backed by an impressive body of research on some of the cultural attitudes and practices that contribute to the low participation of young females in Kenyan schools (Achola and Pillai 2000; KAAC 1994–1995; Kakonge et al. 2001; Wamahiu et al. 1992).

REFERENCES

Abagi, O. 1997a. *Status of education in Kenya: Indicators for planning and policy formulation.* Nairobi: Institute of Policy Analysis and Research.

———. 1997b. *Public and private investment in primary education in Kenya: An agenda for action.* Nairobi: Institute of Policy Analysis and Research.

———. 1999. *National legal frameworks in domesticating education as a human right in Kenya: Where to begin.* Nairobi: Institute of Policy Analysis and Research.

Abagi, O. and J. Olweya. 1999. *Achieving universal primary education in Kenya by 2015—where the reality lies: Challenges and future strategies.* Nairobi: Institute of Policy Analysis and Research.

Abagi, O., J. Olweya, and W. Otieno. 2000. *Counting the social impact of schooling: What Kenyans say about their school system and gender relations.* Nairobi: Institute of Policy Analysis and Research.

Achola, P. P. and V. K. Pillai. 2000. *Challenges of primary education in developing countries: Insights from Kenya.* Burlington: Ashgate.

Buchmann, C. 1999. The state and schooling in Kenya: Historical developments and current challenges. *Africa Today,* 46 (1): 94–117.

Bunyi, G. 2004. Gender disparities in higher education in Kenya: nature, extent and the way forward. *The African Symposium,* 4 (1). Available online at www2.ncsu.edu/ncsu/aern/gendaedu.html

Calhoun, C. 1995. *Critical social theory.* Cambridge, Mass.: Blackwell.

Chege, F. and D. N. Sifuna. 2006. *Girls' and women's education in Kenya.* UNESCO.

The Children Act Monitor. 2004. A Chambers of Justice Monthly Production. Available online at www.nyumbani.org/images_imagesact.pdf

Eshiwani, G. S. 1993. *Education in Kenya since independence.* Nairobi: East African Educational Publishers.

FAWE. 2001. *Female participation in African universities: Issues of concern and possible action.* Nairobi: FAWE.

Giroux, H. A. 1988. *Teachers as intellectuals: Toward a critical pedagogy of learning.* New York: Bergin and Garvey.

Gutek, G. L. 2004. *Philosophical and ideological voices in education.* New York: Pearson Education.

Hall, S. 1993. Encoding, decoding. In *The cultural studies reader,* edited by S. During, 90–103. New York: Routledge.

Hughes, R. 1994. Legitimation, higher education, and the postcolonial state: A comparative study of India and Kenya. *Comparative Education Review,* 30 (3): 193–204.

Kakonge, E., S. Kirea, R. Gitachu, and F. Nyamu. 2001. *Report on girls' education in Wajir and Mandera districts of Kenya.* Nairobi: FAWE.

Kenya Alliance for Advancement of Children (KAAC). 1994–1995. *A case study on development and survival of girls in primary school education in Kuria district.* Nairobi: Author.

Kibera, L. W. 1995. The effects of school stratification on the career and educational aspirations of girls in Kenya's secondary schools. *Third World Studies,* 12: 59–79.

Kiluva-Ndunda, M. M. 2001. *Women's agency and educational policy: The experiences of the women of Kilome, Kenya.* Albany: State University of New York Press.

Kinyanjui, K. 1993. Enhancing women's participation in the science-based curriculum: The case of Kenya. In *The politics of women's education: Perspectives from Asia, Africa, and Latin America,* edited by J. Conway and S. Bourque, 133–148. Ann Arbor: The University of Michigan Press.

Lee, W. O. 1998. Equity and access to education in Asia: Leveling the playing field. *International Journal of Educational Research,* 29: 667–683.

Lewis, M. 1993. *Girls' education in Kenya: Performance and prospects.* Washington, D.C.: Urban Institute.

Lloyd, C., B. S. Mensch, and W. H. Clark. 1998. *The effects of primary school quality on the educational participation and attainment of Kenyan girls and boys.* Nairobi: Population Council.

Ministry of Education, Science and Technology Education (MoEST). 2000. *Education Statistical Booklet, 1990–1998.* Nairobi: MoEST.

——— . 2003. *Report of the task force on implementation of Free Primary Education.* Nairobi: Jomo Kenyatta Foundation.

Njeru, E. and P. Odundo. 2003. *The role of the higher education loans board in pro-poor management approaches to enhancing access to university education in Kenya.* Nairobi: Institute of Policy Analysis and Research.

Njeru, E. and J. A. Orodho. 2003a. *Education financing in Kenya: The secondary school bursary scheme.* Nairobi: Institute of Policy Analysis and Research.

———. 2003b. *Access and participation in secondary school education: Emerging issues and policy implications.* Nairobi: Institute of Policy Analysis and Research. Available at www.ipar.or.ke/socialpubs.htm

Nungu, M. J. 1997. *Affirmative action and the quest for educational equity in university education: The case of Kenya 1974–1994.* Nairobi: Lyceum Educational Consultants.

Obura, A. P. 1991. *Changing images: Portrayal of girls and women in Kenyan textbooks.* Nairobi: African Center for Technology Studies Press.

Odaga, A. and W. Heneveld. 1995. *Girls and schools in sub-Saharan Africa: From analysis to action.* Washington, D.C.: World Bank.

Ogot, B. and J. C. Weidman. 1993. Prospectus for a five-year program of research on higher education in Kenya and East Africa. Available at www.pitt.edu/~weidman/masenoReserachProgram.html

Onsongo, J. 2006. Gender inequalities in universities in Kenya. In *Gender inequalities in Kenya,* edited by C. Creighton and F. Yieke, 31–48. UNESCO.

Republic of Kenya (RoK). 1993. *Primary and secondary education: A gender analysis.* Nairobi: Ministry of Culture and Social Services.

Sadker, D. and M. Sadker. 2001. Gender and educational equity. In *Cultural diversity and education: Foundations, curriculum, and teaching* (4th ed.), edited by. J. A. Banks and C. M. Banks, 251–263. Boston: Allyn and Bacon.

Sadker, D., M. Sadker, L. Foxx, and M. Salata. 1993. Gender equity in the classroom: The unfinished agenda. *The College Board Review,* 170: 14–20.

Sanyal, B. C. and M. Martin. 1998. *Management of higher education with special reference to financial management in African countries.* Paris: IIEP.

Sohoni, N. K. 1995. *The burden of girlhood: A global inquiry into the status of girls.* Oakland: Third Party.

Stromquist, N. P. 1999. Women education in the twenty-first century. In *Comparative education: The dialectic of the global and the local,* edited by R. Arnove and C. Torres, 179–205. New York: Rowman and Littlefield.

———. 2004. Preface. *Comparative Education Review,* 48 (4): iii.

UNICEF. 2003. *The state of the world's children 2004: Girls, education and development.* Retrieved May 10, 2005, www.unicef.org/publications/files/Eng_text.pdf

Wamahiu, S. P., F. A. Opondo, and G. Nyagah. 1992. *Educational situation of the Kenyan girl child.* Nairobi: ENRIKE.

Wamahiu, S. and L. Wanjama. 1993. *Gender, development and education.* Proceedings of the gender sensitization workshop. Nyeri, Kenya.

World Bank. 2004. *World development indicators 2004 (CD-ROM).* Washington, D.C.: The World Bank.

PART II

Structure and Agency of International Forces for Female Education

Promoting Girls' Education in Africa

Evidence from the Field between 1996 and 2003

DAVID W. CHAPMAN
SHIRLEY J. MISKE

Worldwide, girls'[1] access to basic education has improved dramatically over the last decade, but still lags behind that of boys in some parts of Africa and Asia (Wils, Carrol, and Barrow 2005; Herz and Sperling 2004; Bruns, Mingat, and Rokotomalala 2003). Many of the countries in which girls' enrollment still lags have expressed a strong commitment to promote the education of girls and to achieve the Millennium Development Goal of gender parity by 2015, but their efforts are constrained by three challenges. First, as countries make progress in extending access to education, the marginal cost of reaching those still not served increases. The unit cost of reaching the last 10 percent of out-of-school girls is much higher than the cost of increasing girls' participation from 50 up to 60 percent. Moreover, as the unit cost increases, responsible governments have to ask serious questions about the appropriateness of investing in access for the last 10 percent as opposed to investing those same resources to alleviate urgent problems in health, sanitation, and other aspects of national infrastructure across a broader swath of the population.

Second, strategies that were successful in extending educational opportunity when access was low may not yield the same returns as the proportion of children out of school shrinks. The persistently resistant—that last 10 percent—are different. The reasons some families resist sending their daughters to school differ, but often relate to remote location, extreme poverty, or particular religious or cultural views. The information campaigns, feeding programs, and

other incentives used to encourage families to send their girls to school have already failed to reach this group. New ideas are needed. If earlier messages were going to be effective with this group, chances are they would have already worked.

Third, the nature of the problems girls face is changing. In many countries, the emphasis on raising initial enrollment is giving way to promoting the conditions that encourage girls' persistence and achievement in schooling. Recent rapid enrollment increases in many countries, particularly in Africa, have put considerable downward pressure on quality. Students have entered education systems faster than teachers can be recruited and trained, textbooks can be purchased and distributed, and schools can be constructed. Many recognize that access is empty if students, once enrolled, do not learn. And if parents, already reluctant for multiple reasons to send their daughters to school, observe that educational quality is poor, girls can be affected disproportionately (Hyde and Miske 2000).

For all these reasons, it is becoming increasingly important that continuing efforts to increase girls' access to schooling be refined, honed, and focused, drawing on those strategies that have proven most successful in other settings. The environment is no longer conducive to broad scale campaigns involving multiple but unfocused strategies aimed a casting a wide net. The challenge in most countries is to introduce more precision in activities aimed at encouraging girls' enrollment. Charting a way forward requires that we learn from experience of the recent past. To that end, this chapter analyzes the experience of one of the most substantial and far-reaching efforts to promote girls' education of the last fifteen years—UNICEF's African Girls' Education Initiative (AGEI)—which operated from 1996 to 2003 in thirty-four countries. During that time, participating countries experimented with over 180 strategies for improving girls' education access, retention, achievement, and general well-being.

In examining the strategies that were tried, interventions that were particularly successful, and unanticipated problems that were encountered, we draw on Galal's framework for policy formulation. Galal offers three approaches to policy formulation and argues that effective reform requires adopting measures under all three approaches. In the *engineering approach*, education is seen as a production function in which the quantity, quality, and mix of inputs determine educational outputs and longer-term outcomes.[2] When outputs or outcomes are unsatisfactory, interventions involve increasing the quantity of inputs, improving their quality, or changing their mix. In the *industrial organization approach* education is seen as a principal/agent problem. The principal (e.g., a ministry official) is interested in particular outcomes (such as quality education), but has to rely on an agent (e.g., teachers) to obtain these outcomes. The challenge, then, is for individuals at one level

of the system to get individuals at a different level of the system to act in desired ways. The *political accountability approach* concerns the relationship between citizens and policymakers. This approach posits that if citizens can influence decision-makers, politicians, and education managers in their formulation of education policies, setting education priorities, and allocating resources, they can improve educational outcomes.

The engineering approach. A production function model of the educational process provides a useful framework for thinking about the factors that contribute to education quality. Within a simple input-process-output-outcome model, *inputs* are the initial resources used to create the educational experience (e.g., teachers, textbooks, other instructional materials, school facilities). *Process* refers to the means by which educational inputs are transformed into educational outputs (e.g., lectures, self-instructional materials, small group work, use of radio). *Outputs* are the direct and immediate effects of the educational process (e.g., student achievement, attitudes, skills). *Outcomes* are the long-term impact of the educational process. They are the less direct and immediate results of schooling and emerge from the interaction of educational outputs with the larger social environment (Windham and Chapman 1990; Chapman 2005).

From the perspective of the engineering approach, the main responsibility of government and education officials is to secure sufficient financial resources for education, convert those into more direct educational inputs (e.g., teachers, students, buildings, textbooks), and allocate those inputs in the right amount and mix to foster delivery of education in a way that yields desired outputs and outcomes. Engineering greater educational access for girls might involve building schools close to where children live, hiring monitors to provide more security for girls as they walk to school, providing gender-sensitive instructional materials, and training teachers in gender-sensitive pedagogical practices.

The industrial organization approach. In framing policy in terms of a principal/agent relationship, the industrial organization approach shifts the focus from the management of inputs toward more concern with influencing parental decisions within the home and educational processes within schools. A persistently perplexing issue facing education officials is how to ensure that policies promoting girls' access and achievement promulgated at central or district levels actually shape school and classroom level practice in intended ways (Chapman, Mählck, and Smulders 1997).

This influence is exercised through the focused use of *incentives* to encourage desired behavior on the part of parents (to send their daughters to school), headmaster (to ensure girls' safety and appropriate treatment once in

school), and teachers (to use gender-sensitive strategies in their classroom instruction), and *accountability* to ensure that intended actions actually occurred. The use of incentives is illustrated by school feeding programs linked to girls' enrollment, which resulted in increases in girls' enrollment of nearly 12 percentage points in Eritrea and a similar (but less well documented) increase in northern Ghana (Chapman et al. 2004; Miske 2003). Typically, the challenges in employing incentives have been, first, to identify incentives that have sufficient value to family, classroom, and school level decision makers to be able to influence their behavior and, second, to link awarding of those incentives with the desired behavior in a sufficiently clear and timely manner. Teacher incentive systems often founder on just that point—the difficulty of discerning the target behavior and then awarding the incentive in a timeframe in which the teacher recognizes the connection at a level that has motivational value.

The industrial organization approach presumes: 1) that education officials can influence the resource allocations process to reward community and school personnel for behaving in intended ways (e.g., sending girls to school); 2) that those officials understand what combination of inputs and classroom processes lead to desired outcomes (e.g., girls' access, achievement, completion); and 3) that manipulating educational incentives for teachers is an effective way of shaping the eventual outcomes of education for girls. In practice, these assumptions are not always met. While education officials may be able to influence the flow of resources, there may not be consensus about what interventions make the greatest difference in girls' access, achievement, and completion.

In the context of girls' education, the *political accountability approach* operates at several levels. International organizations have been advocating the need for national governments to develop stronger policy frameworks that encourage greater equity in girls' educational access, achievement, and completion rates. Governments that have adopted stronger policy promoting girls' education, in turn, have tried to promote adoption of these policies at community and school levels by enlisting the help of parents and community members. This can cut two ways. Parents who want greater opportunities for their daughters can be a powerful force; but not all parents see greater access for girls as an important goal. Indeed, parents can be a conservative force that may resist girls' education (Wolf and Odonkor 1997; Kane 2004).

Understanding this explanatory framework in terms of agency and structure, Galal's engineering approach appeals primarily to structures—to inputs, outputs, and outcomes—rather than to the agency of individuals or groups. From the industrial organization approach, the principal (e.g., the ministry official) seeks to bring about particular predetermined outcomes through agents, that is, to those at another or "lower" structural level of the organiza-

tion. In contrast, the political accountability approach focuses on purposive actions of citizens and policymakers rather than on the macro structures of the engineering approach. Citizens and decision-makers operate within the boundaries of political and societal structures, but their intentional actions to bring about change as they envision and define the change is the focus of the approach.

THE AGEI PROJECT

Between 1996 and 2003, thirty-four countries participated in the African Girls' Education Initiative (AGEI), which was funded by Norway and implemented through UNICEF. The initiative was grounded in the premise that, by targeting girls, the program would reach a major proportion of the population of children that has been denied access to education. Over the course of the program, the Norwegian Ministry of Foreign Affairs provided US $45 million to support AGEI activities in a total of thirty-four countries, two regional offices, and UNICEF headquarters. While there was a general framework guiding the development of activities in each country, UNICEF country offices and their government counterparts had considerable flexibility in the particular strategies they chose to implement as means of promoting girls' education (Chapman et al. 2004; Miske 2003).

Galal (2002) argues that effective strategies to promote educational reform must utilize all three approaches and that failure to do so can weaken the effort. But what have been the dominant strategies used by governments and international organizations for promoting girls' education? This chapter examines the strategies that were tried across the thirty-four countries, the interventions that were particularly successful, and the unanticipated problems that were encountered. The study provides a basis for assessing the effectiveness of actions widely advocated as strategies for improving the girls' education. To learn from this effort, evaluation data were collected through: a) a comprehensive review of project documents; b) six country studies illustrating different types of context and outcomes and more or less successful experiences (Botswana, Burkina Faso, Eritrea, Ghana, Guinea, Uganda); and c) interviews with key UNICEF personnel involved in the design and implementation of AGEI. To the extent possible, information was validated and cross-checked with other sources. Across both analyses, emphasis was on a) describing the nature of the intervention; b) determining the outputs; c) assessing the outcomes that were achieved; and d) determining the extent of larger impact on the education of girls.

Table 5.1 summarizes the activities that were undertaken across the thirty-four countries, organized by a) whether the primary focus was to engineer a

TABLE 5.1
Activities Undertaken through AGEI to Promote Girls' Education

Engineering approach (inputs within a production function framework)

Country	AGEI-sponsored activity
Early Childhood	
Burkina Faso	15 early childhood development centers
Cameroon	Supported 61 community preschool centers
Uganda	Created 85 community-based early childhood centers in 5 districts
Kenya	ECD caregiver and parent education materials
Togo	Supported the recruitment of 88 preschool teachers
Formal Basic Education	
Angola	Primary schools
Botswana	150,000 HIV/AIDS facts books
Burkina Faso	Books in national languages
Chad	Training plans and modules in basic education, health, nutrition, hygiene, HIV/AIDS prevention, culture of peace, and gender
Comoros	Classrooms
Eritrea	25 community feeder schools
Ghana	Handbooks for teachers promoting human rights
Guinea	25 primary schools; HIV/AIDS and peace education materials
Guinea Bissau	10 schools (60 classrooms)
Kenya	Rehabilitated boarding facilities for nomadic girls
Namibia	Schools with temporary hostels
Burkina Faso	10,000 textbooks and basic school supplies
Burundi	Educational materials for 26,000 pupils
Cameroon	Textbooks; SARA posters, learning materials, books
Cape Verde	10,000 manuals
Chad	Teacher manuals and teaching materials to 36 schools
Ethiopia	Educational materials to 150 girls in cluster schools
Gambia	Textbooks
Guinea Bissau	Teaching materials, equipment, and school kits to about 67,000 pupils
Kenya	Basic teaching materials
Mauritania	Teacher guides in arithmetic for Koranic schools
Mali	Bags and storm lamps to 500 girls; SARA posters, learning materials, books, textbooks; medical examinations for 7,000 pupils
Niger	Instructor guides for 4,000 teachers

(continued on next page)

TABLE 5.1 *(continued)*

Country	AGEI-sponsored activity
Rwanda	Learning materials to children affected by disaster
Senegal	Teacher guides, student workbooks on IST/AIDS & malaria
Somalia	Textbooks, teacher training materials
Sudan	Supplementary reading and teaching materials; provided instructional materials
Swaziland	Supplementary readers to primary pupils
Zimbabwe	Learning kits for P3 and P5 in selected schools
Guinea, Mauritania, Niger, Senegal, Togo	School supplies

Nonformal and Second-Chance Schools

Guinea	15 NFE centers; 5 literacy centers; Support of Nafa centers
Sudan	Village schools for nonformal education
Niger	Construction of warehouses and wells at nomadic schools
Burkina Faso	Support of satellite schools for basic literacy and math in children's first language
Mauritania	Teaching guides and training for teachers in nonformal schools

Industrial organization approach
(intervention relying on principal/agent relationships)

Country	AGEI-sponsored activity

Early Childhood

Burkina Faso, Chad, Cameroon, Liberia	Training in early childhood

Formal Basic Education

Angola, Burundi, Eritrea, Liberia, Niger, Nigeria, Rwanda, Togo	Developed or revised gender training modules
Benin, Burkina Faso, Eritrea, Gambia, Guinea Bissau, Guinea, Mali, Senegal, Togo	School feeding programs

(continued on next page)

TABLE 5.1 *(continued)*

Country	AGEI-sponsored activity
Benin	Girls' peer mentoring
Benin, Burkina Faso, Burundi, Comoros, Ethiopia, Gambia, Guinea Bissau, Kenya, Mauritania, Mali, Niger, Nigeria, Somalia, Tanzania, Uganda	Separate latrines for girls
Benin, Chad, Comoros, Senegal	Water points
Botswana, Burundi, Guinea, Liberia, Uganda	Girls' Education Movement (GEM) clubs
Burkina Faso	Training in integrated curriculum
Cameroon	Mother tongues in learning in primary schools
Cameroon, Cape Verde, Mauritania, Senegal	Life skills education
Cameroon, Burkina Faso, Mali, Mauritania	Children's government
Chad	Remedial courses for 2,000 girls with learning difficulties
Chad, Kenya, Somalia	Gender and HIV/AIDS training for head teachers, SCMs, and community leaders
Eritrea	Water containers
Ethiopia	Gender analysis of learning materials; tutorial and remedial instruction program for about 15,000 girls; guidance and counseling
Gambia	Curriculum review; development of guidance and counseling manual
Gambia, Tanzania	Conferences and discussion groups for girls
Guinea Bissau	Training in mathematics, science, and Portuguese language
Guinea Bissau, Senegal	Training to teach in multi-class settings
Guinea, Mali	Training in health education
Guinea, Guinea Bissau, Mauritania, Eritrea, Angola, Ethiopia	Gender training of teachers

(continued on next page)

TABLE 5.1 *(continued)*

Country	AGEI-sponsored activity
Guinea Bissau	Curriculum revision supportive of girls
Lesotho, Mali	Gender-responsive teaching and learning materials
Madagascar, Lesotho, Kenya, Swaziland, Rwanda	Combined gender and HIV/AIDS training
Nigeria	Provision of first aid kits
Somalia	Training for teachers in maintenance and management of textbooks
South Africa	Math and science camps for 200 girls
Swaziland	Studied relevance of curriculum; developed parenting guide
Togo	Training to teach large classes; hygiene project in 10 schools and supply of pharmaceutical kits
Uganda	Breakthrough To Literacy; gender analysis of instructional materials; manual on interactive methodologies

Political accountability approach

Country	AGEI-sponsored activity

Activities to improve quality of formal education—testing

Cameroon	Gender training of inspectors and head teachers
Comoros	Gender training of education officials; developed test for evaluating learner progress
Gambia	Developed MLA instruments
Uganda	Developed P3 and P5 English and math tests
Zimbabwe	Pilot tested a manual on learning assessment

Activities to improve quality of formal education—training

Angola	Created intersectoral committees for girls' education in each municipality and local school committees in each school
Benin	Parents monitoring children's performance via school-monitoring card
Benin, Ethiopia, Liberia	Gender training of community leaders
Botswana, Rwanda, Benin, Cameroon, Nigeria, South Africa, Sudan,	Life skills and HIV/AIDS
Burkina Faso	Training to new mothers

(continued on next page)

TABLE 5.1 *(continued)*

Country	AGEI-sponsored activity
Eritrea, Ethiopia, Kenya, Uganda, Sudan, Angola, Namibia, Chad, Gambia, Guinea Bissau, Mali, Niger, Senegal	Training in school management and governance
Ethiopia	Established girls' advisory committees in 11 school clusters
Gambia	Literacy training for women; supported sensitization campaign in rural communities and establishment of mothers' clubs
Guinea Bissau	Trained local groups for community awareness; gender training of journalists
Kenya	Formed district education provider
Kenya, Uganda	Community micro-planning and school mapping
Madagascar	Parent education; helped communities prepare school learning achievement program contracts to encourage enforcement of laws protecting minors from sexual exploitation
Mali	Promoted election school committee officers by assembly, giving half of offices to women
Mali, Mauritania	Trained parents in child rights and implementing of girl friendly schools
Niger	Training on chieftainship/leadership and the CRC; gender training of PSA members
Rwanda	Gender training of parents
South Africa	Training for executive committee of National Association of School Governing Bodies
Tanzania	Conducted community meetings (20 districts) on negative impact of heavy workload on girls' achievement
Togo	Parent sensitization and informational campaigns, training of 50 new Student-Parent Committees
Zimbabwe	Community capacity development; Gender training at teacher training colleges

Nonformal and Second-Chance Schools

Uganda, Tanzania	Second-chance schools for out-of-school children (COPE, ABEK; COBET)
Burkina Faso	Gender training of NFE inspectors
Nigeria	Established mothers' clubs in 40 NFE centers

(continued on next page)

TABLE 5.1 *(continued)*

Country	AGEI-sponsored activity
Other Interventions	
Benin, Chad, Gambia, Guinea, Mali	Income-generating activities for mothers
Nearly all countries	National policy development

Source: Adapted from S. Miske, *AGEI Consolidated Report, 2003* (New York: Education Section, UNICEF, 2003).

change in girls' education by manipulating the flow of inputs, influencing the behavior of individuals at other levels of the education system, or mobilizing community and parent interests behind the cause and b) whether the activities were aimed at early childhood development, formal primary schooling, or non-formal education. While some activities overlap the categories of the Galal framework, the general goal in this categorization is to show the predominant pattern that has been used to promote more and better schooling for girls.

Findings

The UNICEF study found that constraints on girls' education are relatively well understood. There was wide agreement across governments about the main factors constraining girls' participation in schooling. The main supply-side constrains included: a) lack of a school within reasonable distance and b) lack of appropriate or sanitary facilities in the school for girls, particularly at the point of puberty. Main demand-side constraints include: a) family values and beliefs that do not value education for girls (e.g., parents' concern about girls being in the same classroom and having contact with boys); b) economic constraints on the family, often centering on the need for girls' labor in the home, particularly to carry water and collect firewood; c) the view of some parents that educating a girl is counterproductive to arranging a good marriage for her; and d) parents' concern (often well founded) for the girls' welfare when they have to travel long distances to the closest school (Chapman et al. 2004).

There was considerably less agreement about what interventions were most appropriate in addressing these constraints. This tended to confirm UNICEF's approach of encouraging wide experimentation to test a variety of approaches. In the absence of clear information on what strategies are most effective, spreading relatively small amounts of money across a large number

of countries to support relatively modest efforts appears to have been a useful strategy, particularly if combined with systematic efforts to assess the relative success of the various strategies being tested (Chapman et al. 2004).

What Strategies Were Tried?

The preponderance of activities to promote girls' education were concentrated on expanding access to formal primary schooling and were *engineering interventions* aimed at providing school-level inputs, for example, more schools, classrooms, textbooks, and other learning materials. The general premise was that the lack of these inputs constrained access and, once the constraint was removed, parents would be more likely to enroll their daughters. Nonformal and second-chance options were for students who either had not gained access to formal schooling or had dropped out prior to finishing the primary cycle. These interventions focus on young adolescent girls and boys (10–15 years of age), who had never been to school or who had dropped out of formal schooling before completing the primary cycle. They offer literacy and vocational training courses. Second-chance opportunities were supported by AGEI in Burkina Faso, Guinea, Mauritania, Niger, Nigeria, Sudan, and Uganda where funds were used mostly for construction, the provision of instructional materials, and training of personnel. The success of these second-chance options seems to depend on the quality of their teachers, the status that is given to them, the opportunities for students to transition into formal schooling at a later stage, and their success in the job market with skills acquired during the training.

Interventions within an *industrial organization approach* sought to shape teachers' classroom pedagogical practices, mostly through the provision of more training. In a few countries, AGEI activities were intended to shape girls' behavior through peer tutoring and in-school socialization activities (e.g., girls' clubs in Uganda, Botswana) or to shape families' child-sending decisions, for example by providing schools with latrines, water, and first aid supplies that would make the environment more manageable for female students. In particular, provision of water and sanitation to encourage access and subsequent retention were used in Benin, Burkina Faso, Burundi, Comoros, Ethiopia, Gambia, Guinea Bissau, Kenya, Mauritania, Mali, Niger, Nigeria, Somalia, Tanzania, and Uganda. Food rations for girls as a means of promoting retention were used in Benin, Burkina Faso, Eritrea, Gambia, Guinea Bissau, Guinea, Mali, Senegal, and Togo.

Fewer activities were undertaken within a *political accountability* frame. Those that were tried tended to emphasize training of parents and community leaders to be able to better assess the activities of the school and achievement testing as a way of garnering information about school performance. In

virtually all AGEI countries, some degree of community participation was sought for the construction of schools, the promotion of girls' enrollment, and the management of schools. Table 5.2 highlights some of the more innovative practices sponsored through AGEI.

Impacts at a Policy Level

The AGEI illustrates Galal's point that effective reform requires adopting measures under all three approaches, in several ways. *First,* the engineering activities aimed at promoting girls' access to education created an environment that supported interventions aimed at the policy level (thereby reinforcing the political accountability frame). Regardless of the specific intervention that was used, the AGEI played a useful role in raising the prominence of girls' education as a policy issue in many countries (Chapman et al. 2004). This occurred both through the attention given to the specific activities supported through AGEI and through the advocacy of UNICEF personnel in meetings of development partners and government. The AGEI program provided both an opportunity and a reason for government and UNICEF to engage in ongoing discussion of the importance of educating girls and to explore and test innovative approaches. It served as a platform for advocacy, irrespective of the particular activities countries were using.

TABLE 5.2
A Sample of Innovative Practices Sponsored through AGEI

Within the engineering (production function) frame
- *Kenya* rehabilitated boarding facilities for nomadic girls
- *Zimbabwe* provided learning kits for students in primary grades 3 and 5 in selected schools

Within the principal/agent frame
- In *Mali,* mothers received *scholarships.* Mothers who sent their daughters to school received payments, based on the daughters' attendance.
- *Nigeria* provided *first aid kits* to schools.

Within the political accountability frame
- *Burundi* created a network of *journalists* dedicated to the promotion of girls' education.
- *Niger* sponsored *radio messages* about the importance of girls' education.
- *Togo* started fifty new *PTAs,* in which at least one-third of the members were women.

Source: Chapman et al. (2004).

Governments in several AGEI countries had finalized (or were close to finalizing) national policies aimed at encouraging the educational access and achievement of girls. These policies were the result of governments' own commitment and the encouragement of the wider international community, but UNICEF was often singled out by both government and development partners as a particularly strong voice in encouraging government action. In many countries, government and various external development assistance organizations viewed UNICEF as a leader in promoting girls' education. This positive visibility was largely independent of the success of the specific interventions themselves. The fact that UNICEF had activities underway generated credibility, separate from the nature or the impact of those activities.

The AGEI helped spark a sustained discussion about the importance of girls' education and the best ways to encourage greater female school access, persistence, and achievement across many countries. While evidence about the importance of girls' education was widely available before AGEI, this continent-wide initiative engaged educators and government officials from a wide range of countries in considering active steps they could take in their own countries to improve girls' education. Above all, the AGEI demonstrated that the strategic allocation of relatively small amounts of money across a large number of countries to support relatively modest efforts can do much to raise the prominence of target issues and shape policy discussion at the national level.

Second, when activities were not successful, it was often because they were narrowly constructed within an engineering framework, with little regard to the larger incentive system and political framework in which the activity was operating. Lack of success was often attributed to one of two things. In some cases, the design of the activity was not aligned with local value systems. For example, parents in Eritrea, fearing for their daughters' safety and morals, expressed reluctance to send their daughters to live in hostels located in urban areas. Student-mothers in Botswana did not send their babies to the day-care center constructed primarily for their use, preferring to have their babies in the care of family members. The other frequent reason for failure was when activities lacked local community ownership and leadership. For example, the nine girls' clubs started in Botswana lacked local champions. After four years, only one club remained active (Chapman et al. 2004). Other less successful activities included construction of hostels (e.g., Eritrea, Botswana) and one-time materials distribution (various countries)—important to a finite group of students, but not sustainable.

Efforts within the industrial organization frame, those that mobilized incentives to influence teacher, student, and parent behavior, while demonstrating a mixed history of success, often were disappointing in their outcomes. A key reason was the difficulty of linking incentives specifically and clearly enough to the intended behavior (e.g., girls' attendance; gender-sensi-

tive teaching). In some cases, incentives backfired. For example, in Ghana there was a community backlash toward the girls' scholarship program. Community reaction was widely negative, with many parents arguing that such programs were unfair to boys. Community pressure was serious enough to force district councils to alter their allocation procedures, to award half of the scholarships to girls and half to boys. In Uganda, when second-chance schools perform better than regular schools, second-chance program completers did not want to reenter government schools, seeing it as a step backward. Good quality of the alternative proved a disincentive to the ultimate goal of getting children back into formal schools.

Across the thirty-four countries, the political accountability approach appeared to be the least used and often the least effective. This was illustrated in the difficulty encountered in sustaining and mainstreaming girls' education activities. A goal of many donor organizations is that the activities they sponsor, once demonstrated to be effective, will be sustained and, ideally, implemented on a wider basis by governments. Overall, very little evidence was found of sustainability or mainstreaming of AGEI activities. One reason was that national policies in support of greater access and better treatment of girls in schools did not necessarily lead to corresponding changes in budgeting practices of finance ministries at national or subnational levels. While national policy frameworks that were adopted represent important accomplishments, those policy frameworks did not always redirect funding flows in ways necessary to sustaining or extending successful activities at the community and school levels. At the other end of the spectrum, community and school level interventions generally did not track cost data in a way that would have provided education financial managers with information about the inputs needed to continue or extend seemingly successful activities. When neither policies at the national level nor successful activities at the local level were linked to realistic assessments of cost, no formal provision for ensuring funds needed for sustaining or mainstreaming AGEI activities were made by governments (Chapman et al. 2004).

Similarly, a premise of some development assistance organizations is that clear evidence of the effectiveness of particular activities will lead to government adopting those activities in other locations and eventually implementing them on a wider scale. This is widely referred to as the "demonstration effect." The experience in several countries suggests that, while evidence of effectiveness is necessary, it may not be sufficient to prompt adoption, even when the intervention is aligned with government policies and government budget is available. Results challenge the efficacy of demonstration projects as a way of promoting good practice. Demonstration and evaluation are not enough, by themselves, to spark adoption on a wider scale. For the most part, when AGEI activities were sustained, it happened only when there was further external funding.[3]

An important element in the political accountability approach is that communities and parents, given information on ideal and actual school performance, will act to hold educators responsible for closing the gap. To be effective, this approach requires that educators, community members, and parents all have information on what constitutes success as a basis for assessing their local efforts. Yet in girls' education efforts, schools, governments, and international agencies often lack a firm basis for anticipating what would constitute a reasonable level of accomplishment. One consequence is that strategies are over-promised in the design phase. Interventions appear to fail not because they are inappropriate, but because they can not achieve inappropriately high goals. Unbridled advocacy for girls' education initiatives needs to be tempered with realistic assessments of what interventions actually lead to school success for girls.

Finally, several countries encountered a paradox related to community participation. One aspect of the political accountability approach is that parents and community members gain influence over the activities of the school through the financial and in-kind subsidies they provide at the community level. If a part of teachers' salaries come from the local community, teachers may be more responsive to local concerns and parents may have more leverage in demanding better teacher attendance and performance. The paradox arose when poor communities were sometimes expected to contribute their labor and local materials to the building of schools and sometimes to the payment of teacher salaries, while affluent communities (e.g., in urban areas) had all school costs covered by government. This sometimes led to participant dissatisfaction with what was otherwise an effective activity.

The Galal framework provides a way to assess national and international efforts to promote girls' educational access, achievement, and completion from a macro perspective. A review of over 180 specific activities across thirty-four countries throughout Africa indicated that most of the activities were efforts to engineer greater access through the provision of inputs aimed at manipulating the size, shape, and structure of the education system.

A more limited number of the AGEI activities were grounded in the industrial organization framework. That is, fewer efforts tried to manipulate incentives for teachers (to influence how they teach), for students (to influence their decision to enroll and persist in school), and parents (to allow their daughters to go to school). Interventions aimed at changing behaviors by changing the structure of incentives were sometimes successful, but sometimes backfired when the incentive value of actions to promote girls' education was misjudged.

In the language of agency and structure, interventions from the engineering approach and from the industrial organization framework attended to the more tangible elements and rules (e.g., incentives) of structures rather than to the less easily quantified dynamics of agency.

Far fewer interventions addressed girls' education from a political accountability approach, aimed at engaging parents and communities in encouraging girls' enrollment and success in school. But the experience of the AGEI countries suggests that engineering and focused use of incentives may not be enough, particularly as the challenge of improving girls' participation increasingly focuses on persistently resistant students. Greater use of political accountability strategies offers a promising direction for further efforts to promote girls' education. Not only do these strategies point to improved educational outcomes (e.g., enrollment, participation, achievement, completion) but, as Subrahmanian (2002) notes, interventions from the political accountability approach can create more enabling environments for women and girls, particularly at local levels, that will enable them to develop voice and to express their choices and priorities without risking social censure in the context of systems in which they are often silenced.

Continued success in promoting girls' education across the developing world will depend on a diversification of strategies employed by governments, communities, and donor organizations. Efforts to date have emphasized an engineering approach. They have focused on structures at the expense of agency. While continued attention to "engineering" greater access is essential, further progress will require more attention to activities grounded in the industrial organizational (principal/agent relationships, incentives) and especially in the political accountability frameworks (e.g., testing, information campaigns).

NOTES

Portions of this chapter are based on Chapman (2004) and Chaptman et al. (2004). The framework is drawn from Chapman and Miric (2005).

1. This chapter uses UNICEF's definition of girls and boys, which is children ages 0–18. The interventions described in this chapter address primarily the issues of adolescent girls and the women they will become, as well as their parents and guardians, particularly mothers.

2. Also see Chapman and Miric (2005) and Chapman (2006).

3. A closer analysis of how six of the "good practice" AGEI projects were taken to scale (Miske 2005) revealed that while some projects were taken to scale with relative ease, others required more elaborate analysis and planning. For example, mothers' clubs in Gambia, which engaged in income generation and offered support to girls' attendance and persistence in school, spread from one community to another, often without start-up seed money. However, nonformal education alternatives such as COBET, which was undertaken as a pilot project in Tanzania, required much more elaborate planning and analysis to be expanded on a national scale. The demonstration of effectiveness alone was not sufficient for wider scale adoption of the initiative.

REFERENCES

Bruns, B., Mingat, A., and R. Rokotomalala. 2003. *Achieving universal primary education by 2015: A chance for every child.* Washington, D.C.: World Bank.

Chapman, D. W. 2004. *Promoting education access, persistence, and achievement for girls: What works.* SEAMEO-UNESCO Education Congress and Expo, Bangkok, May 27–29.

———. 2007. Options for improving the management of education systems. In *Policymaking for education reform in developing countries: volume II: Options and strategies*, edited by J. H. Williams and W. K. Cummings. Lanham: Rowman and Littlefield.

Chapman, D. W., N. C. Coulibaly, B. Coyne, E. Holly, A. Diallo, K. Hickson, S. Issayas, R. Kyeyune, J. Lexow, K. Lokkesmoe, and J. Osei. 2004. *Changing lives of girls: Findings, conclusions and lessons from the external evaluation of the African Girls' Education Initiative.* New York: UNICEF.

Chapman, D. W. and S. Miric. 2005. *Teacher policy in the MENA region: Issues and options.* Background paper prepared for the Middle East and North Africa Division. Washington, D.C.: World Bank.

Chapman, D. W., L. O. Mählck, and A. Smulders (Eds.). 1997. *From planning to action: Government initiatives for improving school level practice.* Paris: UNESCO, International Institute for Educational Planning; and London: Elsevier.

Galal, A. 2002. The paradox of education and unemployment in Egypt. Working Paper No. 67. Cairo: Egyptian Center for Economic Studies.

Herz, B. and G. Sperling. 2004. *What works in girls' education: Evidence and policies from the developing world.* New York: Council on Foreign Relations.

Hyde, K. and S. Miske. 2000. *Education for all 2000 assessment thematic study: Girls' education.* Paris: UNESCO.

Kane, E. 2004. Education in Africa: What do we know about strategies that work? Africa Region Human Development Working Paper No. 73. Washington, D.C.: World Bank.

Miske, S. 2003. *AGEI consolidated report, 2003.* New York: UNICEF.

Miske, S. 2005. *A composite case study and a framework for scaling up UNICEF's good practices in girls' education.* New York: UNICEF.

The State of Eritrea Ministry of Education. 1997. *Girls' education in Eritrea.*

Subrahmanian, R. 2002. Gender and education: A review of issues for social policy. Social Policy and Development Programme Paper No. 9. Geneva: United Nations Research Institute for Social Development.

Wils, A., B. Carrol, and K. Barrow. 2005. *Educating the world's children: Patterns of growth and inequality.* Washington, D.C.: Academy for Educational Development.

Windham, D. M. and D.W. Chapman. 1990. *The evaluation of educational efficiency: Constraints, issues, and policies.* Volume 1 in the Advances in Educational Productivity Series. Greenwich: JAI Press.

Wolf, J. and M. Odonkor. 1997. *How educating a girl changes the woman she becomes: An intergenerational study in northern Ghana.* Office of Sustainable Development/ Bureau for Africa/U.S. Agency for International Development.

The Dance of Agency and Structure in an Empowerment Educational Program in Mali and the Sudan

KAREN MONKMAN
REBECCA MILES
PETER B. EASTON

E mpowerment relies on a strategic and creative dance of agency and structure in reshaping the ways in which we engage in education, development, and social change. Lasting and meaningful empowerment depends on communities' abilities to alter social and cultural structures that promote inequalities. Tostan's participatory nonformal education program began in Senegal in the 1980s and was implemented in twelve Malian and Sudanese villages and communities as the Village Empowerment Program (VEP) in early 2000. The VEP is designed to increase individuals' and communities' empowerment and their engagement in grassroots social change that addresses issues of gender equity. Alongside the educational components of community hygiene, women's reproductive health, human rights, and social change processes, participants (learners) identify local issues of concern and plan and implement change initiatives. In our evaluation research in the Sudan and Mali, female genital cutting (FGC)[1] was selected by many of the villages as one of these local issues of concern; through village-level action the participants, with and through their communities, were able to address inequities in gender relations and thus reduce structural impediments to enduring empowerment. In this chapter we examine how agency and structure were implicated in the processes of villagers' engagement in the VEP and grassroots organizing for social change, particularly around issues related to FGC. As such, FGC becomes the window through which we examine how

women become active agents of change, how gendered structural arrangements are redefined, and also how social structure shapes the ways that these processes unfold.

> [P]rocesses of cultural production [and social change] must be seen as lodged in that space *between* structure and agency, in that space *between* culture and structures. It is the dialectical interaction between structure and culture that we really must explore. . . . Agency is not enacted without reference to social structure . . . ; indeed, it is absolutely enacted in relation to such structure. (Weis 1996, xi, emphasis in the original)

Following a brief discussion of the conceptual framing of this chapter and our research methods, we show how the VEP engages participants in knowledge construction, development of critical awareness, and subsequent individual and collective action. It is this collective action that has potential to reshape social structures, since those structures are constructed by society itself. Through our examination of the dance between structure and agency, we discuss how that dance relates to the processes of empowerment we observed in this program. Embedded in the notion of empowerment is the dynamic interplay of agency and structure.

EMPOWERMENT AND GENDER EQUITY: THE DANCE OF STRUCTURE AND AGENCY

The VEP is a participatory model of education and social change that recognizes and promotes individual and collective agency within and against the realities of social structure. The VEP enables people to identify and address their own problems individually and collectively through a systematic process of critically examining life conditions, developing awareness of contextual and influential dynamics, and planning and implementing change. The facilitative nature of the teachers' work guides the critical analysis of social structural elements of individual and community life, including economic, cultural, political, and legal arrangements relating to gender, health, and social activism.

The concept of *empowerment* is derived from *power* and generally (in gender and development circles) is understood to refer to *power to* and not *power over*. Power is embedded in social relations that shape possibilities for who has access to, use of, and control over resources, both material and ideological resources. Stromquist (1995) suggests that empowerment has four equally important dimensions: personal (e.g., self-confidence), cognitive (emancipatory knowledge), economic (generating and controlling resources), and polit-

ical (participation in relations of power). Each of these dimensions is impli-
cated in the interplay of agency and structure.

Within the VEP's organizational structure, transformative learning
occurs through engaging in analysis of material and ideological structures,
which can lead to collective, informed action. Emancipatory knowledge is
necessary for the development of critical awareness (or cognitive empower-
ment [Stromquist 1995]), and collective action and collaborative struggle are
key to the development of both personal empowerment (e.g., the confidence
to act on one's behalf in the form of individual agency) and political empow-
erment (e.g., the ability to participate as an integral player in decision-making
processes, collective public discussions, social relations of power). While
change in the lives of individuals can improve their immediate *situation*, it is
the structural inequalities embedded in social relations that are the basis or
conditions of social and gender inequities. Therefore, both *situations* and *con-
ditions* of oppression must be examined and addressed.

Molyneux's concepts of "practical gender needs" (PGNs) and "strategic
gender needs" (SGNs) offer us an analytical tool to distinguish between
gendered life situations and conditions (1985; Moser 1989). PGNs reflect
women's everyday problems such as feeding families, health, earning money,
paying school fees; these are particular situations that, when addressed, do
not alter the conditions—structures—that give rise to the situations. SGNs
address institutionalized gender inequality in such areas as legal arrange-
ments, social norms and cultural practices, the gendered division of labor
and equitable sharing of work, ownership of land, and control over one's
own sexuality—the systemic conditions that create gender inequity.
Addressing strategic needs alters gender relations in ways that make it eas-
ier to address practical needs. At the same time, addressing practical needs
builds women's confidence (Stromquist's notion of personal empowerment)
and increases their skills and knowledge base (cognitive empowerment),
which are necessary for engaging in the struggle to meet strategic gender
needs. Kabeer says that

> While most mainstream development agencies have recognized the effi-
> ciency of factoring gender into their policy design, and while some acknowl-
> edge the equity arguments for meeting women's practical gender needs
> within the existing division of resources and responsibilities, few are pre-
> pared to address the underlying inequalities frequently associated with this
> division. The distinction between practical and strategic helps to unpack the
> very real tension between policies which seek to distribute resources in ways
> that preserve and reinforce these inequalities and those which use women's
> everyday practical needs as a starting point for challenging these inequities.
> (Kabeer 1994, 91)

Participatory educational methodologies like the VEP's are strategies to overcome inequitable power relations (Kabeer 1994, 230–232). They look beyond transmitting knowledge to individuals to critically examining the social dynamics that shape learning and living; they also use education to serve social change, in this case, to challenge inequitable gender structures (Kabeer 1994).

PARTICIPATORY RESEARCH AND EVALUATION

This study uses data collected for two mixed-method, participatory evaluations of the VEP in Mali and Sudan. As the external evaluation team, we collected interview and observational data; monitoring data were recorded by the facilitators and program supervisors; and quantitative survey data (pre- and post-implementation) were collected in project villages and control villages primarily by the internal evaluation (monitoring) teams. In this chapter we rely mainly on the qualitative and monitoring data to provide a deeper understanding of the empowerment process as it reflects the relationship of agency to structure. The quantitative survey data, although not reported on extensively here, provide some insight into the extent to which the program increased the health and human rights information available to villagers and changed their attitudes and practices regarding community leadership, the optimal marriage age for girls, household and community health, domestic violence, and FGC.[2]

Our interviews and observations took place in Mali in March 2000 and May 2001. In Sudan, initial field visits were done by a Sudanese external researcher in October to November 2000 and by the authors in January and February 2003. Six villages in each country participated in the VEP; additional similarly situated villages were also included in the surveys for comparative purposes. All participants in Sudan were women but in Mali the groups were mixed. Frequent email communication also enabled collection of some data and promoted an interactive participatory process during intervening times.

During the field visits, evaluators met with program staff and the evaluation teams, observed the facilitators during a regular evening session, met with various village authorities (chiefs, imams, headmasters), participated in individual and group interviews, and reviewed the monitoring data (write-ups of weekly staff meetings; site-specific records kept by facilitators; chronicles of session "products," including dates and number of proverbs, riddles, and songs written by participants, dates and number of times participants met with nonparticipants to discuss what they had learned, dates of village-wide initiatives such as clean-up days, etc.). In the final interviews, nonparticipants were

asked what and how they heard about the program and what resulting changes they had observed. Participants were asked a sequence of questions to draw out their experience of the facilitation methods, what topics they liked and didn't like and why, how they made decisions as a group, what actions they had taken as a result of the sessions (including a discussion of the work of the social action committees), and what changes they have observed, both in their own lives and in the community.

DEVELOPING AGENCY: ACTIVE LEARNING, AWARENESS, ATTITUDES, AND ACTION

Empowerment requires the development of critical awareness and action at both the individual and the collective levels. Gender relations must be a key element if gender equity is a goal. In other words, understanding social structures is necessary if individual and collective agency are to make those structures more equitable. Empowerment requires active engagement.

Active Learning

The VEP curriculum[3] and methods are designed to foster transformative learning and empowerment rather than passive assimilation of information; this requires active learning. Participants and facilitators in Mali mentioned that the active learning techniques were different from anything they had experienced before. An older Malian man said, "Sessions were like an exchange between facilitator and participants. You actually do something, the facilitator presents problems that touch us. If you are involved, you must change" (May 1, 2001). One facilitator contrasted the VEP presentation on FGC with that of another Malian NGO who "paid people to come hear them and gave more to men. [They] never gave the villagers a chance to speak, whereas we do. It is important to start with the reality of the villagers" (May 1, 2001). Sudanese participants were observed actively engaged in dialogue about medical treatment, children's health concerns, problems with flies, domestic violence, and FGC (February 2003). Groups there found ways to engage "shy" women in active processes. One facilitator saw it this way: "If they're going to talk to others [nonparticipants] they [first] need to create an environment where they can speak freely with themselves; they need an informal space" (February 24, 2003); the VEP provides this space.

The difference between the active engagement of participant women who have experienced the VEP and nonparticipants was clearly demonstrated in one of the Malian villages. In a group interview, none of the nonparticipant women was initially willing to talk in front of strangers, with one mumbling,

"We are not used to answering questions" (May 4, 2001). In sharp contrast, the seventeen women participants offered their opinions and reflections and discussed issues among themselves during the meeting, including their views about FGC. In a casual conversation about the benefits of active participation, one Sudanese woman said, without hesitation, "Joining others . . . if I'm not feeling well or if I am not in a good mood, I'm always in a good mood after meeting here!" (February 21, 2003). This positive experience, in turn, stimulates more involvement. Active engagement in learning processes is the vehicle through which critical awareness is developed, attitudes are examined and altered, and agency is encouraged.

Raising Critical Awareness and Reshaping Attitudes

Many participants showed new critical awareness of information and emancipatory knowledge, and the structural relationships related to issues of concern. Knowledge that is emancipatory includes that which is related to rights (human rights, legal rights, women's rights, etc.), sexuality and reproductive health, and other areas of knowledge that examine the structural basis of gender inequality. Understanding the social context within which gender relations are structured is critical to changing social inequities.

Education as a right of women and girls was frequently mentioned by Sudanese participants. During a group interview, one woman used her own educational needs as an example of a women's rights issue. "If my husband says I can't continue my education," she explained, "I'd tell him that wives and daughters have a right to education." Her tone of voice and gestures seemed to indicate that she would confront him and stand firm under challenge. Another woman added, "They [need to know that] women [can] have land and [they have] rights" (February 21, 2003). In this same group interview, one young woman—nineteen years old, pregnant, and quite talkative—brought up the issue of girls' rights to education several times. She had attended school through the fifth grade and was disappointed that she hadn't been able to continue her own education. She was adamant that her children would do so (February 21, 2003).

Before the program, few in Mali were aware of rights for women, and even fewer could name such a right: six examples were named in the baseline surveys. After the program, in response to an open-ended question about favorite topics twenty-one examples were named, all with more detail than in the baseline survey. Typical among these were "Women have the right to equality in the management of the family and its wealth," "Women understand they are equal, especially in communication," and protection against violence in the home. Interestingly, the human right that participants most often cited was the right of women to participate in all aspects of family life and

decision-making. Participation enables the enactment of agency and increases possibilities for change.

Sudanese participants cited a variety of women's health and human rights issues in the follow-up survey, including family planning, FGC, "women's rights," education rights, CEDAW,[4] and violence against women (February 2003). The responses to the open-ended survey questions about identifying "benefits" give an indication of what broad topics captured the attention of the Sudanese participants. Human rights was named 135 times, women's rights 116 times, and health and community hygiene 71 times. Other forms of emancipatory knowledge related to gender violence and forced marriages were conveyed in two skits by Malian participants and in several activities organized by local committees.

In addition to new knowledge, conceptual awareness of the relationships among issues was developed. One male participant in Mali said, "All the modules are developed around the concept of human rights. This was a central element of the sessions for me. If you know the rights, hygiene and health are wrapped up in there" (May 1, 2001).

Personal Transformation

Sharing new knowledge with others is common. In Mali, the main fora for information exchange are group discussions (*causeries* and *grains de thé*, or traditional gatherings of people to drink tea and socialize) and one-on-one exchanges between participants and nonparticipants; diffusion of information through observation is also common. One woman shared, "Family members who participated came back and talked with those in the same courtyard" (May 1, 2001). A male nonparticipant in Mali told of "one woman in my family [who] participated. Before, she was very dirty. Since the program, around the well, everything is clean now. Waste water is thrown far from the well. There is a stake for the bucket. The woman herself has changed" (May 2, 2001). Changes also occurred in individuals who were not participants. One nonparticipant woman in Mali explained that her mother-in-law, a participant, would "tell me never to put the water buckets on the ground. Whenever she saw kitchen utensils dirty, she would scold. She would protect the children from dirt" (May 4, 2001). Similarly, a Malian woman participant said, "I observed a nonparticipant putting a stake by his well because he saw one at a participant's house, not because anyone persuaded him" (May 1, 2001). In Sudan one group of participants disseminated information about hygiene through visits to homes in which they talked about "cleaning the drinking water." Word spread of their work, and they then visited two other villages that rely on well water for drinking. "They explained to them that uncovered [and unclean] wells are good environments for microbes" (Facilitator's final report, n.d.).

Even with more sensitive issues, individual participants' actions influenced others. Several women reported family dynamics in which they influenced husbands or parents. One woman participant told of how she was "able to get back from my uncle the field my husband left me when he died because I learned it is not correct that a women doesn't have the right to own land." A Malian facilitator (May 4, 2001) told of "a man who used to hit his wife for the smallest of things. They were both in the class. The wife confronted him saying, 'Are you going to learn one thing and then do the opposite at home?' . . . they continued to have problems, but he doesn't hit her anymore." In a Sudanese village, a woman talked of how she managed to convince her husband to abandon the practices of FGC with their daughters. After "studying" in the program, she herself had become convinced, and she then talked the matter over with her husband. "I discussed it with him. He accepted the issue and was convinced," she reported (Facilitator's project notes, n.d.). When asked if any other family members ask her to circumcise her daughters, she replied, "Yes, my mother—the [girls'] grandmother . . . but my husband and I refused and insisted on our position, so they accepted it."

Another woman in Sudan indicated, "My husband now promotes doing a less severe type [of FGC]," and another said "I talked to [family members]; they're concerned, but I don't know what they'll do" (February 21, 2003). A facilitator tells about how one Sudanese midwife has engaged others in thinking about FGC:

> I talked with them [midwives] about the circumcision operation. One midwife told me that since she started taking this [class], she has done no more operations because she realizes how damaging it can be. She explained to me that she was raising the awareness of every woman who comes to her to circumcise her daughter. She told me that she herself has a child who is more than thirteen years old and has never been circumcised. When I talked with another midwife about this topic [circumcision], [she said that] it is a necessary habit; there is no way to avoid it; [she] does Sunni circumcisions.[5] But I discussed [these issues] with her and I convinced her that this operation is also hurtful, and that she should support us to end this operation.

> [This same midwife] mentioned to me that she circumcised one of the girls in the village—with the Sunni type [of operation]—but her mother did the operation again, and this time the pharaonic type. When I [looked into this] I found that the mother of this girl was one of the participants in the program. And, the reason that the woman redid the operation was because her tribe was stubborn [and insisted upon it]. So, I asked her [about her

thoughts], and she said, after studying this program, "[I realized that] this operation is hurtful and I will never do it to my other girls. . . . I'll prevent all village women and neighboring village women [from having it done]." (Facilitator's final report, n.d.)

A Malian woman was particularly articulate about strategies of sharing new knowledge and confident about their efforts to change attitudes, in this case to halt the practice of FGC. There had been no cuttings that season, and they were convinced there would be no more in the village. When asked how they would achieve this objective, the woman answered, "We will keep talking to the other women, and we have already talked to the chief of the village to tell him the women want to stop" (May 4, 2001).

Whether these self-reported affirmations can be taken at face value—or to what degree, if any, they may have been aggrandized by social pressures— remains an open question. But it is at least evident that the *discourse* about the topic has changed in these villages, that the topic is being actively discussed and debated, and that personal transformations are underway. The combination of facilitation techniques in the VEP that engage learners actively and solid emancipatory knowledge cast in a human rights framework helped build confidence so people could speak out and mobilize around issues about which they are concerned.

Collective Action

More organized forms of agency are evident in the collective actions planned and carried out by locally formed committees that move beyond awareness and individual action to empowering communities. The VEP curriculum encourages villagers to initiate activities that have immediate results first, to build the confidence of both participants and nonparticipants and to develop problem-solving skills. Next, more challenging activities requiring sustained behavioral change were tried. A Malian male participant distinguished these as "easy" and "hard" activities, explaining that hygiene such as work around wells is easier because "everyone can see the results, can see the benefits; people will change their behavior on their own." He continued: "When the benefit is not clear, it is harder to involve those with different points of view" (May 2, 2001).

All the villages in both countries carried out several "easy" activities while the facilitators were in the villages. "Easy" activities tend to be of shorter duration and require minimal behavioral change (see Table 6.1).

In Sudan a variety of examples were cited in reports and elsewhere, to a lesser degree, in the group interviews. For example, one facilitator recounted in her final report the activities in one village:

TABLE 6.1

Types of "Easy" Activities as Reported by Villages during the Final Field Visits

Country	Number of villages naming each activity	Activities named
Mali	All villages	Regularly cleaning the village
	Four villages	Purification of water
	Two villages	Cleaning around the wells
		Driving in stakes to hang well buckets
		Mobilizing children for vaccinations
		Building latrines
		Improving hygiene in homes
	One village	Taking care of drainage ditches
		Improving pig pens
		Opening kiosk to sell condoms
Sudan	Five villages	Trash collection and removal
	Two villages	Fill ponds of standing water
		Fix pipes (to combat mosquito infestation)
	One village	Transport sick residents to clinics
		License a butcher (to provide healthful and inspected meat)

They did nine trash-cleaning campaigns. Women collected money—about 1,000 pounds [about $0.39 US]—from each participant. This continued through the third campaign in order to encourage them. At that point, all neighborhood residents participated so [that] each house paid 250 pounds for the trash collection and transport. Young men volunteered to carry the trash by cart. Women were praised by the men of the People's Committee and neighborhood residents, because that was the first time they saw that women went out in the street to defend environmental health through volunteer work. . . . The women were ahead of the men. (January 24, 2003)

In another Sudanese village, a committee mobilized to form a "social liability fund" used to transport sick villagers to doctors, and for other related needs.

Several of the Sudanese villages involved the whole community (not just the participants) in trash-collection campaigns, thus educating nonpartici-pants about community hygiene in the process. In one village, a committee of participants was formed to take care of drinking water: "The first job this committee did was to clean the well, which most of the village people rely on for drinking water. They taught all who use this water [(including nonpartic-

ipants)] how to care for drinking water and to [keep it clean]" (Facilitator's final report, n.d.).

Some of the "easy" activities were quite involved, but were readily embraced, perhaps due to there being both individual and collective benefits. One participant in Sudan, for example, in response to the community identifying the poor quality of available meat, became licensed as a butcher, in part to provide more healthful food to the community, and in part to increase family income. The butcher learned about hygienic issues relating to meat; the products he then provided to the community were inspected and verified as healthy.

Activities that require ongoing behavioral change by many individuals, or that challenge power structures, were more difficult for villagers to initiate and sustain. For example, during a walking tour in the Malian villages, we observed several instances where stakes were available by the well but not being used: the bucket was left on the ground as before. Systems for reinforcing behavioral changes varied by village, but only one Malian village had a system that was implemented consistently: the hygiene committee fines people who do not hang up the bucket. Two villages have monitoring systems but no penalties for unhygienic practices. In another, two women were delegated to monitor cleanliness around the wells and water filtering systems; this was easy to enforce because all the women fill up their vessels at the same time each day. In another Malian village the committee has a schedule for visiting households; the head of household is then told if a water jug is found without a cover. One Sudanese community monitored the cleanliness of the village on Fridays [the Islamic Sabbath]. Trash removal in several Sudanese communities became more challenging due to the lack of reliable transportation and convenient locations to deposit the trash. A vehicle loaned initially was not available for subsequent clean-up campaigns, and the locations for trash disposal were quite distant.

Attempts to individually and collectively tackle bothersome but manageable problems were often quite successful in the first round or two of activity and certainly built participants' confidence, but the subsequent confrontation with more deeply rooted causal factors could be daunting and there was no readily available guidance about how to proceed.

The VEP created physical and dialogical space to put "hard" issues such as FGC on the table to be discussed and analyzed in a collective, nonthreatening way during the implementation stages. The intersecting themes of rights and health in the curriculum create a space for a variety of gender issues such as domestic violence, early and/or forced marriages, FGC, access to cultivable land for family sustenance, and so forth. Committees chose to address these "harder" types of issues after the NGOs had ended their active involvement in the villages.

When committees chose FGC as a topic of concern, they were confronting institutionalized gender relations in the form of social customs. Because this program conceptualizes FGC as a social custom, people can mobilize to abandon it if they choose.[6] It became clear that the villagers were divided in their attitudes about FGC. In Mali there were those who had never questioned FGC, those who reacted to radio messages opposed to FGC by reinforcing their support for it, those who had heard new information about the ill effects of the practice (e.g., from the radio or NGOs) but had not acted on it, and those who had direct experience with its ill effects. The last two groups are more likely to have contemplated changing a deep-seated practice like FGC than people who have never questioned the practice and have no new information to prompt rethinking (Izett and Toubia 1999). In Sudan there was a similar polarization. Those who were initially (at the time of the baseline survey) somewhat ambivalent about FGC tended to change their attitudes: the direction of change mirrored participant status. At the time of the final field visits and follow-up surveys, those who were participants in the VEP expressed strong attitudes favoring abandonment of FGC, while many of those surveyed from the control villages (those with no new information but who had heard that the other villages were questioning the practice) had become more adamant about preserving the practice.

Exposure to new information does not automatically nor quickly change attitudes. In Mali, for example, most people didn't begin to question the wisdom of continuing the practice until after the three-day intensive workshop.[7] Two villages had already had a program of awareness-raising about FGC carried out by another Malian NGO. The midwife who worked in the villages for another NGO believed their approach had given people new information and gotten them talking about FGC. As a result, the villagers understood the "unhappy consequences [*malheureuses consequences*]" of FGC (health professional, August 20, 2000). FGC was discussed in-depth first in these villages.

Similarly, in Sudan, changes in attitude and practices were closely linked to generating interest in discussing the topic, discussing it in ways that introduced new knowledge and respectfully challenged the status quo, promoting alternatives that were seen as viable, and creating a critical mass. One committee, for example, collected statistical data about female circumcision, and "[made other] people aware [of] the risks of this operation/process, that it should be eliminated, it should be given up" (Facilitator final report, n.d.). Discussion of these data—seeing trends over time and relationships among FGC and health conditions, for example—helped to stimulate individual and collective action and focus social action initiatives. Many participants reported how their opinions about FGC were changed due to learning about the link to health conditions and human rights. Expanding participatory dialogue creates a supportive critical mass. Three Sudanese classes met together to discuss issues related to FGC:

"The goal of this gathering was to exchange opinions about the program objectives and [to] know the opinions of the participants about harmful habits [*sic*]. This created a spirit of cooperation and familiarity [closeness] among the participants. The visit achieved a very major part of its goals and left good impressions in the participants' minds" (Facilitator's final report, n.d.).

Empowerment derives from critical awareness, which requires new information and a participatory, critical analytical methodology (Izett and Toubia 1999). Collective action can then target structural inequalities. Agency, in our view, reflects the engagement of participants—individually and collectively—in this entire process from critical analysis and knowledge construction to changing attitudes and meanings, to planning and carrying out strategic activities.

GRASSROOTS SOCIAL CHANGE: AGENCY AFFECTING STRUCTURE

The FGC committees have been active since the program ended, encountering both resistance and support from different segments of local society. In several of the villages participants reported that, to their knowledge, no girls had been cut since the program started. When asked how they knew that, Malian participants and facilitators pointed out that girls are celebrated when they are cut: they wear special clothes. Those who circumcise their girls are proud of the event and quite open about it. A village facilitator reported:

> a man who participated in the three-day intensive [workshop] but hadn't participated in the rest of the modules said, "We must do something. . . . We must get together!" Three participants also said, in a strong voice, "We are not going to have our girls cut . . . [and] we are going to talk to others to stop them!" Some participants told me they had spoken out against FGC [and] that everyone was talking about it. I asked to visit the girls who had recently been circumcised. People told me that there weren't any. (May 1, 2001)

In Sudan it was more difficult to know how they knew whether changes were being made. Everyone interviewed said that changes have been made, some indicating that there are no more cuttings, others saying that some families have chosen a less severe type of FGC, and some stating that the incidence of FGC has been reduced but not eliminated. One facilitator relied on her good relations in the community by finding out from a midwife whether the midwives were performing FGC, and, if so, what kinds; she was able to collect this data periodically and track changes over time. She felt sure that no participants were having their daughters cut, and some other community members had considered and opted for less severe types of FGC than they would have previously.

The participants' descriptions of the FGC committees' work suggests that their main focus (at the time of the final surveys) is to sustain the abandonment of FGC. The strategies differ somewhat depending on the village but typically involve circulating among friends, family, and neighborhood social gatherings, meeting with village leaders and heads of households, and visiting households known to be considering FGC for their daughter in order to continue the dialogical processes that encourage critical awareness and individual and collective action.

Participant women spoke about how they had stopped the practice in their village among both participants and nonparticipants, and how they intended to make sure that the change was sustained: "We are all in the same village, we let them know" (group interview, Mali). When asked about sustaining the abandonment of FGC in subsequent years, they replied, "We have already talked to the village chief to have him say we are stopping."[8] The FGC committees in several Malian and Sudanese villages are also building their constituencies to approach the village chief as a group. As one male participant in Mali put it, "He is the [person] who can forbid such things" (May 2, 2001).[9]

In Sudan committees have used such strategies as intervening in families when the issue was being debated, talking with nonparticipants to share their knowledge, supporting a local midwife in having extensive conversations with other midwives, soliciting the support of imams and village chiefs and other men in positions of decision-making power. The village FGC committees are continuing their work without any active support from the VEP. Even though it is premature to tell the future of the practice of FGC, we see structural changes in the ways that women and men organize themselves, mobilize around issues, and promote change. When FGC is discursively framed as a social convention, its structural nature can be shaped through collective agency. The VEP talks of "abandonment" of such a practice. This way of framing it is more amenable to change than "eradication" (which is more typical in FGC programs), as the latter implies a negative connotation of the practice, and by association of those who practice it, and elicits resistance to change. Empowerment depends on voluntary and committed action, deeply rooted in individuals' and collectivities' own motivations.

THE DANCE OF AGENCY AND STRUCTURE IN PROMOTING EMPOWERMENT

Dimensions of Empowerment: The Interplay of Agency and Structure

Three of Stromquist's four dimensions of empowerment are evident in the educational and social change processes in these villages. Personal empower-

ment has been demonstrated through the various narratives of self-confidence as evidenced in women speaking up in a group, talking with men about traditionally taboo topics, and mobilizing to discuss pertinent topics and change opinions and practices. Cognitive empowerment is reflected directly in the emancipatory knowledge of human rights and women's rights, and indirectly in the health-related topics, as participants learn of the health effects of various practices. Political empowerment is reflected in the collective participatory processes in classes, committees, and various discussions within and across families, neighborhoods, and villages about issues related to health and rights.

Stromquist discusses economic empowerment in terms of women's ability to access (earn or acquire) and control financial resources. Economic empowerment is often necessary for one's control over other aspects of life. Income-generating initiatives are a common approach in gender and development projects to address women's economic needs (Boserup 1970; Moser 1993; Kabeer 1994). While economic empowerment was not a focus of this VEP, there were various examples of participants using their economic resources for purposes of collective change, thus reflecting their access to and ability to control (at least some) economic capital. In addition, some communities included income-generating activities in their social action plans. Money was contributed to support several collective efforts, was paid as fines when the well buckets weren't properly cared for, and a group of women were reported to have repaid a loan early. Beyond these small-scale examples, however, the communities expressed larger and recurring needs. In order to create an ongoing strategy for trash collection, for example, transportation is needed, as is a site to deposit the trash; these require long-term financial resources. Several communities wanted to engage in other types of activities, including a literacy class, but needed money to support those endeavors. The local NGOs that implemented the VEP were called upon at various times for advice or help with grant applications even though the VEP had ended. Lack of acknowledgment and inclusion in the curriculum of economic relations in communities and in families is perhaps one weakness of Tostan's program in Mali (although in all fairness, it wasn't designed to address this dynamic). At the same time, however, the NGOs that implemented the VEP curriculum deliberately avoided income generation as a strategy in favor of focusing their attention on the importance of grassroots efforts and to decrease community dependence on development agencies and external funding.

Development education projects such as the VEP depend on development agencies and NGOs for access to resources ranging from funding and the curriculum itself to knowledge about transformative educational methodologies and social change processes. The NGOs bring organizational structures and agendas of their own, along with structural elements linked to funding sources. Involvement by NGOs can be critical in the early phases of social

change, but can also be restrictive later on. The transition from dependency to autonomy signals changing forms of agency and changing structural contexts within which individuals and collectivities engage in social change (Rocha 1997; Monkman, Miles, and Easton 2004).

Making Social Structure More Gender Equitable:
Strategic Structural Change

Transforming the world, in relation to gender inequity, requires structural change in the conditions that create inequality. Through analysis of SGNs, PGNs can be addressed "in ways which have *transformatory* or *redistributive* potential, that is, which help build up the enabling infrastructures essential for the process of self-empowerment" (Kabeer 1994, 301, emphasis in original). The VEP curriculum includes both PGNs and SGNs, although it is in the self-directed committees, after the NGOs were no longer involved, where most of the SGN-focused work was enacted (Monkman, Miles, and Easton 2004). The health concerns can be seen as a reflection of PGNs. Improving community hygiene, which affects incidents of illness, requires (for the most part) changes in habit, not changes in structure to make possible changes of practice. These types of PGNs were the initial foci of the committees; they are fairly uncontroversial and straightforward to address: picking up trash, putting lids on water containers in homes, hanging buckets at wells, and so forth. With the development of personal and political empowerment (Stromquist 1995), new issues were then addressed, including domestic violence and FGC. FGC can be a PGN and/or an SGN. When FGC is addressed purely as a health concern, it reflects a PGN. It can become an SGN by transforming the cultural meanings and social conventions related to this practice. When inter-marrying families agree to abandon the practice, they are able to do so, as they have redefined marriageability requirements and related gendered social relations (Easton, Monkman, and Miles 2003; Mackie 2000).

DOING THE DANCE OF AGENCY AND STRUCTURE

While it is too early to tell what the enduring changes with the practices of FGC will be, there is evidence that the participants and their villages are altering these practices by mobilizing around this issue and stating that they will no longer cut girls. This mobilization has moved the discussions into a more public forum and has made it possible for self-directed collective change, thus reshaping the structural underpinnings of community practice. In essence, this process of empowerment works within and against the normative conceptions of attitudes and activities considered appropriate in these particular sociocul-

tural contexts. When our actions are "against" those conceptions (institutional and ideological structures), we can alter those structural influences to create spaces where women's agency can be more freely enacted.

NOTES

1. We use the term female genital cutting (FGC) in this chapter but wish to acknowledge the more politically charged term *mutilation* (FGM) as signifying the violence inherent in these practices. FGC was adopted as a major health concern by the WHO in 1982 and recognized as a human rights issue in the 1990s. While increasing attention by the West has spawned condemnation of the practice, others argue that this is based on inadequate understanding of the cultures who practice it. FGC is a contested practice, is considered a cultural right by some, and a human rights issue by others, with no consistent agreement on whether it should be embraced, altered, or rejected. See Abusharaf 2001, Kalev 2004, and Silverman 2004.

2. Respondents in the baseline survey in Mali and Sudan (participating and control villages) numbered 239 and 193, and 135 and 152 in the follow-up survey. The surveys collected data on demographics (marital status, number of pregnancies and children, literacy levels, etc.) and the levels and types of knowledge, skills, attitudes, and practices relating to the four modules of the curriculum (community hygiene, women's health, human rights, and social change processes).

3. Sessions 1–5 of the VEP curriculum involve personal introductions and introduction to the program, setting of class rules, and envisioning a desired future. Sessions 6–14 go over the Convention on the Elimination of All Forms of Discrimination Against Women (CEDAW) in detail. Sessions 15–24 focus on the problem-solving process and introduce the concept of prevention. Sessions 25–29 apply the problem-solving methodology to issues of hygiene. The remaining sessions relate to women's health issues.

4. CEDAW, adopted in 1979 by the United Nations General Assembly, is included in the VEP curriculum.

5. There are several types of FGC. The least severe is a procedure where the foreskin of the clitoris is removed; in Sudan, all or part of the clitoris is cut. "Sunni" circumcision generally refers to the removal of the clitoral prepuce and tip of the clitoris. Excision (an intermediate type) involves removal of part or all of the clitoris (clitoridectomy) and part of the *labia minora*. The most severe type is infibulation (pharaonic circumcision in the Sudan); this involves partial closure of the vaginal orifice after excision of varying amounts of vulval tissue. The fourth type can be characterized as recircumcision, sometimes done infrequently and sometimes after each birth (WHO 2000).

6. Some other initiatives seek to "eliminate" or "eradicate" FGC, as opposed to "abandoning" it. Many of these programs meet resistance as they imply that FGC is an evil practice undertaken by barbaric people. Abandonment of a cultural practice entails

addressing the social conventions that relate to the practice. Marriageability, for example, is deeply intertwined with the practices of FGC, so any attempt to alter the practice of FGC should best focus on examining and redefining what it means to be considered marriageable. For more discussion on these differences see Mackie 2000; Easton, Monkman, and Miles 2003.

7. FGC was first brought up in the curriculum in session 10 where health problems were discussed (hemorrhaging, infections, problems at childbirth, etc.). Spontaneous discussions focused on the health care system and public health workers, not on health consequences of FGC. A case study in session 22 focused on FGC as a "concrete example of using the problem-solving process." An animated discussion then occurred in two villages in Mali. One of these villages had also heard about the ill effects of FGC on the radio, and, in the other, one of the participants was the son of a *forgeronne* (traditional cutter). Since these villages expressed interest, the program staff provided additional information. The three-day intensive workshop occurred after these discussions.

8. In this village, the chief is also the local imam, or Islamic cleric. The facilitator said her conversations with him suggest he will make sure FGC is no longer practiced in this village; he thinks a law would help stop it elsewhere. The facilitator affirmed that if the women of this village decide FGC won't happen, the practice will stop in the village.

9. Marriages here appear to take place between families within a village, unlike in some countries where marriages are arranged between villages. The local chief, then, is influential in reshaping the marriageability market.

REFERENCES

Abusharaf, R. M. 2001. Virtuous cuts: Female genital circumcision in an African ontology. *Differences*, 12 (1): 112–40.

Boserup, E. 1970. *Woman's role in economic development.* London: Allen and Unwin.

Easton, P., K. Monkman, and R. Miles. 2003. Social policy from the bottom up: Abandoning FGC in sub-Saharan Africa. *Development in Practice*, 13 (5): 445–458.

Izett, S. and N. Toubia. 1999. *Learning about social change. A research and evaluation guidebook using female circumcision as a case study.* New York: Rainbo.

Kabeer, N. 1994. *Reversed realities: Gender hierarchies in development thought.* London: Verso.

Kalev, H. D. 2004. Cultural rights or human rights: The case of female genital mutilation. *Sex Roles* 51 (5–6): 339–348.

Mackie, G. 1996. Ending footbinding and infibulation: A convention account. *American Sociological Review*, 61 (6): 999–1017.

———. 2000. Female genital cutting: The beginning of the end. In *Female "circumcision" in Africa: Culture, controversy, and change*, edited by B. Shell-Duncan and Y. Hernlund, 253–281. Boulder: Lynne Rienner.

Molyneux, M. 1985. Mobilization without emancipation? Women's interests, state and revolution in Nicaragua. *Feminist Studies*, 11 (2): 227–254.

Monkman, K., R. Miles, and P. Easton. 2004. Achieving equitable gender relations and enduring empowerment through participatory nonformal education: The Tostan experience in Mali. Paper presented at the annual meeting of the Comparative and International Education Society (CIES), Salt Lake City, March 9–12.

Moser, C. O. N. 1989. Gender planning in the third world: Meeting practical and strategic gender needs. *World Development*, 17: 1799–1825.

———. 1993. *Gender planning and development: Theory, practice and training*. New York: Routledge.

Rocha, E. M. 1997. A ladder of empowerment. *Journal of Planning Education and Research*, 17: 31–44.

Silverman, E. K. 2004. Anthropology and circumcision. *Annual Review of Anthropology*, 33: 419–445.

Stromquist, N. P. 1995. The theoretical and practical bases for empowerment. In *Women's education and empowerment: Pathways toward autonomy*, edited by C. Medel-Añonuevo, 13–22. (Report of the International Seminar on Women's Empowerment held at UNESCO Institute for Education [UIE], Hamburg, January 27–February 2, 1993.) Hamburg: UIE.

Weis, L. 1996. Foreword. In *The cultural production of the educated person: Critical ethnographies of schooling and local practice*, edited by B. A. Levinson, D. E. Foley, and D. C. Holland, ix–xiv. Albany: State University of New York Press.

World Health Organization (WHO). 2000. Female genital mutilation. Fact Sheet No. 241. Available online at www.who.int/inf-fs/en/fact241.html, accessed June 2002.

CHAPTER 7

Res Publica Revisited

Gendered Agency through Education in NGOs

CATHRYN MAGNO

INTRODUCTION

NGOs constitute structures within which women's agency, via informal and nonformal education, can be developed. This chapter explores the critical role played by Israeli and Palestinian nongovernmental organizations (NGOs[1]) in providing structure for women's participation and in enabling women's agency through an informal educational process.[2] Examination of the nexus of structure and agency occurring in women's NGOs is significant for several reasons because it helps us to understand the public sphere and its concrete manifestation, civil society, that are brought to life through NGOs as a primary mode of participation and action. Particularly for those whose participation in formal political structures is limited or closed, NGOs provide an "alternative space" (Fraser 1997). In this space, empowerment occurs for marginalized individuals as both independent actors and members of societal groups. Individuals in a democratic society have rights to participate politically, and those rights range from voting to engaging in community activity to occupying public office. However, in practice, those individuals with less societal advantage participate in fewer formal decision-making structures. The formal structure is an exclusive one, with de jure access but de facto barriers (i.e., sexism, racism). In turn, the agency of certain individuals facing these barriers is restricted or completely thwarted, their voices silenced. This reflects the theoretical perspective of Giddens (1991), who suggests that structure and agency are inextricably linked. NGOs can provide an alternative structure

within which women (as a less advantaged social group) can safely cultivate and activate their agency—transforming from civic individuals to civic *actors*. This agency comes as a result of knowledge, skills, and networks gained through participation in NGO activities. In other words, it is precisely in the NGO that a woman can simultaneously participate in an influential structure and experience the personal growth (agency) necessary to take effective action for social and political change.

NGOs, as structured political associations, constitute a significant but understudied part of the political landscape. Their importance is due to at least four factors. First, the number of NGOs has grown exponentially around the world in the past decades (Edwards and Hulme 1996), and therefore their presence must be accounted for in political, sociological, and educational analyses. Second, women tend to participate in NGOs in large and increasing numbers, and we need to understand more about why they are there and how the NGO benefits them. Third, women's participation in politically motivated NGOs contrasts starkly with their low levels of participation in the formal political structure, and it is important to understand the political influence exerted by women via the (alternative) NGO structure. Fourth, the impact of NGOs and women's participation in them has yet to be effectively measured by political scientists or sociologists. As will be empirically demonstrated in this chapter, the potential strength of women's agency, activated through the NGO structure, translates into freedom to critique the government, more political power, an increase in political knowledge and skills, and contributions to public discourse for women who have largely had their voices suppressed by patriarchal political and social structures.

The next section will include the study's underlying theoretical framework based on the structure of the public sphere and the cultivation of women's agency from sociological and feminist perspectives. Following that will be an explanation of the methodology used, and finally, data and analysis will be presented to support the central claim of the chapter, that is, that NGOs constitute structures within which women's agency can be developed.

THE STRUCTURE OF THE PUBLIC SPHERE

The opportunity for citizen participation in public governance has been conceived of in several ways through the centuries. An early conception of the public sphere was the res publica of the Middle Ages and under Roman law, which opposed the public sphere to that of the private (Habermas 1972, 1989). Another early view conceived of an "oppositional public sphere" in which the populace existed as a single unit acting in opposition to the state. Habermas (1989), in modern times, describes the growth of a "bourgeois pub-

lic sphere," which grew out of mixed class crowds at London coffeehouses and Parisian salons, where common citizens could access meaningful dialogue on public interests.[3] The political task of his bourgeois public sphere was to regulate civil society, challenging the monarch's authority. Habermas (1989) concludes by noting that this public sphere is decaying, as the critical public becomes a consumer public. This view is limiting, however. If Habermas (1984) rightly defines the public sphere as space for communicative action, particularly in his later writings, given the multiplicity of cultures, religions, and so forth, in modern society,[4] the public sphere, conceived to be bourgeois and singular, would indeed be obsolete. I contend that the variety of meanings, experiences, and status levels created within multicultural populations provides for an ever-growing, vibrant public sphere, which consists not of one bourgeois strata, but of many differing and critical public spaces.

Today's public spaces, referred to by Benhabib (1992) as the "associational public sphere," often take the shape of NGOs. Here, the public is also separated from the state but is not in stark opposition to it. In this view, private persons come together to promote certain causes and needs, and these publics sometimes struggle against state policy and sometimes work with state representatives or agencies to promote certain policies. These associational publics are close to what Fraser (1997, 90) calls "'strong publics,' whose discourse encompasses both opinion formation and decision making." Benhabib (1992, 78) describes public spaces as potentially becoming "sites of power," and this accurately depicts what happens within many NGOs in democratic states.

Increasingly, formal political institutions and representation seem ineffective in achieving the main goals of democratic politics (Wright 1995), such as the active political involvement of all citizens. Indeed, it has been claimed that "in the experience of women, many assumptions about the nature of the democratic state have not been supported" (Stromquist 1998). Several scholars contend that a democracy's ability to function is largely based on a fully developed civil society, as the concrete manifestation of the public sphere (Putnam 1993; Walzer 1995). A widespread but unproven assumption is that civil society associations in the form of NGOs represent people better than do governments (Tinker 1999). For example, some theorists (Cohen and Rogers 1995, 2) have proposed that associations such as trade unions, women's organizations, and community groups become "on the one hand, effective vehicles for the representation and formulation of the interests of citizens, and on the other . . . directly involved in the implementation and execution of state policies." Such "alternative publics" help certain status groups amass political capital, thus expanding notions of the range and forms of political participation[5] and moving closer to true democracy-building. NGOs take on specific forms of service delivery and democratization projects; they represent diverse segments of the population and have many types of goals (Edwards and Hulme

1996; Ginsburg 1998). Today, NGOs increasingly challenge the dominance and structure of traditional political institutions, as they work to influence policy and modes of participation (Tinker 1999).

In this era of increasing democratization around the world, we need frameworks to examine the informal educational participation of women in NGOs. The data supporting this chapter's conclusions are critical to a thorough understanding of how NGOs, as structures of civil society, and their individual members, as citizens with agency, impact political institutions and society in a democratic state.

AGENCY THROUGH EDUCATION

Bourdieu's (1977, 1986) work on education and stratification offers one way to examine how NGOs cultivate women's agency. Bourdieu questions how social inequalities persist despite efforts toward equalizing social groups through universal education (such as that provided by NGO learning structures and their informal and nonformal educational opportunities).

This question is analogous to my questioning of why women's political exclusion persists in the ostensibly "open" and "democratic" formal sphere, and examines how women resist this inequality through NGO activity. Bourdieu's (1977, 1986) concept of habitus, complimented by critical theory that suggests the possibility of resistance of dominant structures, allows for the moments of emancipation. *Habitus*, as described by Bourdieu (1977), is a set of relatively subconscious ideas about one's chances of success and the way society is structured that are held by members of the same social class or group. These ideas form a "matrix of perceptions, appreciations and actions" that govern every decision and task performed by an individual member of a group (Bourdieu 1977, 83). A person's habitus therefore dictates the tendency toward the reproduction of social distinctions and generates self-fulfilling prophecies regarding life chances. By taking women in Israel as a (low) status group, we can see the potential for empowerment, both for the group itself as well as the individuals within it. Following Steans's (1998, 45) argument that "it is only when oppressed groups come together to see the possibility of changing that order that the arbitrariness of existing social arrangements is exposed," the potential of women's NGOs to influence women's agency, alter life chances, and challenge stratification is revealed. Women's NGOs promote moments of emancipation in which agency is cultivated. Habitus is largely informed by education, and for adult women, the informal and nonformal education they receive in NGOs critically impacts their evolving sense of habitus, thereby changing the way they see the world and inspiring them to take action within it.

Resistance through agency is supported by many feminist critical theorists who believe that "all knowledge is partial and is a function of the knower's lived experience in the world" (Tickner 1992, 17). Critical theory, then, can be used to develop a politics of resistance to dominant ideology and oppression, in this case from women's perspectives. If feminist knowledge is understood to be "a *moment* of emancipation" then feminist critical theory moves beyond critique to "construct 'knowledge' about the world in the service of an emancipatory politics" (Steans 1998, 31). Because, around the world, politics is a male-dominated activity (Randall 1987; Seager and Olson 1986; Phillips 1991), emancipatory politics for women is essential to understand how political institutions are shaped and influenced. As a result of postmodernist and other critical thinking about the political process and the function of civil society, the conditions are now ripe for the examination of different forms of political activity (Steans 1998).

As women participate in large numbers in NGOs and have historically participated in various kinds of voluntary associations throughout the world, it is important to understand the emancipatory moments occurring in these public spaces and how it benefits women themselves and women's issues. This is a Freirean perspective, which theorizes that once a woman knows about and understands her world through NGO learning structures, she will want to take action to change it through NGO activities. This study demonstrates how women's subjective experience in informal education comes together with political knowledge to increase their personal and organizational political capital—thereby effecting social change.

Social change results from subjective experience via the education process of consciousness-raising. Feminist theorists place primary importance on consciousness-raising as "the collective critical reconstitution of the meaning of women's social experience, as women live through it" (MacKinnon 1989, 83). It is empowering and emancipating, as such consciousness "supports a perception of the relationship of gender roles to political roles that allows individual women to legitimate themselves" (Rinehart 1992, 15). Gender consciousness politicizes women, carrying potential policy outcomes as women realize that issues important to their lives are legitimate political questions. However, it is not awareness of these issues alone that will generate social change. The authenticity of consciousness-raising occurs, as Freire (1992, 103) notes, "only when the practice of the revelation of reality constitutes a dynamic and dialectical unity with the practice of transformation of reality." In other words, *conscientization* truly happens when consciousness-raising occurs in conjunction with action—with putting what is learned into practice. Political education programs in NGOs help women to assess their world, and NGO activities allow women to take action to recreate their world.

WOMEN'S VOICES EXPLAIN STRUCTURE
AND AGENCY IN NGOS: THE METHODOLOGY

Ring (1991) urges feminists to make current problems out of former solutions, and this study did so, particularly by problematizing the way in which women's political activity has been taken for granted in the past and subsumed under male norms. As far as traditional political scientists were concerned, "the only groups worthy of study were political parties and interest groups . . . women's behavior as a group was interesting only insofar as women voted, had opinions, joined parties, or formed a cohesive interest group" (Flammang 1997, xi). Most empirical research on political participation thus far has been collected in the form of survey data and has focused primarily on indicators such as voting rates and political party affiliation (Schlozman, Burns, and Verba 1994; Schlozman et al. 1995; Steuernagel 1987; Christy 1987; Clark and Clark 1986). However, to examine women's participation, it is necessary to look at the nongovernmental, informal sectors of political and public life, namely because women are located there, not in the formal arena. Therefore, this chapter relies on qualitative narratives of women engaged in NGOs.[6] The research engaged women in dialogue, providing them the opportunity to speak about their own lives in their own language (Herzog 1996). The research process itself was dialectic, as the interviewees continually helped to shape and reshape the content of my questions and the meaning of their responses in order to best uncover the evidence of their individual and collective agency.

The data for this chapter result from ten months of fieldwork I conducted in Israel in 1999. Interviews, observation, and document review were primary data collection methods. Over fifty women in my referred sample were the subjects of life story interviews that ranged in duration from two to fifteen hours, sometimes over the course of two or more days. Ninety-four percent of the women interviewed were university educated. Most (64 percent) were over age forty-six, with the others between twenty-three and forty-five years old. I attempted to achieve an equal representation of Ashkenazi, Mizrachi, and Palestinian women, however the sample included twenty-five Ashkenazi Jewish, fifteen Mizrachi Jewish, and ten Palestinian Arab women. Three NGOs (Israeli Women's Network, Bat Shalom, and the Haifa Women's Coalition) served as primary research sites where I conducted nearly two hundred hours of observation both at the organizations' offices and in the field during NGO-sponsored activities (e.g., demonstrations, dialogues, classes). While the organizations differ in geographical location (two are in Jerusalem, the political center of Israel, and one is in Haifa, an outlying region) and in types of service provision, all three of these organizations consider social change and political activity to be primary goals.

THE STRUCTURE OF THE SETTING
AND THE AGENCY THAT PARTICIPATES IN IT

NGOS as Structure

Women, and other oppressed groups in stratified societies such as Israel, have found it necessary to form alternative public niches, more in the past decade than ever before, as an attempt for "participatory parity rather than a threat to democracy" (Fraser 1997, 81). NGOs operationalize this need for alternative publics. The women in this study underscore the necessity and power of NGOs within civil society, because they provide a mechanism, a structure, to make their voices heard at an unprecedented volume. One interviewee noted, "NGOs make change. They are a place where civilians make change" (Interview 11). Another said, "Israel has a democratically elected parliament, but it's not a democracy yet. And the NGOs are helping to make it a democracy" (Interview 12).

Women in the study noted the ways in which NGOs act as alternative, public, civil society structures within which they experience *freedom to critique* as well as *power to influence* the formal political structure (i.e., the state). According to one woman, "Our main job [in NGOs] is to infuse a different input into the general political atmosphere, in the general thinking" (Interview 11). NGOs' location outside of the formal structure is critical to their freedom of speech and activity. As one woman put it,

> First of all you have the right to criticize the establishment. You're not dependent on it—you can say whatever you want and do whatever you want and you don't have to [bow] your head. That's a big plus . . . especially when you're speaking about the establishment and you know that it's a male establishment. (Interview 10)

As another woman explained, "We have enormous power of not being in politics, and being able to speak not as self-interested politicians" (Interview 16). A third woman said, "NGOs are free to explore and use other theories that are not accepted by the establishment" (Interview 26).

The structure of the alternative NGO provides a powerful link to the formal arena. One NGO staff member said,

> We are often consulted—the legal department [of the NGO] is often being consulted when it comes to new legislation. We often lobby in the Knesset for things that we are interested in. So we *do* have an influence. (Interview 10)

Another said, "changing the establishment is important. . . . [NGOs] start from the intellectuals and from the social movements, and they penetrate to

the establishment" (Interview 21). Further, they play a definite political role in the larger society, as one woman noted, "I do think that the discourse starts from the outside, from the grassroots. From my experience of being a radical, I think that it goes also into the Knesset" (Interview 8).[7] Knesset member Chazan (1993) states that

> on the level of policy, it is doubtful whether women involved in peace action have been able to directly influence Israeli government decisions or political initiatives. On the level of ideology, however, women [in NGOs] have been at the forefront of reassessments taking place within the Israeli body politic. (Interview 38, 159)

In sum, the alternative structure of the NGO, as separate from formal political structure but accepted by it, unlike an amorphous social movement, allows women to act publicly in ways that demand attention, that is, in ways that channel their agency to make social change.

NGOS CULTIVATE AGENCY: SKILLS, KNOWLEDGE, AND NETWORKS

The educational processes that support the growth of political capital take place primarily in two ways: nonformally, through political education courses offered to adult women by the NGO; and informally, through activity in the NGO, such that by participating in and experiencing the daily work of the NGO one inheres knowledge, skills, and networks.[8]

All three of the women's NGOs in the study offer nonformal political education courses which include instruction in the functions and procedures of government and policymaking, negotiation and conflict resolution, community organizing, and/or fundraising, among other types of political skills and knowledge. Through participation in NGOs and by taking political education courses offered by NGOs, women acquire knowledge that is essential to their full participation in the political life of their society. They learn about how the system works, what the major issues are, and what their rights are (Interviews 12, 13, 14, 37, 41). Women also noted they learned fundraising and negotiation skills and political savvy, all critical to political life (Interviews 5, 9, 23, 41). Women said they gained skills such as public speaking, confidence, analysis, reflection, documentation, and lobbying through participation in the NGO.[9]

Importantly, nonformal education in NGOs also includes aspects of consciousness-raising such as the history of feminism (Interviews 3, 14, 15, 20, 34, 35, policy documents). Consciousness-raising was understood by the sub-

jects of this study as a significant element of the production of knowledge occurring in NGOs. Women felt that it refers to the awareness of problems and the awareness of the possibility of doing something about the problem (Interviews 11, 12). Because this study focuses on women's NGOs, the consciousness spoken of is essentially a feminist consciousness. One interviewee said, "I have a few articles that I read and they kind of—poof—opened up my consciousness. Then in the peace movement I learned about the connection between militarism, fundamentalism, and patriarchy, and then I really saw the combination of feminism and politics" (Interview 8).

An example of informal education is the "café politic" initiated by one NGO, to which women were invited to discuss any political topic they wished. More importantly, however, informal education takes place for women in all three NGOs simply because they are surrounded by political issues and they have to work and think politically. "Working at [this NGO], women do undergo political change, there's no doubt about it, just from the work they do" (Interview 12). They must follow legislative processes, meet with politicians, strategize their activities, and work with others to accomplish the social changes they seek.

One woman summarized the learning gained by explaining the "action and reflection" cycle that occurs in the NGO, expressing her Freirean perspective:

> there has to be some sort of activism and some process of reflection and internalizing what you perceived from your activities. . . . Of course there is reflection that we do automatically, and that's why everyone who does something will learn. But if we want to make the learning process more effective, we have to provide spaces for reflection on our abilities and our experiences. . . . There is a lot of reflection that is done through my being in the NGO. (Interview 1)

The nonformal and informal education of adults can have the effect of adjusting the structural gender inequalities that are quietly reproduced in the formal education system. Because schools often claim to provide opportunity for social mobility as a social equalizer in true democratic fashion while in fact reproducing class, race, and gender divisions of labor and providing unequal access to knowledge,[10] education for democratization must be expanded (Carnoy and Levin 1985). This education can be partially obtained by adult women through participation in NGOs.

Women have, historically, often organized themselves into groups to further their own interests or to participate in community assistance efforts. While men have occupied positions of power in the formal political structure, women's local and national organizations have worked for charity, engaged in networking, and raised timely social issues (Tinker 1999). Interestingly, in

Israel, NGOs are having the effect of politicizing the traditional (nonpolitical) voluntary associations. As one woman said, "the voluntary associations are not radical, they just help women cope with home and work. The NGOs are radical groups who question the rules of society and address issues of social justice" (Interview 48). Another interviewee went on to say, "One of the major influences of [our NGO] has been to, as it were, politicize and feminize the other women's organizations which were mainly concerned with welfare and child care" (Interview 12). This is an example of political capital at work: horizontal networks (an element of political capital) allow women to *educate each other* toward political ends.

NEXUS OF STRUCTURE AND AGENCY

The women in this study reported having the knowledge, skills, and courage to act publicly only after participating in the NGO in some capacity (as a volunteer, a member, or as staff). The founder of one NGO stated, "one needs to educate women politically, one needs to get them involved, and ultimately, some of those women will go and run for office" (Interview 12). In fact, the majority of women interviewed (64 percent) said they would consider running or have run for public office. One woman who would consider running for public office explained, "I think somewhere I'm asking myself, should I or shouldn't I. The problem is that I know why it is important—it is important to be a decision-maker. But I know that to be there today, it demands a lot of things that I'm not ready for" (Interview 1). Another woman said strongly, "women should be there, should be visible, and in big numbers" (Interview 35). There are definite successes that provide inspiration. For example, one interviewee remembered the mayor of Herzliya [saying] openly "that she first thought of entering politics while she was taking one of [the IWN's] training courses. And [the IWN] has had a variety of people to whom that is precisely what happened. . . . So I think that's been a very important educational force for women themselves" (Interview 12). The majority (78 percent) of interviewees believed that NGOs can or do act as stepping-stones into the formal political sphere.

Women in the study expressed their experiences of gaining personal power through participation in a group. One time an NGO employee said to another employee that she never would have had the strength or confidence to call a Knesset member on her own, without the backing of the organization (Observation, IWN). Another time a volunteer explained to a staff member that she would not have spoken out about a certain women's issue if she did not know that other women felt the same way she did (Observation, HWC). One interviewee explained that NGOs feel like protected spaces where "many

women learn to speak up and form their own opinions" (Interview 4). Another described women's NGOs as "a place where you can do your questioning. . . . And the women's groups, of whatever form, are the one place where you can get support, validation of your questioning" (Interview 11).

Another interviewee described the political weight of the NGO as helping her as an individual working for social change. She said that having the organization behind her "was very useful because it allows you to make a lot more dust. I mean, writing [my name] is not the same as writing Israel Women's Network Legal Center. And I realized that one could actually add a lot of—a dynamic, an extra dynamic—to the work" (Interview 33).

For some women, the nexus between structure and agency occurred as an experience of having a personal issue become political through group identification and support. One woman was very conscious about gaining power through the group:

> When you feel the discrimination on your [person] you take it as an individual issue. . . . And when you are talking to other people and see that it's not your own problem . . . you begin to realize that it's your personal problem *and* it's a political problem. (Interview 1)

In the opinion of one interviewee, "men, much, much more than women have reference groups" (Interview 4). She was elaborating on the need for women to create their own spaces and their own reference groups, in order to truly gain support, especially politically. This is because women's education often occurs through relational experiences (Gilligan 1982); that is, women learn from each other and build their confidence and skills faster and stronger in a female-dominated environment where relationships are nurtured. Women need this more than men, because men have a number of powerful reference groups, through the military, business, and so forth. Also, women are often sidelined groups that have a gender mix.

One woman expressed her frustration in working with mixed-gender groups. She explained that "the political decision-making process is normally done, not in the meetings, not in the natural places where women are, they are done mostly over a cup of beer, with friends. And when they are together they don't invite women" (Interview 1). She went on to say, "that's why I think before we proceed as women, we need to organize ourselves, to support other women. Before . . . that, there is no chance. We will continue to be the one and the only here and the one and the only there. And this is very problematic" (Interview 1).

Women wishing to ensure power over their own lives, to make social change, and to have a voice in their society can do so by amassing political strength. One woman noted that "finding your own space has to be learned

in . . . groups—it is very important to train women in leadership training, in terms of communication skills, in terms of discovering your own abilities, what you are good at. Some women are good at talking, some women are good at writing, some women are good in acting—these opportunities have to be provided. They have to be provided to close the gap" (Interview 1). If formal political positions are out of reach because of gender barriers or if they require attachment to structures to which women do not have access, women must then generate political capital through their own alternative structures (i.e., NGOs)—capital that will have a direct political impact. Thus, it is this "different" political capital that opens avenues for social change to those agents who act outside the formal political arena.

CONCLUSION

Education for democratization can occur through the growth of political capital in NGOs. As was shown, through their day-to-day work as well as through nonformal training courses, NGOs serve as learning sites that do not exist elsewhere, where women amass political capital and make social change. This study recognizes the importance of NGOs as they provide an alternative governance structure (i.e., one that is open to women) as well as educational opportunities that women need to become change agents in their sociopolitical contexts.

By consulting literature in feminist politics, this study questions some of the male normative conceptions of how democracy functions and who participates. In order to participate in national decision-making, women have constructed NGOs that seek to impact policymaking, and by so doing, they have carved out some public space for themselves. Within this space, they not only have the potential to craft and submit legislation and other material inputs to the formal government, but they generate political capital for and among themselves, which in turn fosters a fluid relationship between the NGOs and the state, and has the effect of bolstering women's political careers and other political endeavors. In this way, NGOs serve an emancipatory function, as the educational processes occurring there assist women in realizing their political selves (i.e., their agency) and support them (by providing structure) in taking action toward social change. NGOs provide for women a unique public educational space to cultivate certain skills, knowledge, and networks, and offer the opportunity to directly apply their new knowledge to ongoing activities.

In sum, learning opportunities appear essential for women to advance politically. Education together with activism will create social change most effectively. Clearly, women's NGOs make up for the gender gap in political opportunity and access. This study exposes and specifies the significant educational *and* political effects of extra-parliamentary NGO programs and by

implication informs democratization efforts worldwide. By studying women's NGOs, I respond to assertions that it is critical that theory and practice in the area of politics and education be cognizant of the variety of ways in which women access and participate in public life (Fraser 1997). It is important to note also that the impact of learning on women in politics *could be multiplied* if more seminars, training workshops, and the like were held by NGOs to build these skills and knowledge in directed ways.

More women's NGOs are a positive development in Israel, one which engages women in social change and creates educational opportunities for political growth that they would not have otherwise. Through NGOs, "women suddenly find that there is a big world, bigger than their own world . . . I think the more the better. This is what we call civil society now? No question, the more the better" (Interview 4).

NOTES

1. The term *nongovernmental organization* was adopted for use by the United Nations, as it sought to provide a mechanism for citizen-based organizations, or non-state actors, to participate in Economic and Social Council (ECOSOC) deliberations (Weiss and Gordenker 1996). The term broadly conceived includes local and international organizations. However, in refining the term for use in this study, NGO refers to an organization within a nation-state, interacting with the national government of that state—in this case, Israel. This eliminates international NGOs (INGOs) and quasi-nongovernmental organizations (QUANGOs).

2. It is important to note the reason for my use of *gender* in the title, as opposed to *women*. I believe that an examination of women's democratic political participation, including their general exclusion from formal politics partially as a result of their gender condition, evidences a gender issue, rather than a women's problem. Gender, as a social construct, refers to sex-based categories determined by society or culture. Gender is thus differentiated from sex, which is generally reserved for reference to biological categories not influenced by society or culture.

3. Habermas (1989) explains that "the coffeehouse not merely made access to the relevant circles less formal and easier; it embraced the wider strata of the middle class, including craftsmen and shopkeepers." Similarly, "in the salons of the fashionable ladies, noble as well as bourgeois, sons of princes and counts associated with sons of watchmakers and shopkeepers" (33).

4. A multiplicity of viewpoints existed during the time of Habermas's bourgeois public sphere as well (Fraser 1997); they are simply not as well known or documented.

5. A general definition of *participation* would be the following: legal activities by private citizens that are aimed at influencing the selection of government personnel and the actions that they take (Nathan 1998).

6. Nelson (1989) and Tronto (1991) emphasize that all political subjects are gendered and that political science needs to move in a radically democratic direction and look more closely at the contexts in which politics are expressed. This research heralds this call and intertwines work in sociology, political science, and education to understand the lived experience of the private woman turned public.

7. The Knesset is the national legislative body of the State of Israel, akin to the United States Congress.

8. The distinctions between formal, nonformal, and informal education are as follows. Formal education is that which takes place in school or university classrooms. Nonformal education usually occurs with a curriculum and instructor, like formal education, but does not necessarily include accountability or evaluative components. Finally, informal education is that which most often occurs without any sort of educational framework.

9. The NGO education courses are well attended. For example, the IWN has over one thousand graduates of their training courses (Interviews 3, 12, 15). Not all of the IWN's courses directly relate to politics however. Recent courses include the following: The Media and Gender Equality, Pre-Military Service Seminar, Community Education Courses, Reentering the Workforce, Education through Drama, Training Courses on Gender Equality, Training Courses on the Internet, Educational Leadership for Teachers, Conference on the Status of Women in Judaism, Leadership and Empowerment Courses for Immigrants (Israel Women's Network 2000).

10. Of course, following class reproduction theorists (such as Bowles and Gintis 1976; Althusser 1971), class conflict theorists (i.e., Apple 1990; Aronowitz and Giroux 1985; Carnoy and Levin 1985) began to document resistance within schools. They examined schools as sites of struggle and sites where minority or oppressed groups constantly pursue access and power. I contend that women's NGOs are in essence sites of resistance, occurring partially in response to formal schooling.

REFERENCES

Althusser, L. 1971. Ideology and ideological state apparatuses. In *Lenin and philosophy and other essays*, 127–186. New York: Monthly Review Press.

Apple, M. 1990. *Ideology and curriculum.* New York: Routledge.

Aronowitz, S. and H. Giroux. 1985. *Education under siege.* South Hadley: Bergin and Garvey.

Benhabib, S. 1992. Models of public space: Hannah Arendt, the liberal tradition, and Jurgen Habermas. In *Habermas and the public sphere*, edited by C. Calhoun, 73–98. Cambridge: MIT Press.

Bourdieu, P. 1977. *Outline of a theory of practice.* London: Cambridge University Press.

———. 1986. The forms of capital. In *Handbook of theory and research for the sociology of education*, edited by J. Richardson, 241–258. Translated by Richard Nice. New York: Greenwood Press.

Bowles, S. and H. Gintis. 1976. *Schooling in capitalist America.* New York: Basic Books.

Carnoy, M. and H. Levin. 1985. *Schooling and work in the democratic state.* Stanford: Stanford University Press.

Chazan, N. 1993. Israeli women and peace activism. In *Calling the equality bluff: Women in Israel,* edited by B. Swirski and M. Safir, 152–161. New York: Teachers College Press.

Christy, C. 1987. *Sex differences in political participation: Processes of change in fourteen nations.* New York: Praeger.

Clark, C. and J. Clark. 1986. Models of gender and political participation in the United States. *Women and Politics,* 6 (1): 5–25.

Cohen, J. and J. Rogers. 1995. Secondary associations and democratic governance. In *Associations and Democracy,* edited by E. O. Wright, 7–98. London: Verso.

Edwards, M. and D. Hulme. 1996. Too close for comfort? The impact of official aid on nongovernmental organizations. *World Development,* 24 (6): 961–973.

Flammang, J. 1997. *Women's political voice: How women are transforming the practice and study of politics.* Philadelphia: Temple University Press.

Fraser, N. 1997. *Justice interruptus: Critical reflections on the "postsocialist" condition.* New York: Routledge.

Freire, P. 1992. *Pedagogy of hope.* New York: Continuum.

Giddens, A. 1991. *Modernity and self-identity: Self and society in the late modern age.* Stanford: Stanford University Press.

Gilligan, C. 1982. *In a different voice: Psychological theory and women's development.* Cambridge: Harvard University Press.

Ginsburg, M. 1998. NGOs: What's in an acronym? *Current Issues in Comparative Education,* 1 (1): 10 paragraphs. Available online at www.tc.columbia.edu/cice/vol01nr1/mbgart1.htm (accessed August 15, 2005).

Habermas, J. 1972. *Knowledge and human interests.* London: Hienemann.

———. 1984. *The theory of communicative action.* Translated by T. McCarthy. Boston: Beacon Press.

———. 1989. *Structural transformation of the public sphere: An inquiry into a category of bourgeois society.* Translated by T. Burger, with the assistance of F. Lawrence. Cambridge: MIT Press.

Herzog, H. 1996. Why so few? The political culture of gender in Israel. *International Review of Women and Leadership,* 2 (1): 1–18.

Israel Women's Network. 2000. [Online website]. Available online at www.iwn.il

MacKinnon, C. 1989. *Toward a feminist theory of the state.* Cambridge: Harvard University Press.

Nathan, A. 1998. Lecture. Issues in Comparative Politics. New York: Columbia University, April.

Nelson, B. 1989. Women and knowledge in political science: Texts, histories, and epistemologies. *Women and Politics,* 9 (summer): 5–6.

Phillips, A. 1991. *Engendering democracy.* University Park,: The Pennsylvania State University Press.

Putnam, R. 1993. *Making democracy work: Civic traditions in modern Italy.* Princeton: Princeton University Press.

Randall, V. 1987. *Women and politics: An international perspective.* Chicago: University of Chicago Press.

Rinehart, S. T. 1992. *Gender consciousness and politics.* New York: Routledge.

Ring, J. 1991. *Modern political theory and contemporary feminism: A dialectical analysis.* New York: State University of New York Press.

Schlozman, K. L., N. Burns, and S. Verba. 1994. Gender and the pathways to participation: The role of resources. *The Journal of Politics,* 56 (4): 963–990.

Schlozman, K. L., N. Burns, S. Verba, and J. Donahue. 1995. Gender and citizen participation: Is there a different voice? *American Journal of Political Science,* 39 (2): 267–293.

Seager, J. and A. Olson. 1986. *Women in the world: An international atlas.* London: Pan Books.

Steans, J. 1998. *Gender and international relations: An introduction.* New Brunswick: Rutgers University Press.

Steuernagel, G. 1987. Reflections on women and political participation. *Women and Politics,* 7 (winter): 3–13.

Stromquist, N. 1998. *Reframing citizenship: Women as full actors in the nation-state.* Paper presented at the Comparative and International Society National Conference, March, in Buffalo, NY.

Tickner, J. A. 1992. *Gender in international relations: Feminist perspectives on achieving global security.* New York: Columbia University Press.

Tinker, I. 1999. Nongovernmental organizations: An alternative power base for women? In *Gender politics in global governance,* edited by M. K. Meyer and E. Prügl, 88–104. Lanham: Rowman and Littlefield.

Tronto, J. 1991. Politics and revision: The feminist project to change the boundaries of American political science. In *Revolutions in knowledge: Feminism in the social sciences,* edited by S. R. Zalk and J. Gordon-Kelter, 91–110. Boulder: Westview Press.

Walzer, M. 1995. The concept of civil society. In *Toward a global civil society,* edited by M. Walzer, 7–27. Providence: Berghahn Books.

Weiss, T. and L. Gordenker. 1996. *NGOs, the UN, and global governance.* Boulder: Lynne Rienner.

Wright, E. O. 1995. Introduction. In *Associations and democracy,* edited by E. O. Wright, 1–3. London: Verso.

CHAPTER 8

Their One Best Hope

Educating Daughters in China

VILMA SEEBERG

I first learned about the young girl Peng Xiaoyin when I participated in a conference about girls' education and gender equity at Shaanxi Normal University in 2000. My colleague, Professor Zhao, told me that Peng Xiaoyin[1] had started school nine years earlier, but because of family illnesses, she had been forced to interrupt her schooling many times. Xiaoyin, Professor Zhao told me, was finishing fourth grade at age 15, whereas Professor Zhao's own son, one year younger, was about to enter senior high school having passed highly competitive exams.

Xiaoyin was like many girls in remote mountain villages in China with similar stories. Such stories had inspired Professor Zhao to get involved in a scholarship fund for girls. A mere US $10 was enough to cover the school fees for one year of village primary school and made the difference between attending and not.

What was even more striking was Zhao's description of an "unexpected side effect," a subtle but profound cultural shift in the village. A larger issue loomed behind the poverty that forced these children out of school—the fact that it was girls who were forced out to work at home. Zhao noted that the scholarships had impacted more than just their recipients; they had impacted the village as a whole. The villagers realized that the scholarship girls had acquired a new attribute: potential. They would be "little intellectuals" (*zhiqing*), school graduates. The girls now had in their grasp a better material future, which reflected well on their families, who, in turn, basked in the glow of their girls' higher status. They had acquired standing as a "worthwhile

143

investment"[2] and were treated with a newfound respect. Not only the scholarship girls had acquired higher status, but also girls in general came to be seen in a different light. I was astonished and moved that so little could do so much and immediately asked Professor Zhao to help me set up a new scholarship fund in another village. The fund[3] was named the Guanlan Scholarship after my daughter; consequently I became known as "Guanlan Mama" to the recipients. The Guanlan girls will tell in their own voice what the scholarship meant further on. Before hearing from the girls about their wishes and actions, it is necessary to lay out some of the structural background.

At first, I was dubious that such a modest sum of money could return girl children to school, and keep them there, because of the seemingly overwhelming poverty and cultural traditions. I wondered if these small financial gifts could prevail over centuries-old cultural attitudes and expectations. Or is the traditional assumption suddenly placed in question by the cultural significance of the scholarship? Is the psychological dissonance between contradicting values strong enough to counteract the demands of the dire economic straits in which these families live to free up a daughter to attend school? Would families subsisting well below the Chinese poverty line [set at RMB 635 per person per year or US $0.66 per day (Haller 2002, 133)] be willing to forego the labor of their daughter for a relatively small scholarship? The opportunity cost of schooling girls past the age of 9 or 10 can be substantial, especially in families where older members are in ill health.

FROM SON-PREFERENCE TO EDUCATED OFFSPRING

To understand a cultural shift such as girls acquiring sufficient status to be deemed potential scholars, we need to take the larger cultural background into consideration. Traditionally Chinese girls were counted as a loss on the "account books" of the family. After raising them through the most vulnerable years of their lives, the girls would be married out, and would work in the households of the husband's family during the most productive years of their lives. The girl's skills at household tasks could elevate her status to marry her into a better-placed family. In some regions the birth families would rarely see the daughter again. To endure such a final separation, families kept their daughters at a psychological distance, whereas they kept their sons close by. Indeed son-preference is still alive and well in the early part of the twenty-first century in both urban and rural China.

Boys traditionally have been able to rise in status and hierarchy through education and by passing examinations for longer than a millennium. The expansion of mass education since liberation, increased employment opportunities since the hectic post-Cultural Revolution reforms, and the massive

rhetorical support for education from the central government and its highest leaders like Deng Xiaoping have gone a long way to convince the practical Chinese that even girls can benefit from education in reform China. In the major urban areas gender parity has been reached.[4] Stephens (2000) and Colclough, Rose, and Tembon (2000) in their studies of gender and schooling in Ethiopia and Guinea, respectively, noted that cultural and economic factors intertwine to produce gendered outcomes in development. Colclough et al. as well as Stephens looked into what they call "adverse cultural practices" and found them to have importance particularly in rural areas. I argue that just as adverse practices can have important effects, beneficial cultural practices, like the massive expansion of schooling and village girls becoming "little intellectuals," can have a wider cultural impact.

However, the question of how a family can afford to forego the labor of their daughter past the age of 9 or 10, especially in families who are destitute, where grandparents and parents are in ill health, persisted.

ECONOMIC CIRCUMSTANCES IN STONEJAR GULCH

The Guanlan Scholarship village, Stonejar Gulch [Shiwen Gou], lies high on the eastern slope of the Qinling Mountains in the southeast corner of Shaanxi Province. It is one of 632 villages in Shangzhou Prefecture of Shangluo City District. The local chapter of the All-China Women's Federation (ACWF) wrote in 2000 that due to the rugged mountainous environment, poor roads, and a "backward" economy in Shangzhou Prefecture, the average per capita income was RMB 822 or US$100.[5] Most people were farmers, but there was little land, only 0.5 mu per person.[6] The poorest in the prefecture, however, had only 0.06 mu (432 sq. ft.) of land to till, and an average per capita income of RMB 692 (US$84), just above the official poverty line of RMB 635 (US $0.66 per day) (Haller 2002, 133). Some villages had no public road access, one hundred villages were without regular electricity, more than ten thousand people did not have access to safe water (ACWF Shangzhou 2000). The educational level was low and the number of illiterates was growing annually. In 1999, more than 3,400 children had to leave school before ninth grade, 70 percent (2,380) of whom were girls.[7]

Stonejar Gulch village had 82 families and 382 inhabitants. It is one of the poorer villages in Shangzhou with an average annual income of RMB 680 (US $83), approximately 28 percent of the national rural average. Several families, including those of the Guanlan Scholarship girls, fell below the official poverty line (Stonejar Gulch Village Government 2000) with an annual income around RMB 350 for the entire family (ACWF Shangzhou 2000).

In 1999, out of a class of fifty-six students in primary school, seventeen students or 30 percent had to leave school due to poverty (Stonejar Gulch Village

Government 2000), several girls among them before grade 4 (ACWF
Shangzhou 2000). Few girls were expected to continue on to junior high school
(Stonejar Gulch Village Government 2000).[8]

For any of these families to forego their daughter's labor in favor of a
long-term investment even in a highly valued cultural good like education
would certainly be a hardship. Twenty families accepted the challenge and
enrolled their daughters in school.

In 2004 when I went to western China to conduct field research on this
program, in letters from Guanlan girls in 2003 and 2004 and in news reports
from China, I came across additional powerful clues to answer why a small
scholarship would enable impoverished girls to stay in school.

Leaving the Farm

Huge regions in far western China suffer from serious environmental degra-
dation, including loss of farmland, grasslands, and forest areas. Pollution,
overgrazing, and over-logging have lead to erosion that has made large tracts
of the rural environment less productive. Much of the mountain, plateau, hilly,
and basin areas has long not been well suited for highly productive agriculture
(Parham 2001).

The uneven development of the Chinese economy has created an enor-
mous flow of human resources from the underdeveloped areas, mainly the
western and rural areas, to the prosperous, economically vital eastern coast
areas. In 2000, the "floating population," as the migrants were called, was esti-
mated at 100 million (Mancebo 2002), and it had swelled to 140 million[9] a
few years later (National Working Committee on Women and Children and
UNICEF cited in Cui 2004; Luo 2005). According to the *China Economic
Times* (May 10, 2001), several years of falling agricultural prices, coupled with
the lure of the big city,[10] have increasingly resulted in the abandonment of
potentially productive farmland.

The migration has resulted in an imbalance between urban and rural
areas.[11] Urban bias in policy, part of the legacy of the Mao years, has increased
with the implementation of market reforms in 1978. Priority has been given
to cities that boosted national economy and expanded economic opportunities
in the urban areas. This situation has disadvantaged the rural areas by neglect-
ing local needs. For example, in access to health and education the urban-rural
gap is large: local rural governments are mandated to provide services, but lack
the money to pay for them (Armitage 2005).

The effects of migration have been studied in China. For example, a large
international study conducted in central and western provinces found that in
82 percent of surveyed families someone, usually the father, had left home to
find paying work. In 15.5 percent of the cases both parents had left their chil-

dren behind (Sun 2005).[12] Most who left were the fathers (numerous personal communications 2004). Traditionally, son-preference also meant that the son was relied on to provide material support to the birth family. Since the economic reforms, young and working-age males had formed the core of the migrant laborers.[13]

Migrant labor has similar patterns across the world. Some leave permanently; some float from job to job and home again, never staying long leaving the ravaged rural areas depleted of the working-age population. In other words, the loss of working adults leaves behind an age dichotomy of the very old and the very young, as well as unskilled youth (see Mancebo 2002).

In my fieldwork, I too found that working-age males were notably absent in the villages. Only a small fraction of migrant rural laborers could afford to take their children with them to big cities where they worked, and if they did so, they were more likely to take their sons (Interviews 2004).

CHANGED PATTERNS OF SOCIAL EXPECTATIONS

Against the aforementioned cultural and economic backdrop and a long history of education being highly valued and well rewarded, the idea of girls becoming "little intellectuals" brought new hope to their families and villages. With the ecological degradation of the land and male labor leaving the rural areas for the rapidly developing gold coast of China, a new dynamic has developed in the basic societal unit, the family. Girls have assumed a different social and economic role; new relationships in the family and village are shaped.

In the poorest villages of China, girls historically were given extraordinarily little "space." Today, they assume roles as students in an effort to escape extreme poverty. These girls, their mothers and often their fathers as well, saw "persistent patterns of expectations and relations in a social system," as the editor of this volume suggests in the introduction. The brief stories of school-going adolescent girls in the mountains of Shaanxi show how behaviors were no longer consistent with the traditional historical roles and identities assigned to them by the workings of the past society. Only the relationships between them and the new world to whose edges they cling precariously can explain how relatively minor investments of scholarship funds can result in their concentrated dedication to constructing a future they can barely make out but will help create.

DEUS EX MACHINA: THE GUANLAN SCHOLARSHIP

Various events illustrate the importance of the Guanlan Scholarship fund. A brief description of the celebration recognizing the establishment of the fund

provides one example and demonstrates its importance in the area. Professor Zhao, accompanied by a phalanx of officials, arrived in Stonejar Gulch to deliver the scholarship awards and certificates at the onset of the scholarship fund. The television station in Shangluo City, three hours away, had sent a news crew to record the event. The village gate was festooned with a large "WELCOME" and the entire school population sat in the schoolyard facing the long dais. The oldest scholarship recipient, who was returning to school after four years of absence, gave a heartfelt speech expressing the girls' and their families' deepest gratitude. Official speeches followed, reflecting the importance that the local government placed on this event.[14]

The scholarship fund aided many adolescent girls in various ways. Due to the long distance and difficult terrain, the girls in junior secondary school lived at the school and returned to their villages during winter and summer breaks between semesters. Five girls attended Beikuanping Junior High School, which was located 9 kilometers by bus from the village. Their boarding costs, cook's fee, and miscellaneous fees amounted to RMB 4.50 per day, dormitory lodging RMB 95 per year, plus a book fee of RMB 100, altogether adding up to RMB 1,021 or US $125 annually, one and a half times the RMB 680 local average per capita income. One student attended Zhangcun Township Junior High School, which was located 15 kilometers from the village. The fees were RMB 45 less than at Beikuanping Junior High School, and the school "loaned" the student RMB 200, which reduced the fees to RMB 776 (US $95).

Although the fund helped to cover some of the costs of schooling, the scholarships awarded only RMB 100 in the first year and RMB 150 in the second year. The families made up the difference. For families of secondary school students, the fees and expenses seemed prohibitive. Yet, Shangzhou ACWF (2002) wrote,

> The local government, school, people, and families of the scholarship recipients are very grateful for the support and encouragement of the work of the school, and will see to it that the students will develop in a healthy fashion: that they will study diligently, grow healthy, and fulfill the expectations of Guanlan's mother and teacher Zhao. The Women's Association will manage the money well and hope to continue to work together with Guanlan's mother and teacher Zhao to assure and develop for the students a good environment.

Since the spring of the year 2000, twenty girls who had dropped out of school were able to return with the aid of the Guanlan Scholarship. By the end of the 2004 school year, two of these girls had graduated at the completion of their nine years of compulsory schooling. Five girls left school early due to being "overage and alienated," and thirteen continued in school (ACWF Shangzhou 2005).

THE GUANLAN SCHOLARSHIP
STUDENTS AND THEIR FAMILIES

Who are the adolescent girls and their families who benefit from the scholar-ships? The student registration records indicate the ages and number of years in school. The first group of scholarship recipients' ages ranged from 10 to 15 years (three were 10, one was 11, two were 13, two were 14, and two were 15). The girls entered school at different times between 1991 and 1996.[15] The girls, for various reasons, had to leave school for periods ranging from one-half to four years.[16] The second group of scholarship recipients included students of primary school age.[17]

All of the twenty girls were chosen based on financial need. Of the ten girls who received scholarships in the first round, eight had one or two con-sistently sick parents. In four families the mothers were listed as sick and in one family the mother had died. In these remote farming villages, the main income-producing adult was typically the father. However, the burden on the daughter for gender-related household chores would be enormous in the absence of the mother. In one family the father was disabled, which would put a heavy burden on all family members and threaten their survival. In the two families where both mother and father were ill, their survival would be in grave danger. In both of these cases, the opportunity cost of a daughter attending school could be harmful to the survival of the family. The two fam-ilies without financial resources can be understood to be on the brink of col-lapse. In these families the opportunity cost of a daughter attending school would be extra high.

The oldest student, age 14, was met with extremely difficult circum-stances. Her father, age 37, and mother, age 35, were classified as poor farm-ers. Their annual income was RMB 405 (US $50), and there were four mouths to feed. Her family was considered to be in very poor economic cir-cumstances, "no financial resources." There was no listing of illness. To give up their daughter's labor, whether in the home or in the field, would be a sub-stantial loss to such a family, who was just barely sustaining itself.

In Their Own Voice

The words of the Guanlan girls themselves convey a fuller understanding of their situation, the role of the scholarship intervention, and their intense reac-tion, their deeds. The above-mentioned 14-year-old student wrote,

> My home is in a mountain village that is hard to reach, we don't know from
> one day to the next what our financial situation is. I am a fifth grader and,
> although we are poor, my daddy used to borrow money from the neighbors

so I could go to school. But in the end, because we three sisters were all in school, farming our field could not support us any more and even the borrowed money wasn't enough. In the end, no one would lend dad any more money, so he didn't let me go to school anymore. He said I was grown now, I should stop and let my little sister go to school for a while. I also knew that dad and mom had many burdens and the pressure was really great, so that is how I had to leave school. But then, Guanlan's mother heard of our difficulties and you made it possible for me to return to school. I will never forget you . . . if it wasn't for your support I would now be at home grazing the cow. (Guanlan Scholarship Girls 2000)

A fourth grade student from the second group of recipients, who was 14 years old, wrote,

In our village we depend on farming and in my house we did not have anything much put aside. It was difficult for my parents to support my going to school. I often heard them talk about not letting me continue, but I would always cry and tell them I wanted to go to school. I feared the day that I would have to go home and soon it arrived.

Not long after the beginning of the school, the school was collecting the fees. Dad said, "we have no money in the house to send to school, come home. When you see the hopelessness in your mother's eyes about all the money being gone, you won't have the heart to ask for money to study." When I heard dad's words, I cried, and when he saw that, a tear dropped from his eyes. Dad is very strong, he never cries, but that day he shed a tear. I had to listen to dad and return home.

Not long after I got home, I heard the village official say, "Guanlan's mother is coming here to help students who had to leave school." When I heard that I got unbelievably happy, and two days later, really, Auntie Zhao came to our village to rescue us dropout students. I returned to school, to start on a new path, to realize the dream I have had forever. (Guanlan Scholarship Girls 2000)

A ninth grade student from the first group of recipients wrote,

Because here our mountains are high and ravines are deep, our economy and culture is backward. In addition my mother is ill, has been on medicine for years, dad makes a little bit of money, not enough to cover the household expenses, there isn't enough to send my brother and me to school. Just as I had to leave school, several of us heard that Auntie is not afraid of the mountain roads, takes on the difficulties to come because of us dropout girls, to bring us your—Guanlan's mother's help. I want to express here my deepest

gratitude and highest respect, and send our beloved Guanlan's mother our warmest regards.

Thinking back on my time out of school, I would wish upon wish that I could grab my book bag and go to school. How I longed for knowledge, how many times I dreamed I was back in the classroom listening excitedly to the teacher lecture. After waking up, I would cry and cry. One time, I said to my father, "Let me go to school" and father just shook his head. Now, I can once again sit in the classroom and study! I treasure this opportunity to go to school, to study well, and learn well the skills and strive diligently to make our local economy advance rapidly.[18] I write of the real situation here not to burden Guanlan's mother, but to thank you from the bottom of my heart. (Guanlan Scholarship Girls 2000)

The father of another student borrowed money beyond his means to send not only one but three daughters to school. He negotiated to keep as many of his daughters as possible in school.

In 2001, 2003, 2004, and 2005, every one of the Guanlan girls wrote that she had argued fiercely and tearfully with her father to be allowed to stay in school. Some wrote that they "demanded" to stay, despite the seemingly hopeless health and financial problems.[19] In the end, it was concern for their parents' and siblings' plight that the girls cited as the reason for finally accepting defeat and leaving school.

When being able to return to school on receipt of the scholarship, the girls wrote with grand passion about how happy they were to be back. It was their greatest wish and plan that by means of schooling they would be able to "pay for a younger sibling's schooling," "to buy medicines for grandfather," "to take the burden of heavy work off their parents' shoulders," "to bring them comfort in their old age." The girls longed to demonstrate their filial piety toward their birth family—a duty formerly owned by sons only (Guanlan Scholarship Girls 2003, 2005). Two of the students told of their brothers who had gone away for good, never to be heard from again. They did not send money home—they were a loss to the family (Guanlan Scholarship Girls 2003). In contrast, the girls wanted to stay in school and then get steady work close to home to help the family. These findings are supported by Fong (2000), who wrote about Chinese urban singleton children. She noted the gender shift in filial expectations as well. Though their stories differed in detail, what they had in common told of a culture shift favoring girls' education.

In short, the Guanlan Scholarship girls were convinced that education was the most effective way to change the fate of their families from poverty and disease toward health and comfort. They did not want to live the life of the previous generations (*fubei*), and to them education was the single, most applicable means for escaping poverty.

I'm still wondering what is the right choice. I don't know if I need to go back home (drop out of school) to help my father, or to stay at school to continue my studies. But I don't want to be a poor farmer, suffering so much every day from the bully and oppression by officials, even a poor subject to the possible natural catastrophe. Surely, I'll make the wise choice: to stay at school and finish my studies, because nowadays, only the people with knowledge could change their fates. (Peng 2004)

The girls saw education as a way to take charge of their lives instead of staying rooted in the land as did their ancestors. As one girl wrote: "I know that nowadays, a person should possess knowledge before he or she could be able to change his or her fate. I'm hungry for knowledge. I'm longing for a better tomorrow filled up with sunshine. I'm longing to become a respectable contributor sometime . . . to help those in need" (Peng 2005).

Several of the girls wrote (2005) that the scholarship not only helped them financially, but also stimulated their desire to learn and boosted their confidence. The girls mentioned they worked much harder than before at their schoolwork so that they could make "Guanlan Mama" proud. The correspondences from "Guanlan's mother" helped the girls hold on to the belief that as long as they studied hard, education would help them achieve what they wanted in their lives.

I'll definitely work hard, to challenge everyone around me. I believe that people need knowledge. As somebody living in the world, we need to contribute to it. Knowledge is the key to a better future. That's why I decided to work hard to get as much knowledge as I could, not to let down those who love me and care about me. (Peng 2005)

In other words, like adolescent girls their age everywhere, they were also curious about life in the outside world, "the place in their mind that is free of poverty, where everybody lives a life of happiness and comfort" (Guanlan Scholarship Girls 2005).

CONCLUSION

I asked at the outset of the research for this study if it is possible that the provision of a few dollars in scholarship money could overcome the cultural and economic constraints working against girls' enrollment in and continuation through school. The girls' courage, ambition, and persistence in school provide convincing evidence that it does for many of them.

This study illuminated three findings supporting the role of agency in social change. First, the scholarship girls by clamoring for schooling expanded

the cultural value of education to include girls as well as boys. Second, the girls thrust themselves into new roles and responsibilities in the family by filling a vacuum left by the draw on male labor to the manufacturing zones. Third, with the continuing degradation of farmlands, the Guanlan girls were developing new paths for providing for the future well being of the families.

The study also sheds light on the structural constraints and opportunities in the process of social change. In the poorest villages of China, girls had extraordinarily little "space" and few honorable paths out of the quagmire of extreme poverty other than schooling—lots of it. The families knew that without drastic change, their fortunes would decline relentlessly, their region would be left further behind, and the next generation would be worse off than the previous. I suggest that these factors of structure and agency combined to raise the place value of small girl-scholarships to uncommonly high levels.

In short, scholarships are the best and possibly the only hope for girls and poor families in rural China. It is becoming clearer that daughters are more likely to fulfill the filial duty of the younger generation, and more likely to stay closer to home to care for their younger siblings and parents. So much have the family relationships, the society, and culture changed in globalizing China,[20] whether in the midst of its booming cities or on its outer fringes in remote rural villages.

How does this story of the Guanlan girls relate to the theoretical challenge posed by the editor or this book regarding the linkage between agency and structure? First, the economic, social, and cultural structures provide frames within which the people of China, the agents, experience the world economy. The study shows that as material structures change, the cultural barriers, also structures, to girls achieving further education lose much of their traditional stronghold. Second, the girls in this study, the agents, confronted and countered the structures of historical traditions and psychological prejudices of boy-preference. The study showed how they perceived the challenges of their surroundings, and how they reimagined themselves and reconceptualized their roles in society. Third, the political structures surrounding educational policy as well as the expansion of the school system enabled the girls to enter into and struggle through a system that ultimately could not financially support its student body. The scholarship was the external force creating the opportunity to realize the girls' ambition to stay in school, which was driven by their hopes for changing their lives.

And finally, perhaps too obviously, the taking of action based on hope, the leap of faith into the unknown, represents the triumph of agency over structure. In the present case the girls and their families are investing in education in the hope that each Guanlan girl can graduate and find a foothold in the changing economy so they can help support their current and future families. Truly they are taking a leap into the unknown.

NOTES

I would like to acknowledge the help of Jinghuan Liu and Guangyu Tan in the preparation of this chapter. They are two members of the Chinese Girls Education Study Group at Kent State University. Further, I found Vanessa Fong's exceptional study and wonderful book of a similar title, *Only Hope* (2004), though it focused on singleton daughters in urban China, confirmed my analysis of changes in both identity and relationships experienced by daughters in the rural China of this study.

1. The given names of the minors in this chapter have been changed to protect their identity.

2. Children were perceived by their families in many ways of course. Especially in poor families, where survival often constituted the sum-total of the household calculations, children had to be counted as investments in the future.

3. The Guanlan Scholarship fund is set up in a remote mountain village in the District of Shangluo City, Shaanxi Province, China. The scholarship has helped more than twenty-five girls reenter school and proceed through primary and secondary education. Through the communication regarding the scholarship, I have also established personal relationships with the families.

4. "In 2004, the enrollment of boys and girls was 98.97 percent and 98.93 percent, respectively. The difference in access to education between boys and girls was reduced from 0.7 percentage point in 1995 to 0.04 percentage point" (State Council of the People's Republic of China, Information Office, 2005, 14).

5. The national average rural per capita income amounted to approximately RMB 2,456, based on the 2004 growth and per capita income figures furnished by the PRC Ministry of Labour and Social Security's Income Research Institute (*Wall Street Journal*, August 22, 2005).

6. For reference: 1 mu = 0.067 hectares = 0.17 acres; 1 hectare = 107,639 sq. ft.

7. Shangzhou ACWF had received support from the national Spring Buds Program to set up special literacy classes for more than 200 older girls and sponsored another 108 to return to school. Another 318 girls from very poor homes faced the risk of dropping out (ACWF Shangzhou, 2000).

8. ACWF Shangzhou (2002, February 20). Report to the Guanlan Scholarship regarding twenty recipients: summary, handwritten table listing twenty students, three narratives, thank-you letter. Records maintained at Dr. Seeberg, EFSS-Kent State University, Kent, Ohio, USA.

9. National Working Committee for Children and Women (NWCCW) report derives the total number of migrants from a sample estimate of the population. These figures cannot be very accurate because the migrant population is unregistered and floating.

10. Since 2003 incomes in Chinese cities had grown to a per capita income of RMB 9,422 in 2004, whereas rural incomes amounted to only to RMB 2,936 (US $350).

11. *China Daily* cited Su Hainan, president of the ministry's income research institute: "The situation would deteriorate to the most dangerous 'red' stage in 2010 if

no effective measures were taken within the next five years."

12. The article in *China Daily* referred to a study done by Jingzhong Ye of China Agriculture University reporting on a study done under the auspices of Plan China, an international charity, which included ten villages in ten counties in central and western China. Even in a more prosperous farming region of the Yellow River Valley in eastern Qinghai, I learned that in village after village between 70 and 80 percent of the parent population had left (Interviews 2004).

13. Of course older daughters also became part of the stream to the cities as household workers and service and manufacturing personnel. Among the Guanlan girls only older brothers had left. On my field research in 2004, in Tibetan and Mongolian [Munguer] ethnic areas, the great majority of fathers had left, but so had nearly half the mothers and older sisters.

14. In 2004, Professor Zhao and my family were welcomed by the prefecture's party secretary, the mayor of the Zhangcun Township, the principals of the schools, the television station reporter and camera operator, and of course the Guanlan girls.

15. One entered school in 1991, two entered in 1993, three started in 1995, and four began in 1996.

16. Three girls left for one-half a year; two left for one and one-half years, two left for two years, another two left for three years, and one left for four years.

17. Given that the focus of this collection is adolescent girls' and women's education, I will not provide details of the second groups' information. Among the twenty that started at the primary level, eight started on the scholarship in grade 4. Some of them had spent little time in school and it is questionable that they had learned much. However, their schooling apparently had other kinds of meaning, as their stories and their persistence reveal. It is questionable that any student can attain functional literacy within three grades of primary schooling, particularly in rural schools. For an in-depth analysis of literacy achievement by grade level, see Seeberg (1989).

18. This language, "struggling to advance the local economy," is part of the political rhetoric found several times in officials' letters and reports to the Guanlan Scholarship.

19. The girls suffered malnutrition and persistent health problems while they attended school.

20. Vanessa Fong (2004) sees the cultural shift toward a higher valuation of girls as part of the population transition associated with modernization. Because modernization in China is inextricably tied with China's "opening" to the world, particularly economically to world markets, the term *globalization* is used here.

REFERENCES

All-China Women's Federation (ACWF), Shangzhou. 2000, May 11. *Report to the Guanlan Scholarship*. Records on file at Kent State University, Dept. of EFSS. Kent, Ohio, USA.

Armitage, Catherine. 2005. Rural Chinese pay price for ambition. *China Daily Online*, October 24. Retrieved October 24, 2005, from www.chinadaily.com.cn/english/doc/2005–10/24/content_487292.htm

China Daily. 2005. Migrant workers leave 70 million kids behind. October 26. Retrieved November 13, 2005, from www.news.xinhuanet.com/english/2004–11/06/content_2184379.htm

Colclough, C., P. Rose, and M. Tembon. 2000. Gender inequalities in primary schooling—the roles of poverty and adverse cultural practice. *International Journal of Educational Development*, 20 (1): 5–27.

Cui, L. 2004. Some 10% migrant children drop out of school. *Xinhua*, November 6. Retrieved on November 8, 2004, fromwww.news.xinhuanet.com/english/2004–11/06/content_2184379.htm

Fong, V. L. 2004. *Only hope: Coming of age under China's one-child policy*. Stanford: Stanford University Press.

Guanlan Scholarship Girls. 2000, 2003, 2005. *Letters to Guanlan Mama*. Records on file at Kent State University, Dept. of EFSS. Kent, Ohio, USA.

Haller, A. 2002. World Food Programme: Food for education and rural development. In FAO/UNESCO Seminar, Education for rural development in Asia: Experiences and policy lessons, 125–142. Paris: International Institute for Educational Planning. Accessible at www.unesco.org/iiep/PDF/FAO_UNESCO.pdf

Interviews. 2004, September. Records on file at Kent State University, Dept. of EFSS. Kent, Ohio, USA.

Luo, J. 2005, June 27. *Status quo of the left-behind children in rural China and thinking on this issue*. Zhengzhou, Henan, China. Retrieved October 4, 2005, from www.cinfo.org.cn/zhuanti/20050627zgnc.htm

Mancebo, Samuel T. 2002. Asian Pacific Association of educators in agriculture and environment. Responding to the transformation of rural labour markets: Implications of education and training. In Education for rural development in Asia: Experiences and policy lessons by FAO/UNESCO Seminar, 99–108. Paris: International Institute for Educational Planning. Retrieved on November 18, 2005, from www.unesco.org/iiep/PDF/FAO_UNESCO.pdf

National Working Committee for Children and Women (NWCCW) under China's State Council and the United Nations Children's Fund (UNICEF). 2004. Cited in Some 10% migrant children drop out of school, by L. Cui, *Xinhua*, November 6. Retrieved on November 8, 2004 from www.news.xinhuanet.com/english/2004–11/06/content_2184379.htm

Parham, Walter. 2001. Degraded lands: South China's untapped resource. *The Journal of the Federation of American Scientists*, 54, (2). Retrieved November 18, 2005, from www.fas.org/faspir/2001/v54n2/resource.htm

Peng, L. N. 2004, 2005. Letter to Guanlan Mama. Records on file at Kent State University, Dept. of EFSS. Kent, Ohio, USA.

Seeberg, Vilma. 1989. *Literacy in China*. Bochum: Brockmeyer Universitäts Verlag.

State Council of the People's Republic of China, Information Office. 2005, August. *Gender equality and women's development in China.* White Papers of Chinese Government. Retrieved November 15, 2005, from www.china.org.cn/e-white/20050824/index.htm

Stephens, D. 2000. Girls and basic education in Ghana: A cultural enquiry. *International Journal of Educational Development,* 20 (1): 29–47.

Stonejar Gulch Village Government. May 22, 2000. Letter to Guanlan's mother. Records on file at Kent State University, Dept. of EFSS, Kent, Ohio, USA.

Sun, Shangwu. September 10–November, 2005. Rural children need a safety net. *China Daily* (English version), section 4.

UNICEF. 2005. *Gender achievements and prospects in education: The gap report.* Retrieved November 1, 2005, from www.ungei.org/gap/

Wall Street Journal. August 22, 2005. China's widening income gap threatening social stability. Retrieved August 22, 2005, from www.online.wsj.com/public/us

PART III

Social Relations as Structural Parameters Defining Females' Agency in Education

CHAPTER 9

Female Classroom Assistants

Agents of Change in Refugee Classrooms in West Africa?

JACKIE KIRK
REBECCA WINTHROP

INTRODUCTION

Most classes in refugee schools in West Africa are taught by male teachers; there are very few female teachers and even fewer female head teachers or education administrators. Although enrollment of girls and boys in the lower classes is more or less balanced, by the upper primary level, many of the Liberian refugee girls studying in Sierra Leone and Guinea have dropped out of school and boys greatly outnumber girls. This situation can mean that lessons are oriented to boys' needs and experiences, that girls are discouraged from participating actively in class, and that they are deprived of female role models and women who will encourage them in their studies. It can also mean that girls are vulnerable to sexual exploitation by teachers.

Since 2002, the International Rescue Committee (IRC) has been implementing an innovative program of training and deploying female classroom assistants (CAs) in the refugee schools it supports in West Africa. The CAs have an explicit mandate to mitigate against abuse and exploitation of students, but more broadly they help to create a girl-friendly school environment and promote learning. CAs monitor girls' attendance and follow up on absences with home visits, help girls with their studies, support extracurricular health education and social club activities for girls such as needlework, games, and sports. They maintain the log book with students' grades, a task that helps to avoid situations in which teachers can manipulate and exploit girls for sex in exchange for altering their grades.

161

The gender/power dynamics of teaching and learning and the particular experiences of women teachers have been well documented and theorized in Western contexts, but there is little detailed research from development contexts, from Africa particularly, and specifically from refugee schools. A lens of structure and agency as developed by theorists such as Bourdieu and Giddens helps to explore the experiences and activities of the CAs in the classrooms, articulating these in relation to—and quite dependent on—the structural conditions and circumstances in which they take place.

This sociological perspective focused on the nexus of agency and structure is connected to feminist perspectives on education, and particularly on teachers and teaching experience. This enables us to analyze the experiences and activities of the CAs within the gendered spaces of the classroom and the school. Our analysis is informed by feminist educators such as Walkerdine (1990), Munro (1998), Grumet (1988) and McWilliam (1996a; 1996b), who describe the situation of women in classrooms as inherently "tricky," problematic, and even "impossible." The classroom is a gendered space in which gender roles and identities and sexualities are constantly being formed (Anderson-Levitt, Bloch, and Soumaré 1998; Epstein and Johnson 1993; Thorne 1993). Most importantly, the classroom is also a hegemonic male space (Mirembe and Davies 2001) in which women exert agency, but an agency that is formed within and necessarily shaped by the structural conditions of the refugee context. We also draw on feminist scholars of gender and development, particularly Goetz (1997), who helps articulate the gendered relationships within institutional structures in development contexts.

The chapter draws on data collected during fieldwork in Guinea and Sierra Leone in October through November 2004 as part of the IRC's Healing Classrooms Initiative.[1] After a brief introduction to the CA program in IRC-supported schools in Sierra Leone and Guinea, the chapter continues with a brief discussion of the key impacts of the program for the students— and especially the girls. The main section of the chapter, however, relates to the CAs themselves and their somewhat contradictory positions and experiences as agents of change for gender equality in refugee schools.

THE IRC CLASSROOM ASSISTANT PROGRAMS

The IRC is one of the largest education providers for refugees around the world and particularly so for refugee children and youth in Guinea and Sierra Leone. At the time of the fieldwork in the east of Sierra Leone, the IRC's programs were serving an estimated population of 55,000 Liberian refugees in eight refugee camps. In the N'Zérékoré region of Guinea the education program was serving an estimated 80,000 refugees living in camps and in and

around the town. In both countries the IRC education program includes the provision of teaching and learning supplies, in addition to teacher training, and training and support for classroom assistants. Almost all the teachers and CAs in both country's programs are refugees themselves, and with funding from UNHCR, the IRC pays both a small monthly incentive (Kirk 2004b, 2004c).

A report from UNHCR and Save the Children UK (2002) highlighted the extent of the exploitation of girls and young women by humanitarian workers in refugee camps. Teachers were one of the key groups of perpetrators, and the report indicated that teachers were taking advantage of their positions and their authority over girls, offering good grades and other school privileges in return for sex. Teachers in IRC-supported schools were implicated in the findings, and the organization moved quickly to start to address the issue in a number of different ways. These included recruiting and training female classroom assistants (CAs), as well as developing and introducing to all employees the IRC Mandatory Reporting Policies on Abuse and Exploitation. Soon after its introduction in Guinea, IRC Sierra Leone also adopted the classroom assistant program.

The classes in the IRC-supported schools are taught almost exclusively by men. At the time of the fieldwork in Sierra Leone, for example, the IRC was supporting 459 male teachers compared to 20 female teachers. In Guinea, the IRC was supporting 334 men compared to 103 women teachers, over half of whom were teaching in the kindergarten and pre-kindergarten classes. In most classes then, academic success rests in the hands of all-powerful male

FIGURE 9.1
IRC Refugee Education Program, Sierra Leone,
Enrollment by Gender and Grade (Sept. 2004)

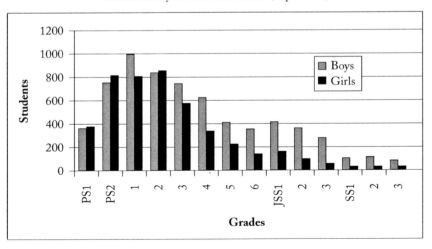

teachers who teach the lessons, set and grade the exams and tests, and then enter the grades into formal school records (Kirk 2004b; 2004c). As was highlighted in the UNHCR and Save the Children report, this sort of situation makes girls especially vulnerable to exploitation and abuse—especially being forced to exchange good grades for sex. In addition to overt sexual harassment of girls, male students can further discourage girls through pejorative comments about their schoolwork, teasing when they get answers right or wrong in class, and generally making them feel uncomfortable in class. In crowded classrooms the few girls are often squashed into small benches and desks besides the boys, with no space or territory of their own.

It is generally believed that if more women teachers could be recruited to the schools, learning environments can be more girl-friendly and protective, and ones in which girls' perspectives are understood and their specific needs met. Recommendations as such are made in the UNHCR and Save the Children report. However, the reality is that in the refugee communities in both Guinea and Sierra Leone, because of long-standing gender disparities in access to education, there are few women with the level of schooling required to become a teacher. Those that do are usually recruited for better-paying positions with UN agencies or NGOs in the camps, or they are unable to leave family duties or other better-paying income-generating activities. This is especially true for the many refugee women who are single mothers, either separated from their husband or widowed during the conflict in Liberia.

The CA program, then, was designed with the specific objective of reducing girls' vulnerability to sexual exploitation in schools and a more general aim of improving girls' educational opportunities. In both countries, CAs have been recruited from the refugee population, with a flexible entry requirement of grade 9 education. CAs participate in a short two- to five-day training workshop, which includes lesson planning, team teaching, tracking girls' grades and attendance, and report writing, in addition to prevention of sexual abuse and exploitation, child rights, and child protection topics. CAs are also trained on communication and counseling skills. The CAs are expected to be at school every day during school hours and to sit in the classes with the students. Home visits and other club activities are conducted outside school hours. The CAs are visited on a regular basis by IRC supervisors, to whom they submit monthly reports detailing girls' attendance, activities, and home visits.

STUDY METHODOLOGY

The CA program was examined in some detail in Sierra Leone and Guinea as part of the IRC Healing Classrooms Initiative teaching and learning assessment in October through November 2004. In both countries a mixed-method

approach was used to gain qualitative insights into teaching and learning in a sample of the IRC-supported refugee schools. In Guinea, three schools in the N'Zérékoré area were selected, two in town and one in a camp. In Sierra Leone, three camp schools were selected in the Eastern Kenama region, in which the IRC program is operating. Common tools (i.e., interview and observation protocols) were used in both sites, but were adapted to fit the specific contexts. Teachers and CAs were interviewed by the principal researcher and students were interviewed and were brought together in focus group discussions by research assistants trained as part of the project. Interviews with teachers and CAs were conducted in English (the language of instruction and of the school system) and the interviews conducted by the research assistants were conducted in a mixture of mother tongue, Liberian English, and "standard" English. Questionnaires were also distributed to teachers in each site. The scope and methods used are detailed in Table 9.1. Detailed handwritten notes were taken during every interview and discussion. Tape recorders were used to check that notes captured the entire discussion. Handwritten notes—and questionnaires—were then entered into word processing software for analysis. The data was analyzed using a two-step narrative method. First, all data texts were read and reread in a holistic, impressionistic way from which the major themes were identified. Within each specific site, the data collected from each group (teachers, CAs, and students) was compared and contrasted around these themes. At the same time, specific texts or sections were identified for closer analysis using Tobin's method of close reading (Tobin 2000). Tobin's point is that in listening closely to the words the children use, we gain insights into the worldviews, concerns, issues, and prejudices of the communities in which they live. These communities are inevitably heterogeneous, and therefore, so are the discursive resources upon which individuals draw when talking. The conflicting views and perspectives of a society are then inevitably reproduced in what individuals say and write. By paying particular attention to the contradictions, by "looking awry" at "things that stick out" (Zizek 1991), we can therefore tease out some of the ideological messages that have currency in that particular community. At the same time, in listening closely to individual instances of resistance to dominant messages, for example from the CAs, we can gain insight into the possibilities for resistance and for alternative positions.

IMPACTS OF THE CA PROGRAMS

This section briefly discusses the impacts at the classroom level. It reports findings of the study organized around the broad objectives of the CA program: protection from sexual exploitation and abuse, creating girl-friendly spaces, creating a conducive learning environment.

TABLE 9.1
Scope and Principal Research Methods

Research method	Sample and methodology	Guinea	Sierra Leone
Classroom observations	RAs conducted observations based on modified classroom observation form.	29 lessons observed	30 lessons observed
Student discussion	Focus group discussions held in target classes. RAs groups worked in pairs, splitting the class into two groups and each taking half.	24 FGD	22 FGD
Student interviews	Individual interviews conducted by the RAs with randomly sampled students from each of the target classes. Interviews held mostly on school premises, but in quiet spots of students' choice. Interviews conducted mostly in English.	82 interviews	38 interviews
Interviews with children who have never been to school	The RAs identified children within their own communities who would be willing to talk to them. Interviews were conducted mostly in or around the interviewee's home. Interviews were conducted mostly in local dialects and translated into English by the RAs.	9 interviews completed	16 interviews

(continued on next page)

TABLE 9.1 *(continued)*

Research method	Sample and methodology	Guinea	Sierra Leone
Interviews with children who have dropped out of school	The RAs identified children within their own communities who would be willing to talk to them. Interviews were conducted mostly in or around the interviewee's home. Interviews were conducted mostly in local dialects and translated into English by the RAs.	21 interviews completed	13 interviews
Teacher interviews	Teachers (of the target classes) were interviewed by principal researcher, either individually or in small groups of 2 or 3. The interviews took place usually in the principal's office, during school hours, and where possible during the teachers' free periods.	25 interviews	21 interviews
Teacher questionnaires	Questionnaires were completed by the teachers. These were done in their own time and were collected during the interviews.	25 completed questionnaires	18 completed questionnaires
Classroom Assistant interviews	CAs were interviewed by principal researcher, in small groups of 2 or 3. The interviews took place usually in the principal's office, during school hours.	17 interviews	15 interviews

Protection from Sexual Exploitation and Abuse

The initial impetus for the program was to eliminate sexual abuse and exploitation of girls in schools, and according to all those interviewed (CA, teachers, and students), there has been a change in teachers' behavior in schools. Although it is impossible to say that there is no longer any exploitation of girls by teachers in school, nor that the risk of it does not exist, it would nonetheless appear that there has been a significant and positive change to which the CAs have contributed. In Guinea, for example, the students talk about there now being "more respectful" relationships between students and teachers; as one girl says, "Teachers are no more collecting money from students in school for grades. Students and teachers are now respecting one another." When prompted to address the issue of sexual exploitation, the CAs are quick to assert that "since we came in we put a stop to those things," that "the teachers can't do anything bad with the students, no, nothing bad like that is happening—I haven't seen anything like that." When asked whether they think the teachers have changed the ways they interact with girls since they came into the schools, CAs in Guinea stress that yes they have. "The teachers are careful," says one CA. "We observe them." In a number of schools, the CAs stress the importance of their being there to observe and see what is happening in the schools, "Things have changed, the teachers don't do it [sexual exploitation of girls]—this is why the girls are so serious now. We are there to observe, so the teachers can't say, like, 'This girl is beautiful.'" One CA explicitly mentions the impact from the girls' perspectives as she says, "The girls are happy that in our presence they know that the teachers cannot do these things. We are there and we can observe them."

Creating Girl-Friendly Spaces

The CAs describe some of the activities they do with the girls in groups, and when asked if they interact individually with them at all, they indicate that yes, if they see a girl who is obviously not well or not happy then they will talk to them. For example, one CA explains:

> Sometimes, if you see one or two [girls] sitting and you ask them their problem and then they will tell you, like one girl, she saying she is working and she comes to school late and they [the other students] are all working and she feel shame. . . . I tell her to not feel shame, to come to school and even if she does come late, she should surely stay.

Another CA explains how she responds to the needs of another girl:

Because some of them are living with people [foster families]—their parents they left in Liberia . . . and this little girl in my class she is living with friends and I see in class that she is so sad and just sitting and so I ask her what is the matter. "Come and talk to me, you can tell me," and she tells me her problem, her secret. She says she is so worried about what will happen when we go from here, how she will get money, how she will eat. I tell her, "I don't have money to give you but I will talk to you, you can tell me your secret and you just come to school because education is the answer. As long as you know book, you'll be alright."

Such interventions can clearly make a very positive difference to girls in schools who would otherwise have no female confidante or mentor.

Creating a Conducive Learning Environment

The CAs also describe what they do to promote learning in the classrooms. One CA in Sierra Leone says:

I am helping the girls with their English. Yes, they like us because we like to sing, do drama, and when there is no teacher then I write on the board for them and get them to copy down. I remind them that they are here for education and for writing. If they are sleeping, I get them to stand and tell them to wake up and concentrate.

CAs in Guinea are doing similar things; one says, ". . . when the teacher is writing on board we can go round and correct and tell them how to write, tell them to put the date and to leave the right spaces. . . ." The results of their interventions are also observed by the CAs: "Since the project started, the girls used to sit and they were not seriously working and now we are there to encourage them and to counsel them and to make them concentrate on the lesson, and so they are more active."

Other positive impacts include improved class participation of girls, especially in English, and more interest in going to the library to study. One of the CAs states that the girls in her class are now doing as well as the boys, and in fact there are five very clever girls and it is the boys who want to sit next to them in the tests. She tells the girls to sit together, though, to avoid any interference from boys.

There is also a consensus among female and male students that the CAs help to make the classroom space a friendlier one, that is more conducive to their learning. In Guinea, girls in a focus group discussion explain how they feel encouraged by the CAs, and, for example, more comfortable to ask questions in class: "Now some of us girls feel more and more safe to ask our teachers any

question that bother us without fear of being provoked by anyone." This improved comfort level is also expressed by one of the boys who describes how, with the presence of the CAs, the teachers will now answer "out of lesson questions."

It would also appear that just the presence of another adult in the classroom encourages the teacher to present his lesson well and at least try to ensure that all the students have understood. In contexts where many of the teachers are inexperienced and underqualified, the students are concerned that they often do not understand the lessons being delivered to them; teachers may not have the necessary skills to link the concepts being taught to the children's own experiences and existing knowledge. As indicated in the aforementioned response, teachers may also refuse to answer questions that may challenge their authority and may also show up their own limited grasp of the subject.

Responses from the teachers also indicate that the CAs "provide maximum support in classroom management and discipline," and clearly this has a positive impact, with enhanced teaching and learning in a calmer and more organized classroom. Teachers in Guinea also recognize explicitly how the quality of their instruction has improved since the CAs started in the school; they write: "[the CA program] makes me work promptly and caring" and "it makes the teacher teach better."

CHANGING THE GENDER DYNAMICS
OF THE CLASSROOM: A COMPLEX TASK

As highlighted earlier, the classroom assistants do make a significant difference to the classroom atmosphere, which is highly appreciated by the girls and also by boys. This contributes to enhanced learning, especially for the girls who are often perceived as being behind and in need of extra encouragement. However, the data also indicate that while on one level the CAs' presence may enhance the school experience for girls, at another, the introduction of paraprofessional, unqualified women into structural contexts in which male teachers and school administrators maintain powerful positions and high status cannot alone achieve long-term change for the protection of girls and for gender equality. The following section examines the potential and actual agency of the CAs, which is dependent on the structural parameters of the classroom context. The data presented and discussed highlight the complexity of the classroom dynamics and relationships between teachers and CAs, and between students and CAs.

Feminist perspectives on the tricky positions of women teachers help to articulate the contradictory position in which the CAs are placed, as women

themselves, subject to gendered subordination within a hegemonic male class-room space but attempting to bring about change in girls' daily experiences of school. From an agency and structure perspective, such as articulated by Bour-dieu, we can see that the classroom is a complex "field" in which there is a par-ticular "configuration of objectively defined positions, imposed on agents or institutions by their present and potential situation (*situs*), in the structure of the distribution of species of power" (Bourdieu and Wacquant 1992, 978). The agency *and* lack of agency of the CAs is constituted within this "field" as a "critical mediation between the [individuals'] practices . . . and their sur-rounding . . . and conditions." For example, motivation and therefore agency for the CAs to encourage girls in their studies is, somewhat contradictorily, constituted through their own lack of education and apparent lack of alterna-tive employment opportunities. The following section is organized around the following themes: teachers and CAs, relationships with girls, followed by a discussion. This is followed by a complementary section on perceptions of girls and strategies for girls' education, again followed by a discussion section.

Teachers and CAs

When the CAs were first introduced to the classrooms, there was a certain amount of discomfort on the part of the teachers; teachers considered them as "sex police" and as classroom spies who would be reporting on their every move. The general consensus now, however, is that the teachers no longer feel so uncomfortable, and that they have started to see that there are some bene-fits to them of having assistants in the class. As one teacher describes:

> Yes, at first the teachers were somehow afraid of them [the CAs] and thought they were just reporting on them, but then the EO [Education Offi-cer] showed us the job description and we felt more comfortable. Even when they came though, we thought they were police.

The CAs are all too aware of the teachers' hostility, and although they also insist that the relationships are now quite different, they also talk about the past. As one CA in Sierra Leone says, "At first the teachers used to be afraid of us but we told them we were there for the girls." In Guinea, there was a similar situation. As one CA explains, at the beginning, "Some [teach-ers] were happy and some were not happy. From the beginning they didn't know and they thought we'd be against them, but now they are seeing that we are helping them too." The teachers are now more accepting of the CAs and have responded to their presence with more respectful behavior, improved les-son planning and delivery, and more interaction with students. However, it is also clear that their expectations of the CAs are limited to relatively menial

tasks and ones that do not challenge their own authority as teachers. The training of the CAs includes the concept of *team teaching*. From a program design perspective, this is considered to be a good way to promote female participation in high-status teaching activities and to build the skills and the confidence levels of the CAs as further incentives toward a teaching career themselves. However, the reality is that none of the teachers talked about any real power sharing in the classroom and made it clear that when the CA was in the classroom alone with the students, she was merely a replacement for him. The CAs may share some of the responsibility for classroom management with the teacher, however, there is little sense from the teachers that they see the CA as an equal partner in teaching and learning processes. In fact when asked specifically about team teaching with his CA, one teacher responds by saying, "Yes, if the teacher goes to urinate then the CA teaches. When the teacher gives question papers, then the CAs correct." Another grade 6 teacher describes his CA as follows: "Sometimes when I am not in the class she takes care of the students, she monitors the tests when I give. She erases the board and also gives some corrections. The teacher cannot be in the classroom all the time."

Generally teachers felt that CAs needed more training, but in contrast to the teacher attitudes previously described, there are two teachers who are quite frank about their own negative experiences. One is an experienced woman teacher and she says quite openly:

> According to what they told us they [the CAs] are there to look after the girls, but I see no use, they can't teach. For example, me, I am handling thirteen subjects and if she [the CA] was capable, she should be helping me. The teaching work is tedious, like preparing grade sheets, etc. In theory, the CAs are useful, but . . . I don't know.

Another teacher is equally questioning of the value of the CAs, and even suggests that they add to the teachers' work: "The CAs are a problem—it is very difficult—they should be educated to know what to do in the classroom. . . . Now we [the teachers] have to do classroom management of students and CAs."

Relationships with Girls

As previously described, girls who took part in interviews and discussion groups were appreciative of the CAs in their classes, seeing them as a friend, big sister, mother figure. However, the data also suggest that the girls—and boys—do not necessarily see the CAs as strong role models.

The question, "Would you like to be a CA?" elicited some very touching responses from students in Guinea that indicate their appreciation for the

CAs. However there are many girls who disagree and say they would not like to be CAs. The reasons for this fall into two broad categories—because of the hard work and low pay and because of the lack of respect that is accorded to them. This latter category of response is of particular interest: one girl says, for example, "No, because CAs get their fair share of headaches from impolite, rude students." Another says, "Some students are challenging the CA in class and mock the CA outside school." The reality is also that the students are more than aware of the financial difficulties of the CAs and this may also contribute to a lack of respect for these women who are there to support and encourage them in school. In one of the schools in Sierra Leone a specific school rule was made for the students to call the CAs "teacher"; the fact this was done specifically to encourage the students to respect the CAs just like they do the teachers is also an indication of a more problematic relationship between the students and the CAs than might have initially been imagined.

The CAs also recognize these tensions in the relationships with girls. Some way into the interviews, some of the CAs in both Guinea and Sierra Leone started to articulate some of the challenges that they face in gaining the trust, confidence, and respect of the girls, especially the older girls. This is not altogether surprising when one considers how their advice to girls to dress modestly, ignore boys, beyond all else to study hard, might be perceived. Furthermore, in a small refugee community where people tend to know each other well, the girls are also very aware that the CAs have not completed their own education, and can be skeptical of what they know and can do. As one CA described, "They will test us—just to check we know it, but it is getting better now. At first they were saying things like, 'Oh look at her, she pretends she knows all this,' and when the teacher leaves the class, they would raise their hands to ask difficult questions to see if the CAs really do know."

But this situation also stimulates response and agency. The CAs have developed strategies to deal with this sort resistance and to squash any perceptions that they are not up to standard; they say that it is important that "you show them [the girls] that you know by writing on the blackboard." Another strategy is to copy the teachers' class notes into their own books and study in the evenings so that they can answer.

Discussion

Teachers generally are placed in a paradoxical situation in which they themselves are subject to comprehensive control within a hierarchical structure, while at the same time they are authority figures with rules and regulations (such as uniform and pregnancy policies) to impose on student bodies (Sattler 1997). This paradox can be especially true when female teachers—and in this case female CAs—are assigned pastoral responsibilities for girls and thus

become responsible for the patrolling and disciplining of girls' bodies, imposing uniform, and behavior rules. The girls in Mirembe and Davies's study of school culture in Uganda (2001) were very resentful of the interventions of female teachers who, in discussions with the researcher, said that they felt ignored the important issues for them. The authors point to the need to recognize that these girl/woman relationships take place within a school context of hegemonic masculinity.

Scholars have described the tricky position of women teachers in Western classrooms and the "impossible fiction" (Walkerdine 1990) of being a woman teacher. Walkerdine points to the tensions and contradictions that are inherent in an identity that asserts power, status, and commands respect (teacher) at the same time that it speaks of subordination, marginalization, and repression (woman). From a structure and agency perspective we can clearly see how the very agency—or lack of it—for individual women teachers can only be examined in relation to the "wholes" of the institution and system (House 1990) in which that woman teacherness is constituted. Although less well explored in development contexts, such conceptualizations of the woman teacher appear to be equally relevant outside of the West (Kirk 2003 and 2004a). If they are true of women teachers in West Africa, then the position of unqualified classroom female assistants is even trickier and even more problematic. For uneducated women, the structural conditions and gender dynamics operating within the classroom "field" may be even less conducive to individual agency.

Walkerdine (1990) eloquently describes the tension that exists for the woman teacher, who is expected to facilitate the individual, rational development of each child and yet has to do so from within the confines of a classroom, where her role is considered similar to that of a nurturing mother. This is certainly true for the CAs, who are described by the girls as motherlike figures, but for the CAs this impossible task has additional layers of gendered complexity. The expectation that they can facilitate the empowerment of girls from a position that has far less status than that of a teacher and is embedded within a hegemonic male classroom space may be even more problematic.

PERCEPTIONS OF GIRLS AND
STRATEGIES FOR GIRLS' EDUCATION

Although the CAs may be strong advocates for girls' education, they also appear to believe that it is the girls who are not serious enough about their education, that it is the girls who need to study extra hard and avoid the attention of men (including teachers) and male students. "They shouldn't wear false hair or makeup as it attracts men, and short skirt," says one CA in Sierra Leone. In the same school, another CA explains how important it is for the

CAs to take care of the girls in school and to make sure they are clean and well dressed and their hair is plaited. A colleague adds: ". . . And their manner of dressing has improved too. Before they were wearing big earrings and polish their lips with color, but now they are more moderate. . . ."

Other CAs also tend to talk about the girls as if the problem lies with them, and as if they are there to make up for the girls' lacunae in comparison with the boys. One CA explains: "Of course, sometimes the boys get angry because we are only helping the girls, but we tell them that the girls are backward and the boys are cleverer and so they [the girls] need more help." Another CA says that they focus their attention on the girls "because they are left behind." This tendency to problematize the girls and the girls' behavior and to assign the responsibility to the girls to change their negative behaviors and attitudes toward school is also reflected in responses from teachers. For example, one teacher writes that the most important aspect of the CAs' work is the CAs' encouragement to the girls in class, "because girls had not been taking education so serious." Another teacher writes, "I think supervision of female students is the most important task. This has encouraged the female students to learn on their own and not to depend on male students for help." For others, it is important to encourage the girls in their lessons and to make sure they are following the lesson in their books. One of the CAs explains one of their strategies: "We tell the teachers to send the questions to the girls, to make sure they are awake and being serious."

Anne Marie Goetz (1997) highlights the problematic nature of gender equality initiatives that focus on women as the problem. She proposes a shift in perspective from "getting women right for the institution" to one of "getting the institutions right for women." Such a shift is one that is very relevant in this context in which, as we have seen, the emphasis has been on the CAs helping the girls to fit better into schools. Rather than focus on the girls' rights and the expectations they should be able to have of the male students and teachers, the CAs stress how important it is for the girls to keep themselves to themselves and to avoid the males in school. They see an important role for themselves in instructing the girls to keep away from the boys. They describe this thus: "We talk to them about not going around with boys," and "we always encourage them [the girls] and tell them of the importance of education—that they shouldn't follow men and not to jump with them. We tell them 'you shouldn't wrestle with boys because in doing that it is dangerous.'" CAs in Guinea explain that the most important aspect of their work is the advice they give to girls not to go around the teachers and other men and risk getting pregnant.

Feminist educators and theorists of education have critiqued initiatives in which it is the problematic, messy, and unpredictable bodies of girls and women that have to be "fixed" in order for them to fit into the androcentric

institutions to which they desire access. The aforementioned responses high-light the CAs' roles in "fixing" the "deficit" girls to first get them into school and then to perform well once in the classroom. One teacher says, "CAs are mainly there to check on the girls and to know why the girls don't come to school, to tell them how to dress as girls and how to behave and tell them what not to do." Neither the teachers nor the CAs articulate any need to change any of the structures or processes of schooling in order to better suit the girls.

Discussion

As Mgalla et al. (1998) find in their study of a somewhat similar guardian pro-gram for girls in Tanzania, the opinions of the CAs on girls, gender equality, and empowerment are grounded in their everyday realities of camp or town refugee life and are indicative of the prevailing social context. CAs, like any women in the refugee context, are implicated in the intersecting and overlapping gendered ideologies of different institutions and organizations (Kabeer and Subrahman-ian 1996) including the family, school, community, and NGOs such as the IRC. This means that their understandings of the barriers to successful education for girls, and the strategies that they develop for addressing these, tend to reflect rather than challenge the prevailing discourses of the community in which they live. We have to remember that at least when the CA program started, the pre-vailing attitude among teachers and others in the community was that the girls were seducing teachers because of their provocative clothing.

From a structure and agency perspective it is clear that the impacts the CAs do have (protection of girls from sexual exploitation, encouraging and mentoring girls to stay in school, and creating more conducive learning envi-ronments) cannot be adequately explained without considering the relation-ships between the CAs and their contexts. Investigation of the relationships between the CAs, the teachers, and the students as structured within the par-ticular social context of the refugee school are particularly important. The understandings that the CAs develop of the "girls' problem" are shaped by pre-vailing attitudes, thereby explaining their attention to the clothing, appear-ance, and demeanor of the girls. The work of the CAs is circumscribed within the traditional gender/power dynamics of the community, further entrenched in the patriarchal institution of the school. While they clearly have agency and have bravely broken new ground in their communities with their different ini-tiatives to promote the girls, it is perhaps not surprising that the power and authority of the teachers remains unchallenged. For women whose financial and social security—and that of their own children—may depend on working within the status quo of the community and not rocking the boat too far, this could be very risky. The agency that they seize to protect and help the girls, as constituted within the classroom setting, is relatively fragile.

CONCLUSIONS

It is clear from the previous data presentation and discussion that the classroom assistant program is successful in creating more comfortable learning environments for girls and has had beneficial impacts for boys too. One of the most important impacts is its contribution to a reduction in sexual exploitation of girls, yet beyond this, the physical presence of the CAs in class, their moral encouragement for the girls, and the concern that they show for their well-being and their academic success contribute to some shifts in the gendered balance of power in the classroom. Agency and structure perspectives, threaded through with feminist perspectives on women teachers, teaching, and learning help to articulate the complex relationships between the CAs as women and the classroom context as a dynamic, gendered "field."

It has to be acknowledged that the CAs are in somewhat tricky positions in the classroom, and that alone they may not achieve the needed long-term impact for girls' empowerment for changing the underlying hegemonic male culture of the school. Agency and structure perspectives help us to acknowledge the work the CAs are doing and to understand that the strategies they use are very appropriate—and practical—responses to perceptions of the problems. These strategies become possible through particular interactions between individual initiatives and contextual factors; the perceptions and the solutions of the CAs are inevitably shaped by the androcentric structural conditions in which they have been formed. The imperative becomes to work with the CAs—but also with the teachers, head teachers and administrators, and students—to support the development of more strategic approaches that ensure the immediate protection of girls in the context but that also move toward long-term empowerment for the girls and the CAs within more gender-responsive schools, classrooms, and communities.

REFERENCES

Anderson-Levitt, K. M., M. Bloch, and A. M. Soumaré. 1998. Inside classrooms in Guinea: girls' experiences. In *Women and education in sub-Saharan Africa: Power, opportunities, constraints*, edited by M. Bloch, J. A. Beoku-Betts, and B. R. Tabachnick, 99–130. Boulder: Lynne Rienner.

Bourdieu, P. and L. J. D. Wacquant. 1992. *An invitation to reflexive sociology.* Chicago: University of Chicago Press.

Epstein, D. and R. Johnson. 1993. *Schooling sexualities.* Buckingham: Open University Press.

Goetz, A. M. 1997. *Getting institutions right for women in development.* London: Zed Books.

Grumet, M. 1988. *Bitter milk: Women and teaching.* Amherst: University of Massachusetts Press.

House, J. 1990. Social structure and personality. In *Social psychology: Sociological perspectives,* edited by M. Rosenberg and R. Turner, 525–561. New Brunswick: Transaction.

Kabeer, N. and R. Subrahmanian. 1996. Institutions, relations and outcomes: Framework and tools for gender-aware planning. IDS Discussion Paper No. 357. Brighton: IDS.

Kirk, J. 2003. Impossible fictions? Reflexivity as methodology for studying women teachers' lives in development contexts. PhD dissertation, McGill University.

———. 2004a. Impossible fictions: The lived experiences of women teachers in Karachi. *Comparative Education Review,* 48 (4): 374–395.

———. 2004b. International Rescue Committee (IRC) Healing classrooms initiative: A follow-up field study in Guinea. Draft Report (IRC Unpublished document).

———. 2004c. International Rescue Committee (IRC) Healing classrooms initiative: A follow-up field study in Sierra Leone. Draft Report (IRC Unpublished document).

McWilliam, E. 1996a. Corpor/realities in the classroom. *English Education,* 28 (4): 340–348.

———. 1996b. Seductress or schoolmarm: On the improbability of the great female teacher. *Interchange,* 27 (1): 1–11.

Mgalla, Z., D. Schapink, and J. T. Boerma. 1998. Protecting school girls against sexual exploitation: A guardian programme in Mwanza, Tanzania. *Reproductive Health Matters,* 6 (12): 19–30.

Mirembe, R. and L. Davies. 2001. Is schooling a risk ? Gender, power relations, and school culture in Uganda. *Gender and Education,* 13 (4): 401–416.

Munro, P. 1998. *Subject to fiction.* Buckingham: Open University Press.

Sattler, C. L. 1997. *Talking about a revolution: The politics and practice of feminist teaching.* Cresskill: Hampton Press.

Thorne, B. 1993. *Gender play: Girls and boys in school.* New Brunswick: Rutgers University Press.

Tobin, J. 2000. *Good guys don't wear hats: Children's talk about the media.* New York: Teachers College Press.

UNHCR and Save the Children UK. 2002. Note for implementing and operational partners on sexual violence and exploitation: The experience of refugee children in Guinea, Liberia and Sierra Leone. Available online at www.unhcr.ch, accessed January 10, 2005.

Walkerdine, V. 1990. *Schoolgirl fictions.* New York and London: Verso.

Zizek, S. 1991. *Looking awry: An introduction to Jacques Lacan through popular culture.* Cambridge: MIT Press.

CHAPTER 10

A World Culture of Equality?

The Institutional Structure of Schools and
Cross-National Gender Differences in Academic Achievement

ALEXANDER W. WISEMAN

INTRODUCTION

The literature on women's and girls' education frequently focuses on gendered inequalities in educational opportunities, educational attainment, and status of women in social, political, and economic arenas both within and across nations (American Association of University Women 1995; Ayalon 1995; Catsambis 1994; Ross 2002; Stacki and Monkman 2003; Stromquist 2001). There is much evidence that suggests that gendered inequality is the product of female oppression in a world dominated by global male hegemony within and across institutions including family, school, politics, and the labor market (Chase 1995; Chase and Rogers 2001; Lesnick 2005; Maslak 2005; Stromquist 1995, 1998; Wiseman and Baker 2007). And, this gender inequality exists even in systems that formally recognize and incorporate women into official institutional policies and organizational structures. The international evidence behind this critique of schooling is steadily mounting. In particular, some of the strongest evidence of gendered educational inequality is the fact that large proportions of school-age children in many developing countries are simply not in school, and most of them are girls (UNESCO 2004).

This problem may seem relatively straightforward, but gendered educational inequality is a complex phenomenon. Indeed, the discussion about women's education has gone beyond a "gender wars" dichotomy to encompass something broader and, frankly, more complex (American Association

of University Women 2001). Some of the most interesting recent scholarship on gender inequality in schools focuses on how gender intersects with race, ethnicity, and class (Bettie 2003; Ferguson 2000; Luttrell 2003; Maslak 2003). Women's education is strongly contextualized by the social and cultural environment of the local schools and national educational systems. This environment is permeated by shared norms and values, which are shared not just by small groups of acquaintances but by larger communities of people who all participate in the worldwide phenomenon of modern mass schooling (Boli and Ramirez 1986; Meyer et al. 1997; Wiseman and Baker 2007).

Alongside the mounting evidence of gendered educational inequality, there is also mounting evidence of a world culture that celebrates equality in education—particularly for women. How can this be? Egalitarian standards are institutionalized components of most social organizations and their policies. These institutionalized egalitarian standards are, in fact, firmly established in world society. Perhaps this culture of equality explains why gendered educational inequality appears to grow even when empirical evidence shows measurable (albeit incremental) progress toward equality for women. For example, as gender equity standards become institutionalized components of school policy and structure it becomes more likely that gendered inequalities will be both observed and identified as inequity. In this way a heightened awareness of gendered educational inequality has in some cases worked on behalf of women.

Although the cultural and social constructions of gender-based inequality are persistent social and educational problems, relevant empirical research and critical policy reports rarely concede that some progress is being made toward greater gender equality in school and society (Elwood 2005; Niemi 2005). This persistent focus on gender equity problems to the exclusion of positive outcomes is surprising given the increasing evidence that females in many nations are actually outperforming males in terms of educational achievement and attainment (Baker and LeTendre 2005; Mullis et al. 2000). And, when enrollment and achievement numbers in most nations are analyzed over time, the evidence shows that "girls have made even more progress than boys" since the 1980s (Lloyd 2005, 82).

Gender equality in education—when it exists—is the result of hard fought and narrowly won battles in many instances. This makes it even more important to analyze trends in gender differences in schooling and academic performance to find out which education-related efforts may be contributing to these success stories however few they may be. Of course, just when empirical evidence seems to be showing the rewards of this hard work there are still the persistent stereotypes of women and schooling (especially math and science education) that arise even in supposedly "enlightened" spheres of influence such as those found in higher education (Ramirez and Wotipka 2001;

Valian 2004). Yet, in spite of the prejudice and stereotyping that still unjustly exists, evidence has shown for some time that girls tend to get better grades in school, and newer evidence is showing that among children enrolled in school more girls around the world are attaining higher levels of education than boys (Downey and Vogt Yuan 2005; Le and Miller 2004; Luyten et al. 2003; Roderick 2003). This positive evidence is, unfortunately, not the focus of much of the discussion about gender and education.

THE GOOD NEWS AND THE BAD

First, the good news. The good news is that recent comparative, cross-national evidence shows a decline in gender differences in school access and achievement since the late 1960s and that there is increased gender equality in the early and middle school years (Baker and LeTendre 2005). As Figure 10.1 suggests, the institutional structure of mass schooling is such that when societal norms shift toward the expansion of gender equality through adult opportunities for women in the social, political, and economic arenas, gender parity in school achievement often increases. And, through improved adult opportunities and achievement, the shift of societal norms toward gender equality becomes more rapid.

The widespread "girls' education" movement has become central to most global education policies and multilateral agencies participating in or directing

FIGURE 10.1
The Impact of Mass Schooling on the Incorporation of Women

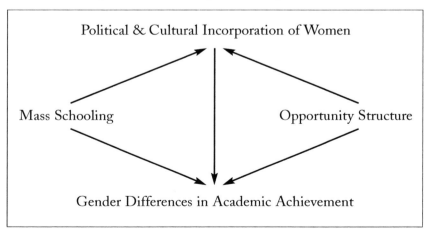

the development of nations around the world (UNESCO 2004; Wiseman and Baker 2007). International organizations such as the World Bank, UNICEF, UNESCO, and other international organizations have helped establish and maintain the girls' education movement, which significantly overlaps with the larger women's rights movement and most nations' formal educational policies (Berkovitch 1999; Chabbott 2003; Chabbott and Ramirez 2000). The far-reaching (some say overreaching) efforts of the 1990 Education for All conference and subsequent initiatives have focused on improving access to and the quality of education for girls and women. As a result, there is increased emphasis on girls' education even in nations that have maintained separate educational systems for girls and boys for social and cultural reasons. For example, Saudi Arabia, which has one of the most rigidly divided educational systems along gender lines, has the equal and increasing participation of girls and women in the public educational system as one of its core educational aims (Saudi Arabia Ministry of Education 2005).

Although this agenda is a relatively recent global phenomenon, improving girls' education is now part of the women's rights agenda in most nations around the world. A society that recognizes women as formal participants in and citizens of a nation-state often provides improved opportunities for women in higher education and the labor market, especially in traditionally male-dominated areas such as those related to science and mathematics (Ramirez and Wotipka 2001). And, as more and more countries or socio-ethnic groups have become "nation-states" the importance of individual citizenship overrides previous sociocultural divisions such as gender (Anderson 1996).

In modern, democratic nation-states, women as well as men are granted formal citizenship (Ramirez and McEneaney 1997). This formal recognition of women as members of and, officially at least, equal partners in the political as well as social culture affects access to and opportunity for formal schooling as well as available opportunities for adults in higher education and the labor force. In a society that formally recognizes women as citizens in the political, social, and economic community, these citizens expect equal access and opportunity in many areas, including schooling.

Modern mass schooling increasingly provides equality of access and opportunity to girls and boys alike—at least officially if not always in practice. Consequently, when girls and boys around the world go to school, especially in the elementary and early secondary grades, they go to the same schools, sit in the same classrooms, learn from the same teachers, and are taught the same curriculum and content. This shared schooling, by virtue of the students' formally equalized opportunity to learn, potentially reduces gender differences in achievement. The longer that girls and boys have the same opportunities to learn, resulting from mass schooling and shared curricula situations, the more equal their achievement becomes, according to this perspective.

Of course, gender parity in access to schooling is a significant concern for parents, educators, and policymakers worldwide. In a recent Education for All report from UNESCO, gender parity in access to education was identified as one of the key indicators of achieving education for all (UNESCO 2003). In fact, this report listed forty countries that had achieved gender parity in primary and secondary education enrollment and thirty-four that were likely to achieve gender parity in the next few years (109). While complete gender parity in educational access has certainly not been achieved in any nation around the world, significant strides have been made and many resources are focused on this effort (Wiseman and Baker 2007). Yet, in spite of these advances in gender parity in access to schooling, the persistent question of gender inequality in education continues to focus most intensely on academic achievement, especially in math and science.

One of the most recent cross-national studies of math and science achievement is the 2003 Trends in International Mathematics and Science Study, or TIMSS 2003, administered by the International Association for the Evaluation of Educational Achievement (IEA). The results of this study suggested that eighth grade girls and boys were not performing at significantly different levels in mathematics in most nations nor in many nations in science. Across the forty-six nations that participated in TIMSS 2003, the average gender difference in eighth grade mathematics achievement was nonsignificant. In fact, in twenty-eight of the forty-five countries (62%) there was no significant gender difference in math achievement. As Table 10.1 shows, there were, however, significant differences in eighteen countries (40%).

Of the eighteen countries showing a significant math achievement gender difference, girls—not boys—had significantly higher achievement in half of these countries. The nine countries posting higher average math scores for girls were Serbia, Macedonia, Armenia, Moldova, Singapore, the Philippines, Cyprus, Jordan, and Bahrain. Interestingly, there were also nine countries that showed boys scoring significantly higher than girls in math. The nine countries posting higher average math scores for boys were the United States, Italy, Hungary, Lebanon, Belgium (Flemish), Morocco, Chile, Ghana, and Tunisia. So in thirty-seven of the forty-six nations (80%) that participated in TIMSS 2003 there was either no significant difference in math achievement by gender or there was a significant girls' advantage over boys in math achievement. These numbers do not suggest widespread male dominance in math achievement—at least not at the eighth grade level in these countries.

The TIMSS 2003 results for eighth grade science achievement are somewhat different. As Table 10.2 shows, in twenty-eight of the forty-six countries (61%) participating in TIMSS 2003 boys scored significantly higher than girls on the eighth grade science test. There were still eleven countries where there was no significant gender difference in eighth grade science achievement

TABLE 10.1
Average National Gender Differences in Eighth Grade Math Achievement
(TIMSS 2003)

Significant Girl Advantage Math Achievement		*No Significant Gender Difference Math Achievement*	
Country	*Gender Difference*	*Country*	*Gender Difference*
Serbia	7	Slovak Republic	0
Macedonia, Rep. of	9	Sweden	1
Armenia	10	Indonesia	1
Moldova, Rep. of	10	Egypt	1
Singapore	10	Bulgaria	1
Philippines	13	Hong Kong, SAR	2
Cyprus	16	Estonia	2
Jordan	27	New Zealand	3
Bahrain	33	Japan	3
		South Africa	3
Significant Boy Advantage Math Achievement		Norway	3
		Russian Federation	3
		Slovenia	3
Country	*Gender Difference*	Botswana	3
United States	6	Romania	4
Italy	6	Lithuania	5
Hungary	7	Scotland	5
Lebanon	10	Korea, Rep. of	5
Belgium (Flemish)	11	Latvia	6
Morocco	12	Netherlands	7
Chile	15	Chinese Taipei	7
Ghana	17	Malaysia	8
Tunisia	24	Israel	8
		Palestinian Nat'l Auth.	8
		Iran, Islamic Rep. of	9
		Saudi Arabia	10
		Australia	13

Source: TIMSS 2003 International Mathematics Results: Findings From IEA's Trends in International Mathematics and Science Study at the Fourth and Eighth Grades by Mullis, I. V. S., Martin, M. O., Gonzalez, E. J., & Chrostowski, S. J. (2004), Chestnut Hill, MA: TIMSS & PIRLS International Study Center, Boston College.

(Egypt, Iran, Chinese Taipei, Botswana, South Africa, Lebanon, Singapore, Estonia, Cyprus, the Philippines, and New Zealand) and seven countries where girls scored significantly higher than boys in eighth grade science (Macedonia, Moldova, Armenia, the Palestinian National Authority, Saudi Arabia, Jordan, and Bahrain). More than one-third (39%) of the nations

TABLE 10.2
Average National Gender Differences in Eighth Grade Science Achievement
(TIMSS 2003)

Significant Girl Advantage Science Achievement		*Significant Boy Advantage Science Achievement*	
Country	*Gender Difference*	*Country*	*Gender Difference*
Macedonia, Rep. of 8		Lithuania	6
Moldova, Rep. of	8	Serbia	6
Armenia	13	Slovenia	7
Palestinian Nat'l Auth.	13	Latvia	7
Saudi Arabia	16	Sweden	8
Jordan	27	Norway	8
Bahrain	29	Romania	9
		Hong Kong, SAR	9
No Significant Gender Difference Science Achievement		Japan	9
		Malaysia	10
		Italy	10
Country	*Gender Difference*	Russian Federation	11
Egypt	1	Morocco	11
Iran, Islamic Rep. of	1	Indonesia	11
Chinese Taipei	1	Scotland	12
Botswana	2	Korea, Rep. of	12
South Africa	2	Bulgaria	15
Lebanon	3	United States	16
Singapore	3	Slovak Republic	16
Estonia	3	Israel	18
Cyprus	4	Australia	20
Philippines	7	Belgium (Flemish)	20
New Zealand	9	Tunisia	24
		Hungary	26
		Chile	29
		Ghana	35
		England	12

Source: TIMSS 2003 International Science Results: Findings From IEA's Trends in International Mathematics and Science Study at the Fourth and Eighth Grades by Mullis, I. V. S., Martin, M. O., Gonzalez, E. J., & Chrostowski, S. J. (2004), Chestnut Hill, MA: TIMSS & PIRLS International Study Center, Boston College.

showed either no significant gender difference or showed a significant girls' advantage in science achievement compared to boys.

Even though the science achievement story is not as positive as the math achievement one, the fact that there is as much equality or girls' advantage in math and science achievement as there is suggests that some improvements

have been made in the schooling of girls worldwide. For example, in both math and science, girls outperformed boys in countries where, according to some studies, they should not be. In particular, there have been studies and reports that have demonstrated the subordination of women and girls in traditionally Muslim nations (Fish 2002; Mehran 1997; Winter 2001), yet the TIMSS 2003 results show either no significant difference in girls' and boys' performance or they show girls outperforming boys by a significant margin in several predominantly Muslim nations including Bahrain, Egypt, Indonesia, Iran, Jordan, Malaysia, Palestinian National Authority, and Saudi Arabia.

Yet, there is still a marked difference in achievement by gender in the later years of secondary school and in post-secondary schooling in most nations. This is troubling. In sharp contrast to the good news outlined earlier, gender inequality in achievement often worsens in the secondary and post-secondary school years. Some interesting, but not often discussed, cross-national data tells this story quite plainly. Prior to TIMSS 2003 discussed earlier, the IEA and participating countries administered an earlier incarnation of the TIMSS almost ten years before in 1995. TIMSS 1995 assessed math achievement for students at three levels of schooling rather than two as TIMSS 2003 did. TIMSS 1995 addressed a third student population comprised of students in their final year of secondary school (U.S. twelfth grade equivalent).

The TIMSS 1995 students in the final year of secondary school posed a special situation and deserve unique explanation. Several characteristics of this sample population make it idiosyncratic. For instance, this "final year" sample is small. Only twenty-two countries participated in this sample in 1995 versus twenty-six and forty-one in the other two age/grades sampled. The final year of secondary school sample is also idiosyncratic in that some of the highest scoring countries in the other grade levels, such as Singapore, Korea, and Japan, did not participate in the final year of secondary school test. The most interesting idiosyncrasy, however, is that this sample represents less influence by a clear mass institutional structure than either of the other sample populations because of the nature of secondary schooling in general and the final or terminal year of secondary school in particular.

For example, the final year of secondary school may not be the same age/grade level for all students in all countries (Gonzalez and Smith 1997). Thus, the opportunity for variation in age, grade, and opportunity to learn is greater in the "final year" sample. In addition, the final year sample was divided into a "literacy" and an "advanced" group in mathematics. The literacy final year mathematics group consisted of all students in the final year sample, and the content of the test was considered grade and age appropriate for what students were expected to typically know during their final year of secondary school. The advanced final year mathematics group was tested on

advanced math content, such as calculus, which was not used when testing the literacy group.

Evidence from TIMSS 1995 shows that the size of mathematics achievement differences by sex varies more in the "final year" sample than in either of the other grades; in fact, the final year gender differences are two or three times as large as either of the other age/grade samples (e.g., gender differences for the final year math literacy sample range from 54.9 in the Netherlands to 5.3 in Hungary for a total range of 49.6, and the gender differences for the final year advanced sample range from 89.5 in the Czech Republic to 11.0 in Greece for a total range of 78.5). Overall, the final year gender differences in achievement fall into two categories: nations showing male advantage and nations showing no significant difference between boys' and girls' achievement scores.

In other words, there is no girls' advantage group in the final year sample. Also, the boys' advantage group is large in the final year sample (91% in literacy and 88% in advanced) whereas the nonsignificant difference group is small (9% and 12%, respectively). This is not a positive story at all, and the obvious question asks why there is such a dramatic shift in the small but positive trends in gender differences in achievement when students in the final year of secondary school are sampled. There are a few possibilities including the more critical explanations related to male hegemony and active female subordination. But, other sociological and organizational explanations exist as well.

In the final year of secondary school and for several years before in many situations, the curricular and course-taking arrangements of students shift from the sole control of schools to allow some parent and student preferences in course-taking. In other words, course selection becomes more choice-oriented in secondary school, and especially the upper grades of secondary school, than before. It is with this shift in institutional structure or, rather, institutional control, that an influx of social and cultural influences may penetrate the schools and increase gender differences in achievement even though schools as institutions support and formally encourage academic gender equality. Add factors such as increased or changing after-school activities, the effects of adolescent peer influence, parental encouragement, along with other, similar factors and, as a result, the stability and equality of the mass schooling institution shift somewhat.

One answer is to look at the institutional structure of education for elements that allow or encourage penetration of informal, nonschooling influences on students. This is often an unintended consequence of equity initiatives. In fact, in recent international studies of academic expectations of parents and teachers for students and of students themselves, females are expected and encouraged to do well in mathematics and attend university more often than males are (Baker et al. 2000). Boys, on the other hand, are

more frequently expected to become economically productive, which means they often drop or stop out of schooling earlier in their academic careers than girls do.

As more and more females are being encouraged as a result of favorable shifts in societal norms and improving adult opportunity structures to do well in and continue their studies of math in particular, inconsistent mathematics course-taking by females beginning in early secondary school may contribute to lower achievement means in more advanced mathematics during a student's later secondary or post-secondary school career. Therefore, while the institutional structure of modern mass schooling may have a positive effect on the academic achievement of girls relative to boys, the effect in the short term sometimes appears as increased gender disparity. Educational researchers and policymakers concerned with gender differences in achievement should take heart, however, because through "false" setbacks such as this the larger goal of gender equity becomes further institutionalized in the formal structure of schooling.

One of the more frequently discussed factors influencing girls' persistence and attainment in education in general and in math and science in particular is related to role models and perceived future opportunities—often referred to as the "pipeline" (Blickenstaff 2005; Hanson, Schaub, and Baker 1996; Holden 2002; Jayaratne, Thomas, and Trautmann 2003; Kulis, Sicotte, and Collins 2002). While previous studies rest their argument on the assumption that the perceived access to and anticipation of future opportunities for women shapes female students' current academic achievement and goals, there are other factors at play. The work of comparative sociologist Francisco O. Ramirez and his colleagues suggests that 1) the influence of women's citizenship and 2) the increased access to and participation in schooling impact not only the larger gendered opportunity structure, but also each other so that the effects of these factors, which are two of the most important influences on gender differences in achievement, are mutually enhanced (Ramirez, Soysal, and Shanahan 1997; Ramirez and Weiss 1979; Ramirez and Wotipka 2001). Indeed, the social, political, and economic incorporation of women as "citizens" is intricately connected to the global expansion of mass schooling and opportunities for women in the labor market.

THE CROSS-NATIONAL IMPACT OF THE INSTITUTIONAL STRUCTURE OF SCHOOLS

This combination of the political incorporation of women, increase in and effects of mass schooling, and decreased gender stratification of opportunity leads to changes in gender differences in achievement. The analyses that fol-

low test this statement. Specifically, these cross-national analyses use data from TIMSS 2003 to test whether 1) there is a combined influence of the political incorporation of women and mass schooling that does influence sex differences in mathematics and science achievement, and whether 2) the institutional structure of modern formal schooling may, in fact, have a positive effect on the academic achievement of girls relative to boys.

TIMSS 2003 provides the largest international dataset on mathematics and science achievement that is available (Martin, Mullis, and Chrostowski 2004). TIMSS 2003 collected data on individual students' math and science achievement, the background characteristics of students, teachers/classrooms, and schools as well as on students' and teachers' attitudes and activities in primary, early-secondary, and late-secondary grades in as many as forty-nine different countries. In particular, the analyses presented here use the TIMSS 2003 data for U.S. eighth gradeequivalent students.

Estimates from OLS regression models were used to determine the effects of the institutional structure of schools and other independent variables on gender differences in math achievement by country. The dependent variable is *gender differences in math achievement.* To measure mean gender differences in achievement, national mean gender differences in mathematics achievement from TIMSS 2003 were used (Mullis et al. 2004a and 2004b). These gender differences in mathematics achievement are given in Table 10.1. The international average gender difference in mathematics achievement is 1 (standard error = 0.6).

Three independent variables were used to estimate the three components of the theoretical model discussed earlier: 1) mass schooling, 2) opportunity structure, and 3) political incorporation of women.[1] Because the dependent variable data is cross-sectional, each independent variable is taken from the same year as the dependent variable data, namely 2003. An indicator of "school life" in years for females available from the UNESCO Institute for Statistics (mean = 14.643, sd = 3.681) was used to measure the effects of *mass schooling* on gender differences in achievement. This variable is an approximation of the total years that females are in school during ISCED 1–6. Because students are staying in school for longer periods of time as a result of modern mass schooling, this indicator acts as a proxy for the nearly universal enrollment that most mass schooling systems either observe or require.

A powerful indicator of a woman's opportunity for education and labor market participation—fertility rates—was used to measure the effects of *opportunity structure* on gender differences in achievement. This variable is a measure of the average number of births per woman in each country in 2003 (mean = 2.01, sd = .94). Fertility rate is a valid indicator of women's opportunity structure because in most countries women bear primary responsibility for child rearing—meaning that the more children a woman has the less likely

she is to pursue higher levels of education or a career outside of the home. It is important to remember that fertility rate is a reversed proxy for opportunity structure. In other words, as fertility rates rise the overall opportunity for women to advance in school or in the labor market decreases.

Finally, an indicator of the year that women were granted voting rights in each country available from the United Nations Development Programme (UNDP) was used to measure the effects of the *political incorporation of women* on gender differences in achievement. This variable is the first year that women were allowed to vote in any capacity, but it is important to note that in some nations this first instance only allowed partial voting rights (mean = 1936.20, sd = 24.04). It was hypothesized earlier that this incorporation measure should be positively associated with gender differences in achievement in the sense that they move in the same direction. In particular, as the year in which women gained voting rights decreases (i.e., becomes earlier in time), gender differences in achievement should also decrease. And, as the year in which women gained voting rights increases (i.e., becomes more recent), gender differences in achievement should be larger.

A baseline model for each independent variable was first estimated (see models 1–3 in Table 10.3). The baseline models suggest that each independent variable acts to significantly reduce gender differences in achievement. The "school life" proxy measure for mass schooling is significant and negative, which indicates that as females stay in school for longer and longer periods of time, gender differences in achievement tend to decrease. The fertility rate proxy for opportunity structure is significant and positive, which suggests that as fertility rates increase (i.e., opportunity structure decreases) gender differences in achievement also increase. On the flip side, as fertility rates decrease (i.e., opportunity structure increases) then gender differences in achievement tend to decrease. Finally, the voting rights proxy for the political incorporation of women is also significant and positive.

At first blush this positive coefficient for the political incorporation of women seems to suggest that as women gain the right to vote that gender differences in achievement begin to increase in the favor of boys, but this is not necessarily the case. The increase in gender differences is actually in favor of girls in many of the countries, so as Table 10.4 shows in countries where women were not granted voting rights until the later half of the twentieth century there is a mix of girls' and boys' advantage in math achievement. This is, in part, due to the fact that in some countries the voting rights measure follows closely with the age of the country (Ramirez, Soysal, and Shanahan 1997. In other words, the year in which women gained voting rights does associate somewhat with the year in which a country was established (i.e., gained its independence). In some of these countries, women were politically incorporated into society in other ways besides voting rights before officially gaining the right to vote.

TABLE 10.3

Cross-National OLS Regression of Math Score Gender Difference on Indicators of Mass Schooling, Opportunity Structure, and Political/Cultural Incorporation of Women

$DV = 8th$ Grade Math Score Gender Difference

Independent Variables	Model 1	Model 2	Model 3	Model 4	Model 5	Model 6
Mass Schooling	-0.592*	—	—	-0.304	0.174	0.383
	(0.293)			(.343)	(.394)	(.412)
Opportunity Structure	—	2.627*	—	2.409+	—	2.779+
		(1.148)		(1.360)		(1.537)
Political Incorporation	—	—	0.147***	—	0.174**	0.162*
			(.042)		(.060)	(.061)
Constant	16.809***	2.694	-276.368	7.772	-331.585**	-315.744*
	(4.426)	(2.543)	(82.092)	(6.903)	(119.836)	(121.559)
R^2	0.092	0.116	0.235	0.166	0.270	0.339
N	41	41	40	38	38	36

(stardard errors in parentheses)

$+p < .1$, $*p < .05$, $**p < .01$, $***p < .001$

TABLE 10.4
Gender Differences in Math Achievement
by Year That Women Received Voting Rights

	Significant Girl Advantage			*No Significant Gender Difference*	
Country	*Year Women Receive Right to Vote*	*Gender Difference in Math Achievement*	*Country*	*Year Women Receive Right to Vote*	*Gender Difference in Math Achievement*
Moldova, Rep. of	1978	10	Botswana	1965	3
Jordan	1974	27	Iran, Islamic Rep. of	1963	9
Bahrain	1973	33	Malaysia	1957	8
Cyprus	1960	16	Egypt	1956	1
Singapore	1947	10	Israel	1948	8
Macedonia, Rep. of	1946	9	Korea, Rep. of	1948	5
Philippines	1937	13	Japan	1945	3
Armenia	1921	10	Slovenia	1945	3
Serbia	•	7	Indonesia	1945	1
			Bulgaria	1944	1
			South Africa	1930	3
	Significant Boy Advantage		Romania	1929	4
			Lithuania	1921	5
Country	*Year Women Receive Right to Vote*	*Gender Difference in Math Achievement*	Slovak Republic	1920	0
			Netherlands	1919	7
			Latvia	1918	6
			Scotland	1918	5
Morocco	1963	12	Russian Federation	1918	3
Tunisia	1957	24	Estonia	1918	2
Ghana	1954	17	Norway	1907	3
Lebanon	1952	10	Australia	1902	13
Italy	1945	6	New Zealand	1893	3
Chile	1931	15	Sweden	1862	1
United States	1920	6	Saudi Arabia	•	10
Belgium (Flemish)	1919	11	Palestinian Nat'l Auth.	•	8
Hungary	1918	7	Chinese Taipei	•	7
			Hong Kong, SAR	•	2

Models 4–6 in Table 10.3 suggest that of the three independent variable categories, the political incorporation of women has the most impact on gender differences in math achievement. In particular, in Model 6 the coefficient of determination (i.e., R^2) is .339 with only thirty-six cases (nations). In other words, these three variables alone explain about one-third of the variation in gender differences in math achievement. While the coefficients resulting from these regression analyses are not extremely large, the estimates are statistically significant with a relatively small sample size (Ns range from 36 to 41). This sort of significance across nations suggests that there are some strong effects of mass schooling, opportunity structure, and the political incorporation of women. And, more specifically, the incorporation of women into the political and cultural community in these nations as evidenced by the years since women's voting rights were established has a significant impact on how well girls do in eighth grade math. So much so that adolescent girls are outperforming or performing on par with boys in most nations for which there is comparable data.

A CULTURE OF EQUALITY?

The results reported do not contradict the fact that gender inequality persists in society, the labor market, politics, and even in schools. These results, however, do confirm that progress toward gender equality is taking place—slowly but surely. Schools, in fact, are the locus for much of the progress that is being made, although there is still much more to be done in order for gender equality to be a consistent characteristic of educational systems around the world. Indeed, mass schooling has helped gender equality become part of a pervasive world culture. This same world culture is also impacting schools through the common structure and shared norms that mass schooling both incorporates and disseminates.

For example, the official policies and formal structures of modern mass schooling now largely avoid formal differentiation in schooling by gender. The global norm is no longer for boys to be assigned to more math and science classes and girls to more history and language courses. These distinctions still do exist, but they largely exist apart from the formal structure and form of modern mass schooling. Instead, quite the opposite has become an institutionalized component of schooling. One example is that girls are encouraged to take and sometimes are pushed into advanced math and science courses—sometimes beyond what they want or believe that they need.

Formal differentiation in schools by gender has largely shifted to formal differentiation in schools by academic achievement in modern mass schooling systems. For example, the official criterion for advancement into advanced math

and science courses is not a student's gender anymore in most schools around the world. Instead, in most cases, the official criterion for advanced math or science course enrollment is demonstrated academic ability. This shift from the more traditional stratification indicator of gender to a more performance-based criterion is typical in most school systems. Mass schooling has played a large part in making this happen. Once the entire school-age population was both given the opportunity to enroll and in most nations compelled to attend school, traditional gendered differentiation was no longer appropriate or effective.

Of course, the public and policymakers alike know that just because official policy says one thing it does not necessarily mean that other (and even opposite) things stop happening. For example, just making it illegal to discriminate in schools based on gender does not mean that gender-biased teachers, administrators, and others who work in schools are going to immediately stop. There also has to be a shift in shared norms and values both within and across communities for the desired changes to take effect. It was and still is the same with gender differences in school and in society. Mass schooling, however, has helped begin this shift in norms and values from one of differentiation to one of equality. Of course, increasingly equalized opportunity structures and the political incorporation of women contribute to this change in culture, but it is the legitimacy that mass schooling has brought to gender equality that has meant more than any official policy or law can do on its own. In this way, mass schooling has changed world culture and vice versa.

The Saudi Arabian educational system is a good example of the way that mass schooling and world culture have worked in concert to establish gender equality in education as a legitimate norm and value even in more traditional societies that are in many ways hostile to girls and women. Public schooling (apart from Qur'anic schools) is a relatively recent phenomenon in Saudi Arabia. The first public primary schools in Saudi Arabia began around 1930, and girls were not formally enrolled in public schools until about thirty years later in 1960. Yet, in spite of this early differentiation, some progress toward gender equality has occurred. Consider school enrollment rates by gender between 1970 and 2000 reported on King Fahd bin Abdul Aziz's official website. Of special note is that the king of Saudi Arabia has a portion of his official, government-sponsored website devoted to gender equality in education in the first place! The obvious question is why.

In large part, world culture is the reason why the Saudi king has gender enrollment statistics on his official website. The significance of this is important. Saudi Arabia is a society where women cannot vote or even drive, girls' and boys' education is officially divided, and there is a social and religious taboo that prevents men and women from different families from mixing or even meeting. Yet, the egalitarian influence of world culture has spread even to this society, and schooling is among the most important and in many ways

the most sacred of world cultural norms and values. In fact, public education is a more important and protected right for women than many other activities that would be considered fundamental in most western, democratic societies (such as voting and driving mentioned earlier).

Girls' enrollment has risen dramatically from only 25 percent of the total Saudi student population in 1970 to approximately 50 percent of the student population in 2000. Furthermore, the Saudi Arabian Ministry of Education declares that girls' education was developed to fulfill the social and economic requirements of the state (Saudi Arabia Ministry of Education 2005). This may indeed be true, but these social and economic requirements exist because of the world culture which legitimizes and places value on gender equality in school and in society. In addition to enrollment equity, Saudi Arabia has also made important advances in achievement equity among boys and girls. As discussed at the beginning of this chapter, Saudi Arabia is one of the countries participating in TIMSS 2003 that either posted significant girls' achievement advantages over boys (in science) or no significant difference between girls' and boys' average achievement (in math).

The Saudi example illustrates the impact that world culture has on education and the contribution that education can make to world culture—often in spite of specific social traditions and cultural values. The institutional structure of schools shapes and is shaped by world culture, and gender equality pervades world culture whether in Saudi Arabia or any other nation around the world. This world culture point of view goes beyond the more obvious explanations of overt or conscious social phenomena to include historically incremental social alignment of individuals, organizations, societies, and institutions.

World culture embeds nation-states in wider cultural meanings and contexts. Much of an organization's or a community's or a nation's legitimacy within the world system is the result of meeting internationally recognized standards for democratic nations. Having a well-informed and participatory citizenry, a strong civil society, and a government that guarantees state/society interactions are all internationally recognized democratic values. And, a key component of each of these democratic values is gender equality in society, the labor market, and the government. Mass schooling is one of the few global institutions that has this sort of impact on individuals' lives—to the point that the worldwide acceptance of gender equality as right and necessary in education and in society is not unique or surprising anymore.

NOTE

1. Other independent variables were included as estimates of the effects of national educational and economic environmental characteristics as well.

REFERENCES

American Association of University Women. 1995. *How schools shortchange girls, the AAUW report: A study of major findings on girls and education.* New York: Marlowe and Company.

———. 2001. *Beyond the "gender wars": A conversation about girls, boys, and education.* New York: Marlowe and Company.

Anderson, B. 1996. *Imagined communities: Reflections on the origin and spread of nationalism.* New York: Verso.

Ayalon, H. 1995. Math as a gatekeeper: Ethnic and gender inequity in course taking in the sciences in Israel. *American Journal of Education,* 104 (1): 34–56.

Baker, D. P. and G. K. LeTendre. 2005. *National differences, global similarities: Current and future world institutional trends in schooling.* Stanford: Stanford University Press.

Baker, D. P., A. W. Wiseman, G. K. LeTendre, M. Akiba, and B. Goesling. 2000. Cross-national gender differences and achievement, 1960s–1990s: Lessons for educational policymakers. Paper read at Consortium for Policy Research in Education Forum on TIMSS, at Washington, D.C.

Berkovitch, N. 1999. *From motherhood to citizenship: Women's rights and international organizations.* Baltimore: The Johns Hopkins University Press.

Bettie, J. 2003. *Women without class: Girls, race, and identity.* Berkeley: University of California Press.

Blickenstaff, J. C. 2005. Women and science careers: Leaky pipeline or gender filter? *Gender and Education,* 17 (4): 369–386.

Boli, J. and F. O. Ramirez. 1986. World culture and the institutional development of mass education. In *Handbook of theory and research for the sociology of education,* edited by J. G. Richardson, 65–90. New York: Greenwood Press.

Catsambis, S. 1994. The path to math: Gender and racial-ethnic differences in mathematics participation from middle school to high school. *Sociology of Education,* 67 (3): 199–215.

Chabbott, C. 2003. *Constructing education for development.* New York: Routledge-Falmer.

Chabbott, C. and F. O. Ramirez. 2000. Development and education. In *Handbook of sociology of education,* edited by M. Hallinan, 163–187. New York: Plenum.

Chase, S. E. 1995. *Ambiguous empowerment: The work narratives of women school superintendents.* Amherst: University of Massachusetts Press.

Chase, S. E. and M. F. Rogers. 2001. *Mothers and children: Feminist analyses and personal narratives.* New Brunswick: Rutgers University Press.

Downey, D. B. and A. S. Vogt Yuan. 2005. Sex differences in school performance during high school: Puzzling patterns and possible explanations. *Sociological Quarterly,* 46 (2): 299–321.

Elwood, J. 2005. Gender and achievement: What have exams got to do with it? *Oxford Review of Education,* 31 (3): 373–393.

Ferguson, A. A. 2000. *Bad boys: Public schools in the making of Black masculinity.* Ann Arbor: University of Michigan Press.

Fish, M. S. 2002. Islam and authoritarianism. *World Politics,* 55 (1): 4–37.

Gonzalez, E. J. and T. A. Smith (Eds.). 1997. *User guide for the TIMSS international database.* Chestnut Hill: International Study Center, Boston College, International Association for the Evaluation of Educational Achievement.

Hanson, S. L., M. Schaub, and D. P. Baker. 1996. Gender stratification in the science pipeline: A comparative analysis of seven countries. *Gender and Society,* 10 (3): 271–290.

Holden, C. 2002. Plumbing the science pipeline. *Science,* 298 (5597): 1331.

Jayaratne, T. E., N. G. Thomas, and M. Trautmann. 2003. Intervention program to keep girls in the science pipeline: Outcome differences by ethnic status. *Journal of Research in Science Teaching,* 40 (4): 393–414.

Kulis, S., D. Sicotte, and S. Collins. 2002. More than a pipeline problem: Labor supply constraints and gender stratification across academic science disciplines. *Research in Higher Education,* 43 (6): 657–691.

Le, A. T. and P. W. Miller. 2004. School-leaving decisions in Australia: A cohort analysis. *Education Economics,* 12 (1): 39–65.

Lesnick, A. 2005. On the job: Performing gender and inequality at work, home, and school. *Journal of Education and Work,* 18 (2): 187–200.

Lloyd, C. B. 2005. (Ed.) *Growing up global: The changing transitions to adulthood in developing countries.* Washington, D.C.: The National Academies Press.

Luttrell, W. 2003. *Pregnant bodies, fertile minds: Gender, race, and the schooling of pregnant teens.* New York: Routledge.

Luyten, H., R. Bosker, H. Dekkers, and A. Derks. 2003. Dropout in the lower tracks of Dutch secondary education: Predictor variables and variation among schools. *School Effectiveness and School Improvement.* 14 (4): 373–411.

Martin, M. O., I. V. S. Mullis, and S. J. Chrostowski (Eds.). 2004. *TIMSS 2003 technical report.* Chestnut Hill: TIMSS and PIRLS International Study Center, Boston College.

Maslak, M. A. 2003. *Daughters of Tharu: Gender, ethnicity, religion and the education of Nepali girls.* New York: RoutledgeFalmer.

———. 2005. Re-positioning females in the international educational context: Theoretical frameworks, shared policies, and future directions. In *Global trends in educational policy,* edited by D. P. Baker and A. W. Wiseman, 145–171. Oxford: Elsevier.

Mehran, Golnar. 1997. A study of girls' lack of access to primary education in the Islamic Republic of Iran. *Compare,* 27 (3): 263–277.

Meyer, J. W., J. Boli, G. M. Thomas, and F. O. Ramirez. 1997. *World society and the nation-state. American Journal of Sociology,* 103 (1): 144–181.

Mullis, I. V. S., M. O. Martin, E. G. Fierros, A. L. Goldberg, and S. E. Stemler. 2000. *Gender differences in achievement: IEA's third international mathematics and science study (TIMSS).* Chestnut Hill: TIMSS International Study Center, Boston College.

Mullis, I. V. S., M. O. Martin, E. J. Gonzalez, and S. J. Chrostowski. 2004a. *TIMSS 2003 International mathematics report.* Chestnut Hill: TIMSS and PIRLS International Study Center, Boston College.

———. 2004b. *TIMSS 2003 international science report.* Chestnut Hill: TIMSS and PIRLS International Study Center, Boston College.

Niemi, N. S. 2005. The emperor has no clothes: Examining the impossible relationship between gendered and academic identities in middle school students. *Gender and Education,* 17 (5): 483–497.

Ramirez, F. O. and E. H. McEneaney. 1997. From women's suffrage to reproduction rights? Cross-national considerations. *International Journal of Comparative Sociology,* 38 (June): 6–24.

Ramirez, F. O., Y. N. Soysal, and S. Shanahan. 1997. The changing logic of political citizenship: Cross-national acquisition of women's suffrage rights, 1890 to 1990. *American Sociological Review,* 62 (October): 735–745.

Ramirez, F. O. and J. Weiss. 1979. The political incorporation of women. In *National development and the world system: Educational, economic, and political change, 1950–1970,* edited by J. W. Meyer and M. T. Hannan, 72–82. Chicago: University of Chicago Press.

Ramirez, F. O. and C. Min Wotipka. 2001. Slowly but surely? The global expansion of women's participation in science and engineering fields of study, 1972–92. *Sociology of Education,* 74 (3): 231–251.

Roderick, M. 2003. What's happening to the boys? Early high school experiences and school outcomes among African American male adolescents in Chicago. *Urban Education,* 38 (5): 538–607.

Ross, H. 2002. Entering the gendered world of teaching materials, Introduction. *Chinese Education and Society,* 35 (5): 3–13.

Saudi Arabia Ministry of Education. 2005. Education for girls. Review of Reviewed Item, www.moe.gov.sa/openshare/EnglishCon/About-Saud/Education6.htm_cvt.htm

Stacki, S. L. and K. Monkman. 2003. Change through empowerment processes: Women's stories from South Asia and Latin America. *Compare,* 33 (2): 173–189.

Stromquist, N. P. 1995. Romancing the state: Gender and power in Education. *Comparative Education Review,* 39 (4): 423–454.

———. 1998. The institutionalization of gender and its impact on educational policy. *Comparative Education,* 34 (1): 85–100.

———. 2001. What poverty does to girls' education: The intersection of class, gender and policy in Latin America. *Compare,* 31 (1): 39–56.

UNESCO. 2003. *Gender and Education for All: The leap to equality.* Paris: Author.

———. 2004. *EFA global monitoring report 2004: Education for All: The quality imperative.* Paris: Author.

Valian, V. 2004. Beyond gender schemas: Improving the advancement of women in academia. *NWSA Journal,* 16 (1): 207–220.

Winter, B. 2001. Fundamental misunderstandings: Issues in feminist approaches to Islamism. *Journal of Women's History*, 13 (1): 9–41.

Wiseman, A. W. and D. P. Baker. 2007. Educational achievements in international context. In *Encyclopedia of gender and education*, edited by B. J. Bank. Westport, CT: Greenwood Press.

Looking Beyond the Household

The Importance of Community-Level Factors in Understanding Underrepresentation of Girls in Indian Education

AMITA CHUDGAR

"We don't educate girls in our community."
—Response of a rural parent when asked why their
daughter is not in school (The PROBE team 1999, 22)

S tudies from India show that even in the present day, Indian parents have very different views about how much educational attainment is appropriate for their sons and daughters. While 50 to 60 percent of parents say that sons should receive as much education as they desire, only 28 to 30 percent of parents say the same for their daughters (International Institute for Population Sciences 2001; The PROBE team 1999; The World Bank 1997; Shariff 1999; Jejeebhoy 1993)

In the following pages, I first explore how the strength of the prevailing structure may influence family decisions to educate their daughters in India. I then discuss a mechanism through which an increase in women's agency can lead to positive changes in the structures. These changes in the structure translate into increased female school participation. In the final section, I show empirical evidence from India to support the argument that the family's decisions to educate its children are influenced by the context and that an increase in women's agency at the community level is related positively to girls' schooling outcomes.

EXTERNAL INFLUENCES ON THE
FAMILY'S EDUCATION DECISIONS

Coleman's (1988) notion of "social capital" provides a useful framework to think about the processes through which decisions in the family are made. He introduces the idea of social capital as a "particular kind of resource" available to an actor. He specifies two elements that are common to different types of social capital that "consist(s) of some aspect of social structures, and (it) facilitates certain actions of actors—whether persons or corporate actors—within the structure" (Coleman 1988, S98). Specifically, he defines forms of social capital as obligation, expectations, and trustworthiness of structures, information channels and norms, and effective sanctions.

While Coleman's framework primarily addresses the positive or beneficial aspects of the structure (as reflected in the use of the term *capital*), it is important to recognize that his work also emphasizes the channels through which the "outside" interacts with the household. Once in place, these channels can facilitate positive as well as negative outcomes. He acknowledges norms' potentially restrictive nature when he notes that "this social capital, however, like the forms described earlier, not only facilitates certain actions; it constrains others." He further notes that, "Even prescriptive norms that reward certain actions ... are in effect directing energy away from other activities" (S105).

Once we acknowledge that through these norms and traditions the context may constraint certain actions, it is also easy to recognize that in a male-dominated society, many of these traditions and common practices more readily limit the school participation of girls compared to boys. And while, we may not "observe" prevailing traditions or norms, we observe the results of these norms in terms of negative attitudes toward educating female children and systematic underrepresentation of girls in schools. The recent Education for All Global Monitoring Report by UNESCO for instance, notes that, internationally, "the power of tradition" is one of the key reasons why girls are still held back from schooling (UNESCO 2003). The importance of these community influences and traditions is acknowledged in the national data collection exercise in India. National Statistical Survey Organization of India includes in their education survey "no tradition in the community" as one of the eighteen reasons why a child is currently not enrolled in school or has dropped out. Not surprisingly, more respondents offer this as a reason for a female child not being in school compared to a male child (National Sample Survey Organisation 1998).

To take a specific example of how a set of norms may affect human capital decisions; the social importance of marriage for a woman and the practice of hypergamy together give rise to a situation, that often negatively affects the education prospects of girls in India. If marriage is considered an important

adulthood outcome for a women, and if it is important that in a union the man ought to be equally or more educated than the woman, there is such a thing as being over-educated for the marriage market or being educated out of the marriage market. The education level of the pool of eligible men forms the threshold or the boundary for how far a girl may be educated. Her parents know that once their daughter acquires more education than that tacitly agreed upon threshold level, it will be harder to find her a suitor within the community. And thus the combination of prevailing norms that necessitate marriage as an important adulthood outcome for women and the practice of hypergamy together ensure that a girl child may be withdrawn from schooling sooner than she otherwise might have been. A recent survey in India on the status of basic education in India asked parents, if "an educated daughter (is) harder to marry?" While this question did not specify any given level of education, that is, "is it harder to marry a girl with a *certain level* of education," 27 percent of the parents said that it was harder to get an educated daughter married (The PROBE team 1999).

INCREASING WOMEN'S AGENCY AND STRUCTURAL CHANGES

The norms, or the structure defined by the norms, lead families to make different schooling choices about their male and female children. In this section I explore a mechanism through which norms change and become more equitable. I propose that in a community where women enjoy greater agency, they are able to redefine the existing structure through informal networks and the process of socialization.

In order to think about the role of women in the emergence and perpetuation of equitable norms, Martha Finnemore proposes that norms go through a three-stage life cycle: norm emergence, norm cascade, and norm internalization. Norms are "actively built by agents having strong notions of appropriate or desirable behavior in their community." They must compete with existing constellation of norms in order to gain acceptance. Norms cascade through the process of socialization. And finally when the conformity of the norm becomes automatic, the norms are internalized (Finnemore and Sikkink 1998, 896). According to Finnemore's framework, when women collectively exhibit greater agency, they also enjoy a greater capacity to reformulate the existing norms. The process by which these changes are accomplished may be a slow, unobtrusive process of change in the social structure. In other words, this collective of empowered women need not participate in an organized women's movement to question prevailing practices. As Purkayastha and Subramaniam (2004, 2) suggest, "Discussions of agency often center on a few individual women or

organized movements while overlooking a process of change discernible through a measure of collective voice instead of individual ones."

Drawing upon the collective presence of empowered women in their community, women engage in informal networks in their neighborhoods and create a space to critically examine existing practices and shape new ones. These are the kinds of networks that come about without any fanfare and are submerged in the broader social fiber. These networks are distinct from the organized women's movement as they have no membership requirements and no formal agendas. Their meetings might be episodic or unplanned, and participation depends on bonds of empathy and obligations between its female members. The salience of these networks may be their capacity to provide a sense of shared concerns while maintaining an understated presence. For instance, a study on the role of informal networks in contraceptive use in Mali (Adams, Simon, and Madhavan 2004) showed that women tended to be parts of large networks with the preponderance of network members residing in the same household or village. They found that these networks, especially when heterogeneous, were an important source of "social learning" about contraception and exposing women to ideas different from the ones they know.

Through "social learning" and "socialization" these informal networks perpetuate norms. The importance of socialization in imbibing values relates closely to the work of Hanna Papanek on socialization for inequality. Focusing on how gender inequalities spread in a society, she suggests that "in any one society or group, specific kinds of inequalities are systematically learned and taught from generation to generations so that, in effect, the moral basis of a society—its sense of justice—embodies and perpetuates these inequalities" (Papanek 2000, 1870).

Papanek notes that there is a prevailing sense of sociocultural entitlements to resource shares that is passed onto future generations through a process of social learning. Women play an important role in perpetuating these biases by what Papanek calls their "complicity" in the process of social learning and teaching (Papanek 1990). However, as Papanek notes herself, it is the same process of social learning and teaching of inequalities that hold the hope for change. To the extent that perpetuation of gender-biased norms happens through a process of socialization, the same channels may also be used to create a slow but definite positive changes in gender norms that in turn may be reflected in increased female school participation.

EMPIRICAL EVIDENCE: DATA SET AND VARIABLES

In this section, using household dataset from rural India, I show that when family decisions to educate male and female children are influenced by the context

of the family and agency of the woman who enjoy higher levels of agency, a distinct improvement in girls' schooling outcome is made.

The nationally representative household data on education is the primary data set. The data are collected by India's National Statistical Survey Organization (NSSO), in its fifty-second round (July 1995 to June 1996). A total of 43,076 rural and 29,807 urban households were surveyed (National Sample Survey Organisation 1998). I use another nationally representative data set on social status of women to calculate the district-level statistics and then merge these district-level indicators of social condition with the data set on education. These data are drawn from the second National Family Health Survey undertaken in 1998–1999 by the International Institute for Population Sciences (IIPS) in conjunction with the Indian Government's Ministry of Health and Family Welfare. The survey covered a representative sample of 90,000 women age 15–49 from twenty-six states that comprise more than 99 percent of India's population (International Institute for Population Sciences 2001).

In order to operationalize the concept of women's collective agency, I construct various measures at the district level. Districts are an important administrative and geographic unit of analysis. In recent years, increasingly educational policy dialogues in India have focused at the district levels. Additionally, compared to state- or regional-level measures districts offer far greater variation in terms of demographic structures, making such an analysis quantitatively more meaningful. In order to create district-level measures of women's agency, I created aggregate values that represented the agency enjoyed by women in a given district as a collective. Specifically I used women's overall literacy and education levels, their autonomy in family decision-making, and their exposure to media as measures of their agency and social status. Table 11.1 provides a detailed list of district-level variables used in the study. It is important to highlight that these district-level collective measures were created using data on women who formed the community of the girls analyzed in the study and not by using information on the girls themselves for whom the schooling outcome was analyzed.

Empirical studies on India have shown that, in terms of gender indicators, the country produces distinctly different outcomes from the two geographically (almost) contiguous zones formed by the northwestern and southeastern states, with northwestern states usually performing poorly compared to southeastern states (Sen 2001). In order to address these regional differences, I created a variable to identify northwestern states, where the variable = 1 if the states were Maharashtra, Gujarat, Rajasthan, Punjab, Haryana, Jammu and Kashmir, Himachal Pradesh, Uttar Pradesh, Madhya Pradesh, Bihar, union territories of Chandighar, Delhi, Goa, Dadar Nagar Haveli, and Daman, and Diu. The remainder of the states formed the category *southeast*. Overall 54 percent of national data fell into the northwest category and the remaining formed the southeast category.

TABLE 11.1
Description of District-Level Measures of Women's Collective Agency

Variable name	Variable description
Proportion of illiterate women in the district	Number of illiterate women in the district age 25 and above, divided by total number of women in the district age 25 and above. (The data are weighted.)
Proportion of women with education above higher secondary level in the district	Number of women with above higher secondary education in the district age 25 and above, divided by total number of women in the district age 25 and above. (The data are weighted.)
District-level indicator of women's autonomy in family decision-making	Principal component (PC) analysis was conducted on four questions: decisions about what to cook, buying jewelry, women's health, and women's freedom to visit their parental homes. The questions had five possible answers, which were ranked so that the highest value (5), stands for highest level of autonomy, i.e., the woman making the decision herself and the lowest value (1), stands for lowest level of autonomy. The data were weighted and so the appropriate method was used to calculate the PC. An index was created by scoring the first component. The first component has an eigenvalue of 2.36 and captures 59 percent of the variance in the four variables. Jewelry and visit decisions loaded most heavily on to the first component.
District-level indicator of women's exposure to media	Principal component analysis was conducted on three questions: exposure to news, TV, and radio. The data were weighted and so the appropriate method was used to calculate the PC. The answers were recoded so that higher value on any variable meant greater exposure to media. An index was created by scoring the first component. The first component has an eigenvalue of 1.66 and captures 55 percent of the variance in the variables. All three variables loaded almost equally into the first component.

METHODOLOGY

The data used for this study have a hierarchical structure with two levels. Level 1 is the individual child/family (I consider the child and the family as the same level), and level 2 is the district in which these children/families reside. I use Hierarchical Linear Models (HLM) to address these two levels in the data (Raudenbush and Bryk 2002).

The outcome variable of interest is dichotomous, where the variable takes the value 1 if the child is in school and 0 otherwise. At level 1, I predict the log odds of being in school versus being out of school for individual i in district j based on the individual/family-level variables. At level 2, I introduce one by one the four district-level variables that measure women's agency or collective social status to model the coefficient on female across districts. I also use the same level 2 variable as a predictor for the intercept to avoid the risk of a "confounding effect" where a level 2 predictor of the intercept "masquerades" as having an effect in the slope equation because the predictor was not introduced into the intercept model. From the perspective of this chapter, the modeling of the coefficient on female using the level 2 or the four district-level variables that measure women's collective social status are especially relevant. These results directly speak to the relationship between women's collective agency and the odds of school participation for an individual female child.

RESULTS OF EMPIRICAL ANALYSIS

Table 11.2 provides descriptive statistics comparing rural girls and boys who are in school versus those that are out of school. At the family level, in terms of literacy of the head of the household; average monthly household expenditure; and membership in traditionally disadvantaged groups, Schedule Caste (SC), and Schedule Tribe (ST), the girls in school are from the most privileged families and the boys out of school are from the most underprivileged families. These findings concur with the existing literature.

Table 11.3 presents the results of HLM analysis where the intercept term and the coefficient on female were modeled at level 2 using the district-level proportion of illiterate women. For convenience of interpretation, the results are presented as odds ratios. Model 1 presents the results for total rural data and models 2 and 3 present the results of applying the same model specification to the data for the two regions. The discussion of results from this table is presented in two parts: first, I discuss the HLM findings that are of primary interest, and then I discuss briefly the overall results from the three models.

Focusing first on HLM results; coefficient values of less than 1 for base, female represent that girls are less likely to be in school compared to boys. Specifically in model 1, the base coefficient for female is 0.47. 1 − odds ratio in this case gives us the value of the percentage by which girls are less likely to be in school compared to boys. For model 1, the odds that a girl is in school rather than outside school compared to a boy are (1 − 0.47), 53 percent less. These odds are especially low for the data from the northwest (model 2), 64 percent less, where as in the case of the southeast or model 3 the odds are 40 percent less that a girl will be in school rather than outside school compared

TABLE 11.2
Rural Children in and out of School Compared by Gender—
Means and (Standard Deviations)

	Male			Female		
Individual variables	In school	Out of school	Total	In school	Out of school	Total
Age	10.75	11.67	11.09	10.1	11	10.57
	(3.39)	(4.6)	(3.92)	(3.16)	(4.14)	(3.7)
Avg. monthly household	2013.2	1660.7	1880.8	2094	1723	1909
expenditure in rupees	(1143)	(847)	(1056)	(1183)	(925)	(1078)
Household size	6.4	6.3	6.39	6.54	6.6	6.5
Female head	.07	.7	.07	.08	.07	.07
Household head literate	.57	.30	.47	.65	.34	.49
ST	.08	.14	.10	.07	.13	.10
SC	.21	.26	.23	.20	.23	.22
Eldest	.26	.30	.27	.24	.26	.25
Youngest	.24	.19	.22	.22	.18	.20
Northwest	.62	.63	.62	.56	.66	.61
District-level variables						
Prop. illiterate women	.75	.81	.77	.72	.81	.77
Prop. women with higher education	.01	.01	.01	.01	.01	.01
Women's autonomy in family decision-making	−.01	−.08	−.04	.06	−.10	−.01
Women's exposure to media	.02	−.12	−.03	.12	−.14	−.007
N	27,741	11,022	38,763	17,205	12,930	30,135

Source: NSSO, Ministry of Statistics, Government of India fifty-second round, schedule 25.2 and NFHS 1998–1999.

to a boy. This observation is compatible with the established differences between northern and southern regions of the country.

Turning to the relationship between women's status as a collective at the district level and the odds of school participation for an individual female child, an increase in the proportion of illiterate women at the district level is further associated with a decline in the probability that a girl will enroll in school compared to a boy. Especially in case of the northwest, a unit increase in the proportion of illiterate women is associated with 94 percent further

TABLE 11.3

Results From HLM Model for Odds of School Participation,
Dependent Variable in School (1 = child in school, 0 = otherwise) by Region,
Rural—Level 2 Variable, District-Level Proportion of Illiterate Women

	All Data Model (1)	Northwest Model (2)	Southeast Model (3)
Female			
Base	0.47***	0.36***	0.60***
District-level proportion of illiterate women	0.13***	0.06***	0.30***
Age	2.8***	3.27***	2.59***
Age2	0.95***	0.94***	0.95***
Household size	0.88***	0.91***	0.80***
Female head	1.33***	1.46**	1.18
Household head literate	2.82***	2.94***	3.07***
Average monthly household expenditure in rupees	1.92***	1.78***	2.69***
ST	0.58***	0.52***	0.56***
SC	0.91	0.88	0.97
Eldest	0.99	0.93	1.10
Youngest	1.13**	1.11***	1.14
N, Level 1	68,894	39,388	29,506
N, Level 2	424	263	161

Source: NSSO, Ministry of Statistics, Government of India fifty-second round, schedule 25.2 and NFHS 1998–1999.

1. *** = p < .001; ** = p < .005
2. Results are reported as odds ratio.

reduction in the odds of a girl being in school compared to a boy. The same trend is true for the southeast. However, a unit increase in the proportion of illiterate women at the district level is associated with slightly lesser reduction (70 percent) in the odds of girls' school participation in the southeast.

In terms of overall results; the household variables have expected relationship with schooling outcomes. In general, children from large, poor, less-educated families are less likely to be in school. Specifically, a unit increase in age is positively associated with the odds of being in school across the three models. The coefficient on youngest children also concurs with the existing literature while the coefficient on eldest children is not significant. Youngest children have 11 to 14 percent higher odds of being in school compared to elder children in the household, depending on which of the three models is

interpreted. Literacy of the head of the household increases the odds of being in school versus out of school by 2.82 times in model 1 and is also related to schooling outcomes in the northwest and southeast. A 1000-rupees increase in a family's monthly average household expenditure, which is roughly one standard deviation change, increases the odds of being in school by 0.92 times in model 1 and by 1.69 times in the model from the southeast. Belonging to a female-headed household also increases the odds of a child being in school by 0.33–0.46 in model 1 and model 2; but interestingly, the gender of the head of the household is not significant in the data from the southeast. Children belonging to traditionally disadvantaged groups ST are less likely to be in school compared to children belonging to the reference category 'open' or the majority group where as the coefficient on SC is not significant.

In the discussion on the HLM results that follows, I will focus only on the coefficient on female and the intercept that I model using district-level variables from level 2. As seen across Tables 11.3–11.6, the overall findings for the rest of the independent variables in terms of magnitude, direction, and significance of the relationships are similar to those previously discussed here and thus not repeated for brevity.

Table 11.4 shows the HLM results where the intercept term and the coefficient on female were modeled at level 2 using a district-level proportion of women with higher secondary education or more. The results show that while such girls are less likely to enroll in school compared to boys, an overall increase in the proportion of women with higher secondary education or more in their district is related positively and significantly with the odds of a girls' school participation in model 1 and for the data from the northwest. Especially in the northwest, a unit increase in the proportion of women with higher secondary education or more in the girls' district is hugely beneficial to the odds of their school participation. For the data from the southeast, while the direction of relationship is positive, the coefficient is not statistically significant.

Results from Table 11.5 show that a unit increase at the district level in the autonomy enjoyed by women in family decision-making, or a unit increase in the collective measure of women's autonomy, is associated positively and significantly with the odds of school participation for girls. In the overall data or model 1, a unit increase in this district-level variable increases the odds of girls' school participation by 63 percent and in the case of data from the northwest a similar increase is associated with a 59 percent increase in the odds of school participation by girls. Once again the results for data from southeast, while in the expected direction, are not significant.

Finally Table 11.6 shows that an increase in women's exposure to media at the district level is also positively associated with the odds of girls' school participation. These findings are true for the overall data and both for northwest and southeast regions, where in each case, a unit increase in the level of

TABLE 11.4

Results From HLM Model for Odds of School Participation, Dependent Variable in School (1 = child in school, 0 = otherwise) by Region, Rural—Level 2 Variable, District-Level Proportion of Women with Higher Education

	All Data Model (1)	Northwest Model (2)	Southeast Model (3)
Female			
Base	0.44***	0.35***	0.56***
District-level proportion of women with higher education	431.9*	9553.4**	32.2
Age	2.8***	3.27***	2.58***
Age²	0.95***	0.94***	0.95***
Household size	0.88***	0.91***	0.80***
Female head	1.36***	1.46***	1.19
Household head literate	2.90***	2.95***	2.84***
Average monthly household expenditure in rupees	1.94***	1.80***	2.70***
ST	0.58***	0.52***	0.56***
SC	0.92	0.88	0.97
Eldest	0.98	0.93	1.05
Youngest	1.14***	1.11***	1.14
N, Level 1	68,894	39,388	29,506
N, Level 2	424	263	161

Source: NSSO, Ministry of Statistics, Government of India fifty-second round, schedule 25.2 and NFHS 1998–1999.

1. *** = p < .001; ** = p < .005; * = p < .01; + = p < .05
2. Results are reported as odds ratio.

women's media exposure at the district level increases the odds of girls' school participation by between 25 to 93 percent.

In summary, these findings show that an improvement in women's collective social status at the district level is associated with an increase in the odds that more girls will enroll in school from that district. In other words, after controlling for family-level variables, a significant variance across districts in the odds that a girl would participate in schooling compared to a boy can be explained by modeling the coefficient on female using district-level variables that measure women's agency as a collective. Though in general girls are less likely to attend school compared to boys, improvements in these community-level conditions mitigate some of the negative effects and actually help raise the odds of female school participation. While the findings for

TABLE 11.5

Results From HLM Model for Odds of School Participation,
Dependent Variable in School (1 = child in school, 0 = otherwise) by Region,
Rural—Level 2 Variable, District-Level Indicator of Women's Autonomy

	All Data *Model (1)*	*Northwest* *Model (2)*	*Southeast* *Model (3)*
Female			
Base	0.47***	0.36***	0.58***
District-level indicator of women's autonomy	1.63***	1.59***	1.21
Age	2.8***	3.27***	2.4***
Age^2	0.95***	0.94***	0.95***
Household size	0.88***	0.91***	0.80***
Female head	1.38***	1.47***	1.26
Household head literate	2.94***	2.95***	3.07***
Average monthly household expenditure in rupees	1.92***	1.79***	2.71***
ST	0.57***	0.51***	0.57***
SC	0.91	0.88	0.93
Eldest	0.98	0.93	1.10
Youngest	1.14***	1.11***	1.14
N, Level 1	68,894	39,388	29,506
N, Level 2	424	263	161

Source: NSSO, Ministry of Statistics, Government of India fifty-second round, schedule 25.2 and NFHS 1998–1999.

1. *** = p < .001; ** = p < .005; + = p < .05
2. Results are reported as odds ratio.

two district-level variables are not significant for the southeast, overall these findings are powerful given their consistency on the whole across different models.

CONCLUDING THOUGHTS

To view families as rational agents devoid of their context is inadequate to understand gender differences in school participation. While families have the agency to decide the schooling investment in their children, the structure or the community within which they live also influences them. In male-dominated societies, the existing norms and structure, more often than not, disadvantage the girl

TABLE 11.6

Results From HLM Model for Odds of School Participation,
Dependent Variable in School (1 = child in school, 0 = otherwise) by Region,
Rural—Level 2 Variable, District-Level Indicator of Women's Exposure to Media

	All Data Model (1)	Northwest Model (2)	Southeast Model (3)
Female			
Base	0.43***	0.37***	0.56***
District-level indicator of women's exposure to media	1.73***	1.93***	1.25*
Age	2.98***	2.94***	2.58***
Age^2	0.95***	0.93***	0.95***
Household size	0.88***	0.92***	0.81***
Female head	1.32***	1.46***	1.18
Household head literate	2.88***	2.94***	2.85***
Average monthly household expenditure in rupees	2.00***	1.78***	2.68***
ST	0.53***	0.52***	0.57***
SC	0.91	0.88	0.97
Eldest	0.99	0.93	1.09
Youngest	1.12***	1.11+	1.13
N, Level 1	68,894	39,388	29,506
N, Level 2	424	263	161

Source: NSSO, Ministry of Statistics, Government of India fifty-second round, schedule 25.2 and NFHS 1998–1999.

1. *** = $p < .001$; ** = $p < .005$; + = $p < .05$
2. Results are reported as odds ratio.

child. The effects of these norms are reflected in underrepresentation of girls in school. However as Giddens persuasively argued, just as the structure influences families, the structure itself is also subject to change and influences (Giddens 1984, 25). More specifically, in a given community, if women enjoy greater agency, they may be able to positively influence the norms in the community, which in turn would be reflected in improvement in the odds of female school participation. The data support these propositions. The results repeatedly show that while girls are less likely to participate in school compared to boys for any given model, in all the cases, an improvement in the community-level measures of women's agency improves the odds of girls' school participation.

The four variables used here to measure women's collective social status capture women's agency or lack of agency. While these are four separate

variables, conceptually they are inextricably linked. In a community if overall more women are actively participating in what happens inside their families from financial to health decisions, if overall more women have higher education, if more women are exposed to the outside world through news and entertainment, or if fewer women are illiterate these are all separately and collectively indicators of greater empowerment enjoyed by women.

The positive impact of an increase in women's agency as a collective on girls' school participation holds tremendous hope for change in the current conditions in India and in various other developing countries. As cited earlier, the recent UNESCO report notes that "tradition" is one of the key reasons globally that leads to underrepresentation of girls in schools. The findings from this study show that, while this may be true, existing norms that negatively affect girls may be changed by improving women's status as a collective in the communities in which these girls live.

REFERENCES

Adams, A. M., D. Simon, and S. Madhavan. 2004. Women's social support networks and contraceptive use in Mali. In *The power of women's informal networks: Lessons in social change from South Asia and West Africa*, edited by B. Purkayastha and M. Subramaniam, 162–181. Lanham: Lexington Books.

Behrman, J. R., A. D. Foster, M. R. Rosenzweig, and P. Vashishtha. 1999. Women's schooling, home teaching, and economic growth. *The Journal of Political Economy*, 107 (4): 682–714.

Coleman, J. S. 1988. Social capital in the creation of human capital. *The American Journal of Sociology*, 94 (Supplement: Organization and Institutions: Sociological and Economic Approaches to the Analysis of Social Structure): S95–S120.

Finnemore, M. and K. Sikkink. 1998. International norms and political change. *International Organization*, 52 (4): 887–917.

Giddens, A. 1984. *The constitution of society: Outline of theory of structuration*. Cambridge, Berkeley: Polity Press, University of California Press.

International Institute for Population Sciences. 2001. National Family Health Survey India: 1998–1999. Mumbai: IIPS, Measure DHS+, ORC Marco, USA.

Jejeebhoy, S. 1993. Family size, outcomes for children, and gender disparities: Case of rural Maharashtra. *Economic and Political Weekly*, 28: 1811–1821.

National Sample Survey Organisation. 1998. Attending an educational institution in India: Its level, nature and cost. New Delhi: Department of Statistics, Government of India.

Papanek, H. 1990. To each less than she needs, from each more than she can do: Allocations, entitlements, and value. In *Persistent inequalities: Women and world development*, edited by I. Tinker, 162–181. New York: Oxford University Press.

————. 2000. Socialization for inequality. In *Routledge international encyclopedia of women*, edited by C. Kramarae and D. Spender, 1870–1874. New York: Routledge.

Purkayastha, B. and M. Subramaniam (Eds.). 2004. *The power of women's informal networks: Lessons in social change from South Asia and West Africa*. Lanham: Lexington Books.

Raudenbush, S. W. and A. S. Bryk. 2002. *Hierarchical linear models: Applications and data analysis methods, advanced quantitative techniques in the social science series*. London: Sage.

Sen, A. 2001. Many faces of gender inequality. *Frontline*, November 9.

Shariff, A. 1999. India: Human development report: A profile of Indian states in the 1990s. New Delhi: National Council of Applied Economic Research.

Subramaniam, R. 1996. Gender-bias in India: The importance of household fixed-effects. *Oxford Economic Papers*, 48 (2): 280–299.

The PROBE team. 1999. Public report on basic education in India. New Delhi: The Probe team and Center for Development Economics.

The World Bank. 1997. *Primary education in India: Development in practice*. Washington, D.C.: The World Bank.

UNESCO. 2003. South and East Asia Regional Report. Canada: UNESCO Institute for Statistics.

PART IV

Women and the Research Setting: The Intersection of Structure and Agency in Methodologies

CHAPTER 12

Life's Structures and the Individual's Agency

Making Sense of Women's Words

FLAVIA RAMOS

"This is like making history, portraying our stories."
—Luz, a sixty-four-year-old Puerto Rican woman

I n this chapter the personal histories and collective memories of a group of low-income Hispanic women are examined through the application of an innovative research tool—the FotoDialogo method (Ramos 1999)—that uses pictures and storytelling as projective techniques. The FotoDialogo method uses a set of original drawings to initiate dialogical interviews, to inspire research participants to tell their stories, and to critically analyze the situations presented in these stories. The development and implementation of this technique is explored, as well as the methodological framework. I also examine how Hispanic women and girls' cultural and social reproductions affect their ability to succeed in a new culture. Last, I explore themes that emerged during the FotoDialogo sessions that illustrate how the women's socialization perpetuates their low social positions, and how dialogue can be used to break that cycle.

THE FOTODIALOGO METHOD
AND THE PARTICIPANTS

FotoDialogo is a qualitative research and nonformal education method I developed and tested on a participatory research[1] project that took place at a

community-based organization (CBO) located at the core of the Hispanic community in Springfield, Massachusetts. In this process, the researcher develops a set of tools—pictures and storytelling as projective techniques—for helping groups of people identify their own problems and work out options for handling them. The FotoDialogo pictures (see Figure 12.1) were inspired by real-life stories told by inner-city women of color. The name was suggested by a woman who said, "What we are creating here is a *fotonovela*[2] of our own lives!" Since the method evolved from dialogue generated by the pictures, we named it *FotoDialogo*.

The method uses a series of thirty black-and-white drawings, each depicting different facial expressions of men, women, and children; and scenes of life situations familiar to the participants. The pictures are drawn based on recurrent themes identified in interviews with participants, are left open to interpretation, and can be arranged in any sequence. My previous experiences as a graphic artist and playwright allowed me to draw the pictures as illustrations of life-based narratives (Phillion and He 2004).[3] I also used collage or cut-outs from magazines. These were often used as a game in which participants are asked to group the pictures into a story sequence and then verbally reflect upon the issues brought up in the storylines. query

Committed to the principles of liberating education, and with the goal of developing and testing the usefulness of the FotoDialogo method, I engaged in dialogue with a group of low-income Hispanic inner-city residents, community-based organizations, and an array of human and health service providers. The method involved two parallel activities: The Latina Women's Dialogue Group (LWDG[4]), consisting of weekly dialogue sessions[5] involving a group of over twenty Hispanic women between the ages of 55 and 70 years old who used the FotoDialogo pictures to illustrate their oral histories, and focus group interviews with and observations of a group of seven adolescent girls from the Sisters' Empowerment Program. I met with

FIGURE 12.1
FotoDialogo Pictures Used to Create "A Woman's Lifeline"

the adolescent girls a dozen times under the auspices of the community-based agency's Sisters' Empowerment Program. I had agreed with the program director to conduct the research study as well as to involve the participants in educational activities that would foster self-esteem and personal development.

Experiential Learning, a model of learning developed by David Kolb (1984), seemed to be an appropriate method to engage the young women in a learning process in which they were active participants instead of recipients of information. Kolb's experiential learning theory is based on John Dewey's emphasis on the need for learning to be grounded in experience, Kurt Lewin's work that stressed the importance of a person's being active in learning, and Jean Piaget's theory on intelligence as the result of the interaction of the person and the environment (Geyer 1975).

I gathered a series of activities and exercises that would serve as concrete experiences upon which the adolescent girls would reflect and then relate to their own life situations. These activities included storytelling, community mapping, and drawing of lifelines. The purpose of these exercises was to get to know the participants, help them reflect upon their social environment, and create a safe space for the young women to tell their experiences from their own cultural perspective. These learner-centered approaches to teaching/learning not only helped put the young women at the center of their learning, but also allowed their voices to emerge, as they related their life experiences to broader social issues affecting their communities.

The FotoDialogo method has a double purpose of investigating perceptions of social reality and raising consciousness among participants of the issues they want to understand and to do something about. Thus, the Foto-Dialogo method is a research tool that aims at building shared meaning through dialogue between researchers/educators and adult learners.[6]

Key elements in Paulo Freire's thematic investigation (Freire 1971, 1973, 1974, 1984, 1985, and 1997) and Henry Murray's Thematic Apperception Test (Murray 1938, 1943, and 1951) provided the guiding methodological framework for the development of the FotoDialogo method. Thematic investigation was employed by Freire and his colleagues in Latin America during their literacy campaigns in order to develop a program relevant to illiterate learners. Freire's literacy method had a two-fold goal of teaching illiterates how to read and write while raising their consciousness to critically analyze their living conditions. Freire (1971, 1973, and 1997) suggests that reflection upon and analysis of people's ways of living must precede any action of critical education. The object of thematic investigation is to examine the language with which people refer to reality, how they perceive that reality, and their view of the world.

Thematic investigation involves three stages: 1) investigation of thinking, 2) thematization (by means of generative words and other codifications), and

3) problematization of social reality (Freire 1997). In the first stage of the investigation, the researcher organizes informal meetings during which participants can talk about certain moments in their lives. Themes and contradictions identified in these meetings are then selected and developed into codifications to be used in the thematization stage. Codifications are images of some significant aspect of the participants' concrete reality, usually conveyed by some type of media (e.g., theater, slides, and stories). After preparing the codifications, investigators begin the decoding dialogues, a process of description, interpretation, and analysis of a concrete, existential, "coded" situation. During the decoding process, the facilitator poses as problems both the codified situation and the participants' own answers.

The Thematic Apperception Test (TAT), introduced by Murray in 1943, is a personality test that consists of a series of black and white drawings commonly used as projective techniques in psychiatric interviews. Projective techniques—using pictures and storytelling as a way to assess individual attitudes, knowledge, and perception—have long been a research tool largely used in clinical psychology, psychiatry, and cultural anthropology.[7] The underlying assumption behind these techniques is that humans tend to project their personal needs and inclinations into verbal responses (Pelto and Pelto 1978). The basic procedure of these tests consists of asking informants to respond verbally to some kind of media presented to them by the researcher. The interpretation of the TAT is made mostly on a qualitative basis; there is no single standardized scoring procedure for TAT responses.

Combining the dialogical approach of Freire's thematic investigation and the administration of projective techniques in Murray's TAT, the FotoDialogo method asks participants to create life-based narratives and reflections of their past and present actions. The ultimate goal is to achieve self-awareness. Ira Goldenberg (1978, 174) explains, "in a fundamental way the need for a sense of self is oriented toward the reconstruction of one's past, toward the discovery of one's racial, sexual, and ethnic prehistory, and toward recapturing the roots of one's group heritage."

MAKING SENSE OF MAJOR THEMES
REVEALED IN DIALOGUE: HABITUS AND FIELD

Family—both nuclear and extended—is a highly valued institution in Latin American cultures and one primary theme revealed in this research. *Familismo*, or the importance of the family as a social unit and source of support, is also a cultural trait and a way in which individuals are connected to the outside world. The family theme emerged from the data collected from Hispanic women's LWDG group as they described their "natural support systems"

(Delgado 1995). The members of the group were very family oriented and regarded their extended family as their most important social group and source of support. They also felt obligated to their family members, and were willing to sacrifice time and resources for their relatives. The level of interdependency among family members was very high.

HIV/AIDS was another theme revealed in this work. The women themselves, their spouses, or other relatives had some problems connected to the use of alcohol, crack, cocaine, marijuana, or tobacco. The women in the LWDG described the cycle of substance dependence. They described its beginnings as an involuntary alienation to escape from their problems, then evolving to drug addiction, then AIDS, and then back again to drug use as a way to alleviate the pain caused by further alienation from AIDS. This fatalistic viewpoint of human life reveals a naïve consciousness in which life is described as a series of uncontrollable events leading to death. This limited view of the world leaves out other possibilities and ways of being, and paradoxically leads to blaming the victims without considering the system—or the social structures—in which they are immersed. Goldenberg, a clinical psychologist, defines the withdrawal into drugs, violence, and despair (the sense of meaninglessness of life) as symptoms of oppression (Goldenberg 1978).

The women's voices, sometimes powerless and depersonalized, described situations of extreme oppression concerning both the family and their HIV/AIDS condition. Using the FotoDialogo method, the storytellers portrayed the female characters as caregivers, as self-sacrificing women who are struggling for survival,[8] as giving and forgiving companions, and as victims of varied forms of oppression. Throughout the sessions, the women's voices appeared to grow stronger as they unmasked the myths of their own inherited powerlessness and began renaming their experiences of struggle as a fight for self-assertion. As Mary Field Belenky and her associates point out in the *Women's Ways of Knowing* study (1986, 164), "gaining a voice and developing an awareness of their own minds are the tasks that [these] women must accomplish if they are to cease being either a perpetrator or a victim of family violence." We witness in these testimonies the life histories of women whose access to power and education has been hindered by a number of factors, including cultural beliefs rooted in patriarchal values.

It appears that the women in the Latina Women's Dialog Group (LWDG), for reasons deeply rooted in fear, had adapted their behavior to face situations in which they felt that they had no power to control or change. Some of these women realized the limitations their socialization has imposed on them. As the stories were exposed, so were the underlying issues that perpetuated their poverty. As they became aware of these issues, the women were able to change their perceptions and in turn were able to face their everyday issues.

Critical reflection of emerging themes helps oppressed women to diagnose the social ills that have affected their lives, and to challenge the previously held notions and perceptions of reality. The low-income Hispanic women and adolescent girls expressed their concerns about the disabling effects of social, cultural, and economic marginalization of the low-income Hispanic community in the United States. Not only did the dialogue sessions disclose their consciousness about their oppressed place in these situations, they also enabled them to express themselves freely, asserting their human rights and taking part in the process of self-transformation and re-creation of the world around them. In short, the FotoDialogo workshops appeared to enable the women to become aware of their challenges and to break the cycle that allows cultural and social reproduction.

The work of the French sociologist and philosopher Pierre Bourdieu may offer insight to help us understand how these social structures are inextricably linked to the women's education in this case study.

Habitus and Field

Bourdieu uses the concepts of *habitus* and *field* as key ideas in the study of social inequalities, the role of education, and cultural factors in the lives of those occupying subordinate positions in society. *Habitus* is a ". . . system of lasting, transposable dispositions which, integrating past experiences, functions at every moment as a matrix of perceptions, appreciations and actions . . ." (Bourdieu and Passeron 1990, 82–83). Habitus, as a product of social conditioning, links actual behavior to structure. There are limited choices and dispositions, or readiness for action within a certain habitus. According to this notion, a person relies upon a store of scripts and a store of knowledge that present that person with a certain view of the world and ways of behaving within it.[9] *Field*, on the other hand, is a social arena in which people struggle over desirable resources to analyze power relationships in society. It is a ". . . network [and] configuration of objectively defined positions, imposed on agents or institutions by their present and potential situation (*situs*), in the structure of the distribution of species of power . . ." (Bourdieu and Wacquant 1992, 978). The relationships between the individuals' agency (or lack thereof) and the economic, social, cultural, and religious structures that define them may be explained with Pierre Bourdieu and Loïc J. D. Wacquant's concept of field. Bourdieu suggests that an analysis of field requires three interconnected actions. First, one must analyze the position of the field vis-à-vis the field of power. Second, one must map out the objective structure of the relations between the positions occupied by the agents or institutions who compete for the legitimate form of specific authority of which this field is the site. And third, one must analyze the habitus of agents, the different sys-

tems of dispositions they have acquired by internalizing a determinate type of social and economic condition, and which find a definite trajectory within the field under consideration a more or less favorable opportunity to become actualized (Bourdieu and Wacquant 1992, 104–105).

Pierre Bourdieu and Jean Claude Passeron's (1973) concept of cultural reproduction—which may include the existence of disadvantages and inequalities passed down from one generation to the next—complements the concepts of habitus and field in this case study. For instance, children of dominant-class families learn certain cultural behaviors that are necessary for educational success in modern societies and to maintain their class position. Whereas, children of working-class, ethnic, and linguistic minorities may not have learned the same set of cultural behaviors that would enable them to reach the educational goals set by the dominant class. According to Bourdieu, the educational system and other social institutions play key roles in the process of cultural reproduction. Social institutions, such as family, and life-threatening conditions, such as HIV/AIDS and drug addiction, are also related to the process of *socialization*. The family and health conditions influence the ways by which, and in which, an adolescent young woman becomes a sociable person. These situations also offer *social control*—ways of keeping people in line by determining what actions are accepted and approved in the social system.

In order to understand cultural reproduction, one must also examine the structure of capital and the various forms of agency as they are passed from one generation to the next. Bourdieu (1986, 241–358) distinguishes four forms of capital: 1) *economic capital*: command over economic resources; 2) *social capital*: resources based on group membership, relationships, networks of influence and support; 3) *cultural capital*: forms of knowledge, skill, education, any advantages people have that give them a higher status in society;[10] and 4) *symbolic capital*: accumulated prestige and honor (Mesthrie, Swann, Deumert, and Leap 2000; Moores 1993).

The Hispanic women and adolescent girls lacked all four types of capital. Most of the older women in the LWDG came from the lower social classes of Puerto Rico with little formal education, and therefore did not possess significant economic capital. Some were illiterate in Spanish and the majority did not speak or read English. They never assimilated into mainstream "American" culture. They kept their language, cultural values, religion—primarily Roman Catholic—and eating habits almost intact, regardless of how long they stayed on the mainland. While they had strong ties to their families, they lacked the social and cultural capital to succeed in the American system. The women did not consider themselves in positions of honor. The same was true of the adolescent girls. Most of them came from working-class families, or families headed by women, many of them single mothers on welfare. Most of the teens had been educated in the U.S. public school system. They

are all bilingual, bicultural, and seemed to function well in the American system. However, they identified themselves as Hispanics, and are perceived as so by their peers. The teens complained about the way they were treated by their peers in school, and about the wide spread of derogatory stereotypes held against Hispanics; hence, they too were not included in the most popular cliques in school. These stereotypes illustrate their lack of cultural, social, and symbolic capital (Nieto 1999).

Bourdieu's work is especially helpful to understand the interrelatedness of social structure and agency in this setting. "Bourdieu's conceptual formation does not oppose individual and society as two separate sorts of being—one external to the other—but constructs them relationally as if they are two dimensions of the same social reality" (Swartz 1997, 96). In a similar way, we cannot completely distinguish biography from history, as C. Wright Mills (1959, 6) suggests in *The Sociological Imagination*:

> We have come to know that every individual lives, from one generation to the next, in some society; that he lives out a biography, and that he lives it out within some historical sequence. By the fact of his living he contributes, however minutely, to the shaping of this society and to the course of its history, even as he is made by society and by its historical push and shove.

In listening to women's personal histories, and encouraging their "voice,"[11] we not only give them a chance to be heard, but we also give their stories biographical significance. While recording women's stories, we must consider how the political, historical, economic, social, and cultural structures interpenetrate the very core of the systems meant to advance women's condition, and to acknowledge the limitations these structures impose on women's agency. Critical analysis of the intersections between biography and history, described in the interaction between and among individuals and social structures, enables participants to free themselves from socially prescribed roles that perpetuate women's oppression. By engaging in collective dialogue and critical thinking, low-income Hispanic women and adolescent girls emerge from a "culture of silence" to a "culture of voice."

Paulo Freire refers to the "culture of silence" in many of his works as a term to define a state of being characteristic of many dependent societies and traditionally subordinate groups. According to Freire (1985, 72), this mode of culture is "a super-structural expression that conditions a special form of consciousness" and "the culture of silence over-determines the infrastructure in which it originates." Furthermore, he explains that:

> This culture is a result of the structural relations between the dominated and the dominators. Thus understanding the culture of silence presupposes an

analysis of dependence as a relational phenomenon that gives rise to different forms of being, of thinking, of expression, to those of the culture of silence and those of the culture that "has a voice." (Freire 1997, 72)

Understanding the intricate dynamics of the "culture of silence"—and announcing its very existence—is the main purpose of Freire's conscientization process. Freire believed that the conscientization process happens not only through an intentional educational program, but also through structural changes happening in society. In other words, critical thinking does not develop spontaneously, it happens through a critical educational process that must emerge from the action of social change. The dialogues throughout this group's discussion furthered that "culture of voice."

DISCUSSION

The FotoDialogo method's illustrated narratives of the group of poor Hispanic women offered one way of viewing the interconnected actions in which they reflected upon their life histories. Researcher/facilitator and participants/learners using the FotoDialogo method are asked to reflect upon the effects of their own positions and consider their own set of internalized structures. In this process, we observe that when women and adolescent girls are invited to revisit past experiences and critically analyze certain life situations and admonitions, they become conscious of the learned behaviors and dispositions that have entrapped them in subordinate positions. For example, through the process of collective dialogue, the women and girls were able to see how they are situated in society—as poor, Hispanic, and female—and began to explain their commonalities and what they see as their "inherited powerlessness." This realization, achieved through the individuals' conversations, relate to agency—the ability to act toward a desired outcome and to influence individual behavior and social change.

Reflecting upon both life-based and imagined narratives through the use of the FotoDialogo method helped participants to question the validity of previously held assumptions, to reveal their perceptions of social reality, and to consequently broaden their view of the world. Placing their life stories in the form of this dramatic construction enabled the women to see things differently. It is the "seeing it differently" that allows them to think and act in ways not yet experienced or constrained by cultural norms. The sharing of personal storylines enables women to make jumps into new identification and insights.

The concept of dialogical education and the construct of knowledge as a collective process were foreign ideas that the women grasped over time.

Although a few participants still assumed that there would be correct answers to the questions raised during our dialogue sessions, other women emphasized the therapeutic aspect of the group process. Being members of a group and sharing their experiences with other women appeared to be an empowering experience for many of the participants. The dialogue sessions became a safe haven for the women to set their voices and their secrets free. The participants also commented on the supportive aspect of the group outside the dialogue sessions. By the end of the project, the women showed more confidence in their own ways of knowing and less dependency on the group facilitator. They also seemed aware of their self-transformation as they became increasingly outspoken in and outside the group situation.

The idea that "we are making history," not only telling stories, reveals the women's consciousness of the historical relevance of their lives and shared knowledge. Also, the discovery that "here we learn things we didn't know" appears to be linked to the unfolding of knowledge as a result of reflection upon past events. Although the situations revealed in the stories were not new to the participants, the reflection was new. Only through reflection and dialogue were the women able to give new meaning to their situations and to perceive the interconnectedness of their lives and the surrounding world. These linkages contribute to their awareness of social and cultural capital and the challenges they face in becoming a part of the broader community.

CONCLUSION

The results of this study indicate that the FotoDialogo method can be a powerful strategy for low-income Hispanic women to break the silence about their experiences of oppression and to begin a process of self-discovery that enables them to see their experiences and memories through a new set of lenses. According to Freire (1997), dialogue implies a mentality that cannot flourish in the "culture of silence." Dialogue is a means to self-actualization and transformation of men and women—and of the world. Hence, dialogical education may exert a tremendous impact on women's lives, as women begin to question the very foundations of the hierarchical social structures, the patriarchal values, and the norms of the dominant culture. The conscientization process gives rise to a new way of thinking and behaving, perhaps not familiar to those who have been victims of oppression. Researchers and educators involved in consciousness-raising, observe that when oppressed groups engage in dialogue and critical thinking they experience a process of self-transformation. The dialogue process used in this study led the group to heighten their self-awareness. Their transformation led them to take action and to intervene in situations at several levels of their lives. After engaging in dialogue sessions,

women who previously responded passively to problems in their families and communities are now participating in community programs and responding proactively to domestic problems. This process of change exemplifies what Naila Kabeer (1999, 437) defines as *female agency*, the "processes by which those who have been denied the ability to make strategic life choices acquire such an ability."

The trust and level of confidence that developed among participants helped them to speak the truth—to reclaim their voices without fear or guilt. They were able to disclose memories they had kept in silence for their whole lives. The experiences of mutuality, equality, and reciprocity among the Hispanic women helped to boost their self-esteem and to open their minds up to different ways of perceiving social reality, as well as acknowledge their capacities for change. The Hispanic women entered the group process with the belief that they knew nothing—"I don't know anything, what do I have to say?" and emerged from the dialogue process acknowledging, "We are making history." At the end of the process, self-acceptance, self-transformation, and empowerment were the key outcomes of the project.

NOTES

1. Participatory research is a method of social investigation involving community participation to help communities and groups tackle their problems. It was first used in developing countries in the late 1960s. Since then, it has been used all over the world, in both rural and urban areas, to help people work on issues related to education, literacy, community health, gender, agriculture, conflict, and many others.

2. *Fotonovela* is a common genre of comic strip in Latin America that uses pictures of people to illustrate narrative plots similar to those in soap operas. This genre is commonly used in development education and in social marketing strategies.

3. The authors refer to "life-based literary narratives as a catch phrase for memoirs, autobiographies, and novels that focus on the intimate, daily experiences of diverse families, parents, students, and teachers" (4).

4. Here I use several terms (i.e., the women, the Hispanic women, the members of the LWDG, the Puerto Rican women) to refer to a particular group of individuals who participated in the Latino Women's Dialogue Group and used the FotoDialogo method to create narratives related to their personal and collective histories. Nonetheless, the unique experiences of and shared meanings embraced by the research participants in this study should not be generalized to those of other low-income Hispanic women in the United States.

5. The dialogue sessions were conducted entirely in Spanish—the participants' native language. Throughout this chapter pseudonyms for actual names are used to protect participants' identities. Accounts are based on transcriptions of interviews and

dialogue sessions. The author took a leadership role in all phases of the research study. She conducted the weekly group dialogue sessions in Spanish and translated transcripts of these sessions into English.

6. Despite my social identity as a Latina, the perceived *otherness* associated with my role of researcher did not dissipate while I was working with the Hispanic women. Cross-cultural miscommunication usually stems from the lack of *shared meaning*—a collective sense of what is important, and why—that different cultural groups embrace. Shared meaning had to be negotiated through dialogue and constant shifting of our perceptions of each other and of our social realities.

7. See Schwartz (1932); Libo (1957); Sherwood (1957); Caudill (1958); Reznikoff, Brady, and Zellner (1959); Goldschmidt and Edgerton (1961); Costantino, Malgady, and Vazquez (1981); Costantino and Malgady (1983); Costantino, Flanagan, and Malgady (2001); Malgadey, Costantino, and Rogler (1984); and McClelland (1999).

8. Most of the women in the group reported some form of neglect, physical abuse, and/or sexual abuse by a family member. Others were HIV positive.

9. Bourdieu sees habitus as the key to cultural reproduction.

10. *Cultural capital*, a sociological term used by Bourdieu, has three distinct forms: a) an *embodied state* (cultural habitus) related to a person's way of thinking, which is formed by socialization; b) an *objectified state* related to things which are owned, such as works of art; and c) an *institutionalized state*, such as educational qualifications, the value of which can be only measured in relationship to the labor market (Bourdieu and Passeron 1973). Children inherit cultural capital from their parents and other influential elders, who provide them with the knowledge and attitudes to succeed or fail in the educational system.

11. Voice "is a powerful psychological instrument and channel, connecting inner and outer worlds," says Carol Gilligan (1993, xvi), and its expression is an essential element in true dialogue as a means to facilitate *true education*.

REFERENCES

Belenky, M. F., B. M. Clinchy, N. R. Goldberger, and J. M. Tarule. 1986. *Women's ways of knowing: The development of self, voice, and mind.* New York: Basic Books.

Bourdieu, P. 1986. The forms of capital. In *Handbook for theory and research for the sociology of education*, edited by J. G. Richardson, 241–358. Westport: Greenwood Press.

Bourdieu, P. and J. C. Passeron. 1973. Cultural reproduction and social reproduction. In *Knowledge, education, and cultural change*, edited by Richard Brown, 71–112. London: Tavistock.

———. 1990. *Reproduction in education, society and culture.* London, Newbury Park, CA: Sage in association with Theory, Culture and Society, Department of Administrative and Social Studies, Teesside Polytechnic.

Bourdieu, P. and L. J. D. Wacquant. 1992. *An invitation to reflexive sociology.* Chicago: University of Chicago Press.

Caudill, W. A. 1958. *The psychiatric hospital as a small society.* Cambridge: Harvard University Press.

Costantino, G., R. Flanagan and R. G. Malgady. 2001. Narrative assessments: TAT, CAT, and TEMAS. In *Handbook of multicultural assessment: Clinical, psychological and educational applications,* edited by L. A. Suzuki, J. G. Ponterotto, and P. J. Meller, 217–36. San Francisco: Jossey-Bass.

Costantino, G., R. G. Malgady, and C. Vazquez. 1981. A comparison of the Murray-TAT and a new Thematic Apperception Test for urban Hispanic children. *Hispanic Journal of Behavioral Sciences,* 3 (3): 291–300.

Costantino, G. and R. G. Malgady. 1983. Verbal fluency of Hispanic, Black and White children on TAT and TEMAS, a new Thematic Apperception Test. *Hispanic Journal of Behavioral Sciences,* 5 (2): 199–206.

Delgado, M. 1995. Puerto Rican elders and natural support systems: Implications for human services. *Journal of Gerontological Social Work,* 24: 115–29.

Freire, P. 1971. *Sobre la acción cultural.* Santiago de Chile: ICIRA.

———. 1973. *Education for critical consciousness.* New York: Continuum.

———. 1974. *Concientización: Teoria y practica de la liberación.* Buenos Aires: Ediciones Busqueda.

———. 1984. *El conocimento como praxis liberadora.* Bolivia: Los Amigos del Libro.

———. 1985. *The politics of education.* Massachusetts: Bergin and Garvey.

———. 1997. *Pedagogy of the oppressed,* 20th ed. New York: Continuum.

Geyer, N. B. 1975. *Designing structured experiential learning.* Washington, D.C.: Mid-Atlantic Training Committee.

Gilligan, C. 1993. Preface to *In a different voice.* Cambridge: Harvard University Press.

Goldenberg, I. 1978. *Oppression and social intervention.* Chicago: Nelson-Hall.

Goldschmidt, W. and R. Edgerton. 1961. A picture technique for the study of values. *American Anthropologist,* 63: 26–45.

Kabeer, N. 1999. Resources, agency, and achievements: Reflections on the measurement of women's empowerment. *Development and Change,* 30: 435–464.

Kolb, D. A. 1984. *Experiential learning.* Englewood Cliffs: Prentice-Hall.

Libo, L. M. 1957. The projective expression of patient-therapist attraction. *Journal of Clinical Psychology,* 13: 33–36.

Malgady, R. G., G. Costantino, and L. H. Rogler. 1984. Development of a Thematic Apperception Test (TEMAS) for urban Hispanic children. *Journal of Consulting and Clinical Psychology,* 52 (6): 986–996.

McClelland, D. C. 1999. How the test lives on: Extensions of the thematic apperception test approach. In *Evocative images: The Thematic Apperception Test and the art of projection,* edited by L. Gieser and M. I. Stein, 163–175. Washington, D.C.: American Psychological Association.

Mesthrie, R., J. Swann, A. Deumert, and W. L. Leap. 2000. *Introducing sociolinguistics.* Edinburgh: Edinburgh University Press.

Mills, C. W. 1959. *The sociological imagination.* London: Oxford University Press.

Moores, S. 1993. *Interpreting audiences: The ethnography of media consumption.* London: Sage.

Murray, H. A. 1938. *Explorations in personality.* New York: Oxford University Press.

———. 1943. *Thematic Apperception Test manual.* Cambridge: Harvard University Press.

———. 1951. Uses of the Thematic Apperception Test. *American Journal of Psychiatry,* 107: 577–581.

Nieto, S. 1999. Fact and fiction: Stories of Puerto Ricans in U.S. schools. In *Learning as a Political Act,* edited by J. Segarra and R. Dobles, 47–73. Cambridge: Harvard Educational Review.

Pelto, P. and G. H. Pelto. 1978. *Anthropological research: The structure of inquiry,* second ed. New York: Cambridge University Press.

Phillion, J. A. and M. F. He. 2004. Using life-based literary narratives in multicultural teacher education. *Multicultural Perspectives,* 6: 3–9.

Ramos, F. S. 1999. The FotoDialogo method: Using pictures and storytelling to promote dialogue and self-discovery among Latinas within a community-based organization in Massachusetts. EdD Dissertation: University of Massachusetts, Amherst, 593 pages; DAI-A 60/05, 1430, November 1999.

Reznikoff, M., J. P. Brady, and W. W. Zeller. 1959. The psychiatric attitudes battery: A procedure for assessing attitudes toward psychiatric treatment and hospital. *Journal of Clinical Psychology,* 15: 260–266.

Schwartz, L. A. 1932. Social-situation pictures in the psychiatric interview. *American Journal of Orthopsychiatry,* 2: 124–33.

Sherwood, E. 1957. On the designing of TAT pictures, with special reference to a set for an African people assimilating Western culture. *Journal of Social Psychology,* 45: 161–190.

Swartz, D. 1997. *Culture and power: The sociology of Pierre Bourdieu.* Chicago: University of Chicago Press.

CHAPTER 13

Policy as Practice, Agency as Voice, Research as Intervention

Imag(in)ing Girls' Education in China

HEIDI ROSS

INTRODUCTION

Despite impressive gains in girls' education since 1990, China's EFA policies are dominated by an instrumental "women in development" (WID) framework that hinders efforts to insure adolescent girls' full participation in school and society (Ross 2005b). Likewise, while a dramatic increase in research on girls' access to school accompanied the implementation of EFA mandates, the daily experiences of girls remained largely undocumented until 2000. As a consequence, "the context in which girls live and learn, and the experiences of girls within the schools" are poorly understood in China as in much of the world (Sutton 1998, 395).

I consider Margaret Sutton's conclusion on two levels. First, I propose a conceptual model to illustrate where China's EFA policies originate and for what purposes. The model's mapping of macro and micro level reform pressures complements Maslak's use of the integrated sociological paradigm. Second, I introduce findings from Shaanxi province's largest NGO-supported girls' education project. These findings provide context for exploring agency and advocacy in girls' educational policy, research, and schooling. The challenge of agency and advocacy for girls and researchers guides my discussion of photovoice, a dialogical methodology that links social action and critical consciousness education to a grassroots approach to photography. Photovoice provides a close-to-the-ground foothold from which to track the moving target of

233

educational opportunities and to learn how girls understand the conditions that shape their school achievement and aspirations. Developed to facilitate collaborative inquiry for individual and structural transformation, photovoice supports critical exploration of the interplay between agency and structure.

Throughout this chapter I explore what Maslak has called "relationism" between agency and structure on the one hand and policy and practice on the other. My primary concern is with agency (allegiant and oppositional) as realized through girls' voices and through the work of scholars whose advocacy through research may identify practices that support the structural concept of equity. Exploring the links between agency and advocacy-for-equity reflects my desire to strike an empirically and ethically defensible balance between social science that is responsive to the "policy community" and to the communities in which I work.

Critical to those ends is discovering how macro policies and discourses intertwine with micro life experiences of social understandings to shape girls' identities and educational outcomes. This task first requires that we apply the theories and knowledge of globalization to understanding female education. For example, identifying the distributive outcomes of globalization is a critical role for research on girls' education. The task further requires an understanding of policy as a

> complex social practice" negotiated by "diverse actors across diverse social and institutional contexts. . . . An emphasis on the purposeful practice of diverse social actors reinstates agency across all levels of the policy process, making it possible to see policy not only as mandate but also as contested cultural resource. (Sutton and Levinson 2001, 1, 3)

In spite of a widely held view that there is "no broad-based and sustained tradition within contemporary social science of focusing qualitative work specifically on policy issues" (Rist 2000, 1015), I take the position that interpretive researchers can and do enrich policy studies by providing "a locally informed, comparatively astute, ethnographically rich account of how people make, interpret, and otherwise engage with the policy process" (Sutton and Levinson 2001, 4).

TRACKING THE MOVING TARGET OF GIRLS' EDUCATIONAL OPPORTUNITIES AND OUTCOMES IN CHINA

The 1990 World EFA conference set three strategic objectives: universalizing primary education, eliminating illiteracy, and ending educational inequality

between men and women—by the end of the decade. China became a high-profile player in female education with other densely populated countries with high illiteracy rates (Ross 2005a). Girls and women accounted for two-thirds of the world's out-of-school children and adult illiterates, figures that closely matched the Chinese experience in 1990. Female education was declared the most important investment a country could make in enhancing household income, improving family health, reducing infant mortality, improving the skills of agricultural workers (the majority of whom are women), in democratizing decision-making at household, community, and national levels, and in alleviating poverty. Even as educated females became development's silver bullet, EFA goals went unmet worldwide, as both the number of children in school and the number of children without access to school climbed.

When world leaders signed the Millennium Declaration in 2000 China ranked high on Elaine Unterhalter's "gender scorecard," which includes girls' net attendance rate and survival rate over five years in primary school, girls' secondary net enrollment ratio, and a country's gender development index. Of thirty-one Asian countries, China ranked fourth (after Japan, Korea, and Singapore) with a gender equality and education score of eighty-nine out of one hundred. China's legislative and policy contexts supported gender parity. The constitution stipulated that women should enjoy equal rights with men in political, educational, and social domains. The Compulsory Education Law asserted that every child at the age of six, irrespective of gender, ethnicity, and race, should have the right to nine years of schooling. Guidelines for the twenty-first century associated with the Program for the Development of Women and the Program for the Development of Children called for equal access to education, employment, and leadership opportunities and to improvements in health, social protection, and quality of life. The guidelines also established 2010 benchmarks for girls' access and attainment, including a net enrollment rate of school-age girls of 99 percent and girls' gross enrollment rates in upper secondary and tertiary schools of 75 percent and 15 percent.

Progress in access and attainment rates for females followed these measures.[1] In 1990 the average attainment rate for women was 5.5 years compared to 7.7 for men. These figures drew closer to parity by 2003, to 7.4 and 8.4 respectively. Between 1990 and 2000 the number of girls with no access to primary school decreased from 1,712,900 to 554,200; the national percentage of school-age girls able to enter primary school increased from 96.31 percent to 99.1 percent; and the percentage of primary-school-age girls attending five years of school increased from 82.2 percent in 1995 to over 94.5 percent.[2] China has basically achieved gender parity in primary schooling. By 2003, 98.8 percent of boys and 98.5 percent of girls completed five years of primary school, and the dropout rate stood at .32 percent for boys and .36 percent for girls. Most but not all studies predict that China will achieve gender parity in secondary education

by 2015.[3] The proportion of female students at all levels of schooling rose from 1995 to 2003. Respectively, female rates during those two periods stood at 47.3/47.1 in primary school; 45.6/47.4 in regular middle school; 40/45.1 in regular high school; and 35.4/44.8 in regular tertiary institutions.

Overall, China faces four education gaps (in descending order of severity) between rural and urban residents, between residents of geographic regions, between ethnicities, and between genders. The percentage of people with primary education or below in rural areas is 3.2 times higher than in urban areas. The percentages of urban residents with senior middle school education, junior college education, and a four-year college education are respectively 3.5, 55.5 and 281.55 times higher than in rural areas. Declining proportions of students from rural areas attend key high schools and universities.[4] Female opportunities for receiving higher education have increased as a result of rapid expansion of tertiary education in the past six years. Yet more females than males are entering junior colleges and adult universities or taking advantage of China's self-study examination, and for rural females the gender gap in higher education has widened (Subject Group 2005, 33). A different trend is notable in metropolitan centers where China's bottleneck to equality of educational opportunity, a shortage of high schools, is thought to advantage female students who outperform boys in junior middle school examinations, enter key high schools in greater numbers, and outnumber males as test-takers in the national university entrance exam (Subject Group 2005).

Broader reforms that have enhanced girls' and womens' opportunities have also reconfigured barriers to their full participation in society. Expanding educational and occupational opportunities and liberating explorations of identity and sexuality in high and popular culture have been accompanied by the feminization of agriculture, discrimination in the job market, and disproportionately high layoffs of "surplus" women. China's global ranking in women's political participation slumped from twelfth in 1994 to thirty-seventh in 2004. Recent reports on China's EFA policies and children's rights offer sobering pictures of discrimination against minority, female, disabled, and migrant children; low expenditures on education that fail to keep pace with increases in overall government revenue; inaccurate reporting of enrollment rates and lack of sex-disaggregated data; failure to eliminate financial obstacles to schooling faced by China's poorest children; and a fragmented system for monitoring progress on children's rights.[5]

If improving gender parity is indeed the best predictor of progress toward EFA goals (EDI 2004, 113), then China presents a mixed picture of notable success with failure at the margins. It is failure at the margins that provides the backdrop for the "spring bud" project discussed in detail further on.[6] The 1990 Institute Spring Bud Project (SBP) supports the education of one thousand girls from villages in Shangluo and Ankang cities in southeast Shaanxi

province. The 1990 institute is a U.S.-based NGO that raises money for the project in partnership with the Shaanxi Women's Federation (SWF). Per capita income of the girls' villages ranged from under US$100 to US$125 in 2000, a figure that has remained relatively constant for most families. Participating girls (who ranged in age from 10 to 16) were out of school (in primary grades 3 or 4) when selected by the SWF to receive 1990 institute funds to attend school in the autumn of 2001. SBP entered phase two in the autumn of 2004 when participating girls received funding to attend junior secondary school.[7]

MAPPING THE SOURCES AND AIMS OF GIRLS' EDUCATIONAL POLICES AND PRACTICES

Elsewhere, I have argued that Chinese EFA policies hinge on two narratives that define females "as important mediators in the modernization process" (Stromquist 2003, 177; Ross 2006). The first narrative is that education provides the key to poverty alleviation. The second narrative is developmentalism. Educated girls become valued as mothers of development and the means for reducing poverty, containing population growth, engendering public health, and strengthening the nation. In the discourse of developmentalism girls are assumed to be recipients and agents of development, not its victims. However, this version of agency is built on a narrowly utilitarian assessment of female lives, rarely considered as ends in themselves.

Studying gender, education, and development in China during the past decade raises two sets of interrelated questions. The first set of primarily macro level questions includes: Who is speaking on behalf of girls' education? From where is advocacy coming? What is the interplay between international and national policies supporting girls' education and girls' own expectations about and engagement in schools? The second set of primarily micro level questions includes: How have women mobilized the narratives and policies of development and of nationalism for their own local/national causes? How do Chinese girls engage through their educational and social environments in identity-making processes? What should the response of educators (and donors) be if the aim of EFA policies is not just nine years of compulsory education but equity?

The model displayed in Figure 13.1 positions these questions through mapping how female education discourse is shaped by: 1) top-down forces of domestic policies and agencies; 2) bottom-up forces of communities, women's groups, and the aspirations of girls and their families; 3) external (top-down and bottom-up) forces of international nongovernment organizations (NGOs) and donor agencies; and 4) middle forces, bridging civil society and state, of domestic government organizations (GO). NGO's involved in female education, such

FIGURE 13.1
Conceptualizing Girls' Educational Reform in China

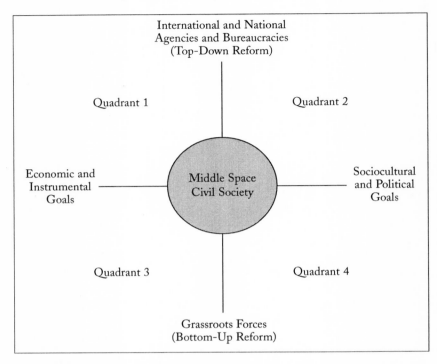

Adapted from Arnove (2005). The model (in terms of idea) is adopted from Paulston and
Leroy but the chart itself as an image is adapted from a similar one from the Arnove piece.

as the Shaanxi Women's Federation. It is in this complex policy/action arena
that girls and women appropriate and mobilize (either in opposition to or sup-
port of) narratives and policies of development. The SBP is concerned with the
consequences for girls of these processes.

The model is adapted from Paulston and LeRoy (1982) and Robert
Arnove (2005). Its vertical axis indicates the sources of reforms influencing
education. The bottom of the axis represents local, bottom-up forces (estab-
lishment of girls' schools, parents taking girls out of school) that originate
with the actions, pressures, and resistance of educators, citizens, and parents.
The top of the axis represents actions and policies initiated by national and
international agencies and bureaucracies, such as the Ministry of Education,
UNICEF, Department of International Development (DFID), and the
World Bank. National and international reforms are positioned as linked in

this way, because state policies for girls' education and conceptualizations of "the girl child" are aligned with the development policies of international agencies. This overlapping international and national policy discourse represents what Kathryn Anderson-Levitt describes as "global models inhibiting and inhabiting local practices" (Anderson-Levitt 2004, 251). The "global" is not an autonomous space but rather a "terminal point" for educational signs or targets like the "girl child." Unattached from a specific context, these signs circulate through the global educational community, ready for appropriation. Thomas Popkewitz has envisioned this process with the metaphor of "indigenous foreigners" who when locally appropriated, "take on the characteristics of that context before they move on to other contexts and become the target of further interpretations and reinterpretations" (Hultqvist and Dahlbert 2001, 11). The girl child as mother of development has become one of the world's most celebrated "indigenous foreigners."

The model's horizontal axis features the aims of educational reform. These range from instrumental (economic development) goals on the left to sociocultural and political goals on the right. In reality, political aims are often complementary to economic purposes and slide along the axis. The two axes meet in the middle space of civil society where international NGOs, volunteer and professional organizations, and GONGOs practice primarily allegiant agency by mediating global/national initiatives for education and local community needs.[8]

The model illustrates four quadrants or domains of policies, actions, and discourse on girls' education. Quadrant 1 represents national and international discourses and policies that are motivated by instrumental purposes. This quadrant is the dominant policy space of girls' education. For example, just before the Fourth World Congress on Women in 1995, the government promulgated the Program for the Development of Women (1995–2000), arguably China's first state blueprint for women (Song 2002). In May 2001, the State Council endorsed the Program for the Development of Women (2001–2010), the latest comprehensive state policy commitment on behalf of women. A content analysis of these policy documents reveals that although the 2001–2010 policy incorporates GAD-like structural and gender-relational thinking, the gender discourse of both documents is largely nonemancipatory and utilitarian.[9]

Quadrant 2 represents national and international discourses and policies designed to serve sociopolitical purposes, including citizenship education and family planning. Policies situated between quadrants 1 and 2 would include those with economic and political aims, such as the state's "two basics" policy of achieving universal nine-year compulsory education and literacy, as well as the Ministry of Education's 1996 initiative to increase girls' school access through government oversight; social awareness; recruitment of female teachers and

headmistresses; responsive school schedules; facilities and curriculum; financial assistance; and research and international cooperation. The National Population and Family Planning Commission's recently initiated Care for Girls program, which promotes respect for girls and gender equality, as well as legal, advocacy, and rural development services benefiting girls, would be located in quadrant 2.

Quadrants 3 and 4 represent individual, local community, and NGO education initiatives for economic/utilitarian or sociopolitical aims. Quadrant 3 would include many NGO development projects that prepare female workers for a changing rural economy. The "middle space" of quadrant 4 might include the Girls' Contemporary Research Network,[10] the SBP, as well as professional organizations promoting girls' rights. A Sino-Britain Capacity Building for Elder Girls Project and a Girls' Rights Project, which, respectively, provide skills training for female adolescents and combat discrimination against girls, would span quadrants 3 and 4.

Primarily, all of these activities reflect allegiant agency. On rare occasions, girls' education practices can foster oppositional agency, particularly in rural areas where education becomes a form of community resistance to pressures of the market, the state, and social inequality (Ross and Lin 2006). Frequently, what underlies this resistance is not only anger about disparity in educational provision but also frustration regarding the unquestioned but fallacious assumption that education can align local communities with global forces. For urban educators the interface between the local and global is assumed to be a relatively unproblematic cultivation of human capital. The realities of rural life tell a different story, which I illustrate as follows by examining how agency and structure shape the processes of rural girls' identity construction through schooling.

THE SPRING BUD PROJECT:
SPACE, SOCIAL IMAGINATION, AND IDENTITY

> If globalization is characterized by disjunctive flows that generate acute problems of social well-being, one positive force that encourages an emancipatory politics of globalization is the role of the imagination in social life.
> (Appadurai 2000, 6)

Two conclusions from interviews conducted with girls in thirty secondary schools in urban, suburban, and rural China between 1996 and 2000 prompted me to associate research that privileges girls' voices with what Appadurai has called the emancipatory politics of education (Lin and Ross 1998; Liu, Ross, and Kelly 2000). The first conclusion is how deeply the processes of globalization dig into girls' identities and recognition of social

place and status. The second conclusion is how girls' voices create spaces for critical understanding of the purposes of schooling.

The potentially emancipatory role of social imagination begins, as I understand Appadurai's argument, with the ability to imagine one's life otherwise, to recognize that one has options. From this perspective, globalization has altered the sources of social imagination. Where once imaginations were vertically rooted in local language and culture, they are increasingly horizontal and transnational. The social imagination of the horizontal self is defined in juxtaposition to the far-flung images of global media and expectations.

Space, Social Imagination, and Identity in China

A visit to Beijing's Red Gate Gallery in 2004 reminded me that artists are frequently the first members of society to spot social trends and share through their media vital insights into changing social patterns. The gallery featured a disturbing installation of paintings by Wang Yuping on the one-child family called Who Will Play with Me? The male and female singletons depicted on Wang's canvases presented a dark portrait of the urban super kids extolled in the international media as the fleetest sprinters across our newly "flat" world. The images diverged dramatically from depictions of China's "spoiled" only children that became in the 1980s the symbol of *filiarchy*, a concept that turned patriarchy on its head to describe the pampered single (usually male) child whose decision-making power within the household turned him into the sun around which grandparents and parents orbited (Chan and McNeal 2004). In contrast, the stricken, even demonic faces of Wang Yuping's singletons matched recent accounts by Chinese psychologists of "at risk" children living in precarious positions at the center of "fragile" families. Vanessa Fong has argued that singletons are a product of state development policy to create a generation of ambitious first world children (2004). What Wang Yuping captured in his paintings was the high social price of this strategy. Singletons are not only at odds with the society around them; they carry on their shoulders unrealistically high familial and social expectations. Wang's latchkey children also recall a rash of recent sensational headlines detailing gruesome attacks on "targeted" preschoolers across China who were slashed, even axed to death, by angry, disoriented men with no clear idea why they lashed out at their society's most vulnerable citizens.

These images of children reflect how the cultural production of childhood is changing as China becomes embedded in the world economy, as community structures are uprooted as larger percentages of the population settle in towns and cities and as social classes diverge. They also suggest how globalization has introduced the concept of space as a contradictory source of Chinese children's identity. Urban and rural girls have come to represent social

prestige and individual agency through markedly different spatial categories. While urban girls use location to indicate their status group as part of a "modern global urban world," village girls (and boys), labeled as "backward" (*luohou*) and "poor" (*pinchong*), describe what is "modern" and "advanced" as "not where they are, but where they are going"—"outward," "upward," "out of the backward village." Confronted with success as defined through market and modernity, they associate poverty with their "culture." In turn, their culture is defined as lacking in "quality" particularly by educational professionals who view school as compensatory. Girls then perceive "success in school," which gets formulated in rural areas "as a civilizing practice that implies and confers proximity to the modern" (Jeffery 2001, 25), as an overwhelmingly positive yet contradictory resource, one that can produce skills, desires, and associations that both complicate and enhance their future identities, family relationships, and career opportunities. In this cycle of rural identity making, there may be no more contradictory social category than the "targeted" girl. She is described simultaneously as the embodiment of feudal ideology and backward cultural beliefs and the mother of development.

This contradiction was crystallized for me in 1999. I was participating in a high school reunion for high-performing rural scholarship students. One of the girls who had returned for the reunion after a successful first year at college was being featured in a television program. The girl's father stood with a reporter and cameraman in the family courtyard, ringed by scores of family members and curious neighbors. Caught off guard by the camera and the fast-talking reporter the father froze. Seconds passed. Slowly, the daughter stepped forward, took the microphone away from the reporter and faced her father, gently putting a hand on his shoulder. The onlookers caught their breaths in expectation, and then sighed with audible relief as the daughter began to interview her father. Later remarking on this moment, in which I saw hard-won authority conferred on a young woman by education and experience, I raised the possibility that she had been "empowered" (a strategy of change that implies redistribution of power). She rejected my conclusion as "too simple." "I don't know where I'll be after school," she said. "And it doesn't take the hurt into account."

Reminded by the daughter that empowerment has different outcomes, not all of which are emancipatory, my use of photovoice methodology was inspired by her demand that hurt be taken into account. Using photovoice became my means for reconceptualizing research as a form of intervention in understanding the social and political contexts of schooling and in clarifying how girls' stories as speech acts and as politics provide them a space for reimagining themselves and their possibilities. In this way, I envision photovoice as a means for moving closer to the ideals of emancipatory globalization (Appadurai 2000, 8).

Photovoice as Intervention, as Agency

> If we are going to trace relationships that stretch out across time and space; and if we are going to analyze activities and cultural forms that are taken up locally but formed or controlled elsewhere, we would seem to need some new ways of doing ethnography, or at least some different methodological priorities. (Eisenhart 2003, 22)

Mirroring recent initiatives that bring the voices of young people into development and educational processes, photovoice methodology is a research and learning tool aimed at building dialogue among culturally diverse groups and examining individuals' perceptions of social reality through the use of photographic images. Photovoice is also an easily understandable and engaging methodology for placing girls' experiences at the center of inquiry.

My approach to photovoice is adapted from the work of Caroline C. Wang and Mary Ann Burris, who developed the activity in the context of a Ford Foundation project on community health care in rural China.[11] Wang and Burris concluded that the approach provided "the possibility of perceiving the world from the viewpoint of the people who lead lives that are different from those traditionally in control of the means for imaging the world" (Wang et al. 1996, 1393). Used as a springboard for interviewing, photovoice shifts the "power" of defining research questions to young people who choose to photograph what they feel is most important in their lives. In the SBP, eighth grade girls were provided with three disposable cameras each to frame, record, share, and evaluate how they understood their lives in three arenas: home, school, and society.[12]

Photovoice has gained in popularity as a result of the ubiquitous emphasis in education and development on "listening to the voices of girls," which has been regarded as a powerful educational and emancipatory tool by feminist scholars and activists, as well as organizations such as the Girl Scouts and the AAUW (Gilligan 1982; Brown and Gilligan 1992; AAUW 1999). Until recently in China, *voice* (*shengyin*) has been associated with *transparency* (*toumingdu*), a reform term meaning to open up decision-making to those it affects, for example, to peasants who have had their land illegally confiscated or to villagers burdened by unfair taxes. In the context of women and agency, voice has been increasingly linked to rights consciousness, exemplified in the recent work of journalist Xinran Xue (2002) and *The Diary of Ma Yan* (Haski 2004).

As a research methodology, photovoice draws inspiration from the use of *voice* in feminist and liberation theories. *Voice* is presented in Denzin and Lincoln's *Collecting and Interpreting Qualitative Materials* (1998) and *Qualitative Research Handbook* (2000) as a foundational concept in interpretive research

methodologies that question power in representation and interpretation and privilege reflexivity, relationship, dialogue, standpoint, and oppositional scholarship. In fact, Denzin and Lincoln identify the signature characteristic of contemporary qualitative research as a "crisis of vocality" (2000, 1055).

Photovoice also borrows from documentary photography, visual ethnography, and visual sociology the central aim of "recording, analysis, and communication of social life through photography, film, and video" (Harper 1998, 130). In doing so, it marks a break from the "documentary truthfulness" of the realist tradition of visual ethnography and sociology, which defined (and in some cases still defines) a photograph as a reflection of reality rather than an interpretation.[13] In contrast, photovoice recognizes the "reciprocal gaze" between a subject and researcher who are both moral agents, thereby rejecting "the traditional power of unilateral ethnographic authority" (Tobin 1999, 125).

Sample Descriptions of Visual Voices from
Two Girlhoods: Tian and Xiao Yang

Tian. In an interview session, we spread prints on a low table. In the first photo Tian sits in shorts and tee shirt in her room in a comfortable looking apartment. It is Saturday, her day off from boarding school. She is relaxed, her legs stretched in front of her computer. She is surrounded by artifacts—posters, music, designer backpack—of global youth culture. A second photo is of her desk, strewn with books, pens, "mountains of homework." She shakes her head, complains about the pressures of schoolwork, and concludes, "My life, my desk—a mess!" In a third shot, Tian laughs with her "beautiful" mother and plays with her small dog on the lawn of her apartment complex. Another photograph shows Tian reflected in a mirror in the entrance way of her school. Tian explains,

> The mirror has significance. It reminds me to be energetic throughout the day. My favorite "heart teacher" told me that every morning we should look into that mirror and smile so that we can be happy for the day. I don't really do it, not for the purpose that my teacher told us about, but I keep his thoughts in mind. They are very kind.

In a fifth photo Tian is standing by a large knot sculpture. "Well, I connect this knot sculpture to the way I give advice." (I ask her to explain. She is silent. I ask her again if she can talk about why she took the picture.) "It gives me a sense of pride, because the sculpture looks like the Chinese character for female, with its interlocking curves." In the last photograph, Tian is back in her room.

This picture shows the symmetry of my room. People think that all-girls' schools are boring. I think they provide balance. Girls are asked to be balanced human beings here, which I think is a good quality.

Xiao Yang. Picking up a series of "water pictures," Xiao Yang points to herself sitting on the banks of the Dan River, gazing at the willows, the sweet potatoes, the lush mountain landscape. Of the next picture she says, "These are my two little neighborhood friends. The picture was taken next to my little flower garden. I took a picture of them, because they are very friendly. Sometimes I play with them together by the river or at school. We catch fish or crabs in the river. It is a beautiful river." A third photo shows Xiao Yang's friends sitting by the river washing clothes. Her friend's hair "is beautiful as it blows in the wind." In the fourth picture Xiao Yang sits at the river's edge watching tourists glide down the current in a raft. They see her as she takes the picture. Next, Xiao Yang picks up a pile of "school" pictures. The first is of a pile of rubble and construction workers building a road.

I took this picture, because I think it shows how the economy has been developing. Before a dirt road ran in front of the school; now it is replaced by this concrete road with a sewer system.

She turns to the next picture.

This is the flower garden of our school with a map of China made of flowers. I like flowers, because we ourselves are like the flowers of our motherland. We must do something to make our motherland proud. . . . And this next one was taken when we were working on our homework in our classroom after our meal. The students are all very diligent, not wasting a second. It is finals, so everyone is working hard. It is really hot, and the fan is on.

She fingers through more pictures. "Here, students rest their heads on their desks. Nobody talks during nap time. Only after we get enough rest can we work really hard. . . . These are some banners hanging around the school: 'Create a future!' 'Cherish life!'"

Xiao Yang picks up her photos of society.

This is a grocery store, right near my uncle's home. It opened last year. This is the pharmacy section. Our hospital recently closed. My aunt has some background in medicine, so she opened a clinic at home for the convenience of local people. The grocery store provides many conveniences for local people. I like the school supply section in that store. . . . This is at my uncle's

home. His house is the best furnished in the village. I like their TV the most. Before, there was only one color TV in the village, and that was my uncle's TV. The rest of the people only had black and white TVs.

Xiao Yang returns to her pictures of home.

My mom is raising these two piglets for cash. They're sleeping. . . . Many people in the village plant beautiful flowers, because they have more free time for leisure. I like plum flowers, because the plum blooms in the winter when all other flowers have died. The plum has a tough spirit which well deserves our respect. We should learn from the plum. . . . Here is my family, my dad, my mom, my grandpa, and my little brother. I don't do very well at school. My family hopes that I work hard. They all work very hard, and they care about my studies a great deal. They work so hard to get me school supplies, just so I can focus on my studies. . . . Every week when I go back home, they will say to me, "Study hard when you go to school." My little brother doesn't do very well at school. They say I'm the only hope for the family. They have pinned all their hopes on me.

CONCLUSION: CONSTRAINED AGENCY (FOR GIRLS) AND ADVOCACY (FOR RESEARCHERS)

Because rural women in China are concentrated in agriculture and/or relatively unskilled temporary jobs, it is widely accepted that perceived lower returns to female education influence parental decisions regarding boys and girls. Yet most recent research on rural schooling in China concludes that parents want education for both boys and girls but believe it is more useful for boys (Hannum 2003). Most studies likewise suggest that son-preference persists in the face of sweeping economic and social change, and that urbanization, female education, and employment only slowly change incentives for sending girls to school (Li and Tsang 2002; Ross 2005b). Parental responses to the SBP indicate that "traditional" attitudes no longer erect severe barriers to girls' access to education, and placing too much weight on "culture" may obscure material obstacles with which girls and their families contend (Ross 2004b). In fact, our research suggests that Chinese educators and parents in the countryside are desperate to define and achieve relevant and quality rural schooling in a policy environment that is directed primarily by urban needs and interests. Parents want their daughters to attend school, because in the poorest villages there is little alternative. It is commonly believed that national economic development will improve opportunities for girls. But, in the short run (before the roads, telephones, TVs, motorcycles, and running water

admired by Xiao Yang as clear-cut measures of rising standards of living are widely distributed), as subsistence farming is abandoned, as fathers who are working away from the village remit cash back to the family, daughters are freer to go to school (if those schools remain affordable).

The delicately mundane talk of the previous excerpts provides barely a glimpse of the lives of two girls, one from a Beijing girls' school, one from a rural middle school in Shaanxi. They begin to reveal in concrete terms how material world and space construct and position girls' identity and opportunities, but it is too early to know whether girls' formal schooling will act as a precursor to local economic development or whether some SBP girls will become local leaders (one of the donor's goals for the project). At present boys expect to grow up and leave the villages in the region of study. Will girls like Xiao Yang, who is setting her sights on high school and college, leave marginalized villages to fully develop her capacities?

As previously noted, many interpretive researchers conceptualize inquiry as a civic and participatory project that joins researcher and subject in ongoing moral dialogue (Denzin and Lincoln 2000). Fewer take the next step and place advocacy at the center of research, with the goal of creating "a set of disciplined interpretive practices that will produce radical democratizing transformations in the public and private spheres of the global post-capitalist world" (Denzin and Lincoln 2000, 1019). This challenge on behalf of oppositional agency is in tension with the understandable (and probably blessed) barriers external actors, such as international scholars and donors, face in exerting "pressure on governments to affect what are, in the end, political changes within their own countries. For these and other reasons, it is perhaps more comfortable for external actors to treat girls' education as an economic issue susceptible to technical solutions" (Sutton 1998, 395). Photovoice helps position researchers in a more tenable relationship with advocacy, in part because the methodology checks the researcher's "paternalism, condescension or idealism toward their lives" (Wang et al. 1996, 1399). Particularly if policy is conceived as practice, then at the very least photovoice can support a "more robust participatory dialogue and encourage a research practice that supports democratic action both in its execution and in its outcomes" (Sutton and Levinson 2001, 4).

Placing the means of imaging the world into the hands of girls creates a unique brand of interpretive interactionism. As such, photovoice brings front and center "the agency of the female" (for both girl and researcher). Reflection upon what photographs to take inspires girls to examine their own lives. Through practice they gain confidence in speaking about their lives with respectful peers and adults, and sometimes, like the college girl who interviewed her father, to "recognize the vitality of their own voices in public spheres" (Wang et al. 1996, 1392).

Albeit less consistently, photovoice also reveals how structures support or obstruct agency. For example, photovoice reveals what realities facing girls are not reflected in (quadrant 1 and 2) policies. By asking girls to imag(in)e their changing lives at home, school, and society, photovoice also begins to address the charge (Stromquist 2002; Rodrick 1997) that scholars lack an understanding of how globalization works in local contexts. Through this process, photovoice counters the portrayal of girls in many agency reports, which have a tendency to thin culture, sanitize politics, and obscure the lived worlds of the girls and their families (Sutton 2001, 93).

Finally, that photovoice succeeds so brilliantly in putting a human face on "problems" for policymakers and donors to "solve" raises a red flag about the compelling images that are the hallmark of photovoice projects. So powerful is the aphorism "one picture is worth a thousand words" that it can be hard to remember that the sometimes idealized, sometimes poignant "visual voices" of daily life are not the data. Instead, the data to be analyzed and the data that policymakers and donors need to "hear" are the questions, concerns, and conclusions that emerge from conversations as girls talk about why they took certain pictures and how those pictures represent their lives. These conversations are also important for what they reveal about the ways schools reinforce gender discrimination through teachers and students taken-for-granted assumptions about girls' abilities and aptitudes (Ross and Shi 2003).

In the hands of a sympathetic and skilled interviewer or a genuinely curious teacher, photovoice enhances interpersonal awareness and critical dialogical learning. Our first round of interviews suggests that female teachers who define school as a mixed bundle of rights, resources, and not-always-benign goods are more likely to be aware of the hierarchies of desire created by uneven economic development, and are explicit about the pain such desire causes rural students who want to "succeed." Their visions of education are more likely to help students counter exclusionary normative categories—of what is modern and what is backward, of what is failure and what is success, and more likely to help female students simultaneously construct, respond to, and resist the implications of familiar discrimination and newly emerging urban-centric subject positions. Photovoice can also sharpen the agency of teachers taking identity work seriously as a way of empowering girls.

Photovoice is limited in its capacity, however, to move critical awareness beyond the lives of individual girls and educators into fundamental policy change. And here it is important to remember the rule of thumb regarding educational policy. To succeed, "an educational agenda must be accompanied by a political agenda" (Stromquist 2003, 196–197). Two overlapping political campaigns in China are relevant to this point. Responding to the negative environmental and social impact of rapid economic growth, one campaign is

"people-centered development" (*yi ren wei ben*). The second campaign is to cultivate a "harmonious society" of "five balances": between economic and human development; between the domestic and external economy; between human beings and nature; between rural and urban development; and between coastal and interior development. These policies present a window of opportunity for educators and girls to appropriate the state's discourse on development, amplify into its functionalist core the lessons of micro-level advocacy and agency on behalf of adolescent girls' well-being, and engage at least in the middle space of Chinese society in a critical reevaluation of the consequences of inequality and developmentalism for adolescent girls' education.

NOTES

I would like to thank Indiana University for funding portions of this research.

1. Except where noted statistics are from the Children's Research and Information Center, www.cinfo.org.

2. Ministry of Education (2003).

3. Maher and Ling (2003).

4. Since 2002, the gap between urban and rural education has narrowed in part because China's population defined as "rural" has decreased. Simultaneously, resources have shifted to urban schools as rural schools are consolidated and boarding schools for rural students are constructed.

5. Tomasevski (2003).

6. This research is part of a longitudinal study of the SBP, designed to answer whether, how, and in what ways schooling improves girls' lives and futures.

7. The program borrows the name "spring bud" from a fifteen-year national campaign to raise "social funds" to insure access to out-of-school girls. See Ross (2004).

8. Whether *civil society* is a meaningful construct in the Chinese context has been a matter of debate. See Ross and Lin (2006).

9. Analysis was conducted by Wang Lei, Ran Zhang, and Phoebe Wakhungu of Indiana University. The study's methodology was adapted from Maslak (2005).

10. This network is a consortium of girls' secondary schools in China.

11. Photovoice has become popular among NGOs working in China, such as the Nature Conservancy and Save the Children.

12. Students use one camera to take images of their lives in school, a second camera to photograph images of life at home, and a third camera to capture images of their lives "in society." For each picture the interviewer begins by asking, "What is this picture and how is this a picture of you?" Students are asked to choose one picture in each arena they feel is most significant and explain why. In a second round of interviews students are organized in focus groups to discuss the diverse themes in their pictures together.

13. The realist tradition dominated research methodology until 1974, when Howard S. Becker argued that photographs in visual sociology reflected the photographer's standpoint. See Harper (1998).

REFERENCES

American Association of University Women (AAUW). 1999. *Gender gaps: Where school still fails our children.* New York: Marlowe and Company.

Anderson-Levitt, K. 2004. Reading lessons in Guinea, France and the U.S. *Comparative Education Review*, 48 (2): 229–253, 251.

Appadurai, A. 2000. Grassroots globalization and the research imagination. *Public Culture*, 12 (1): 1–19.

Arnove, R. 2005. Education around the world: To what ends? The case of China. Paper presented at the Comparative Education Society of Asia meeting, Beijing.

Brown, L. M. and C. Gilligan. 1992. *Meeting at the crossroads.* Cambridge: Harvard University Press.

Chan, K. and J. McNeal. 2004. *Advertising to children in China.* Hong Kong: Chinese University of Hong Kong.

Committee on the rights of the child, consideration of reports submitted by states parties under Article 44 of the Convention. September 30, 2005.

Denzin, N. and Y. Lincoln (Eds.). 2000. Handbook of qualitative research, second edition. Thousand Oaks: Sage.

EDI (Education for All Development Index). 2004. Global monitoring report, 2003/4. Paris: UNESCO.

Eisenhart, M. 2003. Educational ethnography, past, present and future: Ideas to think with. *Educational Researcher*, 30(8): 16–27.

Fong, V. 2004. *Only hope.* Stanford: Stanford University Press.

Gender and education for all, the leap to equality. 2003. Paris: UNESCO.

Gilligan, C. 1982. *In a different voice.* Cambridge: Harvard University Press.

Hannum, E. 2003. Poverty and basic education in rural China: Villages, households, and girls' and boys' enrollment. *Comparative Education Review*, 47 (2): 141–159.

Harper, D. 1998. On the authority of the image: Visual methods at the crossroads. In *Collecting and interpreting qualitative materials*, edited by N. K. Denzin and Y. S. Lincoln, 130–149. Thousand Oaks: Sage.

Haski, P. (Ed.). 2004. *The diary of Ma Yan: The struggles and hopes of a Chinese school girl.* New York: Harper Collins.

Hultqvist, K. and G. Dahlberg (Eds.). 2001. *Governing the child in the new millennium.* New York: RoutledgeFalmer.

Jeffery, L. 2001. Placing practices. In *Notes from China urban*, edited by N. Chen et al., 23–42. Durham: Duke University Press.

Li, D. and M. Tsang. 2003. Household decisions and gender inequality in education in rural China. *China: An International Journal*, 1 (2): 224–248.

Lin, J. and H. Ross. 1998. The potentials and problems of diversity in Chinese education. *McGill Journal of Education*, 33 (1): 31–49.

Liu, J., H. Ross, and D. Kelly (Eds.). 2000. *The ethnographic eye: An interpretive study of education in China*. New York: Falmer Press.

Maher, K. and H. J. Ling. 2003. *Achieving EFA in China*. Background paper for EFA Global Monitoring Report 2003/4. Paris: UNESCO.

Maslak, M. A. 2005. Re-positioning females in the international educational context: Theoretical frameworks, shared policies, and future directions. In *Global trends in educational policy*, edited by D. P. Baker and A. W. Wiseman, 145–172. Amsterdam, Boston: Elsevier.

Ministry of Education. 2003. Statistical report on education. Beijing: Ministry of Education.

Olesen, V. 2000. Feminisms and qualitative research at and into the millennium. In *Handbook of qualitative research*, edited by N. K. Denzin and Y. S. Lincoln, 215–255. Thousand Oaks: Sage.

Paulston, R. G. and G. LeRoy. 1982. Nonformal education and change from below. In *Comparative Education*, edited by P. G. Altbach, R. F. Arnove, and G. P. Kelly, 336–362. New York: Macmillan.

Rist, R. 2000. Influencing the policy process with qualitative research. In *Handbook of qualitative research*, edited by N. K. Denzin and Y. S. Lincoln, 1001–1016. Thousand Oaks: Sage.

Rodrick, D. 1997. *Has globalization gone too far?* Washington, D.C.: Institute for International Economics.

Ross, H. 2004a. "Schooling for one thousand girls, not one less." *1990 Institute Newsletter* (March): 5, 7–11.

———. 2004b. "Narrowing China's great divide, one thousand girls at a time." *1990 Institute Newsletter* (December): 10–15.

———. 2005b. Girls' education discourse and practice in China: Conceptualizing the sources and outcomes of reform. Paper presented at the First International Forum on Children's Development, Beijing, October 29.

———. 2006. Schools and gender stratification: The state, NGOs and transnational Alliances. In *Education, social change, and stratification in China*, edited by G. Postiglione, 25–50. Armonk: M. E. Sharpe.

Ross, H. with contributions by J. Lou, L. Yang, O. Rybakova, and P. Wakhungu. 2005a. Where and who are the world's illiterates: China. A Background Paper submitted to UNESCO Global Monitoring Report. Available online at www.portal.unesco.org/education/en/ev.php-URL_ID=43542&URL_DO=DO_TOPIC&URL_SECTION=201.html

Ross, H. and J. Lin. 2006. Social capital formation through Chinese school communities. In *Research in the sociology of education: Children's lives and schooling across societies*, edited by E. Hannum and B. Fuller, 43–69. Amsterdam, Boston: Elsevier.

Ross, H. and J. Shi (Eds.). 2003. Entering the gendered world of teaching materials, Part II. *Chinese Education and Society*, 36: 3.

Song, W. 2002. *Monitoring and evaluation of the implementation of the Beijing Platform for Action in China*. Bangkok: All-China Women's Federation.

Stromquist, N. P. 2002. *Education in a globalized world: The connectivity of economic power, technology and knowledge*. Lanham: Rowman and Littlefield.

————. 2003. Women's education in the twenty-first century. In *Comparative Education*, edited by R. Arnove and C. Torres. Lanham: Rowman and Littlefield.

Subject Group of Higher Education Research Institute of Beijing Institute of Technology. 2005. Opportunity to receive higher education: Narrowing gaps—report of the subject group of research on equity in China's higher education. Ford Foundation: Beijing.

Sutton, M. 1998. Girls' educational access and attainment. In *Women in the third world*, edited by N. P. Stromquist, 381–396. New York: Garland.

————. 2001. Policy research as ethnographic refusal: The case of women's literacy in Nepal. In *Policy as practice: Toward a comparative sociocultural analysis of educational policy*, edited by B. Levinson and M. Sutton, 77–99. Westport: Ablex.

Sutton, M. and B. Levinson (Eds.). 2001. *Policy as practice: Toward a comparative sociocultural analysis of educational policy*. Westport: Ablex.

Tobin, J. 1999. Method and meaning in comparative classroom ethnography. In *Learning from comparing*, edited by R. Alexander, P. Broadfoot, and D. Phillips, 113–134. Oxford: Symposium Books.

Tomasevski, K. 2003. *United Nations report on economic, social, and cultural rights, the right to education*. New York: United Nations.

Wang, C., M. A. Burris, and Y. P. Xiang. 1996. Chinese village women as visual anthropologists: A participatory approach to reaching policymakers. *Social Science Medicine*, 42 (10): 1391–1400.

Xue, X. 2002. *The good women of China*. New York: Pantheon.

Abbreviated Overview of Selected Policy Recommendations on Education and Training of Adolescent Girls and Adult Women

Fourth World Conference on Women Beijing 1995, Beijing Declaration and Platform for Action	World Summit for Social Development, Copenhagen 1995, The Copenhagen Declaration and Programme of Action	World Declaration on Education for All and Framework for Action, Meeting Basic Learning Needs, Jomtien 1990 Mid-Decade Meeting of the International Consultative Forum on Education for All, Final Report, Amman 1996	Fifth International Conference on Adult Education (CONFINTEA), Hamburg 1997, The Hamburg Declaration. The Agenda for the Future	General Assembly, Twenty-Third Special Session. Supplement No. 3, June 2000 Recommendations from Women 2000 Beijing +5[1]
1. Equal access to education in general: Eliminate discrimination in education 80(a). Advance the goal of equal access to education by taking measures to eliminate discrimination in education at all levels on the basis of gender, race, language, religion, national origin, age or disability, or any other form of discrimination and, as appropriate,	Commitment 5 (c) Promote full and equal access of women to literacy, education and training; Commitment 6 (c) Ensure that children, particularly girls, enjoy their rights and promote the exercise of those rights by making	Jomtien 1990 Art. III, 1. Basic education should be provided to all children, youth, and adults; Art. III, 3. The most urgent priority is to ensure access to, and improve the quality of, education for girls and women, and to remove every obstacle that	13. Raising awareness about prejudice and discrimination in society: (b) by taking measures to eliminate discrimination in education at all levels based on gender, race, language, religion, national or ethnic origin, disability, or any other form of discrimination;	52. Achieving gender equality and empowerment of women requires redressing inequities between women and men and girls and boys and ensuring their equal rights, responsibility, opportunities, and possibilities. Gender equity implies that women's, as

consider establishing procedures to address grievances;

87(c). Conduct an international campaign promoting the right of women and girls to education.

2. Equal access to primary and secondary education

80(b). By the year 2000, provide universal access to basic education and ensure completion of primary education by at least 80 percent of primary-school-age children; close the gender gap in

education, adequate nutrition, and health care accessible to them;

(e) Ensure full and equal access to education for girls and women;

39(d). Taking the necessary legislative, administrative, social and educational measures to protect and promote the rights . . . [of] the girl child.

Programme of Action 36 (a). By the year 2000, universal access to basic education and completion of primary education by at least 80 percent of primary-school-age children; closing the gender gap

hampers their active participation.

Jomtien 1990 Goals and targets proposed in Framework for Action: 8.3. Improvement in learning achievement such that an agreed percentage of an appropriate age cohort (e.g,

29. Promoting the empowerment of women and gender equity through adult learning: (a) by recognizing and correcting the continued marginalization and denial of access and of equal opportunities for quality education that girls and women are still facing at all levels; (d) by eliminating gender disparities in access to all areas and levels of education.

29. Promoting the empowerment of women and gender equity through adult learning: (b) by ensuring that all women and men are provided with the necessary education to meet their basic

well as men's needs, interest, concerns, experience, and priorities are an integral dimension of the design, implementation, national monitoring, and follow-up and evaluation, including at the international level of all actions in all areas.

55. Increased efforts are needed to provide equal access to education . . . and to ensure women's and girls' rights to education;

67(c). Accelerate action and strengthen political

Fourth World Conference on Women Beijing 1995, Beijing Declaration and Platform for Action	World Summit for Social Development, Copenhagen 1995, The Copenhagen Declaration and Programme of Action	World Declaration on Education for All and Framework for Action, Meeting Basic Learning Needs, Jomtien 1990 Mid-Decade Meeting of the International Consultative Forum on Education for All, Final Report, Amman 1996	Fifth International Conference on Adult Education (CONFINTEA), Hamburg 1997, The Hamburg Declaration, The Agenda for the Future	General Assembly, Twenty-Third Special Session. Supplement No. 3, June 2000 Recommendations from Women 2000 Beijing +5[1]
primary and secondary school education by the year 2005; provide universal primary education in all countries before the year 2015; 81(b). Provide universal access to, and seek to ensure gender equality in the completion of, primary education for girls by the year 2000.	in primary and secondary school education by the year 2005; universal primary education in all countries before the year 2015.	80 percent of 14-year-olds) attains or surpasses a defined level of necessary learning achievement.	needs and to exercise their human rights.	commitment to close the gender gap in . . . secondary education by 2005.

3. Eradicate illiteracy among girls and women

81(a). Reduce the female illiteracy rate to at least half its 1990 level, with emphasis on rural women, migrant, refugee, and internally displaced women and women with disabilities;

81(c). Eliminate the gender gap in basic and functional literacy, as recommended in the World Declaration on Education for All (Jomtien).

36(k). Reducing the adult illiteracy rate—the appropriate age group to be determined in each country—to at least half its 1990 level, with an emphasis on female literacy . . . and eliminating gender disparities in access to, retention in, and support for education;

52(d). Promoting the active participation of youth and adult learners in the design of literacy campaigns, education and training programs to ensure that the labor force and social realities of diverse groups are taken into account.

Jomtien 1990
Goals and targets proposed in Framework for Action:
8.4. Reduction of the adult illiteracy rate . . . with sufficient emphasis on female literacy to significantly reduce the current disparity between male and female illiteracy rates; Adult education and literacy should be linked to development activities and be responsive to the needs and aspirations of the learners. A focus on a customer service is crucial.

25. Linking literacy to the social, cultural, and economic development aspirations of learners: (b) by reducing the female illiteracy rate by the year 2000 to at least half of the 1990 levels, with emphasis on rural, migrant, refugee, and displaced persons, indigenous peoples, minorities, women, and women with disabilities.

78(a). Encourage the creation of training and legal literacy programs that build and support the capacity of women's organizations to advocate for women's and girls' human rights and fundamental freedoms;

95(f). Continue to strengthen and support national, regional, and international adult literacy programs with international cooperation in order to achieve a 50 percent improvement in the levels of adult literacy by 2015, especially for women.

Fourth World Conference on Women Beijing 1995, Beijing Declaration and Platform for Action	World Summit for Social Development, Copenhagen 1995, The Copenhagen Declaration and Programme of Action	World Declaration on Education for All and Framework for Action, Meeting Basic Learning Needs, Jomtien 1990 Mid-Decade Meeting of the International Consultative Forum on Education for All, Final Report, Amman 1996	Fifth International Conference on Adult Education (CONFINTEA), Hamburg 1997, The Hamburg Declaration, The Agenda for the Future	General Assembly, Twenty-Third Special Session. Supplement No. 3, June 2000 Recommendations from Women 2000 Beijing +5[1]
4. Higher education, continuing education, and lifelong learning				
80(c). Eliminate gender disparities in access to all areas of tertiary education by ensuring that women have equal access to career development, training, scholarships and fellowships, and by adopting positive action when appropriate;	Commitment 6 (b) Emphasize lifelong learning by seeking to improve the quality of education to ensure that people of all ages are provided with useful knowledge, reasoning ability, skills, and the ethical and social values required to develop their full capacities in health and dignity and to participate fully in	Jomtien 1990 Art. VIII, 2. Societies should also insure a strong intellectual and scientific environment for basic education. This implies improving higher education and developing scientific research. Close contact with contemporary technological and scientific knowledge should be possible at every level of education.	19. Opening schools, colleges, and universities to adults learners: (e) by creating opportunities for adult learning in flexible, open, and creative ways, taking into account the specificities of women's and men's lives.	93(e). With the full voluntary participation of indigenous women, develop and implement educational and training programs that respect their history, culture, spirituality, languages, and aspirations and ensure their access to all levels of formal and nonformal education, including higher education.
88(a). Ensure the availability of a broad range				

of educational and training programs that lead to ongoing acquisition by women and girls of the knowledge and skills required for living in, contributing to, and benefiting from their communities and nations;

88(c). Create flexible education, training, and retraining programs for lifelong learning that facilitates transitions between women's activities at all stages of their lives.

5. *Vocational training, science, and technology*

82(c). Provide information to women and girls on the availability and benefits of vocational training, training programs in science and

the social, economic, and political process of development. In this regard, women and girls should be considered a priority group;

52(e). Promoting lifelong learning to ensure that education and training programs respond to changes in the economy, provide full and equal access to training opportunities, secure the access of women to training programs.

Commitment 6
74(l). Providing equal access for girls to all levels of education, including nontraditional and vocational training,

Jomtien 1990
Art. V. The basic learning needs of youth and adults are diverse and should be met through a variety of delivery

67(a). Ensure policies that guarantee equal access to education and elimination of gender disparities in education, including vocational

Fourth World Conference on Women Beijing 1995, Beijing Declaration and Platform for Action	World Summit for Social Development, Copenhagen 1995, The Copenhagen Declaration and Programme of Action	World Declaration on Education for All and Framework for Action, Meeting Basic Learning Needs, Jomtien 1990 Mid-Decade Meeting of the International Consultative Forum on Education for All, Final Report, Amman 1996	Fifth International Conference on Adult Education (CONFINTEA), Hamburg 1997, The Hamburg Declaration, The Agenda for the Future	General Assembly, Twenty-Third Special Session. Supplement No. 3, June 2000 Recommendations from Women 2000 Beijing +5[1]
technology, and programs of continuing education; 82(e). Diversify vocational and technical training and improve access for and retention of girls and women in education and vocational training in such fields as science, mathematics, engineering, environmental sciences, and technology; [etc.];	and ensuring that measures are taken to address the various cultural and practical barriers that impede their access to education through such measures as the hiring of female teachers, adoption of flexible hours, care of dependants and siblings, and provision of appropriate facilities.	systems. Literacy programs are indispensable because literacy is a necessary skill in itself and the foundation of other life skills. Literacy in the mother tongue strengthens cultural identity and heritage. Other needs can be served by: skills training, apprenticeships, and formal and nonformal education programs in health, nutrition, population, agricultural		training, science and technology, and completion of basic education for girls, especially for those living in rural and deprived areas.

techniques, the environment, science, technology, family life, including fertility awareness, and other societal issues.

82(f). Promote women's central role in food and agricultural research, extension and education programs;

82(i). Develop policies and programs to encourage women to participate in all apprenticeship programs;

82(j). Increase training in technical, managerial, agricultural extension, and marketing areas for women in agriculture, fisheries, industry and business, arts and crafts, to increase income-generating opportunities, women's participation in economic decision-making, in particular through women's organizations at the grass-roots level, and their

Fourth World Conference on Women Beijing 1995, Beijing Declaration and Platform for Action	World Summit for Social Development, Copenhagen 1995, The Copenhagen Declaration and Programme of Action	World Declaration on Education for All and Framework for Action, Meeting Basic Learning Needs, Jomtien 1990 Mid-Decade Meeting of the International Consultative Forum on Education for All, Final Report, Amman 1996	Fifth International Conference on Adult Education (CONFINTEA), Hamburg 1997, The Hamburg Declaration, The Agenda for the Future	General Assembly, Twenty-Third Special Session. Supplement No. 3, June 2000 Recommendations from Women 2000 Beijing +5[1]
contribution to production, marketing, business, and science and technology;				
85(b). Provide funding for special programs, such as programs in mathematics, science, and computer technology, to advance opportunities for all girls and women.				See 93 (e).
6. Nonformal education				
82(b). Provide recognition to nonformal edu-				

cational opportunities for girls and women in the educational system;

83(r). Provide nonformal education, especially for rural women.

7. Equal participation in educational administration and policy- and decision-making

80(d). Create a gender-sensitive educational system in order to ensure equal educational and training opportunities and full and equal participation of women in educational administration and policy- and decision-making;

83(f). Take positive measures to increase the proportion of women gaining access

93(j). Apply and support positive measures to give all women ... equal access to capacity building and training programs to enhance their participation in decision-making in all fields and at all levels;

101(a). Take effective measures to address the challenges of globalization ... in the international economic policy decision-making

13. Raising awareness about prejudice and discrimination in society: (d) by recognizing and affirming the rights to education of women ... by ensuring equitable representation in decision-making processes;

29. Promoting the empowerment of women and gender equity through adult learning: (e) by ensuring that policies and

Fourth World Conference on Women Beijing 1995, Beijing Declaration and Platform for Action	World Summit for Social Development, Copenhagen 1995, The Copenhagen Declaration and Programme of Action	World Declaration on Education for All and Framework for Action, Meeting Basic Learning Needs, Jomtien 1990 Mid-Decade Meeting of the International Consultative Forum on Education for All, Final Report, Amman 1996	Fifth International Conference on Adult Education (CONFINTEA), Hamburg 1997, The Hamburg Declaration, The Agenda for the Future	General Assembly, Twenty-Third Special Session. Supplement No. 3, June 2000 Recommendations from Women 2000 Beijing +5[1]
to educational policy- and decision-making, particularly women teachers at all levels of education and in academic disciplines that are traditionally male dominated, such as the scientific and technological fields.			practices comply with the principle of equitable representation of both sexes, especially at the managerial and decision-making level of educational programs; (m) by promoting women's participation in decision-making processes and in formal structures.	process, in order to . . . guarantee the equal participation process of women . . . in the process of macroeconomic decision-making.

8. Teachers

83(d). Take actions to ensure that female teachers and professors have the same opportunities as and equal status with male teachers and professors, in view of the importance of having female teachers at all levels and in order to attract girls to school and retain them in school.

Jomtien 1990
Art. VII. In Enhancing the role of the teacher for quality education: A gender balance should be sought in the recruitment of teachers.

9. Relation with work and employment opportunities

82(a). Develop and implement education, training, and retraining policies for women, especially young women and women reentering the labor market, to provide skills to meet the needs of a changing

Commitment 5
(i) Formulate or strengthen policies and practices to ensure that women are enabled to participate fully in paid work and in employment;

32. Ensuring access to work-related adult learning for different target groups: (b) by ensuring that work-related adult education policies address the needs of self-employed workers and workers in

68(b). Create and maintain a nondiscriminatory and gender-sensitive legal environment . . . and eliminate [e] legislative gaps that leave women and girls without protection of their rights and without

Fourth World Conference on Women Beijing 1995, Beijing Declaration and Platform for Action	World Summit for Social Development, Copenhagen 1995, The Copenhagen Declaration and Programme of Action	World Declaration on Education for All and Framework for Action, Meeting Basic Learning Needs, Jomtien 1990 Mid-Decade Meeting of the International Consultative Forum on Education for All, Final Report, Amman 1996	Fifth International Conference on Adult Education (CONFINTEA), Hamburg 1997, The Hamburg Declaration, The Agenda for the Future	General Assembly, Twenty-Third Special Session. Supplement No. 3, June 2000 Recommendations from Women 2000 Beijing +5[1]
socioeconomic context for improving their employment opportunities; 82(d). Design educational and training programs for women who are unemployed in order to provide them with new knowledge and skills that will enhance and broaden their employment opportunities, including self-employment, and development of their entrepreneurial skills.	Commitment 6 (i) Strengthen the links between labur market and education policies, realizing that education and vocational training are vital elements in job creation and in combating unemployment and social exclusion in our societies.		the formal economy and facilitate access for women and migrant workers to training in nontraditional jobs and sectors; 33. Diversifying the contents of work-related adult learning; (d) by promoting gender-sensitive approaches within extension services, answering the needs of women in agriculture, industry, and services.	effective recourse against gender-based discrimination; 6(b). Address the barriers faced by women . . . in accessing and participating in politics and decision-making.

13. Women's health and reproductive health

83(k). Remove legal, regulatory and social barriers, where appropriate, to sexual and reproductive health education within formal education programs regarding women's health issues;

83(l). Encourage . . . the elaboration of educational programs for girls . . . and the creation of integrated services in order to raise awareness of their responsibilities and to help them to assume those

responsibilities . . . as well as the urgent need to avoid unwanted pregnancy, the spread of sexually transmitted diseases, especially HIV/AIDS.

Commitment 6
Establish or strengthen both school-based and community-based health education programs for children, adolescents, and adults, with special attention to girls and women, on a whole range of health issues, as one of the prerequisites for social development, recognizing the rights, duties, and responsibilities of parents and other persons legally responsible for children consistent with the Convention on the Rights of the Child.

29. Promoting the empowerment of women and gender equity through adult learning: (f) by combating domestic and sexual violence through . . . supplying information and counseling to increase women's ability to protect themselves from such violence;

38. Ensuring cultural and gender-specific learning programs:
(a) by extending health education for women and men;
(b) by eliminating cultural practices that are harmful and inhumane, and that result in the violation of women's sexual and reproductive rights.

71(h). Eliminate discrimination against all women and girls in access to health information, education, and health care services.

NOTES

This appendix is an abbreviated summary of selected conferences that addressed education for adult women and adolescent girls. It is not intended to provide a complete summary of all policies related to adolescent girls' and adult women's education. Thanks to Shirley Miske (Miske Witt and Associates) and Isabel Byron (UNICEF), whose offices were responsible for assembling parts of this appendix.

1. Available online at www.un.org/womenwatch/daw/followup/as2310rev1.pdf retrieved from www.un.org/womenwatch/confer/beijing5/ on July 25, 2006, A/S-23/10 Rev.1 (Suppl. No. 3) IV. Actions and initiatives to overcome obstacles and to achieve the full and accelerated implementation of the Beijing Platform for Action.

Contributors

David W. Chapman is the Wallace Professor of Teaching and Learning and former Chair of the Department of Educational Policy and Administration at the University of Minnesota. His specialization is in international development assistance. In that role, he has worked in over forty-five countries for the World Bank, the U.S. Agency for International Development, UNICEF, the Asian Development Bank, the InterAmerican Development Bank, UNESCO, and similar organizations. He has authored or edited seven books and over one hundred journal articles, many of them on issues related to the development of education systems in international settings.

Amita Chudgar received her PhD in Economics of Education from Stanford University. Currently she is an assistant professor at Michigan State University's College of Education. Amita's research has focused on equity in access and achievement in Indian education using large-scale data sets.

Peter B. Easton is Associate Professor of Adult and Continuing Education at Florida State University. His research focuses on the transformational processes of empowerment programs in developing countries, the assessment of adult literacy and livelihood training programs in Africa, and the uses of indigenous knowledge in similar contexts. He has lived for ten years in West Africa and worked on a shorter-term basis in Southeast Asia and the Caribbean.

Jackie Kirk is a specialist in education in emergencies and humanitarian contexts, with a special focus on gender and teachers, and is an advisor to the International Rescue's Child and Youth Protection and Development Unit. She is also a research associate and consultant based at the McGill University's Centre for Research and Teaching on Women (MCRTW).

Cathryn Magno currently teaches educational policy and leadership as an Associate Professor at Southern Connecticut State University. Holding a PhD in Comparative and International Education from Columbia University, she is active locally and globally in research that bridges education, sociology, and politics. Through her work on defining and documenting political capital in underrepresented groups, she maintains a focus on the contribution of education to human rights and social justice.

Caroline Manion is a PhD candidate in the Sociology and Equity Studies in Education/Comparative, International, and Development Education program at the Ontario Institute for Studies in Education of the University of Toronto. Her area of specialization is gender and education policy in sub-Saharan Africa.

Mary Ann Maslak is Associate Professor of Education at St. John's University. Her research focuses on girls' and women's education in South and East Asia. Dr. Maslak has served as the chair of the Gender and Education committee for the Comparative and International Education Society (2001–2004) and is currently on the organization's board of directors. Among other distinctions, she was awarded the Fulbright Research Fellowship (2005–2006) in the People's Republic of China for her project entitled "Toward Meeting National and International Goals: The Study of Gender Inequity in Chinese Ethnic Minority Communities."

Rebecca Miles is Associate Professor in the Department of Urban and Regional Planning and the Center for Demography and Population Health at Florida State University. Her interests include investigating the effects of the social environment on health and public safety, and the influence of socioeconomic development on gender systems and health. Her work has focused on the Middle East and West Africa as well as the United States.

Shirley J. Miske is President and Senior Educational Consultant, Miske Witt and Associates, St. Paul, Minnesota. Her areas of expertise in the development of education systems internationally include gender and education, girls' education, education policy, and improving education quality from primary through higher education. Miske and her associates conduct research, evaluations, and trainings in sub-Saharan Africa, Asia, the Caribbean, Latin America, Eastern Europe, and the Middle East.

Karen Monkman is Associate Professor of Social and Cultural Foundations of Education, Department of Educational Policy Studies and Research, DePaul University. Her research focuses on education's relationships to gender, community change, globalization, and immigration in Africa, Latin

America, and the United States. She teaches courses in comparative education, sociocultural foundations of education, and qualitative research methods, and has developed a transnational program for educators in Mexico and the United States. Her advocacy work with women and immigrant groups uses nonformal education and community development approaches to promote empowerment of individuals and communities.

Lucy Mule is Assistant Professor in the Department of Education and Child Study, Smith College. Her research interests include comparative education, literacy education, multicultural education, and teacher education. She also taught high school in Kenya for six years.

Flavia Ramos is a Senior Education Adviser with Juárez and Associates (J&A) in Washington, DC. She has also served as a consultant to international organizations and government agencies (USAID, USDOL, and Johns Hopkins University) in the areas of nonformal education, training, and materials development.

Heidi Ross is Professor of Educational Policy Studies and the Director of the East Asian Studies Center at Indiana University. She has served as the president of the Comparative and International Education Society, is the coeditor of the *Comparative Education Review*, and has published widely on Chinese education and society.

Vilma Seeberg is Associate Professor for International/Multicultural Education at Kent State University. She publishes on international and multicultural education, and stays involved with multicultural education reform in local schools. She authored two books on basic education in the People's Republic of China (2000), *The Rhetoric and Reality of Mass Education in Mao's China* and *Literacy in China: The Effect of the National Development Context and Policy on Literacy Levels, 1949–79*. She is an active mbmer of the Comparative and International Education Society.

Sandra L. Stacki is Associate Professor in the Department of Curriculum and Teaching at Hofstra University. Her scholarly and teaching interests include gender, teacher education and empowerment, critical and feminist theory and pedagogy, qualitative and reminist inquiry, middle level education, education in India, and policy analysis in international and national education reform.

Nelly P. Stromquist is Professor of Comparative and International Education in the Rossier School of Education at the University of Southern California. She is interested in issues of gender equity, state policy, and social change. Two

of her most recent books are *Feminist Organizations and Social Transformation in Latin America* (2007) and *Education in a Globalized World: The Connectivity of Economic Power, Technology, and Knowledge* (2002). She is former president of the Comparative and International Education Society and a 2005–2006 Fulbright New Century Scholar.

Alexander W. Wiseman is Associate Professor of Transcultural, Comparative, and International Education at Lehigh University. He writes extensively on national school systems in international contexts and is the author of several books on this topic including *The Employability Imperative: Schooling for Work as a National Project* (2006) and *Principals under Pressure: The Growing Crisis* (2005).

Rebecca Winthrop has worked with displaced and conflict affected populations for over twelve years. She is currently the Senior Technical Advisor for Education at the International Rescue Committee, a humanitarian aid NGO with education programs in twenty countries around the world, where she works closely with programs in Africa and Asia. Previously, she worked with migrant and conflict-affected populations on nonformal education, gender equity, and community development issues with a range of nongovernmental and UN agencies. She teaches courses on education in contexts of conflict at Columbia University, Teachers College. She holds a master's degree from Columbia University's School of International and Public Affairs.

Index